The mission of the Frederic Remington Art Museum is to collect, exhibit, preserve, and interpret the art and archives of Frederic Remington. The Museum fosters an appreciation for and an understanding of the artist by educating its audience in the visual arts and by providing a context for Remington's life in Northern New York. The Museum is accredited by the American Association of Museums.

Major funding for this catalogue was provided by the Sweetgrass Foundation. First published in an edition of 14,500 hardcover copies and 1,000 paperback.

Unless otherwise noted, all images and artworks are gifts of the Remington Estate.

DESIGNERS: Stephen Horne and Kevan Moss, Paul Smiths, New York
PRINTER: Brodock Press, Utica, New York

Library of Congress Cataloging-in-Publication Data

Dippie, Brian W.
 The Frederic Remington Art Museum Collection / by Brian W. Dippie.
 p. cm.
 Includes bibliographical references.
 ISBN 0-8109-6711-1 — ISBN 0-9651050-1-6 (pbk.)
 1. Remington, Frederic, 1861–1909—Catalogs. 2. West (U.S.)—In art—Catalogs.
 3. Art—New York (State)—Ogdensburg—Catalogs. 4. Frederic Remington Art
 Museum—Catalogs. I. Remington, Frederic, 1861–1909. II. Frederic Remington
 Art Museum. III. Title.

 N6537.R4 D57 2000
 709'.2—dc21 00-049339

Published in 2001 by Frederic Remington Art Museum, Ogdensburg, New York
Distributed by Harry N. Abrams, Incorporated, New York
No part of the contents of this book may be reproduced without the written permission of the publisher.

Frederic Remington Art Museum
303 Washington Street
Ogdensburg, NY 13669
www.fredericremington.org

Harry N. Abrams, Inc.
100 Fifth Avenue
New York, NY 10011
www.abramsbooks.com

THE FREDERIC REMINGTON ART MUSEUM COLLECTION

by Brian W. Dippie

Frederic Remington Art Museum
Ogdensburg, New York

Distributed by Harry N. Abrams, Inc., New York

Table of Contents

Foreword

Frederic Remington, like most artists working today and in years past, had no idea a museum might be established in his honor. Thanks to the thoughtfulness and unflagging hard work of his widow and her sister, his museum came to be. It was Eva Caten Remington and Miss Emma Grace Caten along with some of Remington's lifelong friends that conceived the idea and worked so hard to bring it to fruition. Without their determination to create a lasting memorial, the artworks described herein would probably be scattered across the nation, or absorbed into a larger institution, rather than remaining together in Frederic's beloved North Country.

It was these two sisters, who, after Frederic's death in 1909 managed the estate and upon their passing, gave it to the people of Ogdensburg in care of the Ogdensburg Public Library board of trustees. The collection was managed as the Remington Art Memorial until our chartering by the New York State Board of Regents in 1981, when we gained a board of trustees independent of the library board. We express our appreciation to the current Ogdensburg Public Library trustees and their chairman, Dr. Michael Roarke, and all former trustees for their interest and support during the difficult years when the museum was under their sole purview.

Thanks are also due to the current museum trustees presided over by Mr. Christ Mellas and all former trustees who have helped the Museum's steady improvement to a point where a catalog of our collection is a natural achievement. Special thanks must go to former board president Dr. Robert E. Hentschel who presided over the board at an especially active time and traveled to many distant meetings as we sought Dr. Brian Dippie as our catalog author.

Even though the Frederic Remington Art Museum is a separate entity, it has always received generous financial and political support from the Ogdensburg city administration and area citizens. For this we are thankful.

No task of this magnitude is ever accomplished without people working "behind the scenes" on requirements for the catalog or other duties which must be accomplished to allow work on the main project. Our appreciation is extended to Ms. Laura Foster, Curator, without whose help and hard work this scholarly catalog would not have been possible, and to former staff members Mrs. Beverly Walker, Mrs. Ruth Hunter, Mr. James Barney and Mrs. Lois Wright. Thanks also to current staff; to Fr. Ron Mrozinski, Ms. Debra Ghize, Mrs. Laura Shea, Ms. Lynn Clark, Mrs. Wendy Flood, Ms. Gwynn Hamilton; to the many student interns who worked on the project; and to our humble and dedicated curatorial volunteer, Mr. Philip D. Parks.

I would also like to acknowledge and thank those professionals and institutions that supported the production of this catalog. They include Allan and Kate Newell, who are the museum's best supporters, Mr. Allen Burns for his extensive photography work on this project, the National Endowment for the Arts, the New York State Council on the Arts, and the Sweetgrass Foundation for their financial support, Ms. Kevan Moss and Mr. Stephen Horne for their excellent design work and production management, Mr. Peter Hassrick and Mr. David Tatham for their wise counsel, and lastly, sincere thanks to Dr. Brian Dippie for his enthusiasm for the task of creating a catalog we can all take pride in that will honor the name of the Frederic Remington Art Museum.

Lowell McAllister
Executive Director

Acknowledgments

This is the catalog of the Frederic Remington Art Museum, and I have incurred personal and professional debts while researching in Odgensburg. Laura A. Foster, Curator, was committed to the project from the beginning and has provided the informed collegiality that makes research such a pleasure, while Lowell McAllister, Executive Director, maintained a warm, enthusiastic atmosphere and was ever supportive of my endeavors. He and his family also entertained me royally—literally, since he treated me to a buggy ride one July evening, and everyone knows that horse racing is the sport of kings. JoAnn, Luke and Josh McAllister treated me to some North Country hospitality. Bob Hentschel gave me a boater's introduction to the St. Lawrence. Kevan N. Moss of Paul Smiths, New York, co-designer of this catalog, set the timeline for the project's completion, which I violated and she rescheduled. I greatly appreciate her understanding.

Besides full access to the manuscript collection of the Frederic Remington Art Museum, I have received courteous cooperation in my Remington researches from the staffs of the Bancroft Library, University of California, Berkeley; the Glenbow Museum, Calgary, Alberta; the Henry E. Huntington Library, San Marino, California; the Library of Congress, Washington, D.C.; and the McCracken Research Library, Buffalo Bill Historical Center, Cody, Wyoming. I owe a special debt of gratitude to Paul Fees, Senior Curator, for companionship while I was researching in Cody. I am also grateful for the microfilm series *Archives of American Art*, which proved invaluable, and for the professional expertise of the staff of the Interlibrary Loans Service at the University of Victoria, who located everything I asked for.

Several Remington scholars have shared their expertise with me. David Tatham, Professor of Fine Arts, Syracuse University, Syracuse, New York, and Peter H. Hassrick, Charles M. Russell Chair, University of Oklahoma, Norman, provided helpful critiques of this manuscript and saved me from some embarrassing errors. Michael Greenbaum gave me access to pertinent portions of his detailed study of Remington bronzes, and Melissa Webster, with the Remington catalogue raisonné project at the Buffalo Bill Historical Center, swapped information.

Both works—Greenbaum's *Icons of the West: Frederic Remington's Sculpture* and Hassrick and Webster's *Frederic Remington: A Catalogue Raisonné of Paintings, Watercolors and Drawings*—have appeared since I completed the manuscript for this catalog, and are destined to become standard reference tools. Since I enjoyed access to both prior to publication, I have limited revision here to referencing the *Catalogue Raisonné*'s number for works in the Frederic Remington Art Museum collection. This number appears at the end of each formal entry, following the museum accession number, as "CR[number]."

I am also personally indebted for various kinds of assistance to Jan Brenneman, Director, Sid Richardson Collection of Western Art, Fort Worth, Texas; James D. McLaird, Dakota Wesleyan University, Mitchell, South Dakota; Thomas Minckler, Thomas Minckler Gallery, Billings, Montana; Joseph T. O'Connor, Vancouver, British Columbia; Timothy G. O'Connor, Victoria, British Columbia; Rick Stewart, Executive Director, Amon Carter Museum, Fort Worth, Texas; Shawn Thompson, Gananoque, Ontario; and Darlene Wilson, Appalachian Center, University of Kentucky, Lexington, Kentucky.

Friends and family are an author's mainstay, and I am fortunate in mine. Thanks to Arlene, Angus and Jesse McLaren, Charles W. Cowan, F. Joy McBride, and all the others who have cared. My father, Thomas L. Dippie, kept an eagle eye out for clippings relevant to my work. Blake and Scott are now grown-up companions as well as my sons, and I cherish their company, along with that of Blake's wife, Melanie. Donna, who has stuck by me long enough to know better, believed that I had the capacity to master new technology and bought the word processor on which this book was written. Thank you, Donna—for everything.

Brian W. Dippie

A House, a Legacy, a Collection

It is amazing to find that despite the checkered history of the Frederic Remington Art Museum's collection the Museum is still a place where one feels the artist's presence. The first thing visitors want to know when they enter is, "Did Remington live here?" The answer is no, but this is the place to know him best. The house has been the center of the Museum since its founding in 1923. It is a place Remington surely visited on his many trips to Ogdensburg, the city where his family moved when he was eleven. In 1900 it was remodeled from its original 1810 appearance by Remington's friend George Hall, and it was as Hall's guest that Eva Caten Remington and her sister, Emma Caten, lived here from 1915 through 1918. With the rich quarter-sawn oak interiors, Remington would have felt quite at home. The lobby still takes visitors' breath away.

The depth and breadth of the Museum's Remington holdings is unmatched. The great majority of items came directly from Eva Remington's 1918 estate. Many of them retained for posterity by the artist's widow. They include annotated scrapbooks, endless pages of notes, photographs, even the cigars that were in his pocket before he died. The artist's library is displayed on the second floor of the historic house, near the Remingtons' tall, surprisingly narrow bed and other furniture. Entering the Museum, visitors are treated to an exhibit of fine art from the Remington home in the room that was once George Hall's dining room. On the way to the art galleries, they can see Remington's easel, paintbrushes and sculpting stand, and also such diverse items as his hockey stick and his elk's tooth cufflinks.

So, though the artist never lived here, the range of Remington art and artifacts housed in the Museum, the fact that his widow lived here, and the turn-of-the-century aesthetic of the place all contribute to the feeling that this is where Remington is found. The collection of Remington's paintings, drawings and bronzes represented in this catalog is, of course, the most important thing we have, but it's the combination of all the disparate elements that lets you imagine Frederic Remington here, perhaps smoking cigars and drinking whiskey into the night with any member of his elite circle of friends.

Sitting in the wood-paneled lobby on a quiet day in the light of Remington's Tiffany turtle-back chandelier, one feels part of a continuum stretching from 1923 when the Museum (which until 1981 was known as the Remington Art Memorial) was staffed by just one woman, curator Sarah Raymond, who was succeeded by Ursula Hornbrook. One might expect that the Museum and its collection, geographically so far off the beaten track, has slumbered unmolested until the late 20th century. However, the history of the collection is far more complex and precarious.

The Remington Art Memorial

Frederic's widow, Eva (1859-1918) left most of her Frederic Remington collection to the people of Ogdensburg in care of the Board of Trustees of the Ogdensburg Public Library. The Remington Art Memorial opened on July 19th, 1923, in the historic Parish Mansion. This core collection still constitutes the majority of paintings and bronzes owned and displayed by the Museum. The archival elements of the gift—from the artist's diaries to hundreds of sketches and photographs, as well as ledgers and checkbooks—provide information meaningful to researchers looking into any aspect of Remington's work or personality.

The oil paintings Eva Remington left are largely from the last few years of the artist's life (1861-1909). We know from various records that Eva sold many paintings during the nine years she survived her husband. An ongoing question is why these particular paintings remained in her possession?" Were they her favorites, or the least favorite of buyers? The contents of Eva Remington's diaries, made available through the 1996 gift of Mr. William Deuval, raise additional questions about the composition of our holdings. For instance, on Friday, June 27th, 1913, Eva writes, "In the P.M. I washed Frederic's paintings and varnished them and made a great improvement." (Museums and private collectors are now working to remove yellowed varnish from many of Remington's paintings.) On Thursday, March 18th, 1915, she records, "Went over things in Frederic's desk & burned a lot of photos, etc." We may never know what she deleted from the historic record, or, just as compelling, why she did it. Clearly our holdings were not preserved in a time capsule before they came to us, and parts of the collection were compromised even after the works entered the Museum.

It is hard to get a good view of the Museum's early history since no files exist pertaining to daily operations prior to the late 1960s. The archives contain early correspondence between John C. Howard (Eva Remington's executor) and the Library of Congress pertaining to copyright renewals, as well as correspondence between Sarah Raymond and Ricardo Bertelli of the Roman Bronze Works, where most of the bronzes were cast. One must instead rely on the minutes of the Ogdensburg Library Board of Trustees and several scrapbooks of period press clippings and notes. Formal records of the Museum's holdings were not initiated until 1966.

Early Patronage

The Museum's first and most important patrons were Eva Caten Remington, who founded the collection with her bequest in 1918; John C. Howard, Remington's life-long friend and the Estate of George Hall, Howard's employer, which provided the building to house the collection. The first recorded addition to the Museum's holdings was a gift from Remington's friend and fellow sculptor Sally James Farnham of her busts of President Warren Harding and Marshal Ferdinand Foch. Her bronze *Horse and Rider* was already part of the Remingtons' own art collection. Frederick T. Haskell, an Ogdensburg native, donated a diverse collection of minor European and American paintings and bronzes with the wish that they be sold to fund the purchase of works by Remington. The Haskell collection was displayed in one of the Museum's crowded rooms. The first purchases of Remington art were made by selling art from the Haskell collection. Some examples are: *The Gallic Captive* (purchased in 1947), *The Last March* (purchased in 1948), and *The Apaches Are Coming* (purchased in 1950).

Frederick T. Haskell also gave the Museum a set of Belter dining room furniture and other household items from the Parish family who had built the Parish Mansion and occupied it until 1859 when George Parish auctioned the household property and returned permanently to Europe. Parish was so prominent in the region, as a landowner and employer, and the auction so memorable that auctioned items still retain their history. Parish tables, chairs, footstools and candlesticks still come to the Museum as donations 140 years later. The Parish Mansion and the history of its original occupants has become an unstated, secondary mission of the Museum.

Questionable Patronage

In 1945 Dr. Harold McCracken, who can now be seen as the collection's anti-hero, began a series of visits to Ogdensburg and Canton to interview those who had known Frederic Remington and to study the Museum's art and archives in preparation for his book *Frederic Remington: Artist of the Old West*, published in 1947. McCracken took the initiative to advise the Museum on the purchase of Remington originals and "Remingtoniana." In fact, he made the purchases himself, acting as the Museum's agent and using funds raised by the sale of art

from the Haskell collection. In the late 1940s and early 1950s, the period of McCracken's involvement with the Museum, the president of the Board of Trustees of the Ogdensburg Public Library and the Memorial was Franklin Little, the editor of *The Ogdensburg Journal*. Little was an enthusiastic adherent to McCracken's advice and used his newspaper to celebrate the Museum and rally public support for its activities.

One clipping states that in 1946 Harold McCracken and curator Ursula Hornbrook found a cache of Frederic Remington oil studies in an attic room at the Museum. This discovery became the impetus for the 1954 sale of 452 objects including Native American, Western and military artifacts and 110 oil paintings and studies that comprised most of Frederic Remington's "Indian" or "studio" collection. Upon the advice of Harold McCracken, the Board of Trustees of the Ogdensburg Public Library sold this collection to Knoedler Gallery in New York for $10,000 in cash plus $10,000 worth of painting conservation and re-framing, done by Knoedler. The Museum used the money to replace the coal-burning furnace and paint the building, inside and out, with the work planned and overseen by a Mr. Davidson of Knoedler Gallery. The press focused not on the sale of this collection, but on the accompanying 1955 exhibition at Knoedler, which traveled to a second venue at the Ft. Worth Art Center. In addition to the works that had been sold to Knoedler, the exhibition included many bronzes and oil paintings by Remington that were loaned by the Library Board. When the Memorial's loaned works were returned and the refurbishments were done, the Memorial reopened with a ribbon-cutting ceremony held on June 31, 1955. It is our great consolation that the studio collection, purchased from Knoedler by the Coe family, was later donated by the Coes to the Buffalo Bill Historical Center in Cody, Wyoming, as the founding collection of the Whitney Gallery of Western Art. Harold McCracken was the Center's first director.

By today's standards it would be considered unethical to sell a Museum's collection to benefit its physical plant.

Gains and Losses

Emma Caten, Eva Remington's sister, remained in Ogdensburg after Eva's death and lived in the city until her own death in 1957. Miss Caten maintained a continual presence at the Museum and served on the Ogdensburg Library Board. Remington's sister-in-law outlived him by nearly four decades, and she deserves ample credit for her efforts to keep Remington's legacy alive. She certainly believed in Harold McCracken as Remington's long-sought biographer and proponent, and there is ample evidence that she gave him many gifts of Remington art and property left to her by her sister. Miss Caten owned numerous Remington sketches and paintings, art from the Remington home, household furniture, and other objects. Many of these items rejoined the Museum's collection upon Miss Caten's death, but she gave away an unknown number of Remington items to friends and family. Three separate donors have recently given the Museum one of Remington's paperweights, his ivory folding bone and six of Eva Remington's diaries, all of which had belonged to Miss Caten. There are even tales of boys receiving original Remington art in payment for shoveling Miss Caten's driveway. It is easy now to lament the losses to the collection.

At some unfortunate point in the collection's history an unknown quantity of Remington sketches, torn from his sketchbooks, were sold at the front desk of the Memorial for 75 cents and a dollar apiece. We know this because many of our loose sketches still have price marks in the corners. In the early 1990s, two gentlemen visiting the Museum from Canton, Ohio carried with them dozens of these sketches that had come to them through a relative who had lived in Ogdensburg long ago. The Museum can only hope that some of the lost sketches can be returned to the collection.

The Maturing Museum

In 1973 Remington Art Memorial staff re-created Remington's Ridgefield, Connecticut, studio in the west room of the ground floor. They bought and borrowed hundreds of artifacts to approximate Remington's own items that had been sold in 1954. The Museum has more recently opted to display only artifacts that belonged to Remington, making no attempt to 're-create' his studio. The Museum is pleased to have the long-term loan of six of Frederic Remington's firearms from the Buffalo Bill Historical Center which were part of the 1954 sale to Knoedler. In addition, the Museum is fortunate to have an exchange program with the Buffalo Bill Historical Center which allows the Museum to borrow and display fifteen North Country based oil studies—part of the 1954 sale as well—in exchange for the loan of a major Western Remington oil paintings from our collection.

Contemporary Benefactors

The Newell family, whose notable ancestor, Allan Albert Newell, was a boyhood friend of Frederic Remington, has provided the most meaningful patronage since Eva Remington's original gift. In the last quarter-century the Newells have provided major support for two capital expansion projects and have offered a steady stream of support for the Museum's priority needs, including, at times, salaries, Remington acquisitions, art and furniture conservation—even the printing of this catalog.

In 1976 William Allan Newell funded an addition to the historic Parish Mansion to provide two modern galleries, an art storage vault, and a small archives room. The Newell Wing provided a separate, fire-safe structure for the storage and display of Remington's art. The Parish Mansion was then developed as a historic house, emphasizing its early history (1810-1859) when it was the home of the Parish family and the three years (1915-1918) when it was occupied by Eva Remington.

The Museum expanded again in 1997, adding gallery space and a collection work room in an improved Newell Wing. The wing physically links the Parish Mansion with the historic 311 Washington Street house that provides Museum offices and public reception rooms. The improvements go far beyond increasing gallery space and collection work areas. The architect and exhibit designer carried the 19th-century oak motifs and period colors—of which Remington would have approved—throughout the gallery spaces, providing visual continuity between the old and new parts of the Museum.

Collecting Today

Since 1985, the Museum has pursued an acquisitions program, collecting art and property connected to Frederic Remington or the Parish family. Due to the ever-escalating values of Remington art, acquisitions are now achieved almost entirely through the gifts of generous donors. The Museum is currently poised to begin an endowment campaign and has a growing foundation. This funding will further the Museum's endeavors to create effective exhibits, maintain and expand a strong collection, improve research capabilities and develop education programming that encourages understanding of Remington and perpetuates a sense of the artist's presence.

Laura A. Foster
Curator
October 6, 2000

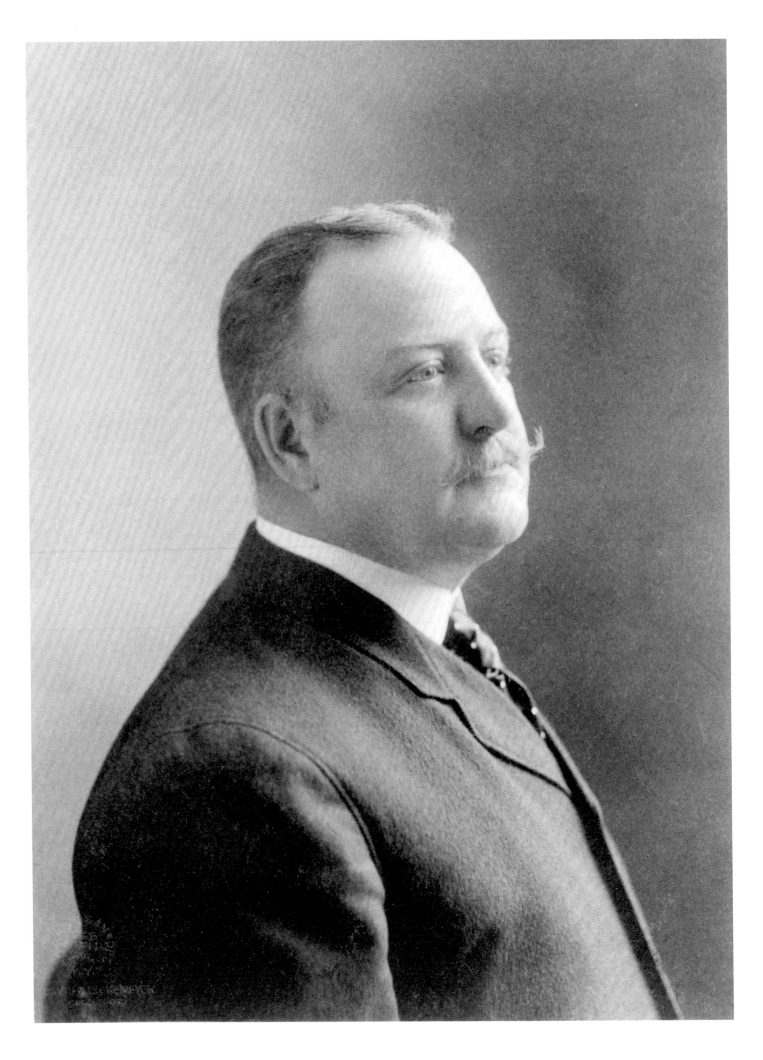

Frederic Remington (1861–1909)
Photograph by Davis and Sanford Co.
New York, NY
FRAM 1918.76.15

Introduction

Frederic Remington, America's most popular Western artist at the end of the nineteenth century, is the most controversial today. No one, least of all his critics, would deny his cultural importance; the issue is the message his art conveys. A century ago Remington was widely recognized as the man who had made the West "his own."[1] Today, he is the victim of radical surgery. Violently extracted from his times, he has been judged—relentlessly—by current standards and found guilty on every charge. He now serves as a particularly unpleasant exemplar of late nineteenth-century elitism, sexism, racism and jingoism.

Perhaps his subject matter doomed him to such a role. Born in Canton, New York, on October 4, 1861, he was steeped in the Civil War and raised, full of yearning admiration, in the long shadow cast by veterans like his father, Colonel Seth P. Remington, Eleventh New York Cavalry. He went on to specialize in soldiers and the "grand frontier," the final act in what Theodore Roosevelt called "the winning of the West." The West gave ample scope to Remington's boyhood passion for things military and the out-of-doors—riding, boating, fishing and hunting. An instinctive imperialist, he championed the army; a social snob, he reviled labor protesters as anarchists, deplored the new immigrants flocking to America, and proclaimed the West a last bastion of old-fashioned Anglo-Saxon values. Remington particularly doted on colorful Western vestiges—the panoply of frontier "types" that he, like the historian Frederick Jackson Turner, believed defined a distinctive American character that was short on the niceties but long on self-reliance and courage. But frontiering was finished by the 1890s, and with it the mountain men, prospectors, soldiers, scouts and free-riding cowboys, who along with Indians and Mexicans, peopled his art. Remington sighed at their passing, and made himself their pictorial historian.[2]

Today, some do not like what Frederic Remington liked, and do not like what his art has to say. His work invites a painful confrontation with a past that will not conform to current fashions. "The conquest and settlement of the West… has been the stupendous feat of our race for the century that has just closed," Roosevelt, as vice president, asserted in a speech delivered in Colorado in 1901:

In all the history of mankind there is nothing that quite parallels the way in which our people have filled a vacant continent with self-governing commonwealths, knit into one nation. And of all this marvelous history perhaps the most wonderful portion is that which deals with the way in which the Pacific coast and the Rocky Mountains were settled.

The men who founded these communities showed practically by their life-work that it is indeed the spirit of adventure which is the maker of commonwealths. Their traits of daring and hardihood and iron endurance are not merely indispensable traits for pioneers; they are also traits which must go to the make-up of every mighty and successful people. You and your fathers who built up the West did more even than you thought; for you shaped thereby the destiny of the whole republic, and… profoundly influenced the course of events throughout the world….

Such is the record of which we are so proud. It is a record of men who greatly dared and greatly did; a record of wanderings wider and more dangerous than those of the Vikings; a record of endless feats of arms, of victory after victory in the ceaseless strife waged against wild man and wild nature. The winning of the West was the great epic feat in the history of our race.[3]

How could Roosevelt's generation have guessed that a hundred years later some of their descendants, still occupying the lands they settled, would express more shame than pride in the conquest of "wild man and wild nature?" They agreed with their future president that the advancement of civilization was a national duty, "a great and righteous task" of "incalculable benefit to mankind." As Roosevelt told a crowd in Minnesota in 1901, "The men who with ax in the forests and pick in the mountains and plow on the prairies pushed to completion the dominion of our people over the American wilderness have given the definite shape to our nation. They have shown the qualities of daring, endurance, and far-sightedness, of eager desire for victory and stubborn refusal to accept defeat, which go to make up the essential manliness of the American character."[4] How could Roosevelt's audience have guessed that the feats he extolled would, a century later, be

widely repudiated, or that an artist like Frederic Remington, who gave them visual form, would be characterized as the champion of a "blatantly racist conception of American manhood?"[5]

For Frederic Remington, after all, was much like the nation that produced him. Reared in the rural outback of northern New York State, he grew up in an America rapidly transforming into an urban, industrial power. In the summer of 1876, when he was an impressionable fourteen-year-old thrilling to the improbable news of Custer's Last Stand on the Little Bighorn River in Montana, a great exposition marking the centennial of the Declaration of Independence was attracting thousands to Philadelphia. Its theme was a "Century of Progress," but fair-goers met the future as well as the past in Machinery Hall, where such marvels of modern technology as the telephone and the internal combustion engine vied for attention.[6] Remington was just thirty-one, though already preeminent as a Western illustrator, in 1893 when Chicago hosted another world's fair, this one celebrating four centuries of progress ("the marvelous era of expansion," as Roosevelt put it, "which began with the discoveries of Columbus").[7] Prognosticators confidently forecast more of the same: there could be no limit on American growth or universal improvement. "I think that I can see, a hundred years hence, an ocean-bound republic over every part of which the Stars and Stripes will proudly wave," a Treasury Department official wrote at the time, "an American republic which shall embrace… all the remainder of the North American continent now under British, Mexican, or minor domination." "With the record of the past to study, we have reasonable ground for believing that men will grow wiser, better, and purer in the years to come," a Kansas senator added. "Onward and upward will move the multiplying millions of earth…"[8] Caught up in the unfolding drama of American progress, Remington's contemporaries naturally admired his vivid record of the final phase of the winning of the West. Today it is easier to reject both the message and the messenger.

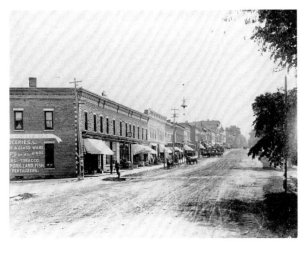

Main Street in Canton, NY, 1880
FRAM 1918.76.160.288

Seth Pierpont Remington (1834–1880), ca. 1875
The R. W. Norton Art Gallery, Shreveport, LA
Remington's watercolor portrait is based on a
photograph of his father, the Colonel.

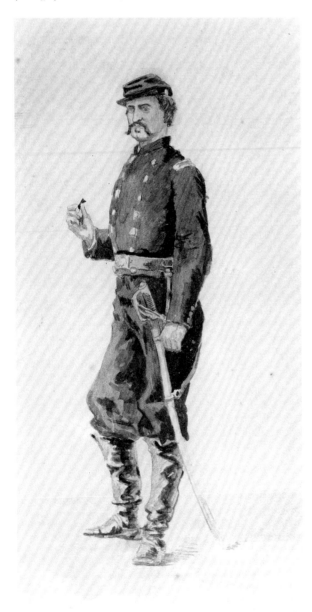

The only child of Seth and Clara B. (Sackrider) Remington, Frederic grew up in Canton and in Ogdensburg, eighteen miles to the northwest, where the family moved in 1870 when his father, the editor of Canton's weekly *St. Lawrence Plaindealer*, was appointed Collector of Revenue for the district of Oswegatchie. The Colonel (as he was known) was a staunch Republican, and Remington learned his politics as well as his love for horses and the military at the paternal knee: he would be a lifelong Republican. But northern New York offered a boy more enticing diversions than politics. The outdoors beckoned, and the rivers and streams interlacing the area became part of his mental landscape. In 1900, as an established artist long resident in New Rochelle, a suburb of New York City, Remington acquired a six-acre island of his own, Ingleneuk, in Chippewa Bay on the St. Lawrence River, and there, through 1908, passed some of his happiest summers. The North Country, where he grew up and is buried, rather than the West, with which he is commonly identified, remained home for Remington. It bred in him those tastes that eventually brought him fame.[9]

Family surrounded Remington in his childhood, as did family expectations, and these took him away from Ogdensburg to be enrolled as a cadet in the Vermont Episcopal Institute in Burlington in 1875 and, the next fall, to the Highland Military Academy in Worcester, Massachusetts, where he studied for two years. Cadet Remington complained about both schools, but not about soldiering. He liked drawing men in uniforms, as the sketches that decorated his school texts attest, and he liked wearing uniforms, though he found the discipline and academic requirements onerous. Art was one release. "Bud" Remington, as his classmates dubbed him, even began a book of pictures and text in 1878 documenting life as a cadet. He did not get very far with the text portion—only two pages, in fact—but "Sketches of Highland Military Academy" anticipated the illustrated essays that, within a decade, would cement his reputation as an expert on the West.[10] Remington exhibited an irreverent streak as a cadet, but there is perhaps affection as well as schoolboy bravado in the note he jotted inside the front cover of his copy of Professor W. T. Welcker's *Military Lessons*:

"The H.M.A. is a fraud."

———

This book belongs to
Fred'c Remington
Ogdensburg
N.Y.
Class of '79.

Cadet Remington, ca. 1876, Vermont Episcopal Institute.
Photograph by S. A. Atwood, Burlington, VT
FRAM 1918.76.160.351

A page from "Sketches of Highland Military Academy," 1878
FRAM 70.758.14

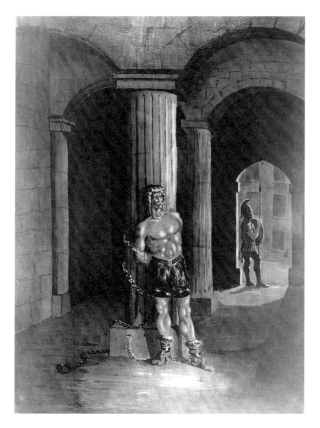

The Captive Gaul (*The Gallic Captive/The Chained Gaul*) 1876
Oil on linen (window shade), 48 x 36" (121.9 x 91.4 cm.)
Unsigned.
Gift of Henry L. and Mary H. Sackrider, Canton, NY; Henry M.
Sackrider, Canton, NY; FRAM 66.100, CR 4

Farnese *Hercules*, Museo Nazionale, Naples

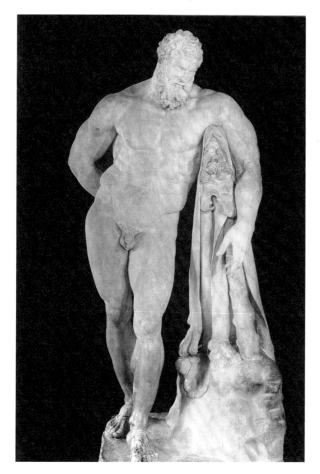

Remington filled the book with sketches of soldiers from around the world, and on the back endpaper listed the names of all his classmates.[11] As an only child, it felt good to belong.

Remington's schoolboy art shows no special aptitude. He was inconsistent and often careless in his drawing of anatomy, getting heads and limbs out of proportion and turning hands into paddles. He plugged away, however, producing multi-figure action scenes that served notice of the scope of his ambition. While on vacation from school in 1876, the young artist whiled away a rainy afternoon in Ogdensburg painting an historical subject in black, white and brown on an old window shade. *The Captive Gaul* was his most ambitious effort to date, its central figure a cross between a classical statue (the Farnese *Hercules* comes to mind) and a modern comic book superhero, all rippling muscle and heaving chest topped by a tiny head.[12]

The Captive Gaul represented physical perfection to Remington who, as a husky adolescent of sixteen, stood five feet eight inches tall and weighed 180 pounds. He loved grub, he admitted, but added, "I go a good many on muscle."[13] Contemporaries agreed. Remington was physically prepossessing, with the neck of a heavyweight boxer and, by 1878 when he entered Yale as a student in the School of Fine Arts, a stout build perfect for football. He was a first-string forward, or rusher, on the 1879 varsity squad that included among its halfbacks the legendary Walter C. Camp. Football, a brutally physical game played with minimal padding in Remington's day, was his introduction to the violent emotions of war. It may have had a more lasting influence on his art than the Fine Arts school ever did, though he was exposed to formal instruction in form and proportion and to studio courses in drawing and perspective in his first year. Sketches from this period indicate some progress in rendering shade and volume, though less than one would expect of a serious student, and his drawing suffered from a certain stilted quality that would dog him even as a professional illustrator.

Remington's studies at Yale terminated abruptly with the illness and death of his father in February 1880. He dropped out of college at the end of term in 1879, bided his time at various jobs, mostly in Albany, and in August 1881, satisfying an ambition to see the West, left Canton for Montana "to make trial of life on a ranche."[14] Biographers (perhaps noting his August departure) have speculated that his real motive was a disappointment

Remington at Highland Military Academy, Worcester, MA, ca. 1877: "I go a good many on muscle."
Photograph by The Notman Photographic Company, Albany, NY
FRAM 1918.76.94.2

Remington as a "Rusher," Yale, 1879.
Photograph by G. W. Pack; FRAM 1918.76.69

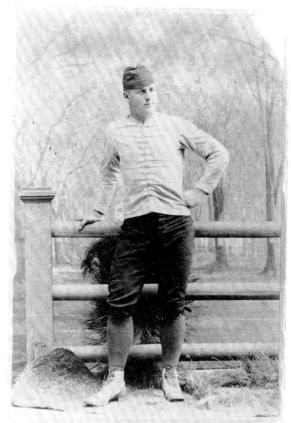

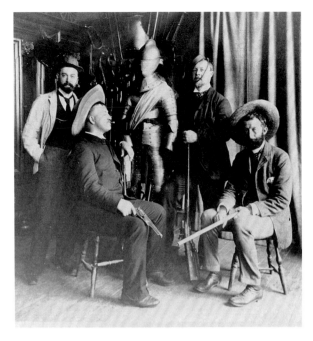

Remington and friends, likely from his stint at the Art Students League, New York, 1886
Photograph by Langill & Darling, New York, NY
FRAM 1918.76.160.634
Inscribed to Remington (seated on the left) by Thure de Thulstrup, staff artist at *Harper's Weekly* who redrew Remington sketches for reproduction in the *Weekly* of March 28, 1885, and May 29, 1886; De Thulstrup may be the man seated on the right.

The Yale Cowboy, Arizona, ca. 1888
FRAM 1918.76.71.2

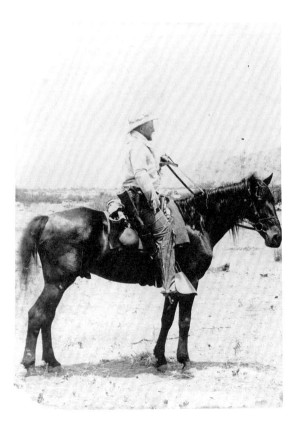

in romance. In August 1879 he had met and begun wooing Eva Adele Caten, who was visiting Canton from Gloversville, northwest of Albany. Two years his senior, Eva was his first and lasting love. The next August he requested her hand in marriage— only to be turned down by her father on the unassailable grounds that he had no serious prospects. A year later, Remington departed for Montana, where he stayed about two months, long enough to sketch some impressions of Western life that brought him early recognition when one was redrawn by a staff artist and published in *Harper's Weekly* for February 25, 1882, under the misleading title *Cowboys of Arizona*. Upon returning home he marked time at another clerkship in Albany, await-ing his twenty-first birthday, when he would come into the bulk of his inheritance. The West was in his blood now, and he was determined to go back.

Remington's story took a turn toward the legendary in February 1883. Acting upon the advice of a former Yale classmate, he plunged his inheritance into a quarter-section sheep ranch some ten miles south of Peabody, Kansas (pp. 42–47). Thus began his only sustained residence in the West. He remained about a year, doubling the size of his spread and passing idle time with a set of like-minded bachelors bent on having fun. They raced horses, chased rabbits, boxed, and engaged in minor rowdyism, making themselves more or less obnoxious to their neighbors. The culminating event was an unwise practical joke. Ejected for drunkenness from a Christmas gathering in a schoolhouse in the small community of Plum Grove, Remington and his pals lit a pile of straw outside the door and shouted "Fire!," creating a panic that landed them in court. Remington was properly humiliated, and pulled up stakes early in 1884, returning to Canton and selling off his sheep ranch that February. It was an inauspicious introduction to Western realities far tamer than those Remington had imagined. A small-town boy from New York had found small-town life in Kansas constraining, and the West not nearly wild and woolly enough to suit his taste. He would have to search for a West commensurate to his expectations or, failing that, create one.

Events moved rapidly in 1884. Remington proposed to Eva Caten again. This time she accepted, and that October 1 they were married in Gloversville. Meanwhile, a partnership in a Kansas City hardware store dissolved, and Remington dissipated the remainder of his inheritance buying into a saloon. Eva did not know his business when

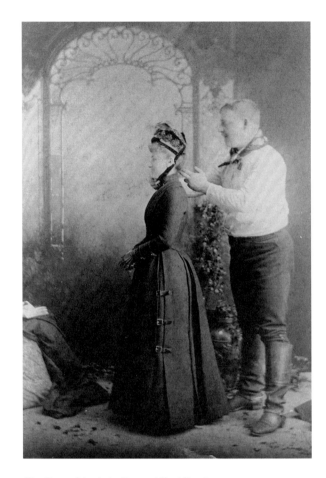

The Young Marrieds, Eva and Fred Remington, Brooklyn, NY, ca. 1886. FRAM 1918.76.95

they wed, but learned soon enough after accompa-nying him to Kansas City. She reacted by returning home before the year was out, leaving Remington to fend for himself. It was in this period that he finally settled on a career. He had never stopped playing at art; now it would be his profession. With-out overdramatizing what followed, his rapid rise to prominence was simply astonishing. Remington left Kansas City in August 1885 for four weeks of wandering in the desert, a kind of catharsis of the soul; he returned resolved to reclaim his wife and his respectability while he labored to prove himself an artist. (Just three years later, he had the pleasure of reporting to Eva after a visit to Kansas City, "they all are mighty impressed with my importance there.")[15] The couple reunited in Brooklyn, and Remington made the rounds of the publishing houses with his portfolio of Western sketches. His timing was impeccable. Just when it seemed that Indian warfare was passé, an Apache outbreak in Arizona revived popular interest in the West, and the name Geronimo was suddenly on every tongue. Buffalo Bill Cody's Wild West show and countless dime novels had encased the West in romance; it was up to Remington to show an equally enthralling reality.

The winter of 1885 was a lean one for the Remingtons, but 1886 began with a cover and a full-page spread in *Harper's Weekly* (p. 46). Both illustrated scenes from the Apache war were rendered in a direct, spare and unsentimental style with an attention to detail that made them seem like snapshots of specific incidents. In truth, like much of Remington's reality, they were generalizations, not documents, created by extrapolating freely from firsthand observation. The very awkwardness of his drawing only enhanced its credibility, however, and though he attended the Art Students League from March through May, polishing his craft, it was the authenticity, even crudity, of his work that first attracted publishers. Better the West as a school than the Art Students League. So Remington spent June traveling in the Southwest and Mexico, gathering impressions that could be converted into illustrations for *Harper's Weekly*. That fall he realized the wisdom of his choice when he dropped in on his old classmate Poultney Bigelow, editor of *Outing* magazine. "It was as though he had given me an electric shock," Bigelow recalled of his first glance at a Remington drawing. "Here was the real thing, the unspoiled native genius dealing with Mexican ponies, cowboys, cactus, lariats and sombreros. No stage heroes these…"[16] Remington was hired at once to illustrate a series of articles on the Apache war. Bigelow saw him as a kind of Yale cowboy; he got his foot in the door because of the School of Fine Arts, but it was the cowboy part that secured the commission.

Remington had arrived. By 1887 he was a regular in *Harper's Weekly* and *Outing*, and was branching out. The next year his work was in *Century*, and the year after in the prestigious *Harper's Monthly*, where it would be showcased through the 1890s. No illustrator had achieved so much so quickly. He illustrated fiction and nonfiction by almost every important writer who interpreted the West for a generation smitten with the last frontier. His visual imagery complemented the prose of Theodore Roosevelt, the popular fiction of Owen Wister, and the histories of the venerated Francis Parkman, linking his name inextricably with theirs. He illustrated Elizabeth B. Custer, Richard Harding Davis, Bret Harte, Henry M. Stanley, John Muir, Alfred Henry Lewis, Emerson Hough, Captain Charles King—and even Buffalo Bill himself. And when Western material ran short, he made sure he still had work on his table by writing and illustrating essays and stories of his own.[17] He was phenomenally productive, the

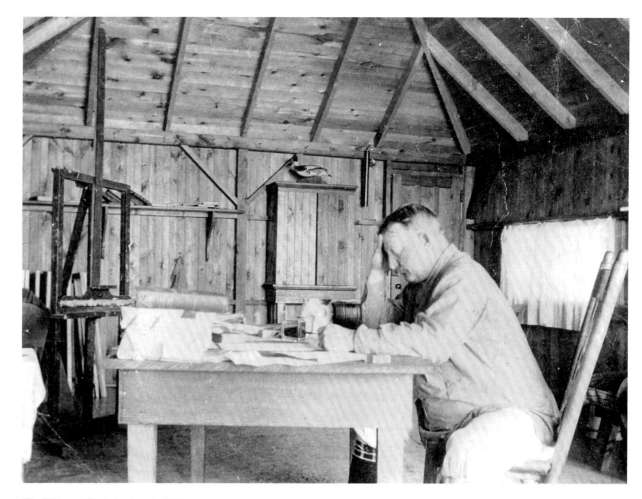

The Writer at Work, Ingleneuk, 1902
Photograph by Edwin Wildman. FRAM 1918.76.51

ultimate professional when it came to turning out product. The lackadaisical boy had turned into a driven and highly successful man. His pictures were everywhere, and unavoidable. Others copied his subjects, imitated his treatment, and sometimes just incorporated his images wholesale into their own. In no time at all, to say "the West" was to say Frederic Remington.

More than just an artist, he was a celebrity. The Remington mystique turned on the idea of an educated and relatively sedentary Easterner stepping down from a passenger train out West, mounting a horse, and riding off with the cowboys and the cavalry to chase outlaws and fight Indians. "This blond, youngish giant who sat idly smoking a cigarette and looking as if he had led a sheltered existence between walls and amid refined surroundings all his life," a journalist wrote in 1907, "was once a ranger on the limitless prairies, a hard-riding, rough-living, free-fighting cow-puncher."[18] The legend-making began early. J. Henry Harper, the publisher of *Harper's Weekly*, related a favorite story about his first meeting with Remington. The artist had been in a small Western town, broke and in need of funds, when he happened upon a poker

game. He quickly determined that two professional gamblers were cheating a tinhorn salesman from the East. Coolly drawing his pistol, Remington leveled it at the cardsharps and rescued the hapless salesman from their clutches. He kept the gamblers at bay overnight, and in gratitude the salesman the next day paid his passage back to New York City, where he was soon regaling Harper with the tale. Its moral was compelling: Western badmen were no match for "a young Hercules" from the East.[19]

It was *because* Remington bridged different worlds and seeming contradictions, and not in spite of it, that he made the West so inviting to other Easterners. Alvin H. Sydenham, a cavalry lieutenant who met Remington at the end of October 1890 "on the dusty, alkaline banks of the Tongue river, among the Montana foot-hills of the Big Horn mountains," recalled his first impressions of "a fat citizen dismounting from a tall troop horse":

The horse was glad to get rid of him, for he could not have trained down to two hundred pounds in less than a month of cross country riding on a hot trail…. over his closely shaven head was a little soft hat rolled up a trifle at the edges so as

not to convey quite that barren impression which you get from inspecting the head of a Japanese priest. Tending still more to impress the observer with the idea of rotundity and specific gravity was a brown canvas hunting coat whose generous proportions and many swelling pockets extended laterally, with a gentle downward slope to the front and rear, like the protecting expanse of a brown cotton umbrella. And below, in strange contrast with the above, he wore closely fitting black riding breeches of Bedford cord, reinforced with dressed kid, and shapely riding boots of the Prussian pattern, set off by a pair of long shanked English spurs.

There was a touch of the dandy in this, but nothing to prepare Sydenham for his meeting with Remington a year later in New York City's Grand Hotel:

His crowning glory was a tall silk hat that took the place of the skull cap; and a dark blue top coat of graceful model occupied the position formerly filled with credit by the expansive garment of brown canvas…. Tan kid gloves, patent leather shoes, and a portly stick with a buckhorn handle combined their effect to enforce the disguise; but in vain, for nothing could hide his broad good-natured face and laughing blue eyes…. As far as I could see he was different only in the surface covering from the weighty party who had descended from the horse at the head of the troop that day on the Tongue river.

The clashing imagery captures Remington's appeal. Because of his Western experience, he was a novelty in his natural setting, the clubs and galleries and publishing houses of the East. At the same time, the "fat Easterner" proved to other Easterners that the West could be theirs as well for the taking. By personifying the West, he had made the remote accessible.[20] But would the West continue to hold its fascination?

Frederic Remington was an American military artist who happened to find the one available outlet for his enthusiasm—the West—and, increasingly, he was a Western artist who distinguished himself from established traditions in European military art by his choice of subject matter. But his theme was martial—the *winning* of the West—and this left him at sea by the mid-1890s. Assignments had taken him all over the Western states and territories, and into Canada and Mexico. He had covered the Sioux Ghost Dance

War of 1890–1891 as a field correspondent for *Harper's Weekly*. But the West was now "won," and the theater of action bound to shift elsewhere. Thus Remington sniffed the air for opportunities, and began retooling himself as an illustrator specializing in outdoor subjects generally, from moose hunting in the Canadian woods to Bedouins charging across the Arabian desert on magnificent horses. Foreign armies and the prospect of war abroad were enticing until he accepted the fact that it was the *American* epic that stirred him, not just any war. Manifest Destiny, however, had turned its eye away from the interior of the continent. Would he be able to shift with it when the time came, or would he be stranded, an anachronism still churning out frontier subjects long after the public had ceased to care?

This was a serious question for one who earned his living primarily as a Western illustrator, and in 1895 Remington raised it with the writer Owen Wister, who had a substantial career stake in the Old West as well. Remington had just cast *The Broncho Buster*, his first bronze sculpture, and was delighted by the results (p. 112). "I do not speak through a season on the stage," he wrote Wister on October 24, "—I am d— near eternal if people want to know about the past and above all I am so simple that wise-men & fools of all ages can 'get there' and know *whether or not*." Nevertheless, he worried that *The Broncho Buster* was already an anachronism. "I think I smell *war* in the air," he wrote Wister a few weeks later. "When that comes the Wild West will have passed into History and History is only valuable after the lapse of 100 years.—and by that time you and I will be dead." An accompanying sketch showed a frontiersman riding by a buffalo skull and into the setting sun. But the enthusiastic reception that greeted *The Broncho Buster* persuaded Remington his eulogy was premature. His sculpture brought the kind of critical recognition that had eluded him when he exhibited his paintings and drawings in 1893 and again in November 1895, precipitating his fear that the West was dead as a subject. He was in an ebullient mood when he wrote Wister again: "I think we are going to have that war—then we are as yesterday—? But we may not get lost in the shuffle after all—we are pretty quick in the woods ourselves."[21]

Remington had experienced a rebirth of hope for himself as an artist and for the Old West as a subject. The West would not be just another historic episode relegated to the forgotten past; it would live on in the collective imagination of Americans as a vital expression of national values.

Artists and writers, having planted it there, could spend their lifetimes tending it. Remington's role in all this, quite apart from his stature as an artist, constitutes his claim to enduring cultural importance. *His* West became the standard version.

As early as 1892, the critic William Coffin recognized Remington's primacy in shaping public perceptions of the West. Easterners who actually went West, he wrote, "would expect to see men and places looking exactly as Mr. Remington has drawn them."[22] Though it did not really matter to his point, Coffin assumed that Remington's work was strictly factual. It was not, and in 1909 the writer Emerson Hough twitted Remington by quoting a newspaper editor of his acquaintance: "Facts! What do we want of *facts*? We are running a newspaper. What we want is the *story*!" Hough drew the lesson: "Buffalo Bill, Ned Buntline, and Frederic Remington—ah, might one hold the niche in fame of e'er a one of these tripartite fathers of their country! It is something to have created a region as large as the American west, and lo! have not these three done that thing? Never mind about the facts. They are the story."[23]

Remington had created his West by establishing what was typical through constant repetition, and the sheer volume of his illustrative work swept aside competing versions. When Wister worried that he was publishing too much and becoming overexposed, Remington set him straight: "That about being too much before the public is d— rot—…. The public is always in a frame of mind to forget you if you will let them and shortly they will give up trying to get rid of you." When he received Wister's next story to illustrate, he congratulated him warmly: "You have an air tight cinch on the West—others may monkey but you arrive with a horrible crash every pop."[24] The West was one monopoly Remington favored. The illustrator's craft required the ability to generalize persuasively by placing recognizable types in typical situations, and the best known illustrators were known for their types—a Howard Pyle pirate, an Edward W. Kemble or Arthur B. Frost rustic or Southern black, a Charles Dana Gibson girl. Remington was known for his types as well, "men with the bark on." He filled his boyhood sketchbooks with typical soldiers, and as a professional illustrator defined what the roughhewn characters of the far frontier should look like. He was at his happiest when reality corroborated his impressions. When it did not, he chastised reality. Upon meeting a seasoned cavalryman in 1893, Remington told him he was "the most

disappointing man he had ever seen"—he looked more like a college professor than a cavalry officer. Asked by the cavalryman what he should look like, Remington "avoided specifying."[25] The answer, of course, was in his art. In an amusing exchange with Francis Parkman over the coveted assignment to illustrate a new edition of *The Oregon Trail*, Remington rejected the actual likeness of Henry Chatillon, Parkman's companion in 1846, claiming that Chatillon's photograph made him look more like a fishmonger than a frontier trapper. So he shaped Chatillon to his own image of a mountain man instead—and Parkman approved. Now *there* was "the real old mountain type," Remington told another correspondent on receiving a photograph of the fabled Jim Bridger.[26] It was Remington's sense of what was and was not appropriate to a type that gave his art its power. *His* types peopled *his* West until, for many, there were no others.

In 1895, the New York journalist Julian Ralph, whose work Remington often illustrated, paid tribute to his friend's achievement:

> We almost forget that there was a time when we were not keenly alive to the merits of our soldiers—… the valorous, active "youngsters" on the frontier to which he introduced us. We almost forget that we did not always know and admire the whole little army of the rough riders of the plains, the sturdy lumbermen of the forest, the half-breed canoe-men, the unshorn prospectors, the dare-devil scouts, the befringed and befeathered red men, and all the rest of the Remingtoniana that must be collected some day to feast the eye, as Parkman and Roosevelt and Wister satisfy the mind.[27]

This was appropriate. Roosevelt thought Parkman the greatest of American historians and his work a model "for all historical treatment of the founding of new communities and the growth of the frontier." He exchanged letters with Frederick Jackson Turner over his frontier thesis, disagreeing "as to the unity of the west" but agreeing that "in *type* the men were the same." He complimented Wister, a Harvard friend, on nailing down the Western type in his stories ("men of strong and simple nature"), and Remington on his backwoods ranger, which he liked "almost as much" as his "cowpuncher, redskin and trouper."[28] Types still abounded when Roosevelt as President paid formal tribute to Remington: "He is, of course, one of the most typical American artists we have ever had, and

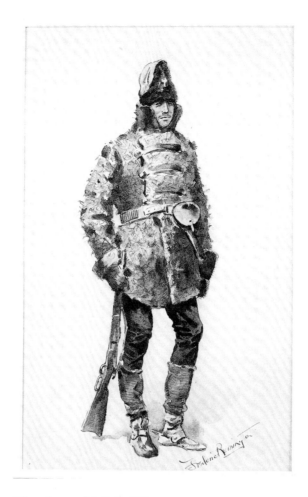

Winter Costume of the Police 1893
Black and white wash drawing on paper,
15 ³/₄" x 9 ¹¹/₁₆" (40 x 24.76 cm.)
Promised by bequest of a private collector; CR 1694

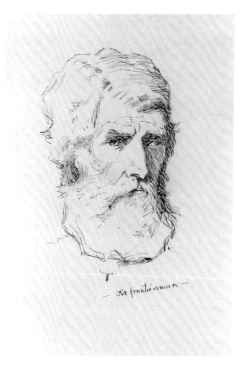

Old Frontiersman 1897
Pen and ink on paper,
9" x 6 ¹/₂" (22.9 x 16.51 cm.)
FRAM 66.94

he has portrayed a most characteristic and yet vanishing type of American life. The soldier, the cowboy and rancher, the Indian, the horses and the cattle of the plains, will live in his pictures and bronzes, I verily believe, for all time."[29] Thus did a coterie of like-minded Easterners render up a *typical* West. And here, precisely, is the crux of the modern controversy: What ends did the West they had created serve?

Roosevelt and Wister were to the point. The West for them was a white man's domain, and the cowboy an embodiment of the masterful qualities of "our conquering race."[30] On the frontier, where "life is reduced to its elemental conditions," Roosevelt wrote, cowboys flourished.[31] In a single paragraph in an essay illustrated by Remington and published in 1888, he fleshed out the type:

> They are smaller and less muscular than the wielders of ax and pick; but they are as hardy and self-reliant as any men who ever breathed— with bronzed, set faces, and keen eyes that look all the world straight in the face without flinching as they flash out from under the broad-brimmed hats. Peril and hardship, and years of long toil broken by weeks of brutal dissipation, draw haggard lines across their eager faces, but never dim their reckless eyes nor break their bearing of defiant self-confidence. They do not walk well, partly because they so rarely do any work out of the saddle, partly because their chaperajos or leather overalls hamper them when on the ground; but their appearance is striking for all that, and picturesque too, with their jingling spurs, the big revolvers stuck in their belts, and bright silk handkerchiefs knotted loosely round their necks over the open collars of the flannel shirts. When drunk on the villainous whisky of the frontier towns, they cut mad antics, riding their horses into the saloons, firing their pistols right and left,… and indulging too often in deadly shooting affrays,… but except while on such sprees they are quiet, rather self-contained men, perfectly frank and simple, and on their own ground treat a stranger with the most whole-souled hospitality…. Although prompt to resent an injury, they are not at all apt to be rude to outsiders, treating them with what can almost be called a grave courtesy. They are much better fellows and pleasanter companions than small farmers or agricultural laborers; nor are the mechanics and workmen of a great city to be mentioned in the same breath.[32]

In an 1895 essay also illustrated by Remington, Owen Wister extended Roosevelt's description into the realm of racial theory. "The Evolution of the Cow-puncher" asserted what for Wister required no proof: the cowboy was the Anglo-Saxon masculine ideal incarnate. "Directly the English nobleman smelt Texas," Wister wrote,

the slumbering untamed Saxon awoke in him, and mindful of the tournament, mindful of the hunting-field, galloped howling after wild cattle, a born horseman, a perfect athlete,… fundamentally kin with the drifting vagabonds who swore and galloped by his side. The man's outcome typifies the way of his race from the beginning. … No rood of modern ground is more debased and mongrel with its hordes of encroaching alien vermin, that turns our cities to Babels and our citizenship to a hybrid farce, who degrade our commonwealth from a nation into something half pawn-shop, half broker's office. But to survive in the clean cattle country requires spirit of adventure, courage, and self-sufficiency; you will not find many Poles or Huns or Russian Jews in that district; it stands as yet untainted… Even in the cattle country the respectable Swedes settle chiefly to farming, and are seldom horsemen. The community of which the aristocrat appropriately made one speaks English. The Frenchman to-day is seen at his best inside a house; he can paint and he can play comedy, but he seldom climbs a new mountain. The Italian has forgotten Columbus, and sells fruit. Among the Spaniards and the Portuguese no Cortez or Magellan is found to-day. Except in Prussia, the Teuton is too often a tame, slippered animal, with his pedantic mind swaddled in a dressing-gown. But the Anglo-Saxon is still forever homesick for out-of-doors.[33]

Remington, too, thought of the West as America's last bastion of Anglo-Saxonism. He was not given to subtlety, and in his public and private pronouncements was a walking catalog of the prejudices of his age and class. (See pp. 90–97.) He was an equal-opportunity hater, denouncing urban "mobs" and labor protesters as "un-American rats."[34] Jews, Chinese, Japanese, Italians, Hungarians, and all the "new immigrants" fell under his censure. His fondness for racial caricature wavered in the face of an acquired respect for the black troopers he rode with in Arizona, but he still greeted the prospect of war in Cuba with regret that "so many Americans

have had to be and have still got to be killed to free a lot of d— niggers who are better off under the yoke." Still, "this time," unlike the Civil War, "we will kill a few Spaniards instead of Anglo-Saxons, which will be proper and nice."[35] When it came to cowboys, Remington noted that the Anglo-American foremen, in contradistinction to their Mexican hands, had "all the rude virtues." He had come to admire "their moral fibre and their character.… They are not complicated, these children of nature, and they never think one thing and say another."[36] As the nineteenth century drew to a close, he summed up the cowboy's appeal to his circle of friends, expressing a sentiment common to Roosevelt and Wister as well: "I wish that the manhood of the cow-boy might come more into fashion further East."[37]

Was the myth of what Roosevelt called "cowboy-land" a manipulative fantasy imposed on an unsuspecting public by a self-interested coterie of privileged Easterners to serve capitalist, imperialist and class ends? Not merely a natural outgrowth of the values of those who popularized it, was the myth an insidious tool purposely designed to control public opinion?[38] Remington would have been baffled by such questions. Even Emerson Hough, who charged him with inventing the West, never suggested a malign purpose behind the invention. Indeed, Hough idolized Roosevelt and the masculine code that Roosevelt expounded and Remington embraced.[39] That code—the "strenuous life" ethic—explains much of the West's attraction for their entire generation.

The strenuous life ethic argued for a manly man, with boyish enthusiasms tempered by a matured philosophy. Sometimes the boyish enthusiasm outweighed the maturity. The journalist Richard Harding Davis liked Remington "immensely" when they first planned an excursion to Cuba at the end of 1896, but a few weeks together was enough. "I am so relieved at getting old Remington to go [back to the United States] as though I had won $5000," Davis wrote his mother from Cuba. "He was a splendid fellow but a perfect kid and had to be humored and petted all the time."[40] Still, Davis continued to admire the exemplar of the style, Theodore Roosevelt, who had been preaching the strenuous life ethic even before he gave name to it. In an 1894 essay on "The Manly Virtues and Practical Politics," Roosevelt urged on those who planned a career in public service

the need of the rougher, manlier virtues, and above all the virtue of personal courage, physical as well as moral. If we wish to do good work for our country we must be unselfish, disinterested, sincerely desirous of the well-being of the commonwealth, and capable of devoted adherence to a lofty ideal; but in addition we must be vigorous in mind and body, able to hold our own in rough conflict with our fellows, able to suffer punishment without flinching, and, at need, to repay it in kind with full interest. A peaceful and commercial civilization is always in danger of suffering the loss of the virile fighting qualities without which no nation, however cultured, however refined, however thrifty and prosperous, can ever amount to anything.[41]

It was this credo, elaborated by Roosevelt in subsequent essays, that his own service in 1898 in the Spanish-American War best typified for his generation. "Slothful ease" was the enemy, "the life of effort the life supremely worth living":

The twentieth century looms before us big with the fate of many nations. If we stand idly by, if we seek merely swollen, slothful ease and ignoble peace, if we shrink from the hard contests where men must win at hazard of their lives and at the risk of all they hold dear, then the bolder and stronger peoples will pass us by, and will win for themselves the domination of the world. Let us therefore boldly face the life of strife, resolute to do our duty well and manfully… it is only through strife, through hard and dangerous endeavor, that we shall ultimately win the goal of true national greatness.[42]

Beneath the noisy chest-thumping rhetoric was that most American of preachments—a jeremiad, conveying personal, class and national anxieties.[43]

The "strenuous life" ethic reached back to the historical theory of organic cycles, exemplified by the warning of a Harvard professor in 1798 that "experience proves that political bodies, like the animal economy, have their periods of infancy, youth, maturity, decay, and dissolution." Following a period of "manly vigor" and "greatness" came a period of decline: "Their prosperity inflates and debauches their minds. It betrays them into pride and avarice, luxury and dissipation, idleness and sensuality…."[44] Roosevelt's take on this theory, a century later, was that the United States was entering a dangerous phase in its national existence.

Americans had become too citified, too soft and "over-civilized," and the traditional leadership class (Anglo-Saxon, that is) too fond of its comforts. The youthful energy that in just three centuries had carved a nation out of the wilderness was flagging as pioneer challenges evaporated with the smoke billowing from the nation's factories. Soon everyone would be sitting at a desk or answering the morning whistle's call, another cog in the industrial machine. America was thriving economically, but no nation was "ever yet truly great if it relied upon material prosperity alone," Roosevelt warned, echoing the conclusion (if not the logic) of Lewis Henry Morgan's *Ancient Society; or, Researches in the Lines of Human Progress from Savagery Through Barbarism to Civilization* (1877), sacred text to a generation of social evolutionists. "A mere property career is not the final destiny of mankind," Morgan stated, "if progress is to be the law of the future as it has been of the past."[45] Were Americans to lose sight of their pioneering heritage and "the great fighting, masterful virtues" it engendered, stagnation and decay would surely follow.[46] The only real antidote, the life-giving panacea, remained the out-of-doors. On lakes and mountain trails and in the depths of the forest, Americans could still find the personal challenges that would harden muscles, test resolve, teach self-reliance, and forge character. But the West was America's last, best hope. And so the myth of cowboy-land.

For Remington, the strenuous life ethic had always been critical to his work and its acceptance. His art was "masculine and aggressively modern," a contemporary observed. "It was conceived without any thought of pleasing a dilettante taste… it was the strenuous life of the open that appealed to him."[47] His writings praised that life as well. "To suffer like an anchorite is always a part of a sportsman's programme," Remington wrote of the North Country wilderness that had first inspired him, and, after visiting a ranch in the Sierra Madres in 1893, he compressed the code into a single sentence: "I believe that a man should for one month of the year live on the roots of the grass, in order to understand for the eleven following that so-called necessities are luxuries in reality."[48]

Actually testing one's mettle in forest or field or on the Western plains was another matter. As president, Roosevelt loved to show up his desk-bound military officials by inviting them on grueling hikes about the capital or long distance horseback rides into the teeth of a gale. General Leonard

Wood, who shared Roosevelt's love of physical exertion, recalled that "a tramp with the President usually meant that the invited ones would arrive rather smartly turned out," only to depart "more or less complete wrecks."[49] The rigors of a wilderness excursion could prove even more daunting for a sedentary city-dweller, and, for those who subscribed publicly to the strenuous life ethic, it was embarrassing to be found out. Emerson Hough, an outdoor writer of national reputation, stumbled unhappily through a descent of the Mackenzie River in 1913, when he was fifty-six, and, having abruptly quit the expedition to return home, was forced to confess his inadequacies: "I am a little old and ill to make a full hand in a game which is new to me."[50] Preparatory dinners at an officers' club or a sportsmen's lodge where spirits flowed freely and male spirits grew more expansive with each dram, were sometimes better than the thing itself. Expectations clashed with morning-after realities, as Remington, overweight and over-pampered, repeatedly discovered. His letters to Eva Remington from the Southwest in 1888 became a litany of complaints: "I have sweat and sweat my clothes full—I can fairly smell myself—I am dirty and look like the devil and feel worse and there is no help for me. Well you can bet I am going to make the dust fly and get through as soon as I can."[51] Go West—and suffer like an anchorite, indeed. Remington was only twenty-six in 1888, and his griping intensified

"The hills grew steeper for him:"
Remington out-of-doors and out of shape. FRAM

with age. After a particularly discouraging trip to Wyoming in the early fall of 1908—a trip that signaled unmistakably the end to his playing at being a rugged outdoorsman—he disembarked the train in New York exhausted and eager to sink into the soft luxury of his own bed and his comfortable routine. (See pp. 206–208.) Two days later, he purchased an expensive overcoat and a derby hat. Now he was Frederic Remington again.[52]

In subscribing publicly to the strenuous life ethic, Remington put his credibility on the line. His ballooning weight was a case in point. Those who met him usually commented on his size. At twenty-nine he dwarfed "the average man in height and width and weight." "Tall, broad shouldered, deep chested, stout, and muscular," Julian Ralph wrote, he "betrays physical vigor in every movement."[53] In his forties, Remington carried around three hundred pounds and was a walking catalog of gastric complaints. Nevertheless, contradicting his case for a grass roots diet, he still consumed huge meals and clambered on and off the water wagon with revealing regularity. "I go to bed by candle light and I find that sitting up nights doesnt improve the stuff above the signature F. R.," he wrote during one of his periodic dry spells. "I got the high sign to slow down some little time since. Therefore I have cut out the 'boys'—God bless 'em for I find them just as irresistible as ever despite all I know. I always loose my bridle and when I get going never know when to stop."[54] After Remington's death in December 1909 from a ruptured appendix at the age of forty-eight, Augustus Thomas, his neighbor in New Rochelle, the New York suburb where the Remingtons had moved in 1890 when success brought the first inklings of future prosperity, wrote bluntly about Remington's physical deterioration. His "body had been splendidly cultivated and came to be unwisely overtaxed," he said. "The waning of his great strength was a more sensitive subject with him than his increasing weight, which produced the condition. Gradually in our Sunday walks, the hills grew steeper for him. His favorite ruse for disguising the strain on him was to stop occasionally and survey the landscape," suggesting where as an officer he would deploy his troops. Thomas played along, maneuvering soldiers of his own.[55]

Long after Remington had surrendered to obesity, interviewers continued to insist that he was "in the pink of condition."[56] "Remington is of elephantine bulk," Perriton Maxwell wrote in 1907. "But he is not of the fat, round-stomached type. He is huge of frame, and superbly muscled."[57] The

truth was something else. An Omaha reporter the same year told how Remington dodged a longhorn at the stockyards by scrambling "puffily up a high board fence," and observed: "He doesn't appear to have lived exclusively on a diet of art."[58] Remington would have appreciated the justice of the barb. He was forever trying to get back into a semblance of shape, hitting tennis balls, exercising with a medicine ball, riding the "white horses" in his canoe at his island home on the St. Lawrence River. His condition mattered because he had made it an issue. His work—and his West—were understood to be extensions of himself. Consequently, interviewers continued to repeat the comfortable fiction that the overweight man before them lived up to the code he honored in his life as in his art.

The strenuous life ethic was a demanding taskmaster. At thirty-six, Remington followed its siren call to Cuba. He had hankered after a war all his days, it seemed, and with one in the offing so close at hand could not resist the chance to cover it. He was accredited as a correspondent for the New York *Journal* on April 30, 1898, and with the *Harper's* publications lined up as well, was eager "to see men do the greatest thing which men are called on to do."[59] Cuba turned out to be a harsh awakening. Remington had invested a lifetime in the idea of war; nothing prepared him for its reality. The misery and suffering of sick and wounded and dying men cut through his love of uniforms, and attitude, and posturing. There might be glory on the front line, but there was no glory in the rear, just "broken spirits, bloody bodies, hopeless, helpless suffering."[60] A similar discrepancy between Western fantasy and reality had never affected him so deeply. Indeed, he had answered the challenge by making what he found out West conform to his expectations, overlooking the mundane and dreary to highlight the exciting and exotic. "Wretched creature," he wrote a fellow Cuban war correspondent in June 1899, "do you know that tomorrow my tribe goes West—to the Yellowstone—to the Big Horn Basin—back to the atavistic landscape—to the mountain air…. Shake Pard. I am as happy as a man can be who is where he dont want to be & who knows he is going just where he wants to be."[61] After 1900, Remington would repudiate the West as well, but only its present manifestation. Its past— *his* West—he still celebrated in his art, but Cuba had permanently disillusioned him. He was shortly on record as having no further interest in painting contemporary soldiers. It was difficult even to glorify the soldiers of frontier days. With the Indian

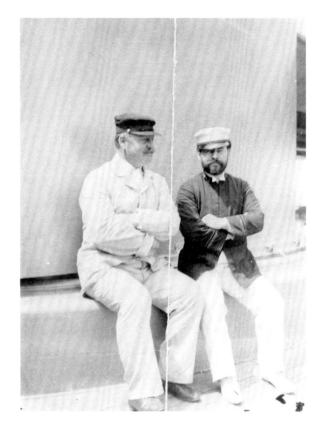

The Cuban war correspondent and colleague, Cuba, 1898
FRAM 1918.76.2

wars over, Remington discovered that he admired the vanquished almost as much as the victors. In defeat, they attained a certain "nobility of purpose," and a measure of respect, even sympathy, followed on that recognition.[62] Indians figured more prominently in his later paintings than soldiers. Defeated, they were the story. His vision darkened, literally, as he turned to night scenes that obscured the sad triumph of the mundane by cloaking the West in mystery, and his work grew still—full of hushed expectancy rather than the violent action that might momentarily ensue. The world waited, uncertain, tense and poised. Remington had always painted triumphant images of an ongoing saga, the winning of the West. But it was over, and time now to tend the myth that he had done so much to plant in the public's mind, turning from narrative (since progression was no longer possible) to mood. To the extent the strenuous life ethic survived into Remington's last years, it survived in his readiness to tackle new challenges in his art.

Simply, Frederic Remington wanted to be something more than a popular illustrator. He wanted to be recognized as one of America's great artists, and to travel in the select company of the American Impressionist landscape painters, who were the darlings of the critics. He worked on his color sense, the bane of any illustrator in black and

white, and moved towards a more painterly and even Impressionistic technique in his oils. He enjoyed successes. In 1900, Yale's School of Fine Arts awarded him an honorary bachelors degree as "its most distinguished pupil," and in 1903 he signed a lucrative contract granting *Collier's Weekly* exclusive reproduction rights to twelve paintings of his choice each year for four years, at a flat rate of $1000 a month.[63] This income freed him from illustration, permitted him to experiment with his art, and ensured him continued popularity, since his work would be reproduced in color and subsequently sold as prints. But past slights still rankled. From 1887 to 1899 Remington had exhibited thirteen paintings at the National Academy of Design, and apart from election as an associate member of the academy in 1891, he had received no special recognition. Since 1897, he had held a one-man exhibition each year except 1902, and by December, 1906, when he first showed his paintings at New York's M. Knoedler & Company, was exhibiting both spring and fall. Despite this busy exhibition schedule, he still awaited critical acceptance. His bronzes continued to find a more sympathetic reception than his paintings. Then, in 1909, the critics at last yielded. They have "all 'come down,'" Remington wrote excitedly in his diary on December 9: "I have received splendid notices from all the papers. They ungrudgingly give me a high place as a 'mere painter.' I have been on their trail a long while and they never surrendered while they had a leg to stand on. The 'Illustrator' phase has become a background."[64]

Remington had won critical acceptance by sheer effort, not by abandoning what he stood for. Each working day he left behind his rich man's ease and all his worries over stocks and bonds and politics, picked up his brush or modeling tools, and went about the business of creating life-and-death struggles on the "Grand Frontier."[65] In his studio, he could revisit a West purged of discomfort and of corrupting modernity. His studio was self-consciously a masculine refuge—a place for cigar smoking, whisky drinking, down-to-earth conversation, and painting. The walls of his New Rochelle studio, built in 1896, and those of his last studio at Lorul Place, his gentleman's estate in Ridgefield, Connecticut, built in 1909, were festooned with the trappings of Remington's West: chaps, hats, headdresses, pottery, masks, beaded shirts, cradleboards, pipe bags, shields, saddles, necklaces, moccasins, spoons, flutes, rattles, tomahawks, stirrups, pistols, canteens, battle flags, animal and human

skulls—even Calamity Jane's complete outfit![66]

Remington's no-nonsense work routine was much the same at home or at Ingleneuk, his island on the St. Lawrence. Planning his pictures for the year, knowing precisely what his audience expected of him and what would and would not do, he experimented with color and dissolved line to create an Impressionistic effect. But he never for a second lost sight of how he made his living. His art, he stressed, was *about something*, and "big art," he said in 1902, "is a process of elimination… cut down and cut out—do your hardest work outside the picture, and let your audience take away something to think about—to imagine…. What you want to do is to just create the thought—materialize the spirit of a thing, and the small bronze—or the impressionist's picture—does that; then your audience discovers the thing you held back, and that's skill."[67] Remington was never more explicit about his artistic goals. The writer who took down his comments later put them in perspective:

> He works like a Trojan over his art. He studies
> and masters the most minute details, he makes
> sketch after sketch, study after study, runs across
> a continent for an impression, drifts out on the
> bosom of the St. Lawrence in the wake of a rebel-
> lious inspiration, and then when he sits down at
> six o'clock in the cool of the morning to the broad
> canvas stretched across the easel he relegates all
> the technique of his work to the background, for
> the central idea of his picture he wants to be
> revealed without the suggestive detail that fills
> his mind as he paints it. If it doesn't strike the
> observer at once it's all wrong, to Remington's
> way of thinking, and he forthwith studies it out
> and works until he puts it there.[68]

Figures dominated Remington's Western paintings, with setting serving mainly as a stage for action. He had always painted woodsy scenes in the Adirondacks and the Thousand Islands, however, and by the 1900s landscape was a growing passion. He went West only to paint the scenery, he told a reporter in 1907, since it was all that remained of his West—while Ingleneuk each summer allowed him to renew his North Country ties.[69] The "unpoetic" boy could as a man wax almost poetic about a sunset on the St. Lawrence: "Seems as if I must paint them—seems as if they'd never be so beautiful again." But, he told the same interviewer who recorded his philosophy of art in 1902, "the people won't stand for it—they want cowboys and Indians,

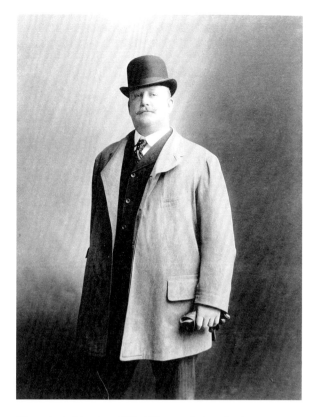

The artist in his prime: "The 'Illustrator' phase has become a background." FRAM 1918.76.31.3

so I just paint the sunsets up here to take home and look at in the winter."[70] By 1908 he was taking his landscapes to New York City as well, and including them in his annual Knoedler exhibition. He was even making excursions specifically for the purpose of painting outdoors—Connecticut for snowscapes, Wyoming for early fall coloring—and, after he sold Ingleneuk to finance his move to Lorul Place, the Quebec woods for summer greenery. Was he, then, a man frustrated in his desire to branch out, and trapped by his own success?

To the end, Remington affirmed the centrality of subject matter in his art. Everything he did was controlled by the desire to show something. His love of figures was implicit in his love of sculpting, a medium that returned him to his literal, illustrative roots. What he tired of was the macho posturing his art seemed to require, and the impression it created. Back in 1899, already trying to divorce his work from his life, he enjoined an interviewer, "Don't write about me, but speak of my art!" The interviewer's response said it all: "But you and your art are one."[71] His problem was how to convince others "It's the work that counts." As a Western illustrator he had done much to foster his cowboy mystique, since promoting himself promoted his art; a year before his death, he was urging a writer to "consider my Art and not myself. I hope the Art is interesting but I assure you I am not. I

am utterly commonplace."[72] In 1909 the critic Royal Cortissoz wrote a tribute to Remington's burgeoning artistry that became unexpectedly a memorial tribute to the man. It began with J. H. Chapin, the editor of the art department of *Scribner's Magazine*, approaching Remington on October 18 to propose a well-illustrated article covering the "totality" of his work. In an earlier exchange, Remington had pointed the magazine away from his career as illustrator to his recent painting and sculpture. He was not looking for another survey of his rise to prominence. Nor was he looking for what Chapin now proposed, an article written "by such a man for example as Stewart Edward White, who is in sympathy with all phases of western life (which you so faithfully portray in your canvases)."[73] What Remington had in mind in 1909 was something entirely different—a critical appreciation of his artistic development—and the man he wanted to do it was Royal Cortissoz, who had reviewed his exhibitions for years, sometimes severely.

After Remington's Knoedler show opened in December 1908, Cortissoz had written a fan letter:

> There are some emotions which have got to
> be expressed in more personal fashion than is
> possible in "cold type" and so I wish you would
> allow me to tell you here with what gusto and
> rejoicing I have looked at your new paintings.
> Man, but they are a comfort; will it annoy you if
> I take the liberty of saying as a friend what I
> shall presently be saying as a critic (and be
> hanged to you) that you have added a full cubit
> to your stature? So full of life they are, so chock
> full of interest, and oh! so rippingly painted! It
> just warmed my heart. … Well I don't know
> any better sensation than that of looking on
> while a fellow human is making one splendid
> stride after another, painting good pictures, and
> then damned good ones, and then damneder,
> and all the time doing it off his own bat, being
> himself in the fullest sense, making something
> beautiful that no one else could make. More
> power to your elbow. You make me happy.[74]

This was the kind of response Remington was seeking in 1909, not more invented biography and tired clichés about his Western expertise. And it was exactly what Cortissoz provided in his *Scribner's* piece which, because it did not appear until the February 1910 issue, instead of the triumphant coming out party Remington had envisioned, became a memorial tribute instead.

Cortissoz dismissed Remington's field sketches and illustrations—"I do not believe that they have the smallest chance of lasting, save as so many documents"—but acknowledged them as necessary to his artistic development. Working in black and white had retarded his color sense but honed his reportorial skill. "He knows how to make an absolutely clear descriptive statement," Cortissoz noted, and had successfully overcome his defects:

> For a considerable time his pictures were invariably marked by a garishness not to be explained alone by the staccato effects of a landscape whelmed in a blaze of sunshine. I have seen paintings of his which were as hard as nails. But then came a change, one of the most interesting noted in some years past by observers of American art. Mr. Remington suddenly drew near to the end of his long pull. … His reds and yellows which had blared so mercilessly from his canvases began to shed the quality of scene-painting and took on more of the aspect of nature. Incidentally the mark of the illustrator disappeared and that of the painter took its place. As though to give his emergence upon a new plane a special character he brought forward… a number of night scenes which expressly challenged attention by their originality and freshness.

While Cortissoz favored Remington's nocturnes, he summed up the artist's development with the observation, "Under a burning sun he has worked out an impressionism of his own."[75]

Cortissoz's essay was a broadly generous assessment of Remington's achievement at the fullness of his artistic powers, and a key contemporary document in the reevaluation of Remington that continues to this day. In 1988, adopting a curatorial strategy that focused on aesthetic issues rather than content, a Remington Masterworks exhibition opened in St. Louis on a schedule that took it to Cody, Wyoming, and Houston, culminating at the Metropolitan Museum of Art in New York, the city where Remington had established his reputation. The reception was unanticipated. The New York critics made it clear they did not like Remington the man, and most dismissed his art. Condescension characterized the major review in the New York Times, by John Russell: "Remington has traditionally been regarded as a popular favorite whose work is of no esthetic interest whatever…. Shooting and scalping were the things that most excited him in life. Why should he have his banner outside the Met?" Grudging praise for a few of his works was mostly qualified, and comparisons with other artists uniformly unfavorable. But Remington's flawed character was the real issue. "As a man" he was "just awful," Russell stated, a "bloated lout," a liar, a racist and a coward who might be allowed his despicable views if he were "a great genius" like Richard Wagner instead of "a poor blown-up barrel of nothing."[76] And had he been a great genius, perhaps the New Yorker could have spelled his name correctly in its one-sentence dismissal: "From the vague and documentary to the laughably impressionistic to the corny and moonlit, Frederick Remington's paintings of Indians chasing cowboys, his lacklustre illustrations for Harper's, and his clichéd bronzes of riders on horseback are unworthy of serious attention by a major art Museum."[77]

An aesthetician has argued for the idea of beauty by suggesting its opposites—the ugly, the meaningless, the insignificant, the irrelevant, the boring. Critics have freely applied all five judgments to Western art in general, and Remington in particular. However, as Ruth Lorand notes, "the meaningless may become meaningful through learning," while boredom may be "a result of the object being far from the spectator's interests or understanding."[78] Instead of assuming Remington's art to be boring and reprehensible, his critics should earn the right to their opinions. After all, they have a point. Remington's character and his art were interrelated in that he believed in what he showed. In 1901 Theodore Roosevelt proclaimed "we are a nation of pioneers"; Remington's work was proudly dedicated to that proposition.[79] The hard reality of Cuba led to a mellowing of his artistic vision unaccompanied by a similar shift in his personal outlook. He was as given to ethnic stereotyping after 1898 as before. But his personal values were increasingly marginalized in an art intended to be as big as its subject, and self-consciously mythic. "I am working for big effects; I am trying to picture the West as I saw it, big and full of color," he said. "I can't do it any other way."[80] Assessments of Remington are a sensitive barometer of the status of the Western past. The "new Western history"—an outgrowth of a general shift in history in the 1970s away from major events and prominent figures to broad social issues loosely defined by ethnicity, class and gender—can have little patience with a man who stood so staunchly for old values. As long as the celebration of white American pioneering is condemned as "triumphalism," Remington will remain in disfavor, and those unsympathetic to the Western myth will continue to revile both the artist and his art.[81]

Remington helped build the mythic structure, after all, then stood outside of it, admiring what he had wrought. He even fancied himself a puppetmaster, which should interest those who see the Western myth as manipulative and the public who bought into it as puppets. "Some well bred boys" called at his island studio one summer's day, "and they take my pictures for veritable happenings and speculate on what will happen next to the puppets so arduous are boys imaginations," he noted in his diary.[82] Theirs was for him a gratifying response—a tribute not to mind control, but to his mastery of narrative effects and visual realism. The acceptance of his work not simply as accurate but as truth proved its faithfulness to core American values. It appealed to boys "from ten to seventy" because its message touched them.[83] Remington's experimentation was with form, not substance, and his genius was an artistic vision that represented not a radical departure from convention, but an unconventional affirmation of it. His work is the heartbeat of Western myth.

Frederic Remington died on December 26, 1909, after an emergency appendectomy performed on a tabletop in his kitchen at Lorul Place on the 23rd failed to stop the spread of peritonitis through his system. He was brave before the operation, and cheerful after when it seemed as though the worst might be over. He even opened a few presents on Christmas day, but "after midnight he sank rapidly," and died at 9:30 the next morning. Eva Remington made the entries in his diary recording his final hours. The torch had already passed to another's hand.[84]

Eva Remington has long been obscured by the mammoth shadow her famous husband cast. A photograph illustrating an 1896 article on Remington seems apt. It shows the artist posing in front of Endion (as they called their home in New Rochelle), with Eva sitting on the veranda behind, barely visible.[85] During their twenty-five years together, he would always occupy the foreground, while she remained discreetly out of sight, meriting at best a passing mention in the publicity about him, which focused on his masculine pursuits as the key to his art. Indeed, Remington's dislike of domestic fuss and bother and his disinterest in women as subjects for his brush were standard refrains in such essays. Edwin Wildman made a nod towards gallantry in 1908 when he wrote that "Remington loves his work—he loves nothing else in life except 'the Kid,' who is Mrs. Remington and 'the only woman who understands me.'"[86]

Recently Eva Remington has stepped out of the shadows and come into her own.[87] She took no part in managing her husband's art or his career, but did accompany him on the occasional Western jaunt (something his readers, who were supposed to be impressed by such rugged trips, never learned). She spent the summers with him at Ingleneuk and, in 1909, at the Pontiac Game Club in Quebec. At home, she was the Remington social convener, attending to visits and other formalities. In company, she was content to sit embroidering while her "Darlin" hogged the limelight. An officer's wife recalled evenings at New Rochelle, the wives listening raptly, she claimed, while the men held forth.[88] However, Eva had outside interests to divert her, including spiritualism and the psychic arts, and opinions of her own to offer. Her letters to mutual friends were nearly as pungent as "Darlin's." "There certainly is something most attractive about a uniform & so much more so when worn by a bright man mounted on a beautiful horse," she wrote a cocky young cavalry officer they both

Remington posing in chaps in front of Endion.
FRAM 1918.76.152.79

Eva Adele (Caten) Remington (1859–1918)
FRAM 1918.76.7

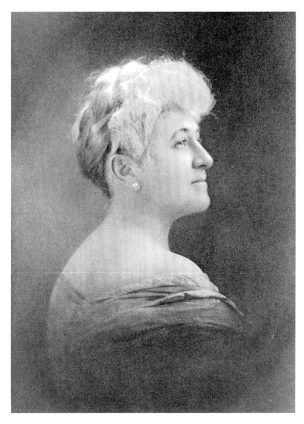

admired. She liked Orizaba in Mexico because "it was so clean and the place so old & every one looked so happy," but she hated Havana. "It is *vile*," she complained, "very nasty, not the least picturesque & made of dead cats, chickens etc. lying in the streets. Excuse me from living in such a country. The United States can not be beaten...." Eva Remington shared her husband's prejudices, in short, but framed them her way. "When an Englishman is bright you cannot help but like them," she observed, "but when stupid they make one so very tired."[89] Remington, who insisted he was no portrait painter, sketched Eva in profile more than once (see p. 175), making her the exception to his rule of never doing women, and in his own gruff-awkward fashion, worried about his "Missie," doted on her, and knew when to tiptoe around her. He could expect no sympathy from that quarter when suffering the after-effects of dissipation, for example, and she was fully capable of cutting "my massive husband" down to size.[90]

Having taken little interest in business while Frederic Remington was alive, Eva Remington took charge immediately upon his unexpected death. After recording his last moments in his own diary, she turned to business. Remington's entire estate (including home and contents) was valued at $97,783.23, a substantial sum, but not adequate to the expenses she faced in maintaining Lorul Place, the forty-six acre Ridgefield property. Income was essential. Eva managed his stock portfolio, valued at $32,040, and arranged for the sale of his leftover paintings through Knoedler.[91] A transaction undertaken just as Remington fell ill, involving a cut-rate price on an oil painting for a friend, she concluded with a letter edged in black.[92] In particular, Eva attended to Remington's one renewable legacy, his bronzes, as a steady source of revenue. She also seized upon projects not uncommon to the widows of famous men—a book of reminiscences that would pay him tribute (she hoped Owen Wister would write it), a public monument to his memory—and learned, like other widows, how fleeting fame can be. Condolences poured in—for a while. The newspapers ran their obituaries, *Collier's Weekly* published a Remington Number, a few fond reminiscences appeared in print—then, silence. But Eva persevered. In 1915 she sold Lorul Place, which had become a financial drain, and relocated in Ogdensburg, close to Canton, where he lay buried. She donated Remington's collection of Indian curios to the Ogdensburg Public Library; his books and art would follow after her death. Hopes

for a permanent memorial were rekindled by a life-long friend, John C. Howard, who, with another public-spirited citizen, George Hall, agreed to cover the cost of building a new library in Ogdensburg to house the Remington collection. World War I brought delays. With the deaths of Eva on November 3, 1918, and Hall the next year, Howard was left to carry on alone. To honor Hall's commitment, the Parish Mansion, the home he owned where Eva and her sister Emma (Grace) L. Caten had lived in Ogdensburg until shortly before Eva's death, was turned over to the library. On July 19, 1923, it opened its doors as the Remington Art Memorial.[93]

For all Eva's efforts, the drop in Remington's renown had been precipitate. Without her determination to see that he was properly honored, he might have sunk into the obscurity that awaited many of the popular illustrators of his day. The Frederic Remington Art Museum (as the Memorial has been known since 1981) is still located in the Parish Mansion, across the street from the Ogdensburg Public Library and a short walk from the banks of the St. Lawrence River. In accordance with Eva Remington's wishes, the Museum is custodian of the Frederic Remington legacy. Her will specified that his unsold paintings, his sketchbooks, his library, two of his bronze sculptures (*The Sergeant* and *Polo*), and the art by others that he owned were to go to the Museum. As well, a cast was to be made "from each model, (not already in the Frederic Remington Collection)," after which all the models were to be broken and casting cease. Costs were to be covered by Eva's estate, the bulk of which was designated for the upkeep of the Remington collection.[94]

As repository of the Eva Remington Estate, the Frederic Remington Art Museum is the essential beginning point for a study of the man. Its collection has been substantially augmented over the years with paintings and sketches, lifetime castings of certain bronzes, and correspondence. Remington made no copies of his own letters, which were always handwritten, but Eva saved her letters from him, along with family photograph albums and the like, and they are an important part of the original bequest that forms the nucleus of the collection.[95] Remington's personal papers show a man conscious of his own stature and that of his acquaintances. He kept his contracts with publishers, records of his illustrations and copyrights, address books, autograph books, honors that came his way, and invitations and letters from the famous people his own fame brought into his orbit. Given

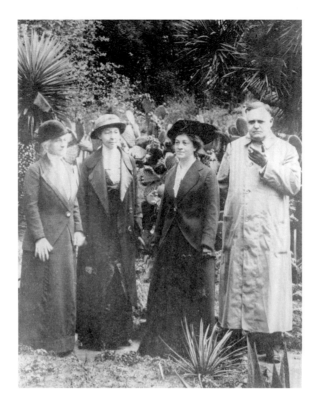

Eva Remington, Charlotte Howard, Emma Caten, and John Howard: Three of the principals in the Remington Art Memorial on a visit to California.
FRAM 1918.76.160.488

his penchant late in life for destroying his earlier work—notably canvases that might cloud the case he was making for himself as an artist—it is a miracle that as much survives as does. The examples of his boyhood art were probably donated to the collection in later years by family members— *The Captive Gaul* (1876), for example, came from his mother's family, the Sackriders—but he may have held onto some of this ephemera himself. Remington retained notebooks from his various excursions to the West and abroad, and a great number of sketches, ranging from doodles to fully detailed drawings and compositional studies.

If there is a surprise at all in this, it comes from Remington's dark mutterings about his early work and the embarrassment it caused him, and his own proclamation of new artistic priorities in the 1900s that might seem to have rendered meticulous field studies and notes unnecessary. Of course, he also eventually proclaimed his freedom from the use of photographs as sources for his illustrations, yet maintained an extensive photographic file, which he augmented whenever he traveled. He added artifacts to his studio collection throughout his life, and they often appear in his work. (The studio collection was lost to the Museum in the 1950s when it was sold off to finance continuing

operations; today, it is on display at the Whitney Gallery of Western Art in the Buffalo Bill Historical Center, Cody, Wyoming, along with some of Remington's finest landscapes in oil, which were sold at the same time.)[96] Until the day he died, then, Frederic Remington never entirely shook his training as an illustrator: he continued to validate his imaginary creations through factual data, and he took a real measure of pride in authentic detail.

Scholars have utilized all of the Frederic Remington Art Museum's holdings—correspondence, notebooks, sketches, and photographic files—more or less thoroughly. (The photographic files are particularly rich, and deserve further study.) Remington's diaries are also well known, though a careful transcription of them is still to be prepared. They cover the last three years of his life, and provide a vividly human portrait, however unflattering at times, of the artist at the pinnacle of his fame. He began as a reluctant diarist in 1907 and made only a few brief entries before March 6. But he was an opinionated man who liked to grouse as well as to strut, and he took to diary keeping with all the zeal of one confident of his place in history, peppering his reports on the weather and domestic affairs with his prejudices. Workers (even longtime employees) were shirkers who abused his good nature and never knew their proper station. Worse, they were given to preposterous demands. *His* creature comforts were earned and thus deserved. Stock reports, investments, income, expenditures, and bank balances, all precisely recorded, were fair indicators of his social position. Remington also noted his own frailties, and worries, and disappointments. Once in the habit of keeping a diary, through travel or dyspepsia, he was faithful to the task. He did not miss a day until his final illness, and even then saw to it that Eva kept it up. These are remarkable sources to have for any artist, and uncommonly revealing of the man behind the paintings and bronzes. We know of his artistic struggles and his mood swings, from self-congratulation and a certain cockiness when a particular effect or a finished work satisfied him, to frustration, despair and even self-destructive anger when what he sought to achieve eluded him. Once a year—February 8, 1907, January 25, 1908, and February 15, 1909—Remington engaged in a little spring cleaning of his own, burning up paintings that had earned his displeasure. Some were old illustrations that he wanted purged from the record in his quest of critical acceptance as a major artist. Others were more puzzling: recent works that

had been reproduced in *Collier's Weekly* and were obviously still salable. Remington's diaries reveal an often pompous, fatuous and ungenerous man; they also reveal a driven artist demanding of self and absolutely true to his own standards.

One of the neglected treasures of the Frederic Remington Art Museum is the artist's library. It is not pristine, since it has been adulterated by additions—some of the books were Eva's, or her sister's, not Remington's—and compromised during the years the collection was integrated into the holdings of the Ogdensburg Public Library. Books once owned by Remington have escaped onto the marketplace. Some may have been given away (he did, for example, present Theodore Roosevelt with a desirable title or two); others were perhaps borrowed and never returned. What remains of the artist's library is very revealing, however, since Remington was a reader. His diaries record sorties into fiction and, particularly, history, and this was a lifelong habit. He was always interested in books, and added to his collection on his travels and whenever he came across titles of interest. Julian Ralph in 1891 observed that Remington's "library has an unlooked for bulk, and emphasizes, in the study of the man, that literary inclination which is one of his peculiarities. A man's books often tell more of him than his works, and so it is with Remington's library…. it is enough to say that, though the present demand upon his pencil is mainly for Western scenes, he has other subjects at heart."[97] Remington was not a rare book collector, but he confessed to the temptation and took pride in the uncommon and expensive titles he had acquired at bargain prices. "First editions have ruined more 'good' men than rum and women," he told a friend: "I have only two firsts 'Catlin colored prints' and 'Tanner's Narrative'—I stumbled on them and the book sharp had seen so few in his lifetime that he wasn't on."[98]

Remington's own extra-illustrated copies of his school texts (a wonderful source for his youthful military enthusiasms) and an occasional treasure like his copy of Elizabeth Custer's *Boots and Saddles*, with its original pen sketch of General Custer, provide useful information about his artistic development. In 1887, two years after acquiring *Boots and Saddles* in Kansas City, he would illustrate Mrs. Custer's second volume of reminiscences, *Tenting on the Plains*. Indeed, inscriptions and notes in several of his books add to the biographical record. Presentation copies from Charles Dana Gibson, Howard Chandler Christy, Madison Grant,

Caspar Whitney, Buffalo Bill Cody and others, including those whose works he illustrated, trace his circle of friends. Equally revealing are the books Remington acquired for reference purposes. He owned albums of British and European military uniforms; picture books reproducing the paintings of Detaille and de Neuville; histories of England, the colonial period and national costume; and works on steamboating, wildlife, Mexico, Germany, Africa, and French Canada. Naturally his collection was biased towards Western history, with an emphasis on native culture (George Catlin was well represented), the Indian wars of the eighteenth and nineteenth centuries, early exploration, and the fur trade. Remington's research tool, his library, can be our own.

Of the paintings and sculptures in the Frederic Remington Art Museum, little need be said here since they are discussed at length in the catalog that follows. Several acquisitions have significantly strengthened the Museum's collection over the years, but its core remains the same today as in 1923. The inventory of the Frederic Remington estate prepared by Eva Remington immediately after her husband's death listed twenty-nine paintings, *The Charge of the Rough Riders*, *The End of the Day*, *Hauling the Gill Net*, *The Sentinel*, *The Snow Trail*, and *The Sun Dance* among them. These were still in Eva's possession when she died in 1918, and were included in her bequest to the Frederic Remington Collection along with *Full-Dress Engineer*, *The Howl of the Weather*, *River Drivers in the Spring Break Up*, *Evening in the Desert. Navajoes*, and a number of bronzes, landscapes, horse studies and unfinished paintings.[99]

The entire body of Remington material provides a context for its parts. Stylistic innovations in his work are important, and are duly noted in this catalog. But the consistency of Frederic Remington's artistic vision is a more critical consideration in accounting for his cultural influence. Thus my commentaries stress continuities in his art, drawing on the unique strengths of the Frederic Remington Art Museum's holdings to demonstrate links between photographs, sketches, illustrations, bronzes, and the major paintings featured here.

1. Charles Belmont Davis, "Remington—The Man and His Work," *Collier's Weekly*, March 18, 1905, p. 15.

2. For examples of presentism in recent writing on Remington and his era, see Peter Schjeldahl, "How the West Was Lost," *7 Days*, March 15, 1989, p. 71 (Remington was "a pig" from "a lousy time"), and Jane Tompkins, *West of Everything: The Inner Life of Westerns* (New York: Oxford University Press, 1992), p. 183: "Remington's paintings and statues… embody everything that was objectionable about his era in American history. They are imperialist and racist; they glorify war and the torture and killing of animals; there are no women in them anywhere." Richard White, "Frederick Jackson Turner and Buffalo Bill," in White and Patricia Nelson Limerick, *The Frontier in American Culture* (Berkeley: University of California Press, for the Newberry Library, Chicago, 1994), advances a far more subtle interpretation but does describe Remington's West as "an unabashedly masculine and nasty place" (p. 52). For biographical detail on Remington and his family, see Peggy and Harold Samuels, *Frederic Remington: A Biography* (Garden City, NY: Doubleday & Company, 1982), chap. 1. Major, Brevet Colonel, Seth Remington was mustered out of service on March 11, 1865, having distinguished himself in combat. His record understandably impressed his son.

3. Theodore Roosevelt,"Manhood and Statehood," *National Ideals/The Strenuous Life/Realizable Ideals* (The Works of Theodore Roosevelt [National Edition], Vol. XIII) (New York: Charles Scribner's Sons, 1926), pp. 454–455 (Address at the Quarter-centennial Celebration of Statehood in Colorado, at Colorado Springs, August 2, 1901).

4. Theodore Roosevelt, "National Duties," in ibid., pp. 478, 469–470 (Address at the Minnesota State Fair, September 2, 1901).

5. John Russell, "A Popular Favorite, a Poor Reputation," *New York Times*, February 10, 1989.

6. See Brian W. Dippie, *Custer's Last Stand: The Anatomy of an American Myth* (Lincoln: University of Nebraska Press, 1994 [1976]), pp. 7–10.

7. Roosevelt, "Manhood and Statehood" (1901), p. 453.

8. Asa C. Matthews and William A. Peffer, quoted in Dave Walter, comp., *Today Then: America's Best Minds Look 100 Years into the Future on the Occasion of the 1893 World's Columbian Exposition* (Helena, MT: American & World Geographic Publishing, 1992), pp. 49, 67–68.

9. This biographical discussion incorporates passages from my essay "Frederic Remington's Wild West," *American Heritage* 26 (April 1975): 6–23; 76–79. For Remington's North Country connections, see Atwood Manley, *Some of Frederic Remington's North Country Associations* (Ogdensburg, NY: Northern New York Publishing Company, for Canton's Remington Centennial Observance, 1961); David Tatham and Atwood Manley, *Artist in Residence: The North Country Art of Frederic Remington*, (Ogdensburg, NY: Frederic Remington Art Museum, 1985); and Atwood Manley and Margaret Manley Mangum, *Frederic Remington and the North Country* (New York: E. P. Dutton, 1988).

10. FR, "Sketches of Highland Military Academy" (1878), Frederic Remington Art Museum (hereafter: FRAM), FRAM 70.758. The drawings, all finished in pen and ink, feature off-duty cadets smoking, nipping at bottles, and loitering in town, junior versions of the insouciant officers Remington later so admired. For examples of Remington's work in his teenage years, see Orin Edson Crooker, "A Page from the Boyhood of Frederic Remington," *Collier's Weekly*, September 17, 1910, p. 28 (sketches sent to his friend, Scott Turner, in 1877); *Frederic Remington (1861–1909): Paintings, Drawings, and Sculpture* (Shreveport, LA: The R. W. Norton

Art Gallery, 1979), pp. 48–50; Harold McCracken, *A Catalogue of the Frederic Remington Memorial Collection* (New York: The Knoedler Galleries, for The Remington Art Memorial, Ogdensburg, NY, 1954), p. 10; and Allen P. Splete and Marilyn D. Splete, eds., *Frederic Remington—Selected Letters* (New York: Abbeville Press, 1988), pp. 10–22 (hereafter cited as *Selected Letters*).

11. Remington's copy of W. T. Welcker, *Military Lessons: Military Schools, Colleges, and Militia* (New York: Ivison, Blakeman, Taylor & Co., 1874), FRAM 71.821.

12. See Clarence J. Webster, "Frederic Remington's Early Canton Days" and "Remington Originals in Canton Homes," *St. Lawrence Plaindealer* (Canton, NY), August 16, 30, 1932; McCracken, *Catalogue of the Frederic Remington Memorial Collection*, p. 11; and for the immensely popular Farnese *Hercules*, Francis Haskell and Nicholas Penny, *Taste and the Antique: The Lure of Classical Sculpture, 1500–1900* (New Haven: Yale University Press, 1982), pp. 229–232, 97. Remington's *The Captive Gaul* is also known as *The Gallic Captive* and *The Chained Gaul*.

13. FR to Scott Turner, [1877], *Selected Letters*, p. 14.

14. *St. Lawrence Plaindealer*, August 10, 1881, quoted in Samuels and Samuels, *Frederic Remington*, p. 33, which offers the most reliable and thorough account of his life in these years.

15. FR to Eva Remington, June 10 [1888], *Selected Letters*, p. 54.

16. Poultney Bigelow, *Seventy Summers* (1925); quoted in Harold McCracken, *Frederic Remington: Artist of the Old West* (Philadelphia: J. B. Lippincott Company, 1947), p. 50. Bigelow went on to make a wistful observation that says much about why Remington's work became so popular so quickly in the East (p. 52): "He had turned himself into a cowboy, and I had become a slave to a desk."

17. Remington's writings have inspired a bibliography of their own. The starting point is the anthology compiled and edited by Peggy and Harold Samuels, *The Collected Writings of Frederic Remington* (Garden City, NY: Doubleday & Company, 1979) (hereafter cited as *Collected Writings*). For a straightforward introduction to his prose, see Fred Erisman, *Frederic Remington* (Western Writers Series No. 16) (Boise, ID: Boise State University, 1973); interpretive, and provocative, studies linking Remington's writing and art are Ben Merchant Vorpahl, *Frederic Remington and the West: With the Eye of the Mind* (Austin: University of Texas Press, 1978), and Christine Bold, *Selling the Wild West: Popular Western Fiction, 1860–1960* (Bloomington: Indiana University Press, 1987), chap. 2.

18. Perriton Maxwell, "Frederic Remington—Most Typical of American Artists," *Pearson's Magazine* 18 (October 1907): 399.

19. J. Henry Harper, *The House of Harper: A Century of Publishing in Franklin Square* (New York: Harper & Brothers, 1912), pp. 603–605. Since Harper gave Remington his illustrative assignments, it was good business to persuade Harper that the West was wild and woolly, and that Remington needed to be there covering it. See, for example, FR to Harper, December 17 [1890], *Selected Letters*, p. 110.

20. Alvin R. Sydenham, "Frederic Remington" [1892], *Selected Letters*, pp. 182,184; and see Deoch Fulton, ed., *The Journal of Lieut. Sydenham 1889, 1890; And His Notes on Frederic Remington* (New York: The New York Public Library, 1940). For related discussions, see the sources cited in n. 44.

21. FR to Owen Wister, October 24 [1895], [early November 1895], March 6 [1896], *Selected Letters*, pp. 275, 214 (which scrambles two words and the meaning), 281.

22. William Coffin, "American Illustration of To-day," *Scribner's Magazine* 11 (March 1892): 348.

23. Emerson Hough, "Texas Transformed: A Story Regarding the Exchange of Certain Historical Hats," *Putnam's Magazine*

7 (November 1909): 201–202. Remington had previously illustrated Hough's "The Settlement of the West: A Study in Transportation," *Century Magazine* 63 (November 1901, December 1901, January 1902).

24. FR to Owen Wister, [early October 1894], [November 1–10 1894], *Selected Letters*, pp. 254, 260.

25. Hugh Lenox Scott, *Some Memories of a Soldier* (New York: Century Co., 1928), p. 186.

26. FR to John B. Colton, December 11, 1899, JA 805, Huntington Library, San Marino, CA; and see Brian W. Dippie, *Remington & Russell (Revised Edition): The Sid Richardson Collection* (Austin: University of Texas Press, 1994), p. 54.

27. Julian Ralph, "Frederic Remington," *Harper's Weekly*, February 2, 1895, p. 688.

28. Theodore Roosevelt to Francis Parkman, July 13, 1889, April 23, 1888; to Frederick Jackson Turner, April 10, April 26, 1895; to Owen Wister, December 13, 1897; and to FR, October 26, 1897, in Elting E. Morison, ed., *The Letters of Theodore Roosevelt*, 8 vols. (Cambridge, MA: Harvard University Press, 1951–54), I, pp. 172, 139, 441, 446, 742, 700. As president, Roosevelt wrote Remington on February 20, 1906: "You know I have appointed to office in the West, and in the case of Bat Masterson, in the East, a number of the very men whose types you have permanently preserved with pencil and pen…" FRAM 71.823.16

29. Theodore Roosevelt to Mr. Little, July 17, 1907, FRAM 71.823.22; published in *Pearson's Magazine* 18 (October 1907): 395.

30. Owen Wister, "Remington—An Appreciation," *Collier's Weekly*, March 18, 1905, p. 15.

31. Theodore Roosevelt, "In Cowboy-Land," *Century Magazine* 46 (June 1893): 276.

32. Theodore Roosevelt, "Ranch Life in the Far West," *Century Magazine* 35 (February 1888): 502. Some drew a direct correlation between Roosevelt's own cowboy persona and his character—for example, "A Puny Boy, by Physical Culture, Becomes the Most Vigorous of American Presidents," in Orison Swett Marden, ed., *Little Visits with Great Americans; or, Success Ideals and How to Attain Them*, 2 vols. (New York: The Success Company, 1905), I, pp. 181–187. Wister treasured an editorial cartoon by J. N. Darling, *The Long, Long Trail*, commemorating Roosevelt's death: "He is in cowboy dress, on his horse headed for the Great Divide; but he is turning back for a last look at us, smiling, waving his hat. On his horse: the figure from other days; the Apparition, the crusader, bidding us farewell." (*Roosevelt: The Story of a Friendship, 1880–1919* [New York: Macmillan Company, 1930], p. 8, and facing p. 370.) Wister might have added that, fittingly, the pose of man and horse were derived from a Remington illustration, *Opener of the Trail*, published in *Outing* in February 1888—the very month and year that Roosevelt and Remington began the collaboration in *Century Magazine* that forever after identified both men with the cowboy.

33. Owen Wister, "The Evolution of the Cow-puncher," *Harper's Monthly* 91 (September 1895): 603–604.

34. FR to Poultney Bigelow, July 27, 1894; to Owen Wister, [September 1894], *Selected Letters*, pp. 212, 252.

35. FR to Owen Wister, [early April 1896], in Ben Merchant Vorpahl, *My Dear Wister—: The Frederic Remington-Owen Wister Letters* (Palo Alto, CA: American West Publishing Company, 1972), p. 221. This book offers the entire Wister-Remington correspondence, heavily interpreted.

36. FR, "A Rodeo at Los Ojos," *Harper's Monthly*, March 1894; *Collected Writings*, pp. 136–137.

37. FR, "Life in the Cattle Country," *Collier's Weekly*, August 26, 1899; *Collected Writings*, p. 388. Remington's circle of friends *is*

instructive. Like Roosevelt and Wister, he might romanticize and heroize the ordinary frontiersman, but he traveled in the company of the wealthy and prominent—ranchmen and officers, not cowboys and enlisted men. He was always as alert to the upbringing of his hosts and how it prepared them for the rugged western life, as he was to how that life shaped certain types. The point was that the West was not an alien land to the native-born Easterner, the true American. Instead it was his natural domain. Remington's peers cultivated a mock-tough language, meant to be at once sentimental and gruff—that is, properly masculine. It was the language of privileged men, sprinkled with "ain'ts" and selected slang, and replete with nicknames and code words signifying membership in a secret fraternal order, or, better yet, an exclusive boys' club. One uttered certain profundities plainly, and they resonated with meaning. Owen Wister, for example, introduced a collection of Remington's western drawings by talking about the freemasonry of those who had been "out there," who "understand." Remington, soliciting Wister's help in exposing an upstart Western artist, used the code words, anticipating that Wister would flash "the countersign" in return by preparing "a statement… which will stop dead the fools who are trying to confuse the public, by their ignorance, into thinking that they too understand." (Owen Wister, "Concerning the Contents," Frederic Remington, *Drawings* [New York: R. H. Russell, 1897]; FR to Owen Wister, [September 1902], *Selected Letters*, p. 303. In 1902 Rudyard Kipling, an idol to both men, published "The Palace," a poem in which a king expresses wisdom born of experience: *"After me cometh a Builder. Tell him, I too have known."* The usage was evidently a common-place. Rudyard Kipling, *The Complete Verse* [London: Kyle Cathie Limited, 1990], p. 311.) Remington's correspondence was all breezy understatement. Commas and periods surrendered to dashes, which added urgency to the rushing tumble of his words. His prose surged even when expressing sentiment (of the manly variety, of course). Wister, a more formal correspondent, perfectly characterized Remington's epistolary style. "As I think over Remington's letters," he wrote Eva Remington, who hoped to publish them, "my fear is that they may be too fragmentary in expression, & too personal also. His way (since we were both corresponding about the same thing) was often to leave his ideas half said—almost like conversation." (Remington spoke as he wrote, apparently, in short staccato bursts rather than full sentences. The writer Hamlin Garland, who was out of sympathy with Remington's politics, reported "a long, confused monologue" by him on the army: "He is never fluent even when at his best, and on this occasion he was at his worst—truculent and hesitant." Augustus Thomas, who liked Remington, echoed Garland: "His speech was laconic. If his friends had known the sign language he would generally have used it. His own vocabulary was small, vital, and picturesque, singularly free from slang, but strongly colored with military terms and phrases.") Remington's letters were literally conversational, then, often to the point of being cryptic, and he carried the habit of breezy statements laden with meaning over into his formal prose. It gave his writing an edge that verged on affectation. But his prose could be enormously economical in conveying essence as well as fact. At its best it was efficient, meaty and direct. (Owen Wister to Eva Remington, April 18, 1910, FRAM 96.8.5; Hamlin Garland, *Roadside Meetings* [New York: Macmillan Company, 1930], p. 394 [in the diary entry for January 5, 1899, on which this recollection was based, Garland noted that Remington "was a little confused by drink, so I said nothing"—Donald Pizer, ed., *Hamlin Garland's Diaries* (San Marino, CA: The Huntington Library,

1968), p. 181]; Augustus Thomas, "Recollections of Frederic Remington," *Century Magazine* 86 [July 1913]: 354.) Remington shared his age's fondness for broad dialect, and got his ideas across as "theories" ("I have a theory"). Things in which only a man was supposed to take pleasure were "immense" or even "pretty"—an officer-friend, Powhatan H. Clarke, used that adjective in letters to Remington to describe expert roping, a group of officers in full uniform rising for a toast, and a cavalry "charge in line over the prairie in the bright moonlight." "You have the facility of not taking people or life seriously and that's at the heart throb of modern literary men," Remington responded appreciatively. Sensitivity, in short, was best conveyed by a language that proved men could feel deeply without growing maudlin, though a little throat clearing was acceptable. When Remington received a poem from his boyhood friend John Howard, couched in humor, regretting the sale of his island in Chippewa Bay and thus the loss of his company each summer, he replied: "O Bully Old John I greatly appreciate your sentiments so gracefully hidden behind the guard of a poem but I'll tell you that there are other places besides Chippewa and we'll manage to meet in some of them often enough to keep up the association of 40 years and dont you forget it." (Powhatan H. Clarke to FR, [October 1890], December 7 [1890]—transcribed and edited by Remington for possible publication, FRAM [Clarke's first letter is in *Selected Letters*, pp. 174–75, with many transcription errors, but worth comparing to Remington's edited version]; FR to Clarke, September 1, 1890; to John Howard, [Feb 1909], *Selected Letters*, pp. 99, 422.)

38. See, for example, Richard Slotkin, *Gunfighter Nation: The Myth of the Frontier in Twentieth-Century America* (New York: Atheneum, 1992), pp. 29–62, 101–06, 163; and, drawing on Slotkin, David M. Emmons, "Constructed Province: History and the Making of the Last American West," *Western Historical Quarterly* 25 (Winter 1994): 451: "There was something fundamentally counter-revolutionary about this mythical West and in rapidly changing worlds with changes as far-reaching as those of the nineteenth century, men in positions of power eagerly seized and elaborated upon all counter-revolutionary devices. The myth of the West was thus a production, as surely as were the tons of steel ingots and the miles of cotton cloth, of a market driven industrializing society. It gave to the dominant elements of that society—mostly eastern—a powerful argument against those who challenged their dominance." For an apposite rebuttal, see William Cronon, "The West: A Moving Target," ibid., pp. 480–81.

39. Delbert E. Wylder, *Emerson Hough* (New York: Twayne Publishers, 1981), pp. 27, 37–39, 61.

40. Richard Harding Davis to his Family, December 26, 1896, and to his Mother, January 15, 1897, in Charles Belmont Davis, ed., *Adventures and Letters of Richard Harding Davis* (New York: Charles Scribner's Sons, 1917), pp. 189, 193.

41. Theodore Roosevelt, "The Manly Virtues and Practical Politics," *American Ideals/The Strenuous Life/Realizable Ideals*, p. 32 (*The Forum*, July 1894).

42. Theodore Roosevelt, "The Strenuous Life," ibid., pp. 319, 331 (Speech before the Hamilton Club, Chicago, April 10, 1899); and "National Duties" (1901), p. 470. The power of Roosevelt's assumptions is suggested by Richard Harding Davis's bout of self-reproach after declining an officer's commission in 1898 on the advice of friends (including Remington) that he continue on as a war correspondent instead: "On reflection I am greatly troubled that I declined the captaincy.… my having had too much excitement and freedom… spoils me to make sacrifices that other men can

make.… It is a question of character entirely and I don't feel I've played the part at all. It's all very well to say you are doing more by writing, but are you? It's an easy game to look on and pat the other chaps on the back with a few paragraphs, that is cheap patriotism. They're taking chances and you're not and when the war's over they'll be happy and I won't.… I had a chance of a life time, and declined it. I'll always feel I lost in character.…" (Davis to Charles Davis, May 14, 1898, in Davis, ed., *Adventures and Letters of Richard Harding Davis*, pp. 240–41.)

43. See Sacvan Bercovitch, *The American Jeremiad* (Madison: University of Wisconsin Press, 1978), especially chaps. 5–6.

44. David Tappan, *A Discourse, Delivered to the Religious Society in Brattle-Street, Boston… on April 5, 1798*; quoted in Stow Persons, "The Cyclical Theory of History in Eighteenth Century America," *American Quarterly* 6 (Summer 1954): 152–53.

45. Roosevelt, "The Strenuous Life" (1899), p. 323; Lewis Henry Morgan, *Ancient Society; or, Researches in the Lines of Human Progress from Savagery Through Barbarism to Civilization*, ed. Eleanor Burke Leacock (Cleveland: Meridian Books, 1963 [1877]), p. 561. It should be noted that Morgan and Roosevelt drew different lessons from a common premise: Morgan, a universal ethic, Roosevelt, a nationalistic one.

46. Roosevelt, "The Strenuous Life" (1899), p. 323. For background to the strenuous life ethic, see David G. Pugh, "Virility's Virtue: The Making of the Masculinity Cult in American Life, 1828–1890" (Unpublished Ph.D. thesis, Washington State University, 1978), a thesis that rests on the premise of male role anxiety. G. Edward White, *The Eastern Establishment and the Western Experience: The West of Frederic Remington, Theodore Roosevelt, and Owen Wister* (New Haven, CT: Yale University Press, 1968), remains the best work on the involvement of certain Easterners in creating the Western myth, especially in showing that their version of the West was entirely consistent with their own code of values. For additional sources, see Brian W. Dippie, *Frederic Remington (1861–1909): Paintings, Drawings, and Sculpture*, notes to introduction, pp. 7–23, reprinting "Frederic Remington's Wild West." Current historical interest in masculinity, derived from women's history's concern with the construction of gender, finds a ready focus in Roosevelt: see Arnaldo Testi, "The Gender of Reform Politics: Theodore Roosevelt and the Culture of Masculinity," *Journal of American History* 81 (March 1995): 1509–1533; and Gail Bederman, *Manliness & Civilization: A Cultural History of Gender and Race in the United States, 1880–1917* (Chicago: University of Chicago Press, 1995), chap. 5.

47. "Frederic Remington," *Boston Transcript*, December 27, 1909.

48. FR, "Black Water and Shallows," *Harper's Monthly*, August 1893, and "In the Sierra Madre with the Punchers," *Harper's Monthly*, February 1894; *Collected Writings*, pp. 104, 129.

49. Leonard Wood, "Roosevelt: Soldier, Statesman, and Friend," preface to Theodore Roosevelt, *The Rough Riders and Men of Action* (The Works of Theodore Roosevelt [National Edition], Vol. XI) (New York: Charles Scribner's Sons, 1926), pp. xi, xiii–xiv. A contemporary biographer, Francis Leupp, in *The Man Roosevelt: A Portrait Sketch* (New York: D. Appleton and Company, 1904), pp. 198–99, stressed Roosevelt's emphasis on a "sound physique": "… hunting big game, hard riding, bouts with the gloves and foils, twenty-mile tramps over rough roads, scaling mountain crags, polo, football, wrestling, are to the individual, in Mr. Roosevelt's view, what occasional stimulation of the war spirit is to the nation. They harden his muscles, improve his

wind and steady his nerves. They bring him face to face with danger till he learns to despise it. They sharpen his senses. They make him resourceful almost in spite of himself. They quicken his wit and strengthen his will. They teach him self-care, self-control, self-confidence."

50. Emerson Hough to James K. Cornwall, September 4, 1913, in Wylder, *Emerson Hough*, p. 51. For Hough's wilderness ethic, see *Let Us Go Afield* (New York: D. Appleton and Company, 1916), p. 145: "We wiped the West off the earth, if not off the maps, long ago, and now we seek to water its grave with national irrigation. The terms civilized and savage are, however, but relative, and there is always some sort of balance struck between them. Continually we make war upon the wilderness, its people, its creatures; yet, having done so, we covet again the wilderness, yearn for it, depend upon it, and ape it even in our clothing. We may abolish the wilderness from the earth and from the map, but we cannot abolish it from our blood."

51. FR to Eva Remington, July 1, 1888, *Selected Letters*, p. 60.

52. Diary, September 29, October 1, 1908, FRAM 71.817

53. Julian Ralph, "Frederic Remington," *Harper's Weekly*, January 17, 1891, p. 43. "Its a great consolation to [a] fat gentleman to know that he looks solid whether he is or not," Remington joked a few days after his twenty-seventh birthday. "Sleeping in ash barrels and missing meals dont put lining under a mans vest." (FR to Powhatan Clarke, October 31, 1888, *Selected Letters*, p. 64.)

54. FR to Daniel Beard, undated, Daniel Carter Beard Papers, Library of Congress, Washington, D.C.

55. Thomas, "Recollections of Frederic Remington," pp. 354, 357–58.

56. [Edwin Wildman], "Along the Water Trail to Frederic Remington's Island Home," *New York Herald*, Magazine sect., August 23, 1908. Wildman continued: "His face is as ruddy as a longshoreman's, and his muscles are as strong as a trained athlete's…. Tall, rotund as Taft, small of face and form, muscular and light on his feet as an Indian, Remington is a feature of island life on the St. Lawrence…." These comments were based on observations made in 1902. At the time, echoing Julian Ralph's much earlier assessment, Wildman had written: "Lethargy and idleness… have become associated with fleshy men. Remington is big—'tremendous,' as he might put it; but he is a bundle of nervous energy that gives him the liveliness of a boy of ten." ("Frederic Remington, the Man," *Outing* 41 [March 1903]: 712.)

57. Maxwell, "Frederic Remington—Most Typical of American Artists," p. 397.

58. "Frederic Remington Spends a Day in Omaha," unidentified clipping [April 1907], FRAM Box 18 B

59. War Correspondent's Pass, No. 11, U.S. Navy Department, April 30, 1898, FRAM 96.8.15; FR, "With the Fifth Corps," *Harper's Monthly*, November 1898; *Collected Writings*, p. 338.

60. FR, "With the Fifth Corps;" *Collected Writings*, p. 348.

61. FR to John Fox, Jr., June 26 [1899], Fox Family Collection, Appalachian Center, University of Kentucky, Lexington. My thanks to Darlene Wilson for bringing this correspondence to my attention.

62. FR, "How Stilwell Sold Out," *Collier's Weekly*, December 16, 1899; *Collected Writings*, p. 397.

63. John F. Weir to FR, July 15, 1900, *Selected Letters*, p. 312. Like the great comedian yearning for the status of a tragedian, some of America's most popular illustrators, including Remington, were desperate for recognition as fine art painters. Exclusive contracts such as Remington enjoyed with *Collier's* were a reward for that very popularity; thus the *Collier's* stable Remington joined was populated with

celebrated illustrators like himself. See Judy L. Larson, *American Illustration, 1890–1925: Romance, Adventure & Suspense* (Calgary, Alberta: Glenbow Museum, 1986), pp. 37, 31–2, 43.

64. Diary, December 9, 1909, FRAM 71.816.

65. This was Remington's revealing usage: "I am going to give the Hepburns a painting—a small landscape—not the 'Grand Frontier' but a small intimate Eastern thing which will sit as a friend at their elbow." (July 30, 1909, Diary, FRAM 71.816.)

66. "Remington Collection Contains Many Objects of Rare Interest," *Ogdensburg Journal*, undated clipping (ca. May 1915), FRAM; and see Peter H. Hassrick, "Frederic Remington's Studio: A Reflection," *The Magazine Antiques* 146 (November 1994): 666–73, which compares Remington's studio to that of William Merritt Chase.

67. Wildman, "Frederic Remington, the Man," pp. 715–16.

68. [Wildman], "Along the Water Trail to Frederic Remington's Island Home."

69. Maxwell, "Frederic Remington—Most Typical of American Artists," p. 405; and see Tatham and Manley, *Artist in Residence*, for a generous selection of Remington's North Country landscapes.

70. Wildman, "Frederic Remington, the Man," p. 716; and [Wildman], "Along the Water Trail to Frederic Remington's Island Home." In an oft-quoted letter to Scott Turner written in 1877 (*Selected Letters*, p. 14) when he was sixteen, Remington observed: "There is nothing poetical about me."

71. Charles H. Garrett, "Remington and His Work," *Success*, May 13, 1899; in Marden, ed., *Little Visits with Great Americans*, I, p. 328.

72. FR to Mary Fanton Roberts, [December 1908], December 11, 1908, Mary Fanton Roberts Papers, Archives of American Art, Roll D 163. He was delighted [ca. January 1910] when he read her article in draft: "I find it very much all right;… the best statement of actualities I have seen as yet." The essay appeared under the pseudonym Giles Edgerton as "Frederic Remington, Painter and Sculptor: A Pioneer in Distinctive American Art," *Craftsman* 10 (March 1909): 658–70, and emphasized his evolution from illustrator to artist.

73. J. H. Chapin to FR, October 18, 1909, *Selected Letters*, p. 448.

74. Royal Cortissoz to FR, Tuesday, December 2 [December 1, 1908], FRAM. This letter, perhaps because of its own confused dating, has been misdated 1904 in Samuels and Samuels, *Frederic Remington*, p. 358, and *Selected Letters*, p. 358, where the text is also printed with many variations due to Cortissoz's difficult handwriting. Remington's Knoedler exhibition opened December 1, 1908. The next day, while he accepted congratulations over lunch at the Players Club, he heard that Cortissoz was "much impressed," and the day after received a "fine letter" from him about his paintings. (Diary, December 2–3, 1908, FRAM 71.817.)

75. Royal Cortissoz, "Frederic Remington: A Painter of American Life," *Scribner's Magazine* 47 (February 1910): 184, 186–87, 192. When Cortissoz reprinted his essay on Remington years later as a chapter in his *American Artists* (New York: Charles Scribner's Sons, 1923), he retained the ending, rendered in the past tense, and after observing of Remington's late work, "It suggests a talent that was always ripening, an artistic personality that was always pressing forward," added: "There was tragedy in its untimely loss" (p. 243).

76. Russell, "A Popular Favorite, a Poor Reputation."

77. "Goings On About Town," *New Yorker*, March 6, 1989, p. 14. With as much perspicacity, David M. Lisi, in a review of the Masterworks catalog in *Art & Auction* 10 (June 1988): 114, paraphrased a standard judgment he was not about to challenge: "Western art has always been considered a sort

of idiot-cousin, exiled to the dusty attic of American art." A notable exception was Anne Matthews' thoughtful "Remington: Not Just at Home on the Range," *New York Times*, February 5, 1989.

78. Ruth Lorand, "Beauty and Its Opposites," *Journal of Aesthetics and Art Criticism* 52 (Fall 1994): 403–04.

79. Roosevelt, "National Duties" (1901), p. 469.

80. [Wildman], "Along the Water Trail to Frederic Remington's Island Home.

81. There is a voluminous literature about the new Western history; for a sampler, see Patricia Nelson Limerick, Clyde A. Milner II, and Charles E. Rankin, eds., *Trails: Toward a New Western History* (Lawrence: University Press of Kansas, 1991).

82. Diary, July 10, 1907, FRAM 71.815.

83. [Wildman], "Along the Water Trail to Frederic Remington's Island Home." "In other words," Wildman explained Remington's remark, "he paints to young blood that feels the pulse of youth and the fire of things that move." In "Frederic Remington, the Man," p. 716, Wildman rendered Remington's comment on his audience differently: "Boys—boys between twelve and seventy—can't draw a woman—never tried but one, and washed her out of the picture. Horses, men—men of the Big West…."

84. Diary, December 23–26, 1909 (entries in Eva Remington's hand), FRAM 71.816.

85. C. M. Fairbanks, "Artist Remington at Home and Afield," *Metropolitan Magazine*, 4(July 1896): 445–46.

86. [Wildman], "Along the Water Trail to Frederic Remington's Island Home."

87. Eva Remington figures prominently in Samuels and Samuels, *Frederic Remington*; Manley and Mangum, *Frederic Remington and the North Country*; and *Selected Letters*.

88. Martha Summerhayes, *Vanished Arizona: Recollections of the Army Life of a New England Woman* (Salem, MA: The Salem-Press Co., 2nd ed., 1911), p. 289.

89. Eva Remington to Powhatan Clarke, May 24, September 13 (postscript), 1890; June 1, 1891, *Selected Letters*, pp. 94, 101, 111–12.

90. Eva Remington to Poultney Bigelow, January 28, 1897, *Selected Letters*, p. 219.

91. Eva Remington, Executrix, Frederic Remington Estate Inventory, April 12, 1910, FRAM 96.8.11 a–e.

92. Eva Remington to Albert S. Brolley, February 11, 1910, Buffalo Bill Historical Center, Cody, WY.

93. Eva Remington to Albert S. Brolley, June 10, 1910, Buffalo Bill Historical Center, Cody, WY; Samuels and Samuels, *Frederic Remington*, pp. 442–46; Manley and Mangum, *Frederic Remington and the North Country*, pp. 216–28, a more sympathetic (and detailed) account than draws on Eva's diary; "Remington Collection Contains Many Objects of Rare Interest"; John C. Howard, *A History of the Ogdensburg Public Library and Remington Art Memorial* (Ogdensburg: Trustees of the Ogdensburg Public Library, [1938]), reprinting an article from the *Ogdensburg Journal*, May 31, 1938; and Margaret Fitzhugh Browne, "Frederic Remington's Wild West Comes East," *Boston Evening Transcript*, Magazine sect., August 4, 1923.

94. Last Will and Testament of Eva A. Remington (probated December 23, 1918), copy, FRAM 97.3.

95. There are notable gaps in the correspondence. Remington would most certainly have written Eva during their separation in the strained first year of their marriage, for example. But Eva (and after her, her sister Emma, who managed the estate) had ample time to sort through his letters and destroy those considered too personal.

96. See Peter H. Hassrick, *The Remington Studio* (Cody, WY: Buffalo Bill Historical Center, 1981).

97. Julian Ralph, "Frederic Remington" (1891), p. 43.
98. FR to Albert S. Brolley, December 10 [1905], *Selected Letters*, p. 432.
99. Remington Estate Inventory hand-corrected copy, FRAM 96.8.11 a–e (April 12, 1910); Last Will and Testament of Eva A. Remington (December 23, 1918); and *The Frederic Remington Memorial, Ogdensburg, N.Y. Opened July 1923* (Ogdensburg, NY: *Republican-Journal*, [1923]).

The Collection

Frederic Remington Art Museum

Packing and Paddling in the Adirondacks.
 Sketches by Frederic Remington (sketchbook title page) early 1880s
Ink (and pencil added later) on paper, 12 x 9⅛" (30.5 x 23.2 cm.)
FRAM 66.317.6, CR 35a

"Big" early 1880s
Watercolor on paper, 11¾ x 9" (29.9 x 22.9 cm.)
Inscribed lower left: "Big"
FRAM 66.240

A Hunting Outfit early 1880s
Watercolor on paper, 8⅝ x 11⅜" (21.9 x 28.9 cm.)
Inscribed lower left: A Hunting Outfit.
FRAM 66.317.9

"Eph" on the Trail early 1880s
Watercolor on paper, 11¾ x 9" (29.9 x 22.9 cm.)
Inscribed lower left: "Eph" on the trail.
FRAM 66.241

It was Frederic Remington's proud boast, "I was born in the woods and the higher they get the buildings the worse I like them."[1] Camping and hunting and fishing with boon companions were tonic to him, and defined his character and his art. His boyhood preoccupations were his adult preoccupations as well: horses (he was, a journalist remarked in 1896, born into "horsey surroundings"), things military, the outdoors, and the West.[2] The West, of course, conveniently encompassed the other three, adding the wide open spaces of deserts and plains to the forest wilderness of lakes, rivers, and mountain trails of northern New York. The consistency of Remington's vision is evident from his earliest art, including a portfolio of sketches in pencil, ink and watercolor aptly titled "Packing and Paddling in the Adirondacks." The drawing style and the awkward passages in the anatomy of some of the full-length figures indicate that Remington made these sketches in the early 1880s—perhaps even before he took up residence in Kansas in 1883.[3] His portrait of an Adirondack companion, *"Big,"* for example, and his Kansas study *Boss of the "Badger State" in Spring Lambing* (p. 45) share similarities, including the men's poses, that suggest both were done at about the same stage in Remington's artistic development.

"Packing and Paddling in the Adirondacks" included sketches of scenery but focused on outdoorsmen and their activities, anticipating Remington's interest in frontier "types" more than

Packing and Paddling in the Adirondacks. Sketches by Frederic Remington early 1880s

Right:
A Hunting Outfit early 1880s

Bottom left:
"Eph" on the Trail early 1880s

Bottom right:
"Big" early 1880s

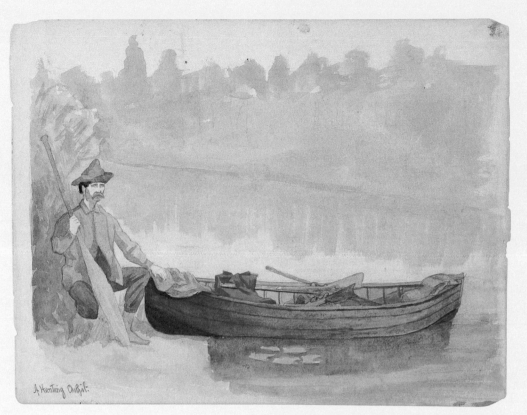

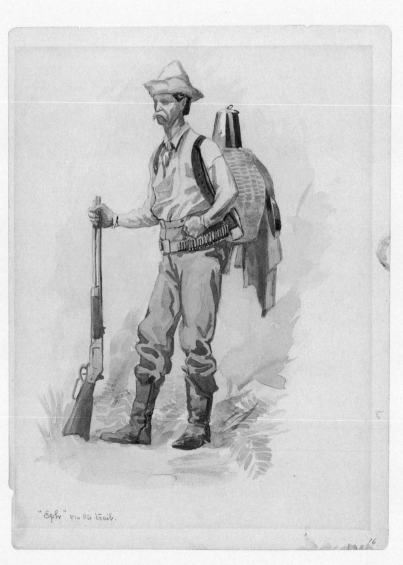

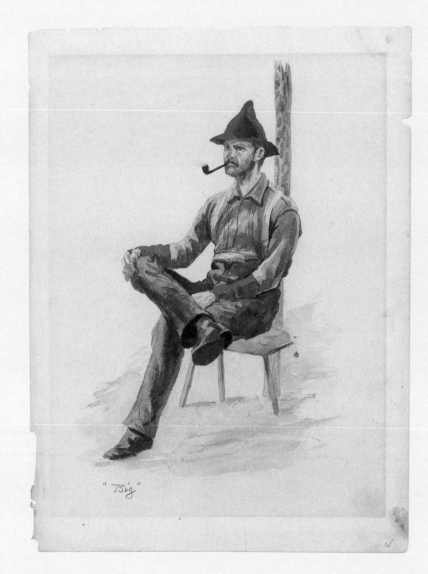

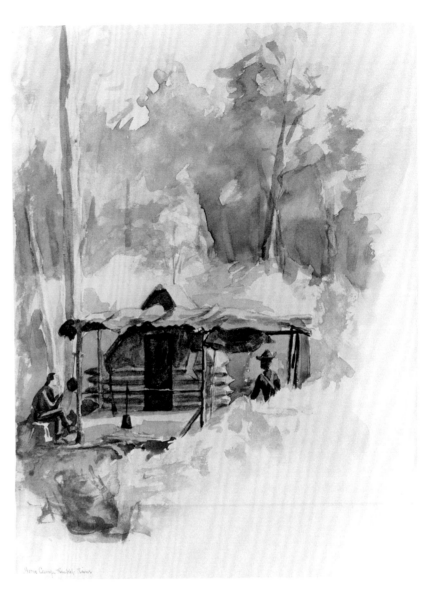

Early Morning in Camp early 1880s
Pencil on paper, 11½ x 8⅞" (29.2 x 22.5 cm)
Inscribed lower left: Early morning in Camp.
FRAM 66.317.5

Home Camp, Racket River [Raquette River] early 1880s
Watercolor on paper, 11⅜ x 8½" (28.9 x 21.6 cm)
Inscribed lower left: Home Camp, Racket River.
FRAM 66.251

Snaking Up a Rapid early 1880s
Pencil on paper, 11⅞ x 9" (30.2 x 22.9 cm.)
Inscribed lower left: Snaking up a Rapid.
FRAM 66.252

Running a Rapid early 1880s
Pencil on paper, 12 x 9⅞" (30.5 x 25.1 cm.)
Inscribed lower left: Running a Rapid.
FRAM 66.317.4

his late-life enthusiasm for landscape.[4] The close attention to detail and the obvious pleasure taken in outdoor adventure—and routine—evident in *Early Morning in Camp; A Rough Trail; Home Camp, Racket River; Extemporized Camp on Burnt Island 40° Below;* and *Snaking Up a Rapid* are hallmarks of the realism that made Remington so successful as a Western illustrator. *Running a Rapid*, for example, found a Western translation in Remington's illustration *An Indian Canoe on the Columbia* (p. 156).

The guides were of particular interest to Remington. He was the "sport," they were the professionals, and in costume and demeanor anticipated the rough-hewn Western "men with the bark on" whom he subsequently immortalized. *A Hunting Outfit* shows one of the party, perhaps *"Big"* again, posed with an Adirondack guideboat (slim, portable, and fast on the water), while *"Eph" on the Trail* shows another member, apparently a guide, transporting an Adirondack packbasket (light, durable, made of ash-strip).[5] Photographs of Remington with guides Bill and Has (Harrison) Rasbeck, taken at Cranberry Lake about 1890, indicate he was comfortable hiking or canoeing in his outdoors gear. But he still looked very much the sport in their company—like the "dude" that he was, within limits, willing to be thought when he was around seasoned troopers and working cowboys out West.[6]

It is often noted that Remington was essentially a summer excursionist in the West, on assignment as an illustrator or in pursuit of fresh inspiration as a painter. Similarly, once he married and settled down to his busy career, he was essentially a city dweller who vacationed in the North Country. Bishop's Hotel on Cranberry Lake was a favorite destination. It offered creature comforts in a wilderness setting, an unbeatable combination for a successful artist who had learned to like high buildings just fine. Remington, with two friends, acquired property at Witch Bay on Cranberry Lake, and through the 1890s he found recreational release in the Adirondacks.[7] His watercolor, *Sam Bancroft's Home* (ca. 1894), captures the rustic appeal that lured him. Remington subsequently purchased an island on the St. Lawrence and beginning in 1900 made it his annual summer destination instead (see pp. 190–94). Still, the North Country wilderness of his youth remained close to his heart.

A Rough Trail early 1880s
Ink wash on paper, 11½ x 8⅞" (29.2 x 22.5 cm.)
Inscribed lower center: A rough trail.
FRAM 66.317.12

Extemporized Camp on Burnt Island 40° Below early 1880s
Watercolor and ink on paper, 11½ x 9" (29.2 x 22.9 cm.)
Inscribed: Extemporized Camp on Burnt Island 40° below
FRAM 66.253

Remington at Cranberry
Lake, about 1890
FRAM 1918.76.153.10

1. FR to Powhatan Clarke, March 19, 1892, *Selected Letters*, p. 129.
2. C. M. Fairbanks, "Artist Remington at Home and Afield," *Metropolitan Magazine* 4 (July 1896): 447.
3. The sketches are dated circa 1890s in *Artist in Residence: The North Country Art of Frederic Remington* (Ogdensburg: Frederic Remington Art Museum, 1985), "Checklist to the Exhibition," and circa 1885, CR 35a.
4. Indeed, the soldiers' heads sketched (at a later date) on the title page accurately indicate Remington's priorities as an illustrator. He also used pages from "Packing and Paddling in the Adirondacks" as sketching paper for military studies—*A Sketch from Memory* (*Artist in Residence*, p. 51) and a watercolor landscape titled *Little Rips above Downie's* (see p. 54). He also did portraits of his companions on the Adirondacks outing at the time—see *The Bicknell Rips Party* (p. 91).
5. Anne LaBastille, "Doctors of the Wilderness," *Natural History* (May 1992): 43–44. The "sports," of course, were eager to shed their citified ways and blend in with the guides and the out-of-doors. Thus "Big" may actually be Remington's Yale classmate and professional associate Poultney Bigelow, and it is possible that Eph was another city friend.
6. For Remington and the Rasbecks, see Atwood Manley and Margaret Manley Mangum, *Frederic Remington and the North Country* (New York: E. P. Dutton, 1988), pp. 113–14, 118–19.
7. Ibid., p. 114.

Frederic Remington with
Bill and "Has" Rasbeck,
Cranberry Lake, about 1890
FRAM 1918.76.153.5

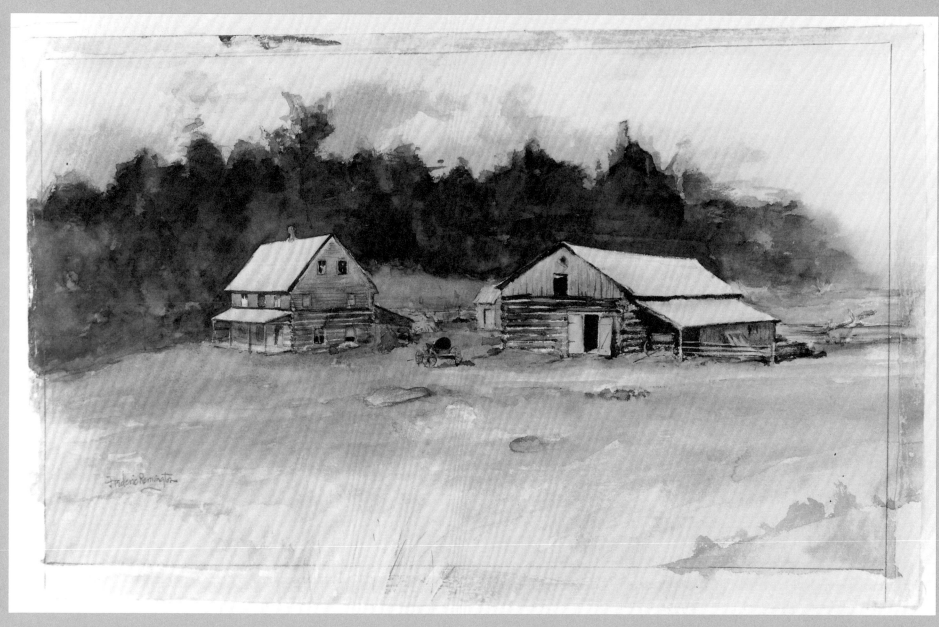

Sam Bancroft's Home (*Cranberry Lake, Sam Bancroft's Home—Caretaker*) ca. 1894
Watercolor on paper, 11 x 18½" (27.9 x 46.6 cm.)
Signed lower left: Frederic Remington
FRAM 66.89, CR 1784

My Ranch 1883

Pen and ink and watercolor on paper, 8⅞ x 11⅞" (22.5 x 30.2 cm.)

Inscribed lower right: my Ranch.

FRAM 66.248, CR 15

Boss of the "Badger State" in Spring Lambing 1883

Pen and ink on paper, 11⅞ x 8⅞" (30.2 x 22.5 cm.)

Inscribed bottom center: Boss of the "Badger State" in Spring Lambing.

FRAM 66.242

Any Thing for a Quiet Life 1883

Pen and ink on paper, 8⅞ x 11⅞" (22.5 x 30.2 cm.)

Inscribed lower left: Any thing for a quiet life.

FRAM 66.246

Feeding 1883

Pen and ink and watercolor on paper, 11⅞ x 8⅞" (30.2 x 22.5 cm.)

Inscribed lower left: Feeding.

FRAM 66.243, CR 14

This unassuming group of drawings—part of a larger body of sketches made in Kansas in 1883—are mementos of a crucial formative experience for the young Remington. Upon turning twenty-one in October 1882 he came into his inheritance, some $9,000, and shortly after invested the bulk of it in a sheep ranch in Butler County, Kansas. That fact, unremarkable in itself, gains considerable importance when it is remembered that Remington's time on his sheep ranch would constitute his only extended residence in the rural West, and it was an experience which he gradually edited out of his life in order to create the full-blown Frederic Remington myth.

Remington referred to himself in 1888 as "an ex cow-puncher,"[1] but his first major biographical notice, written by his friend Julian Ralph and published in *Harper's Weekly* in January 1891, stated matter-of-factly, "From college he went to the far West and established a sheep ranch."[2] Subsequently, Remington omitted the word "sheep" in interviews. "At nineteen," he told a reporter in 1899, "I caught the fever to go west, and incidentally to become rich… I ranched it, and got into Indian campaigns." The interviewer elaborated. Remington had found

Remington plays out his cowboy fantasies: the making of a "Man with the bark on," ca. 1888
FRAM 1918.76.160.294

life in Albany, New York "too prosaic": "He went to Montana and became a 'cow-puncher.' Later, he made money on a Kansas mule ranch, and was cowboy, guide and scout in the southwest."[3] In 1907 Perriton Maxwell further embroidered the tale. He described Remington as "once a ranger on the limitless prairies, a hard-riding, rough-living, free-fighting cow-puncher," and cloaked Remington's Kansas sojourn in generalities:

From clerk to cow-boy seemed at the time a rapid rise in the world and in a measure it was. … Later as a stockman on a ranch he assumed greater dignity and found some leisure to draw. Naturally he turned for his subjects to the frontier life around him…. The life he led, the men he encountered were not pretty, but they were men, men with the bark on….[4]

Remington's first biographer, Harold McCracken, had a chance to correct the record in *Frederic Remington: Artist of the Old West* (1947). Instead, he contributed to the confusion—and the myth. In a chapter titled "College Boy to Cowboy," McCracken told how "the nineteen-year-old Easterner" roamed the Wild West:

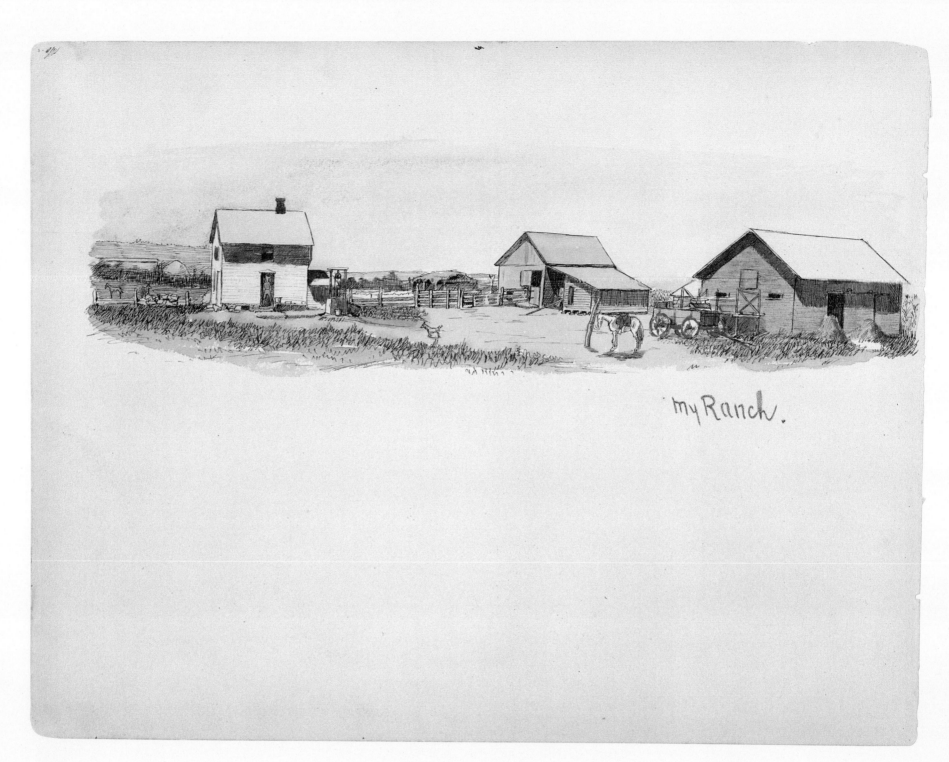

My Ranch 1883

Already an excellent rider and judge of horse-flesh, he quickly learned to throw a lariat with the skill of a trained cowboy and to handle a six-gun like a master. His fists were powerful weapons and he never feared or avoided a fight. All these were essential equipment for good health and good standing, but Frederic brought more to the West—he brought the artist's observant eye, an insatiable curiosity, a boundless interest in people and places. He wandered through the Dakotas, Montana, Wyoming, Kansas and the territories of states still unnamed. He sought out the roughest and most exciting parts of the country, and the roughest and most colorful of the people who gave the country its character.

When it came to specifics about what Remington actually *did* in Kansas, McCracken fudged: "he made an attempt to settle down near Kansas City, in the little town of Peabody, Kansas, where he tried his hand at ranching and raising mules." No mention of sheep here, or in McCracken's closing observation: "In the early spring of 1884 Remington disposed of his ranch, which had been, if not an outright failure, at least far from the gold mine he hoped for, and once more headed westward, planning to go deep into the Southwest and over into Old Mexico."[5]

It was left to Robert Taft in 1948 to rein in the Remington legend and introduce the homely truth. A chemistry professor at the University of Kansas with a longstanding interest in the photographers and illustrators who depicted the nineteenth-century Western scene, Taft was well placed to dissect Remington's Kansas experience. His sheep ranch, Taft noted, was far removed from the rowdy frontier he would glorify in his art. To be sure, there was open country around Peabody, and hard riding to be done by a young man who had a coterie of bachelor friends as irresponsible as himself. But there was precious little wild about his West. He took up residence on his quarter-section Kansas "ranch" in March 1883, made improvements, added another quarter-section to his holdings, and was gone by the end of the year. His more earnest neighbors considered him spoiled and lazy, and his behavior justified their opinion. He was young, restless, and given to pranks. He also sketched incessantly, which struck more sober-minded folk as the height of foolishness. Certainly they did not see the future artistic celebrity in him. When his property was sold off in February 1884, Remington

got back seven of the nine thousand dollars he had invested and went on to other, even more unsuccessful ventures in Kansas City. His only residence in the rural West had lasted just ten months; it would be his great achievement to transform what Taft called the "prosaic" reality of "life on a Kansas sheep ranch" (as prosaic as a clerkship in Albany) into something more—an entrée into that land of breathless excitement and perilous adventure that Remington called "*my West.*"[6]

Thus the importance of the sketches Remington made in Kansas in 1883. They have been fairly described as "clean in line but tenuous and poorly proportioned."[7] Nevertheless, they offer a charming glimpse into the artist's daily routine. *My Ranch* expresses a proprietorial pride that goes beyond the title. The sketch would reassure family at home that Remington had not frittered away his inheritance; at the age of twenty-one he *owned* something—two barns, a well, and a three-room frame house divided into a living area and upstairs sleeping quarters, with a kitchen built on. Horses, dogs and wagons rounded out his holdings. Remington's Yale classmate and Kansas neighbor, Robert Camp, who had arranged the purchase for Remington, dedicated himself to sheep-raising and made a success of it. Remington's sketch portrait of Camp, *Boss of the "Badger State" in Spring Lambing*, indicates why. Camp took a hands-on approach to his sheep; Remington, who considered them "woolly idiots,"[8] favored the overview (*Any Thing for a Quiet Life*), probably leaving the chores to his hired help (*Feeding*). Remington's Kansas sketches are documentary in the purest sense. They give an unembellished view of ordinary life in the American West in the 1880s. They are faithful to fact, closely observed, and entirely undramatic. Indeed, they exude sleepiness—and that just would not do. The public hungered for "men with the bark on." Eastern readers, Robert E. Strahorn observed in 1877, "demand experiences from the western plains and mountains which smack of the crude, the rough and the semi-barbarous."[9] Remington would become Remington when he gave up raising sheep and satisfied that other hunger instead.

1. FR to Powhatan Clarke, January 3, 1888, *Selected Letters*, p. 47.
2. Julian Ralph, "Frederic Remington," *Harper's Weekly*, January 17, 1891, p. 43.
3. Charles H. Garrett, "Remington and His Work," *Success*, May 13, 1899; in Orison Swett Marden, ed., *Little Visits with Great Americans; or Success Ideals and How to Attain Them*, 2 vols. (New York: The Success Company, 1905), I, pp. 328, 332.
4. Perriton Maxwell, "Frederic Remington—Most Typical of American Artists," *Pearson's Magazine* 18 (October 1907): 403–04.
5. Harold McCracken, *Frederic Remington: Artist of the Old West* (Philadelphia: J. B. Lippincott Company, 1947), pp. 33, 36–37. For a strong critique, see Robert Taft's review in *Nebraska History* 29 (September 1948): 278–82.
6. See Robert Taft, "The Pictorial Record of the Old West, V: Remington in Kansas," *Kansas Historical Quarterly* 16 (May 1948): 113–35, and the corresponding chapter in his *Artists and Illustrators of the Old West, 1850–1900* (New York: Charles Scribner's Sons, 1953), chap. 13. Also see Peggy and Harold Samuels, "Frederic Remington, the Holiday Sheepman," *Kansas History* 2 (Spring 1979): 2–13, the basis for part of a chapter in their *Frederic Remington: A Biography* (Garden City, NY: Doubleday & Company, 1982), pp. 38–47; and, for a few tidbits, Alta M. Crawford and Gordon R. Schultz, "Frederic Remington: Artist of the People," *Kansas Quarterly* 9 (Fall 1977): 88–118.
7. Samuels and Samuels, *Frederic Remington*, p. 44.
8. FR, "On the Indian Reservations," *Century Magazine*, July 1889; *Collected Writings*, p. 38. Theodore Roosevelt had used the same phrase in "Ranch Life in the Far West: In the Cattle Country," *Century Magazine* 35 (February 1888): 501, suggesting it was a commonplace, or else that Remington remembered Roosevelt's description.
9. Taft, "Pictorial Record of the Old West, V: Remington in Kansas," p. 119.

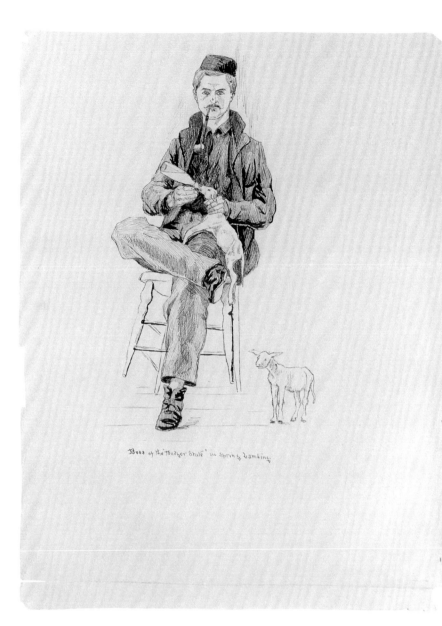

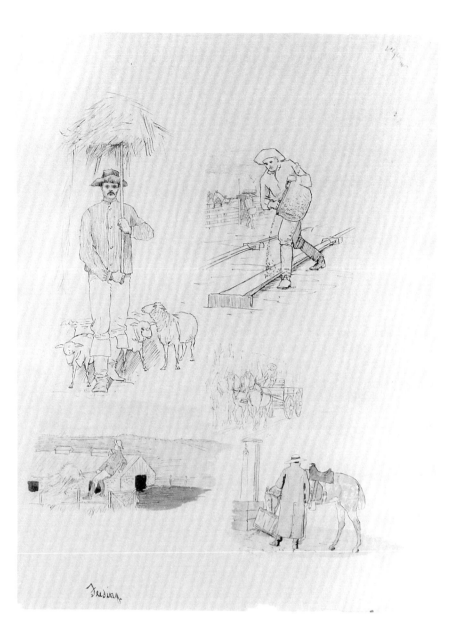

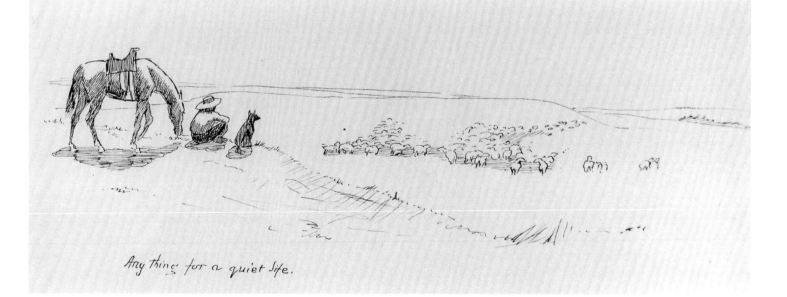

Top left:
*Boss of the "Badger State" in
Spring Lambing* 1883
Pen and ink on paper, 11⅞ x 8⅞"
(30.2 x 22.5 cm.)
Inscribed bottom center: Boss of the
"Badger State" in Spring Lambing.
FRAM 66.242

Top right:
Feeding 1883
Pen and ink and watercolor on paper
11⅞ x 8⅞" (30.2 x 22.5 cm.)
Inscribed lower left: Feeding.
FRAM 66.243, CR 14

Right:
Any Thing for a Quiet Life 1883
Pen and ink on paper, 8⅞ x 11⅞"
(22.5 x 30.2 cm.)
Inscribed lower left: Any thing for
a quiet life.
FRAM 66.246

Sunday Morning Toilet on the Ranch 1885

Watercolor on paper, 13½ x 17½" (34.3 x 44.5 cm.)
Signed center left: F. Remington. Arizona Ty. 85
Inscribed lower left: Sunday Morning Toilet on the ranch.
Promised by bequest, Charles R. Wood, Lake George, NY; CR 36

The Apaches Are Coming 1885–1886

Pen and ink, wash and gouache on paper, 14¼ x 20¼" (36.2 x 51.4 cm.)
Signed lower left: Remington
Museum purchase, 1950; Ex-collection: Mannados Book Shop, New York; FRAM 66.98, CR 40

Remington's Kansas sketches serve as a base line for comparative purposes. Less than three years after he recorded the sedate reality of sheep-raising in Butler County, he offered *Harper's Weekly* readers something far better geared to popular taste—*The Apaches Are Coming*, published in the January 30, 1886, issue. It was his second appearance in *Harper's Weekly* that month and (a breakthrough for the young artist) both were under his own name. Frederic Remington was about to become famous.

Notably, *Harper's* chose to publish this action piece instead of another watercolor painted in 1885 and presumably based on direct observation, *Sunday Morning Toilet on the Ranch*. Set near Casa Grande, Arizona Territory, it likely derives from the period after Eva Remington left Kansas City and a chastened Frederic "wandered" the Southwest. In his art, Remington chose to emphasize a certain masculine jauntiness in overcoming deprivation. Like Henry David Thoreau, he believed that "It would be some advantage to live a primitive and frontier life, though in the midst of an outward civilization, if only to learn what are the gross necessaries of life...."[1] Hunting, fishing, and traveling in remote country provided opportunities for learning. Remington doted on the routine of camp life, and often pictured outdoorsmen rustling up grub and grooming themselves—shaving, bathing, getting haircuts. *Sunday Morning Toilet on the Ranch* is one of his earliest Western studies in this vein, and James K. Ballinger has praised it as a more successful work of art than *The Apaches Are Coming*.[2] It went unpublished in Remington's lifetime—likely because it was deemed deficient in

In the Hands of the Camp Barber at Tampa 1898
Photo courtesy of Mongerson Galleries, Chicago, IL

drama—but it belongs in the established Western genre tradition of Charles Christian Nahl's *Sunday Morning in the Mines* (1872), which showed California prospectors at ease on the Sabbath, and its central figures reappeared thirteen years later in another Remington drawing, *In the Hands of the Camp Barber at Tampa*, that was published in 1898.

Remington's work was still awkward in 1885, and *The Apaches Are Coming* is a case in point. Its composition is cluttered, the reactions of the figures exaggerated, and some of the poses stiff. But it was an attention-grabber. *Harper's Weekly* readers who had been following the most recent Apache outbreak in Arizona were bound to be thrilled. The Apaches were supposedly "the tiger of the human species," their very name synonymous with terror.[3] Urban amenities—and urban humdrum—evaporated before the realization that out there, in the remote desert wastes, desperate life-and-death struggles with Indians were still being waged. Geronimo! Apache uprising! The war in 1886 was every headline that made the West exciting, glued young readers to the pages of the latest dime novel, and lured Americans in droves to witness the newest entertainment sensation, Honorable William F. (Buffalo Bill) Cody's Wild West. It did not matter that Remington's drawing was itself a melodramatic invention, or that the setting derived from a watercolor of a sleepy little *Post Office*. The picturesque adobe structure, the sombreros and the peasant costumes were *facts* that verified the action and established Remington's credentials. He might be a neophyte illustrator, but he was a shrewd one. His compositional clutter served a purpose: it proved that he *knew* the Southwest. Just so was his reputation made.

Charles Christian Nahl,
Sunday Morning in the Mines 1872
E. B. Crocker Art Gallery, Sacramento, CA

Post Office ca. 1885
Watercolor on paper
14 x 20¼" (35.6 x 51.4 cm.) Unsigned.
FRAM 66.270

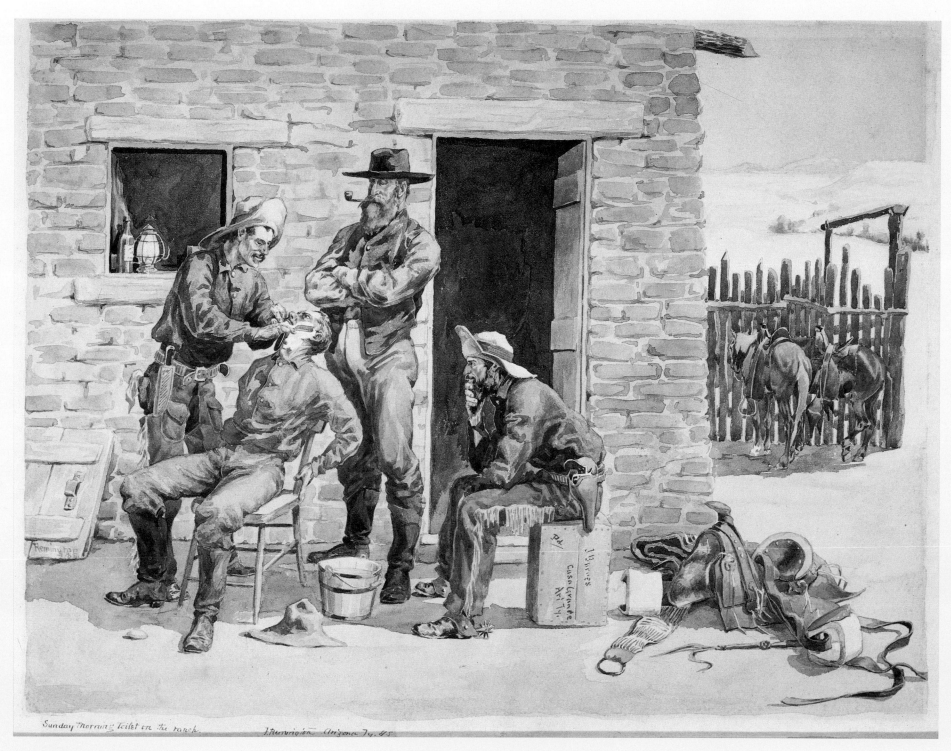

Sunday Morning Toilet on the Ranch 1885

Above:
An Overland Station: Indians Coming in with the Stage 1897
Frederic Remington, *Drawings* (New York: R. H. Russell, 1897)

Below:
The Apaches! 1904
Photo courtesy of the John F. Eulich Collection, Dallas, TX;
Sid Richardson Collection of Western Art, Fort Worth, TX
CR 2711

Remington liked this subject enough to rework it twice—in his 1897 wash drawing *An Overland Station: Indians Coming in with the Stage*, which repeated three of the figures while advancing the action; and in his 1904 oil painting *The Apaches!* which simplified the composition and reversed the perspective but repeated major elements of the original drawing. Over time, Remington's painterly preoccupation would eliminate many of the stylistic hallmarks of his early illustrations, but not his subjects or his treatment of them.[4]

1. Brooks Atkinson, ed., *Walden and Other Writings of Henry David Thoreau* (New York: The Modern Library, 1950), p. 10. Remington echoed this (see p. 21) and other observations from *Walden* (1854)—for example, Thoreau's dismissal of those things that "moth and rust will corrupt and thieves break through and steal" (ibid., p. 5), which anticipated Remington's case for sculpture's superiority over other forms of art.

2. James K. Ballinger, *Frederic Remington's Southwest* (Phoenix: Phoenix Art Museum, 1992), pp. 10–12.

3. George Crook, "The Apache Problem," *Journal of the Military Service Institute of the United States* 7 (September 1886): 269. The literature on Geronimo and the Apache wars is substantial. A readable narrative is Odie B. Faulk, *The Geronimo Campaign* (New York: Oxford University Press, 1969).

4. For the continuities in Remington's art, see Brian W. Dippie, "Frederic Remington's West: Where History Meets Myth," in Chris Bruce, et al., *Myth of the West* (New York: Rizzoli, for the Henry Art Gallery, University of Washington, Seattle, 1990), pp. 110–19.

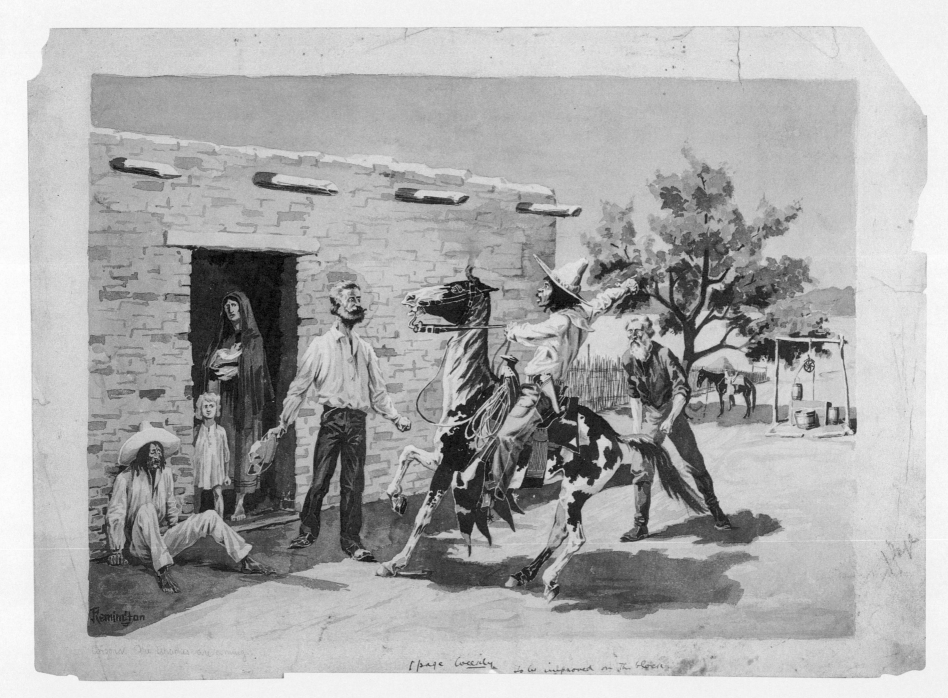

The Apaches Are Coming 1885–1886
Pen and ink, wash and gouache on paper, 14¼ x 20 ¼" (36.2 x 51.4 cm.)
Signed lower left: Remington
Museum purchase, 1950; Ex-collection: Mannados Book Shop, New York;
FRAM 66.98, CR 40

Civil War Battle Scene ca. 1885
Pen and ink on paper, 14¼ x 22½"(36.2 x 57.2 cm.)
Unsigned.
Acquired in 1973; FRAM 73.21, CR 22

The Noonday Halt 1887
Pen and ink on paper, 8¼ x 13⅜" (21 x 34 cm.)
Signed lower left: Remington.; inscribed lower left margin: —The noonday halt.—
Donated by Mershon Miller, Sheila McDowell DeLany, Laura Armstrong Brownlee
in memory of Laurance Brownlee, Col. (U.S.A. Ret.) and Mershon Kessler Brownlee;
FRAM 86.8, CR 150

Remington was frank about his limitations as a pen-and-ink artist. "The pen was never natural with me," he told an interviewer in 1907. "I worked with it in the early days only to get away from the infernal wood engravers.... Pen and ink is a splendid medium for presenting familiar, every-day subjects, but my stuff was utterly strange to most people when I began picturing Western types."[1] The last statement is a bit disingenuous; Remington's limitations were pronounced by the standards of the really talented pen-and-ink illustrators of his day. In comparison to Arthur B. Frost and Edward W. Kemble, for example, he came up short in the estimate of a respected critic, Joseph Pennell, who, writing in 1889, observed of one of Remington's Western drawings, *A Dispute Over a Brand*,

there is a certain scrawl of meaningless lines over the grass which is found in nearly all his work; the drawing is not so well thought out as Frost's, and it has a mechanical look which is much more evident in… [a large] reproduction than ordinarily, because his drawings are usually reduced to a much smaller size. The intelligent critic will of course ask what has become of the cow's other horn. My only answer is that I am sure I do not know. For a man with such a thorough knowledge of animal anatomy this omission is rather curious. His drawing of the men's hands is not as careful as Frost's or Kemble's.[2]

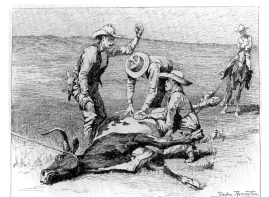

A Dispute over a Brand 1887
Century Magazine 35 (February 1888): 506

With qualifications, Remington could cheerfully accept this judgment (a copy of Pennell's book containing this criticism remained in his personal library) because he never thought of himself as a pen-and-ink man—he aspired to be a painter. But sketching was as natural to him as to any budding artist, and he did his share of pen and ink drawings over the years.

In 1877 Remington wrote to another youthful artist with whom he swapped sketches, "You draw splendidly, and I admire your mode of shading, which I cannot get the 'hang' of."[3] Shading was only one of his problems. Long after he was an established illustrator—indeed, a celebrity—he could be offhand in his drawing, and a reviewer of his last exhibition in 1909 chided him for carelessness in some of his depictions of horses.[4] Critics complained about his human faces, which were often expressionless masks since he specialized in fixed attitudes rather than emotions. Anatomy also periodically bedeviled him. Remington was one artist who did not make his own body type the standard. Instead, he tended to elongate the human figure, thereby contributing to the stereotype of the tall, lanky Westerner. And movement presented problems, too. Remington was a master of action, but he was also capable of freezing figures in stiff, unnatural poses.

The pen and ink drawing *Civil War Battle Scene* represents an early stage in Remington's artistic development. It dates from around 1885, judging from some of his watercolors painted that year, and is unusual in its subject matter. Remington

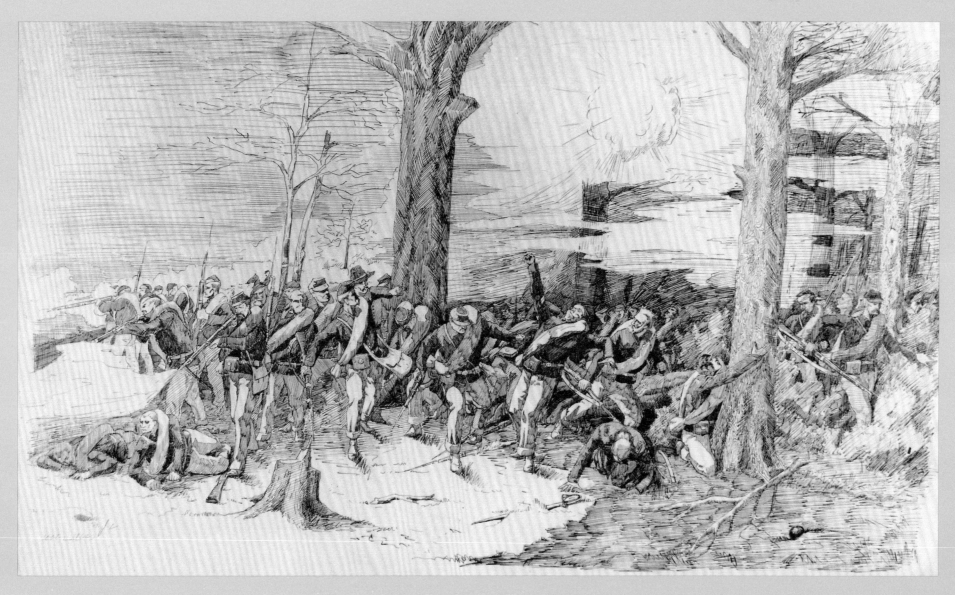

Civil War Battle Scene ca. 1885

envied his father's Civil War service, and as a boy he often sketched battle action. But he avoided the Civil War period in his mature art on the sensible principle that "I do not know enough about it."[5] *Civil War Battle Scene* evinces many of Remington's artistic faults. The anatomy is suspect, the action stilted. The figures are like cutouts strung across the picture on a single plane, without a care for composition. Most likely, Remington's inspiration was a woodcut; certainly his overwrought pen style is imitative of the engraver's craft, with its stippling, cross-hatching and outlining.

Another Remington pen and ink published in 1887, *The Noonday Halt*, shows progress.[6] Its surface is less busy, the figures have some volume, and the contrasts in light and shadow are more pronounced. It is not a particularly ambitious drawing. But there is heat in the air, a patch of shade provided by the leafy boughs, and enlisted men doing what soldiers have done throughout history. Here is not the drama of battle, but the quieter drama of everyday service. *The Noonday Halt* anticipates Remington's enduring achievement as a military artist. He might be known for his action pieces, but their claim to authenticity rested always on his close observation of soldierly routine.

1. Perriton Maxwell, "Frederic Remington—Most Typical of American Artists," *Pearson's Magazine* 18 (October 1907): 403. Remington's grousing about the engravers should be put in perspective. Illustrators routinely blamed engravers for any deficiencies in their published work, but as an historian of American illustration has pointed out, theirs was a reciprocal relationship: "Illustrators were aware that most of their works would survive only as reproductions; therefore, their reputations were made by the reproductions, not by the original.... artists continued to blame the engraver or the printer if their work came out muddy or blotchy. Engravers and printers, on the other hand, were trained craftsmen and could turn a mediocre drawing into a decent reproduction." (Judy L. Larson, *American Illustration, 1890–1925: Romance, Adventure & Suspense* [Calgary, Alberta: Glenbow Museum, 1986], p. 29.)

2. Joseph Pennell, *Pen Drawing and Pen Draughtsmen…* (London and New York: Macmillan & Co., 1889), pp. 210–14. The drawing in question illustrated Theodore Roosevelt, "Ranch Life in the Far West: In the Cattle Country," *Century Magazine* 35 (February 1888): 506. Both the stiffness of the figures and the missing horn may be attributable to Remington's use of photographs, which left him vulnerable when he relied exclusively on what he could discern in a given image. *A Dispute Over a Brand*, for example, combines two photographs by L. A. Huffman of Miles City, Montana; the one Remington used as the basis for his "cow" does not show the horn omitted in his drawing. But he could hardly produce Huffman's pictures to support his own, since he followed them rather too closely. The problem was also of his own devising because he chose to depart from Huffman in making his steer a longhorn, thus creating the anatomical impossibility Pennell criticized. The Huffman photographs are conveniently found in James D. Horan, *The Great American West: A Pictorial History from Coronado to the Last Frontier* (New York: Crown Publishers, 1959), p. 162. Remington, who entered Huffman's name and address in a notebook (1887 ff.) at the time of the *Century* commission (FRAM), apparently borrowed the photographs from Roosevelt in making his illustrations. In the fall of 1917 Charles Kessler purchased the lot at auction and notified Huffman: "I just find that your #34, in The Spring Roundup 'Heard Something Drop' [see Horan, *Great American West*, p. 162] is shown on page 858 *Century Magazine*, April 1888, and is literally copied by Remington, who illustrated Roosevelt's articles. Did you know this?" (Charles Kessler to L. A. Huffman, December 22, 1917, Huffman Papers, courtesy of Thomas Minckler, Billings, MT.) Remington's dependence on photographs in his Roosevelt illustrations is well documented in Estelle Jussim, *Frederic Remington, the Camera & the Old West* (Fort Worth: Amon Carter Museum, 1983), pp. 50–59.

3. FR to Scott Turner, March 3, 1877, *Selected Letters*, p. 14.

4. "Works by Mann and Remington," *American Art News*, December 11, 1909.

5. FR to Mr. Sparhawk, November 26, [1890], *Selected Letters*, p. 84.

6. *The Noonday Halt* illustrated W. R. Hamilton, "On the March," *Outing* 10 (July 1887): 303.

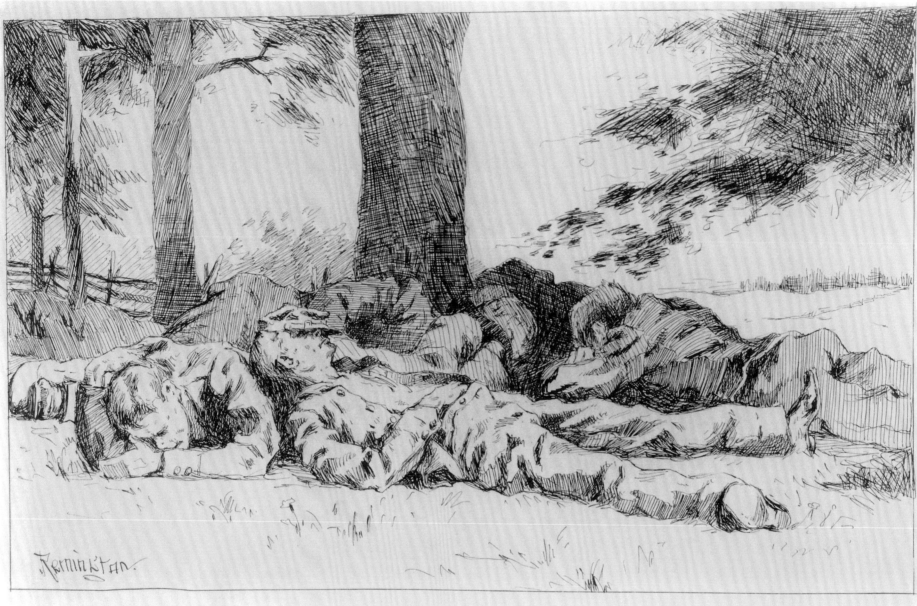

The Noonday Halt 1887
Pen and ink on paper, 8 ¼ x 13 ⅜" (21 x 34 cm.)
Signed lower left: Remington.; inscribed lower left margin: —The noonday halt.—
Donated by Mershon Miller, Sheila McDowell DeLany, Laura Armstrong Brownlee
in memory of Laurance Brownlee, Col. (U.S.A. Ret.) and Mershon Kessler Brownlee;
FRAM 86.8, CR 150

The Messenger 1887
Black and white oil on canvas, 15½ x 24½" (39.4 x 62.2 cm.)
Signed lower right: Frederic Remington./'87
FRAM 66.61, CR 84

Full-Dress Engineer 1889
Oil on academy board, 28½ x 19" (72.4 x 48.3 cm.)
Signed lower left: FREDERIC REmington./ENGINEER BARRACKS—City of MEXICO
FRAM 66.72, CR 525

Lieutenant, Engineer Battalion 1889
Watercolor on paper, 17½ x 13½" (44.5 x 34.3 cm.)
Signed lower right: Remington.—
FRAM 66.70, CR 528

"Taps." (Cavalry Bugler in Full Uniform.) 1890
Watercolor on paper, 17¹¹⁄₁₆, x 9¹³⁄₁₆" (44.9 x 24.9 cm.)
Signed lower left: Frederic Remington/90.
FRAM 66.74, CR 1191

Frederic Remington might profess to know little about art when he wanted to present himself to an interviewer as a man of action. But he knew what he liked from boyhood on, and what he liked was soldiers. "Your favorite subject is soldiers," he wrote a budding artist in 1877. "So is mine"—and he requested a drawing of a battle between Turks and Russians, soldiers and Indians, *anything*, except "dudes" or women.[1] Remington filled the margins of his schoolbooks with sketches of roughhewn types; soldiers marched and charged and postured across his pages; frontier scouts and Western Indians and Bowery toughs also found a place. A wash drawing likely made in the 1880s, *Little Rips above Downie's*, served Remington as sketching paper for some quick pencil impressions of soldiers. By superimposing the military over the landscape, he anticipated his mature work in which landscape functioned as a backdrop to his human actors (see *A Mining Town, Wyoming* [*The Red Man's Load | Red Medicine*], pp. 128–129).

When Remington illustrated the army in the Southwest in the 1880s, he sometimes placed his figures outside an adobe dwelling. It was a simple and effective way of establishing a Western setting. *The Messenger* is a case in point. Painted in 1887, this black and white oil was obviously intended for reproduction. It is a military set piece, showing a courier delivering a message. His exhausted mount and the reactions of the men receiving the news convey the urgency of the situation. Compared to the watercolor *The Apaches Are Coming* (p. 49), it shows how much Remington had advanced in his craft in just two years. Though some of the poses are melodramatic, the overall effect is naturalistic and convincing. Both illustrations feature adobe structures that prove the artist had been *out there*—and knew whereof he drew. Remington kept photographs of several adobe buildings in his research files. The one shown in *The Messenger*, with its distinctive support poles and thatched roof, obviously pleased him as a stage prop, since it reappeared in the closely related painting *Arrival of a Courier* (1890), where the officers' attitudinizing is almost precious, and, much later, in *Waiting in the Moonlight* (p. 177).[2]

Remington worked several variations on the time-honored theme of a scout or courier reporting to a group of officers,[3] and they link him to the European tradition in military art, notably to the French painters Jean-Louis-Ernest Meissonier, Edouard Detaille and Alphonse de Neuville. Meissonier's *Les Ordonnances*, Detaille's *Alerte!* (1880) and de Neuville's *Information* (1876) all bear a resemblance to *The Messenger*, and raise the broader issue of artistic influences.[4] Meissonier's artistic biography, for example, reads like a template for Remington's. Meissonier adhered to the doctrine of strict realism: the artist must be true to nature. He was meticulous in his attention to detail, and surrounded himself in his studio with a collection of military paraphernalia to insure accuracy in his work. Often reviled as a colorist

Little Rips above Downie's early 1880s
Ink wash and pencil (ca. 1890s) on paper, 9 x 11⅞" (22.9 x 30.2 cm.)
Inscribed middle left: Little Rips above Downie's; notation upper left: Hale / Harding / Cleveland.
FRAM 66.317.13

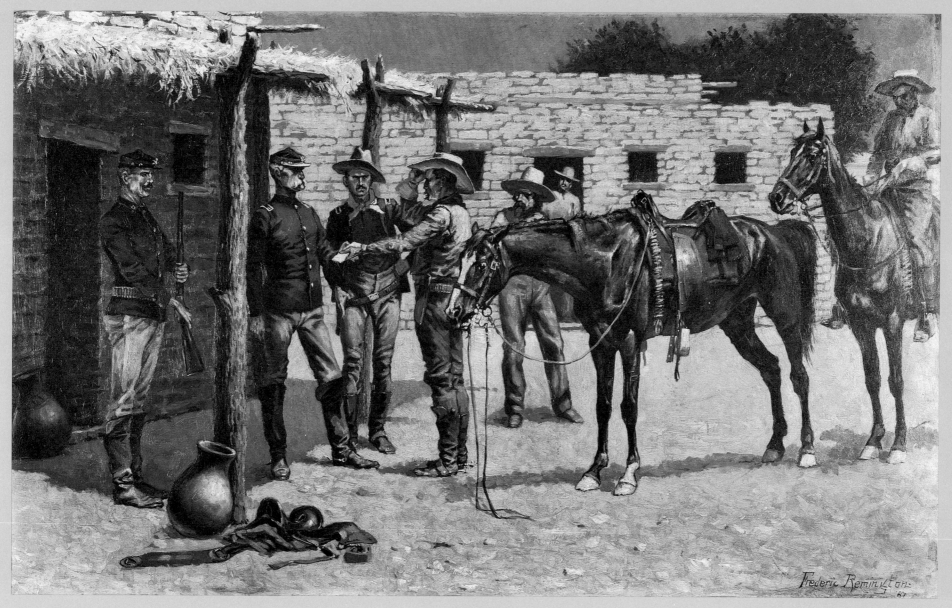

The Messenger 1887

Arrival of a Courier 1890
The R. W. Norton Art Gallery, Shreveport, LA; CR 1139

because he chose to be faithful to things as they are, he was a perfectionist capable of destroying a canvas that failed to meet his standards. He rarely painted women, and carried on a lifelong love affair with horses. In two respects only did Meissonier differ fundamentally from Remington: he labored over each painting, doing reams of preliminary sketches; and he would not depict an actual *battle* because he had never seen one. But through such celebrated paintings as *Napoleon III at Solferino* and *1814*, Meissonier left his mark on every military artist who followed him, including Remington.[5]

The influence of Detaille and de Neuville on Remington is undeniable. To walk through the Salle Chanzy of the Musée de l'Armée in Paris is to leave all doubt behind. In battle scene after battle scene are the touches Remington loved— the gallant gesture, the agonizing but perfect, manly death. A discrete section of a panorama of the battle of Champigny on which Detaille and de Neuville collaborated in 1882, *Le fond de la Giberne*, shows a fallen soldier passing ammunition to a comrade advancing to the attack; the inscription on one's canteen reads "Al. de Neuville," on the other's, "E. Detaille."[6] It was irresistible stuff. Remington's photograph collection included a print of Detaille's battle scene *Charge of the 9th Regt. Cuirassiers, Village of Monsbronn, Aug. 6, 1870,* and he added the latest de Neuville autotype to a teasing Christmas wish list he sent an aunt in 1879.[7] He acquired books of prints and was familiar with the pictures of common soldiers of the Franco-Prussian War period by both artists, though his closest affinity may have been with de Neuville. In 1889 Remington made his second visit to Mexico on assignment for *Harper's*, and jotted in his notebook, "The Mx cavalryman beats the happiest phase of soldier vagabondism that de Neuville ever conceived." He captured that de Neuville "look" in the single figure studies he made of soldiers from the various branches of the Mexican army. These were individual portraits, but not once did Remington identify a subject by name. They were types to him—*A Regimental Scout, Artillery Sergeant, Bugler of Cavalry, Infantry of the Line, Cavalry of the Line, A Rural* (or rurale, whose gorgeous accoutrements impressed Remington), *A Gendarme,* even the *Undress Engineer* who posed so patiently for him in the oppressive heat:

Edouard Detaille and Alphonse de Neuville
Le fond de la Giberne 1882
Musée de l'Armée, Paris

Soldier that I was sketching (the undress of the engineers) fainted as he was posing. Great consternation—officer got brandy and I grabbed a watering pot from a peon. He was weak having not eaten any breakfast. When I was through I gave him a dollar. The poor fellow instantly was overcome with emotion. He begged me to take it back—much as a woman might. These people are very emotional and when ever they are excited they betray it as perfectly as a finished actor might.

Remington recorded the incident, but the soldier goes nameless. In the tradition of the French military school, the type was greater than the individual. "They are little men very brown—and their dirty canvas clothes are more picturesque than pretentious," Remington observed.[8] This impression comes across in his oil portrait of the *Full-Dress Engineer*, whose unmilitary bearing and slightly bemused expression make him a peasant in uniform, kin to de Neuville's *Sapeur.*[9]

Lieutenant, Engineer Battalion, in contrast, has the swagger of Remington's American officers, and anticipates such generic military studies as *"Taps." (Cavalry Bugler in Full Uniform.)*—which, in turn, readily compares to Detaille's pastel *Trompette du régiment de Uhlans no. 15 (Schleswig-Holstein) 1870–1871.*[10] In his painting of the Mexican officer, Remington only implied the

Alphonse de Neuville
Sapeur
Jules Richard, *En Campagne: Tableaux et dessins de A. de Neuville* (Paris: Boussod, Valadon & Cie., n.d [1880s]), p. 76
FRAM 70.763.67

adobe wall behind, but he would have been annoyed by the engraver's failure to represent it at all when the watercolor was reproduced, along with the rest of his Mexican army types, in *Harper's Monthly* of November.[11] The backdrops were part of the effect he wanted to achieve.

His portraits of Mexican and American soldiers were a conscious bid for recognition as America's premier military artist. In 1893, he exhibited them for sale by auction, along with several European studies he had made the

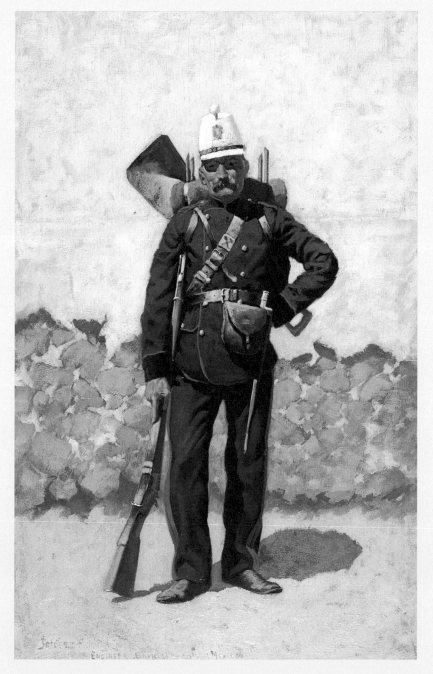

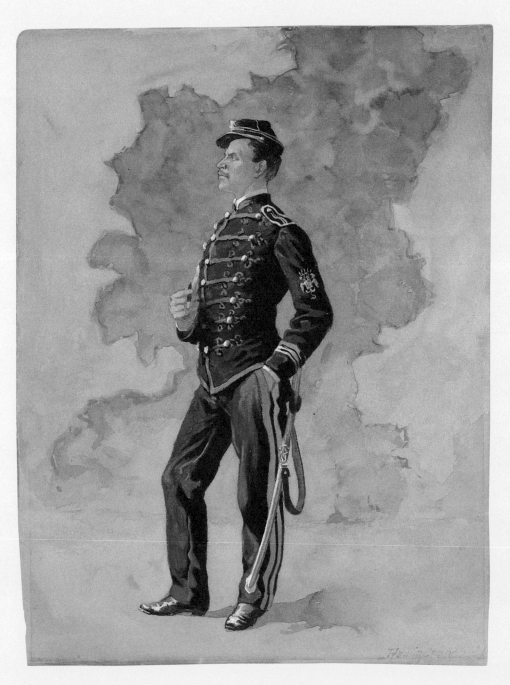

Full-Dress Engineer 1889
Oil on academy board, 28 ¹/₂ x 19" (72.4 x 48.3 cm.)
Signed lower left: FREDERIC REmington./
ENGINEER BARRACKS—City of MEXICO
FRAM 66.72, CR 525

Lieutenant, Engineer Battalion 1889
Watercolor on paper, 17 ¹/₂ x 13 ¹/₂" (44.5 x 34.3 cm.)
Signed lower right: Remington.—
FRAM 66.70, CR 528

previous year. *"Taps"* was offered as *A Bugler—U.S.A.* and *Full-Dress Engineer* as *Mexican Engineer Soldier*. Both sold, the watercolor for $50, the oil for $75. These were considered good prices, and the exhibition, which realized a total of $7,005, was pronounced a success in the press.[12]

Remington may have thought otherwise. Some paintings sold at a fraction of their previous asking price. (*Arrival of a Courier*, for example, listed in the National Academy of Design's exhibition in 1891 at $500, went for $130 in 1893.) But Remington had succeeded in establishing himself as America's "soldier-artist," and his friend Julian Ralph sang his praises:

> … he is nearly alone in a field so large that, to attempt to fill it, he must give it all his time and work. Other men make sketches and studies of Western life. Other men make pictures of the American soldier, and of his respected enemy the Indian. And many other men make pictures in which horses figure…. But no man in this country so much as Frederic Remington has dedicated his life to the study of these themes. He is, in a sense, a war artist in peace as well as on the instant that any troops are called upon for serious service, and find him on the ground. He loves the American soldier as much as he appreciates his value to the republic— and that is tremendously.

Despite Ralph's praise, Remington by 1895 had moved on from soldiering as such to make the Western epic his paramount theme. "The subject had been treated by others," Ralph continued, "but he took it up with a vigor of admiration and sympathy that became contagious. He peopled our minds with the actual characters in the thin thread of humanity that was linking East to West. They had been shadows before, but he gave them flesh and blood." Soldiers were part of the story, of course, but only part. A whole galaxy of types— "the white settler and his pioneers, the cowboys and prospectors"—made up Frederic Remington's Wild West.[13]

1. FR to Scott Turner, March 5, 1877, [1877], *Selected Letters*, pp. 14–15.
2. See James K. Ballinger, *Frederic Remington's Southwest* (Phoenix: Phoenix Art Museum, 1992), p. 12.
3. For example, *The Addled Letter-Carrier* (where it is an officer's wife receiving the message), in Elizabeth B. Custer, *Tenting on the Plains; or, General Custer in Kansas and Texas* (New York: Charles L. Webster & Co., 1887), p. 673; *A Cavalryman's Breakfast on the Plains* (ca. 1892; Amon Carter Museum, Fort Worth); *At the Mouth of Rapid Creek—General Carr Receiving the Report of a Scout, Harper's Weekly*, January 16, 1892; and *The Soldier Leaped from His Saddle* [*The Messenger*], in Charles King, *A Daughter of the Sioux* (New York: The Hobart Company, 1903), p. 94.
4. See Peter H. Hassrick, "Remington: The Painter," in Michael Edward Shapiro and Hassrick, *Frederic Remington: The Masterworks* (New York: Harry N. Abrams, for the St. Louis Art Museum, in conjunction with the Buffalo Bill Historical Center, Cody, WY, 1988), pp. 73, 76–77; James K. Ballinger, *Frederic Remington* (New York: Harry N. Abrams, in association with The National Museum of American Art, Smithsonian Institution, Washington, D.C., 1989), pp. 42–43; and especially Joan Carpenter, "Frederic Remington's French Connection," *Gilcrease* 10 (November 1988): 1–26, which reproduces both *Information* and *Alerte!*.
5. See Henri Barbusse (translated by Frederic Taber Cooper), *Meissonier* (New York: Frederick A. Stokes Company, 1914), for *Les Ordonnances, Napoleon III at Solferino* and *1814*.
6. For a revealing selection of sketches and paintings by Detaille and de Neuville, see Paul Willing, *L'Expédition du Mexique (1861–1867) et la guerre Franco-Allemande (1870–1871)* (Arcueil: P.R.E.A.L., for Société des amis du Musée de l'Armée, 1984).
7. FRAM 1918.76.158.12; and FR to Marcia Sackrider, [1879], *Selected Letters*, p. 25. Also Perriton Maxwell, "Frederic Remington—Most Typical of American Artists," *Pearson's Magazine* 18 (October 1907): 407 (quoting Remington): "I have tried to keep free from influences, as free as a man can. But de Neuville, Joseph Brant, [Antoine-Louis] Barye the animal sculptor, a few of the Polish painters and lately some of our American landscape artists—who are the best in the world—have worked their spell over me and have to some extent influenced me, in so far as a figure painter can follow in their footsteps."
8. Notebook, FRAM 71.812.8; also FR to Powhatan Clarke, March 14, 1889, *Selected Letters*, p. 70: "I am just home from the city of Mexico where I have been doing the army. They are immensely picturesque and I have some good subjects."
9. Also see Hassrick, "Remington: The Painter," p. 76, which parallels Remington's *Bugler of Cavalry* with de Neuville's *Bugler* (ca. 1875).
10. Painted in 1890, it illustrated E. S. Godfrey, "Custer's Last Battle," *Century Magazine* 43 (January 1892): 384.
11. Thomas A. Janvier, "The Mexican Army," *Harper's Monthly* 79 (November 1889): 813–27.
12. *Catalogue of a Collection of Paintings, Drawings and Water-colors by Frederic Remington, A.N.A.* (New York: The American Art Galleries, 1893), #3, 41, priced copy marked "Statement," FRAM 96.8.22; "Art Notes of Real Interest," *Quarterly Illustrator*, April-May-June 1893, in Helen Card Scrapbooks, Metropolitan Museum of Art Library, NYC, AAA: N 68–26; and see Peggy and Harold Samuels, *Frederic Remington: A Biography* (Garden City, NY: Doubleday & Company, 1982), p. 179, which arrives at a different total for the sale ($7,300) but a similar conclusion as to the disappointing results.
13. Julian Ralph, "Frederic Remington," *Harper's Weekly*, February 2, 1895, p. 688. One officer who had benefited from the full Remington treatment, Lieutenant Samuel C. Robertson, commander of the Crow scouts at Fort Custer, Montana, wrote him on December 31, 1890: "When fifty or sixty years hence, you depart from mundane affairs & join, in the happy hunting grounds, the spirits of the Indians your clever pencil has created, *I'll* see that the U.S. Army—Scouts included—keeps your grave green. In addition, you shall have a head stone at my own private expense on which will be traced a grateful tribute to your efforts in behalf of the service— It is not too much to say that I believe your pencil has done more for us than any other single influence I know of. Personally I am grateful to you for your last dissertation in *Harpers Weekly* ["Indians as Irregular Cavalry," *Harper's Weekly*, December 27, 1890] anent Indian scouts." FRAM. Also see *Frederic Remington: The Soldier Artist* (West Point, NY: The United States Military Academy—The Cadet Fine Arts Forum, 1979).

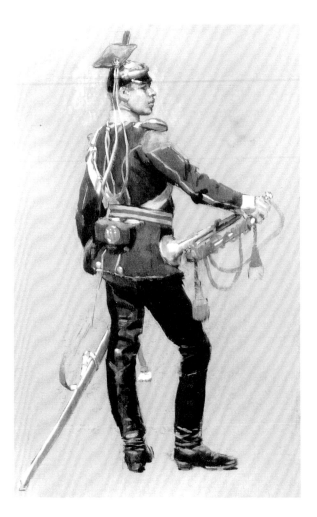

Edouard Detaille
Trompette du régiment de Uhlans no. 15 (Schleswig-Holstein) 1870–1871 ca. 1873
Musée de l'Armée, Paris

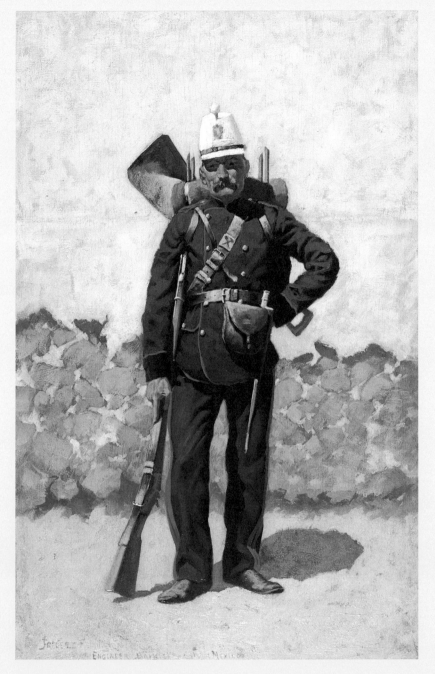

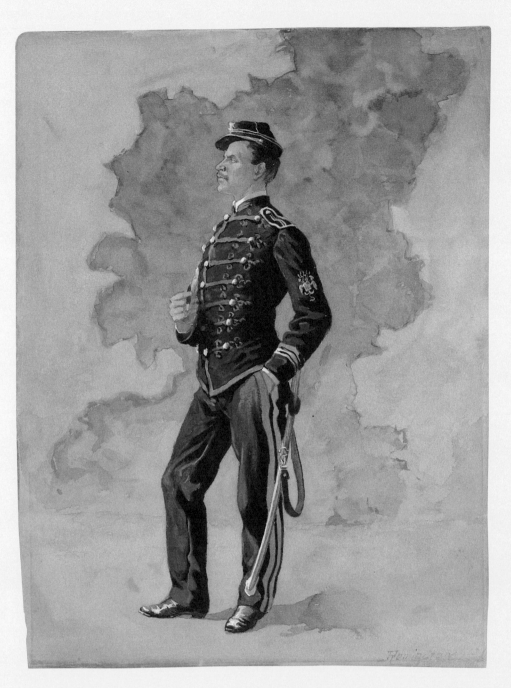

Full-Dress Engineer 1889
Oil on academy board, 28¹/₂ x 19" (72.4 x 48.3 cm.)
Signed lower left: FREDERIC REmington./
ENGINEER BARRACKS—City of MEXICO
FRAM 66.72, CR 525

Lieutenant, Engineer Battalion 1889
Watercolor on paper, 17¹/₂ x 13¹/₂" (44.5 x 34.3 cm.)
Signed lower right: Remington.—
FRAM 66.70, CR 528

previous year. *"Taps"* was offered as *A Bugler—U.S.A.* and *Full-Dress Engineer* as *Mexican Engineer Soldier.* Both sold, the watercolor for $50, the oil for $75. These were considered good prices, and the exhibition, which realized a total of $7,005, was pronounced a success in the press.[12]

Remington may have thought otherwise. Some paintings sold at a fraction of their previous asking price. (*Arrival of a Courier*, for example, listed in the National Academy of Design's exhibition in 1891 at $500, went for $130 in 1893.) But Remington had succeeded in establishing himself as America's "soldier-artist," and his friend Julian Ralph sang his praises:

> … *he is nearly alone in a field so large that, to attempt to fill it, he must give it all his time and work. Other men make sketches and studies of Western life. Other men make pictures of the American soldier, and of his respected enemy the Indian. And many other men make pictures in which horses figure…. But no man in this country so much as Frederic Remington has dedicated his life to the study of these themes. He is, in a sense, a war artist in peace as well as on the instant that any troops are called upon for serious service, and find him on the ground. He loves the American soldier as much as he appreciates his value to the republic— and that is tremendously.*

Despite Ralph's praise, Remington by 1895 had moved on from soldiering as such to make the Western epic his paramount theme. "The subject had been treated by others," Ralph continued, "but he took it up with a vigor of admiration and sympathy that became contagious. He peopled our minds with the actual characters in the thin thread of humanity that was linking East to West. They had been shadows before, but he gave them flesh and blood." Soldiers were part of the story, of course, but only part. A whole galaxy of types— "the white settler and his pioneers, the cowboys and prospectors"—made up Frederic Remington's Wild West.[13]

1. FR to Scott Turner, March 5, 1877, [1877], *Selected Letters,* pp. 14–15.
2. See James K. Ballinger, *Frederic Remington's Southwest* (Phoenix: Phoenix Art Museum, 1992), p. 12.
3. For example, *The Addled Letter-Carrier* (where it is an officer's wife receiving the message), in Elizabeth B. Custer, *Tenting on the Plains; or, General Custer in Kansas and Texas* (New York: Charles L. Webster & Co., 1887), p. 673; *A Cavalryman's Breakfast on the Plains* (ca. 1892; Amon Carter Museum, Fort Worth); *At the Mouth of Rapid Creek— General Carr Receiving the Report of a Scout, Harper's Weekly,* January 16, 1892; and *The Soldier Leaped from His Saddle* [*The Messenger*], in Charles King, *A Daughter of the Sioux* (New York: The Hobart Company, 1903), p. 94.
4. See Peter H. Hassrick, "Remington: The Painter," in Michael Edward Shapiro and Hassrick, *Frederic Remington: The Masterworks* (New York: Harry N. Abrams, for the St. Louis Art Museum, in conjunction with the Buffalo Bill Historical Center, Cody, WY, 1988), pp. 73, 76–77; James K. Ballinger, *Frederic Remington* (New York: Harry N. Abrams, in association with The National Museum of American Art, Smithsonian Institution, Washington, D.C., 1989), pp. 42–43; and especially Joan Carpenter, "Frederic Remington's French Connection," *Gilcrease* 10 (November 1988): 1–26, which reproduces both *Information* and *Alerte!.*
5. See Henri Barbusse (translated by Frederic Taber Cooper), *Meissonier* (New York: Frederick A. Stokes Company, 1914), for *Les Ordonnances, Napoleon III at Solferino* and *1814.*
6. For a revealing selection of sketches and paintings by Detaille and de Neuville, see Paul Willing, *L'Expédition du Mexique (1861–1867) et la guerre Franco-Allemande (1870–1871)* (Arcueil: P.R.E.A.L., for Société des amis du Musée de l'Armée, 1984).
7. FRAM 1918.76.158.12; and FR to Marcia Sackrider, [1879], *Selected Letters,* p. 25. Also Perriton Maxwell, "Frederic Remington—Most Typical of American Artists," *Pearson's Magazine* 18 (October 1907): 407 (quoting Remington): "I have tried to keep free from influences, as free as a man can. But de Neuville, Joseph Brant, [Antoine-Louis] Barye the animal sculptor, a few of the Polish painters and lately some of our American landscape artists—who are the best in the world—have worked their spell over me and have to some extent influenced me, in so far as a figure painter can follow in their footsteps."
8. Notebook, FRAM 71.812.8; also FR to Powhatan Clarke, March 14, 1889, *Selected Letters,* p. 70: "I am just home from the city of Mexico where I have been doing the army. They are immensely picturesque and I have some good subjects."
9. Also see Hassrick, "Remington: The Painter," p. 76, which parallels Remington's *Bugler of Cavalry* with de Neuville's *Bugler* (ca. 1875).
10. Painted in 1890, it illustrated E. S. Godfrey, "Custer's Last Battle," *Century Magazine* 43 (January 1892): 384.
11. Thomas A. Janvier, "The Mexican Army," *Harper's Monthly* 79 (November 1889): 813–27.
12. *Catalogue of a Collection of Paintings, Drawings and Watercolors by Frederic Remington, A.N.A.* (New York: The American Art Galleries, 1893), #3, 41, priced copy marked "Statement," FRAM 96.8.22; "Art Notes of Real Interest," *Quarterly Illustrator,* April-May-June 1893, in Helen Card Scrapbooks, Metropolitan Museum of Art Library, NYC, AAA: N 68–26; and see Peggy and Harold Samuels, *Frederic Remington: A Biography* (Garden City, NY: Doubleday & Company, 1982), p. 179, which arrives at a different total for the sale ($7,300) but a similar conclusion as to the disappointing results.
13. Julian Ralph, "Frederic Remington," *Harper's Weekly,*

February 2, 1895, p. 688. One officer who had benefited from the full Remington treatment, Lieutenant Samuel C. Robertson, commander of the Crow scouts at Fort Custer, Montana, wrote him on December 31, 1890: "When fifty or sixty years hence, you depart from mundane affairs & join, in the happy hunting grounds, the spirits of the Indians your clever pencil has created, *I'll* see that the U.S. Army— Scouts included—keeps your grave green. In addition, you shall have a head stone at my own private expense on which will be traced a grateful tribute to your efforts in behalf of the service— It is not too much to say that I believe your pencil has done more for us than any other single influence I know of. Personally I am grateful to you for your last dissertation in *Harpers Weekly* ["Indians as Irregular Cavalry," *Harper's Weekly,* December 27, 1890] anent Indian scouts." FRAM. Also see *Frederic Remington: The Soldier Artist* (West Point, NY: The United States Military Academy—The Cadet Fine Arts Forum, 1979).

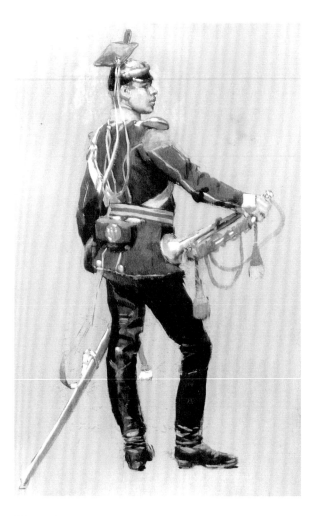

Edouard Detaille
Trompette du régiment de Uhlans no. 15 (Schleswig-Holstein) 1870–1871 ca. 1873
Musée de l'Armée, Paris

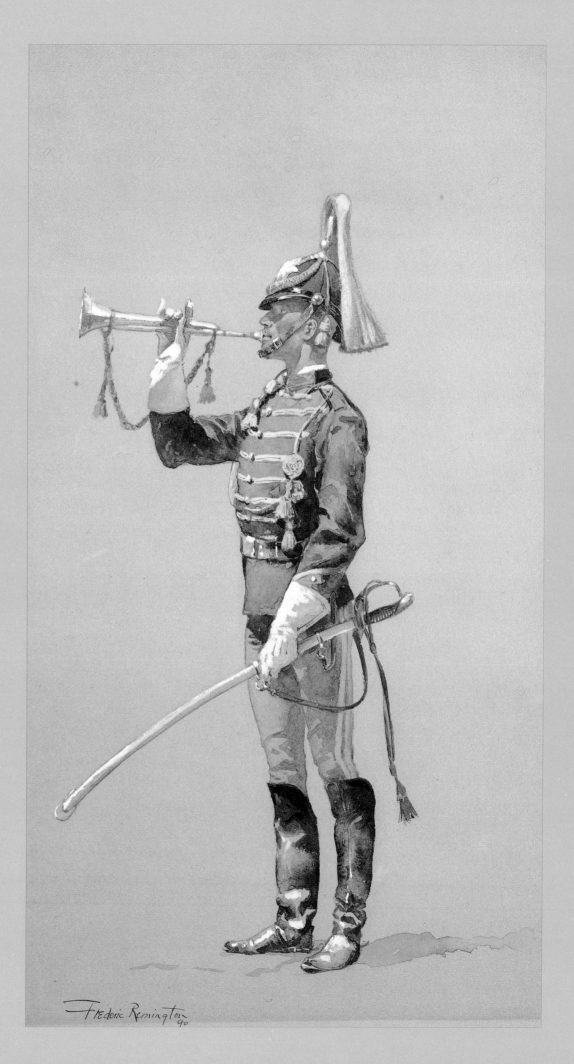

"Taps." (Cavalry Bugler in Full Uniform.) 1890
Watercolor on paper, 17¹¹⁄₁₆ x 9¹³⁄₁₆" (44.9 x 24.9 cm.)
Signed lower left: Frederic Remington/90.
FRAM 66.74, CR 1191

The Capture of the German 1887–1888
Black and white oil on board, 14½ x 18" (36.8 x 45.7 cm.)
Signed lower right: Remington—
Bequest of Robert Purcell, New York; Ex-collection: Mannados Bookshop, New York; FRAM 92.6, CR 302

On Guard at Night 1887–1888
Black and white oil on board, 21 x 21½" (53.3 x 54.6 cm.)
Signed lower left: Remington.
Bequest of Robert Purcell, New York; Ex-collection: Mrs. Hugh Hyde; M. Knoedler & Co., New York; FRAM 92.7, CR 306

The most important commission Remington ever received was one of his earliest. His work in 1887 attracted the attention of a twenty-eight-year-old New York State politician, Theodore Roosevelt, who thought it a visual match for his prose. Roosevelt had spent an invigorating three years, from 1883 to 1886, ranching in Dakota Territory and, with a fondness for literature and a desire to put his name before the public, had written six essays on "Ranch Life in the Far West" that were published in the *Century Magazine* in 1888.[1] They ranged in content from general comments on frontier types and conditions to detailed accounts of personal experiences, and Remington illustrated them all. He liked to do outdoor subjects, preferably Western, and preferably cowboys and soldiers— "other things are irksome," he would tell a friend in 1891.[2] Thus Roosevelt's articles were tailor-made for him. "I enjoyed some of my art jobs in those days," he recalled years later. "Among other things I did the illustrations for Theodore Roosevelt's cow-boy articles when most people didn't know whether cow-boys milked dairy cattle or fought in the Revolution. I knew more about cow-boys then than I did about drawing."[3] Nevertheless, in his Roosevelt illustrations, Remington relied more on photographs than on personal knowledge. Several of his generic cowboy subjects were based on pictures taken by L. A. Huffman of Miles City, Montana, while those depicting specific episodes used photographs borrowed from Roosevelt.[4]

Some contemporaries recognized the tell-tale signs of Remington's copying: stiffness in his

Theodore Roosevelt in plains garb ca. 1885
Theodore Roosevelt Collection
Harvard University, Cambridge, MA

figures and impossible perspectives caused by combining elements from more than one photograph. He could do better. A relatively spontaneous sketch made at the same time, *Blizzard*, showed the effects of a bitter winter on the northern plains and has some of the concentrated emotional power of Charles M. Russell's cowboy masterpiece *Waiting for a Chinook* (ca. 1887).[5] In contrast, many of Remington's published illustrations from 1888 seem perfunctory and trivial. But they were a showcase for the young illustrator. When in 1895 he wrote that cowboys were "gems and porcelains" to him, it was to the Roosevelt commission most of all that he owed his good fortune.[6] But this did not fill him with gratitude. Remember, he told a would-be contributor to *Century Magazine*, "that the *Century* is read by women children—idiots and every other class of people who wouldnt know the sidereal movement of the earth from a government wagon."[7] Such an attitude goes far to explain his heavy use of photographs in his illustrative work—what would the readers know, or care? And Remington at this time was frank about his procedures. Take pictures, he often urged his army friends. "Glass plates are the only thing—a little more trouble but whats the use of shooting a camera for a week and getting two good pictures and [a] lot of fog. With care all your glass exposures will be of use and photography is like love, one success is better than a thousand failures."[8]

In his essay "Sheriff's Work on a Ranch," Roosevelt described his boldest frontier adventure, the capture in March 1886 of three thieves who stole a boat from his Elkhorn Ranch and made off with it down the Missouri. Roosevelt and two of

Blizzard ca. 1887–1888
Pencil and wash drawing on paper
13⅛ x 10¹¹⁄₁₆" (33.3 x 27.1 cm.)
Unsigned
FRAM 73.21.4, CR 20

The prisoners 1886
Photograph by Theodore Roosevelt, from James D. Horan, *The Great American West: A Pictorial History from Coronado to the Last Frontier* (New York: Crown Publishers, 1959, p. 183.)

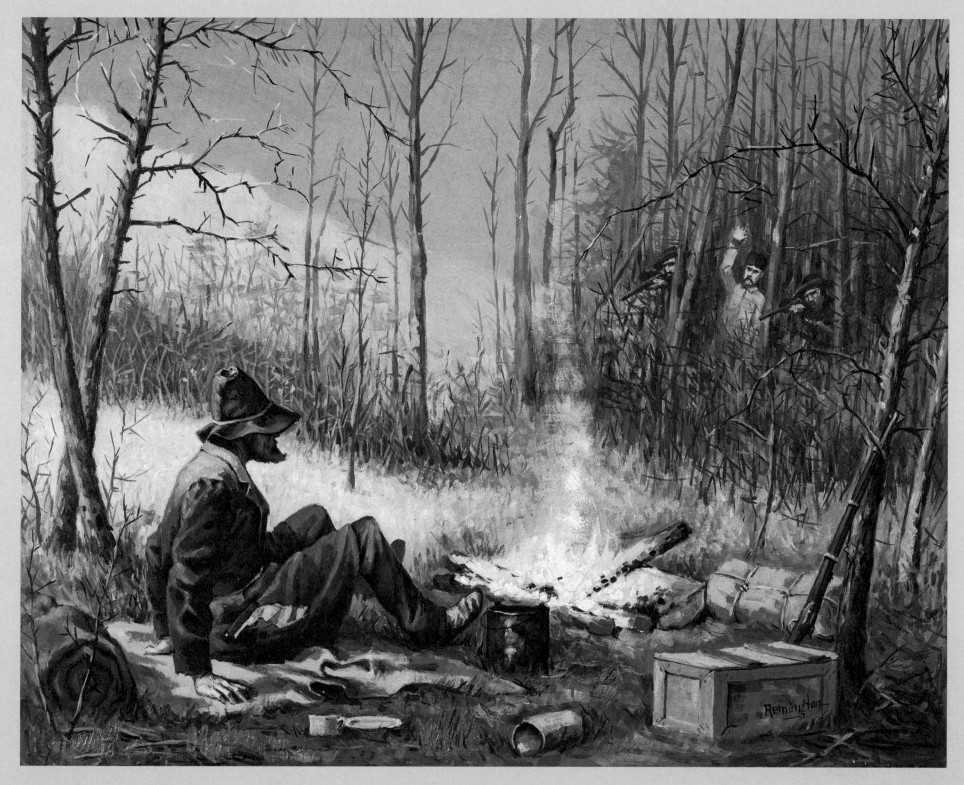

The Capture of the German 1887–1888

his cowboys followed in hot pursuit, though the weather was formidably cold and provided the severest challenge they would encounter. In illustrating this essay Remington relied on photographs that Roosevelt lent him. His black and white oils in this period had a heavy, dense quality. He was excessively literal and tended to overelaborate detail. *The Capture of the German*, for example, is a busy composition. The camp paraphernalia is spread about, the grass and thicket elaborated blade by blade and twig by twig. Roosevelt described the capture:

> *Finally our watchfulness was rewarded, for in the middle of the afternoon of this, the third day we had been gone, as we came round a bend, we saw in front of us the lost boat,... moored against the bank, while from among the bushes*

some little way back the smoke of a camp-fire curled up through the frosty air. We had come on the camp of the thieves.... For a moment we felt a thrill of keen excitement, and our veins tingled as we crept cautiously towards the fire, for it seemed likely there would be a brush; but, as it turned out, this was almost the only moment of much interest, for the capture itself was as tame as possible.

The men we were after knew they had taken with them the only craft there was on the river, and so felt perfectly secure; accordingly, we took them absolutely by surprise. The only one in camp was the German, whose weapons were on the ground, and who, of course, gave up at once, his two companions being off hunting.[9]

Remington's illustration featured Roosevelt wearing the cap and jacket he posed in for a photographer, while the German is copied from a photograph that showed him with his hat, coat and beard profiled against the Missouri. Remington emphasized the German's distinctive profile by seating him with a clear patch of ground behind his head and shoulders.

On Guard at Night illustrates Roosevelt's strategy to prevent an escape attempt. He had the captured thieves remove their boots when they bedded down. Remington's illustration shows the soles of the boots of the guard (whose likeness is also based on a photograph) and his sleeping companions on one side of the fire and the sock feet of their captives on the other. This is compact visual storytelling, though the axe in the foreground seems unwise, since it lies temptingly close to the prisoners.

1. See David McCullough, *Mornings on Horseback* (New York: Simon and Schuster, 1981), especially chap. 15, for Roosevelt's Dakota years in context.
2. FR to Powhatan Clarke, June 20 [1891], *Selected Letters*, p. 119.
3. Perriton Maxwell, "Frederic Remington—Most Typical of American Artists," *Pearson's Magazine* 18 (October 1907): 403.
4. For a selection of Huffman's rangeland photographs, see Mark H. Brown and W. R. Felton, *Before Barbed Wire: L. A. Huffman, Photographer on Horseback* (New York: Henry Holt and Company, 1956); and for more on Remington and Huffman, see the commentary, p. 52, n. 2.
5. See Theodore Roosevelt, "The Home Ranch," *Century Magazine* 35 (March 1888): 667, for *Line Riding in Winter*, a winter scene that lacked the symbolic implications of *Blizzard*. *Blizzard* anticipates the rare 1900 Remington bronze *The Norther*, particularly in depicting the horse's wind-ruffled mane. See Michael Edward Shapiro and Peter H. Hassrick, *Frederic Remington: The Masterworks* (New York: Harry N. Abrams, for the St. Louis Art Museum, in conjunction with the Buffalo Bill Historical Center, Cody, WY, 1988), pp. 188–89; and, for Russell's *Waiting for a Chinook*, Brian W. Dippie, ed., *Charles M. Russell, Word Painter: Letters 1887–1926* (Fort Worth: Amon Carter Museum, with Harry N. Abrams, New York, 1993), p. 13.
6. FR, "Cracker Cowboys of Florida," *Harper's Monthly*, August 1895; *Collected Writings*, p. 208.
7. FR to George W. Baird, June 2, 1890, *Selected Letters*, p. 95.
8. FR to Powhatan Clarke, September 13, 1890, *Selected Letters*, p. 102.
9. Theodore Roosevelt, "Sheriff's Work on a Ranch," *Century Magazine* 36 (May 1888): 46.

Above:
Ready to start 1886
Photograph by Theodore Roosevelt, from James D. Horan, *The Great American West: A Pictorial History from Coronado to the Last Frontier* (New York: Crown Publishers, 1959), p. 183.

Opposite page:
On Guard at Night 1887–1888
Black and white oil on board, 21 x 21 ½" (53.3 x 54.6 cm.)
Signed lower left: Remington.
Bequest of Robert Purcell, New York; Ex-collection: Mrs. Hugh Hyde; M. Knoedler & Co., New York; FRAM 92.7, CR 306

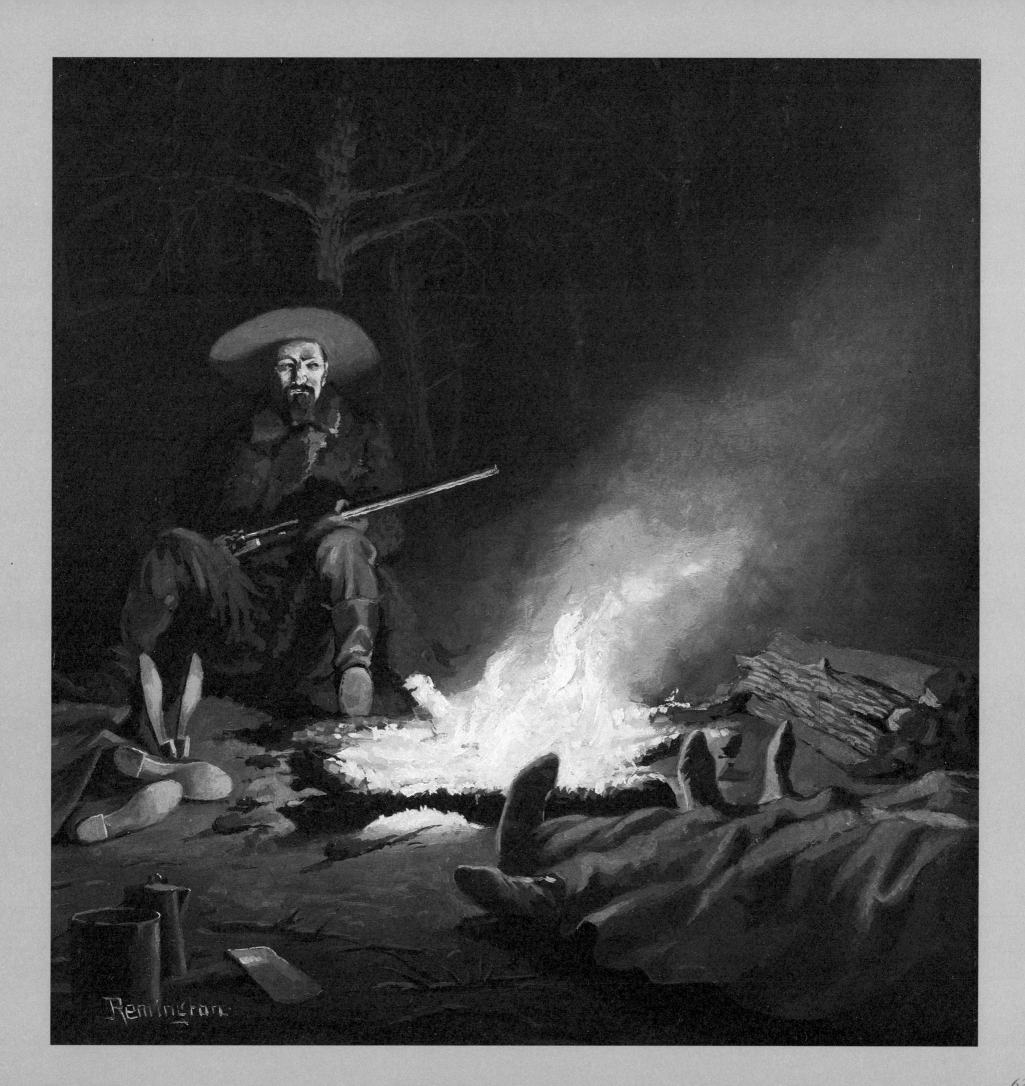

Indian Flute, Cheyenne 1889

Pen and ink on paper, 8⅝ x 11⅟₁₆" (21.9 x 28.1 cm.)

Signed lower left: Hiawatha-Remington; upper right: No 17.

Museum purchase, 1980; Ex-collection: Kennedy Galleries, New York; FRAM 80.4, CR 715

Lance and Shield 1889

Pen and ink on paper, 11⅛ x 8¾" (28.3 x 22.2 cm.)

Signed upper left: No 135 Remington's "Hiawatha."; upper right: lance & shield

Museum purchase, 1980; Ex-collection: Kennedy Galleries, New York; FRAM 80.1, CR 728

Comanche Legging 1889

Pen and ink on paper, 9 x 10⅟₁₆" (22.9 x 27.8 cm.)

Signed upper left: No 113. Hiawatha Remington.; upper right: Comanche leggin'

Museum purchase, 1980; Ex-collection: Kennedy Galleries, New York; FRAM 80.2, CR 631

Snow-Shoe 1889

Pen and ink on paper, 8⅞ x 11⅟₁₆" (22.5 x 28.1 cm.)

Signed lower left: Hiawatha. Remington; lower right: Snow-shoe—

Museum purchase, 1980; Ex-collection: Kennedy Galleries, New York; FRAM 80.3, CR 851

Medicine or Totem Bag 1889

Pen and ink on paper, 10⅞ x 8⅝" (27.6 x 21.9 cm.)

Signed lower right: Hiawatha—Remington del.—; lower right: —medicine or totem bag; upper right: No 20.—

Museum purchase, 1980; Ex-collection: Kennedy Galleries, New York; FRAM 80.5, CR 746

Moose Head 1889

Pen and ink, 11¼ x 8½" (28.6 x 21.6 cm.)

Signed lower right: Hiawatha—Remington del.—; upper left: No. 1

Museum purchase, 1992; Ex-collection: Kennedy Galleries, New York; Christie's, New York; FRAM 93.4, CR 759

Buffalo Hunter Spitting a Bullet into a Gun 1892

Ink wash and watercolor on paper, 21⅛ x 15½" (53.7 x 39.4 cm.)

Signed lower left: FrEderic Remington. / "Buffalo hunter spitting a bullet into a gun"—;

Museum purchase, 1973; Ex-collection: James R. Clarke; FRAM 73.13, CR 1390

A Peril of the Plains ca. 1890

Gouache on paper, 18⅝ x 25" (47.3 x 63.5 cm.)

Signed lower right: REMINGTON

Bequest of Robert W. Purcell, New York, NY; FRAM 92.4, CR 419

Two commissions in particular confirmed Remington's status as America's premier artist of frontier life. Late in 1888 he contracted to illustrate a new edition of Henry Wadsworth Longfellow's poem *The Song of Hiawatha* (1855), and then, in 1892, another American classic, Francis Parkman's *The Oregon Trail* (1847). Illustrating Parkman was akin to a passing of the torch; Remington's art "must be collected some day to feast the eye," Julian Ralph wrote in 1895, "as Parkman and Roosevelt and [Owen] Wister satisfy the mind."[1]

But each commission also brought with it a melancholy recognition: the West on which Remington had staked his artistic future, the West as high adventure, was already finished. Parkman had set the tone in *The Oregon Trail* when he reported that within a year of his return to Boston "Fort Laramie and its inmates" seemed "less like a reality than like some fanciful picture of the olden time; so different was the scene from any which this tamer side of the world can present."[2] Transience was Parkman's message, and Longfellow's, too, when he ended his Indian romance with a prophecy

Top row, from left:
Comanche Legging 1889; *Medicine or Totem Bag* 1889; *Lance and Shield* 1889

Bottom row, from left:
Indian Flute, Cheyenne 1889; *Snow-Shoe* 1889

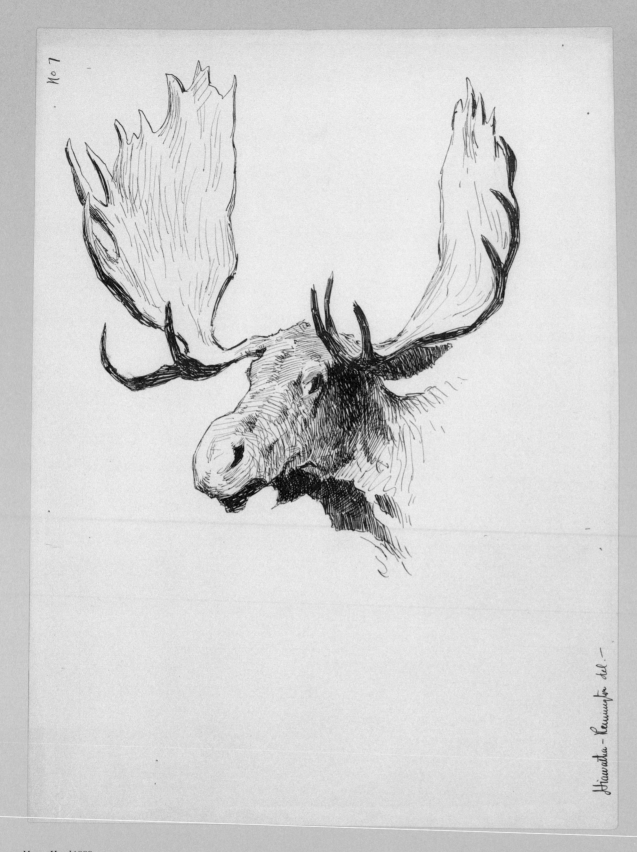

No. 7

Hiawatha — Remington del.—

Moose Head 1889
Pen and ink on paper, 11¼ x 8½" (28.6 x 21.6 cm.)
Signed lower right: Hiawatha—Remington del.—; upper left: No. 1
Museum purchase, 1992; Ex-collection: Kennedy Galleries, New
York; Christie's, New York; FRAM 93.4, CR 759

of cultural doom:

> *On the shore stood Hiawatha,*
> *Turned and waved his hand at parting;*
> *On the clear and luminous water*
> *Launched his birch canoe for sailing,*
> *From the pebbles of the margin*
> *Shoved it forth into the water;*
> *Whispered to it, "Westward! westward!"*
> *And with speed it darted forward.*
>
> *And the evening sun descending*
> *Set the clouds on fire with redness,*
> *Burned the broad sky, like a prairie,*
> *Left upon the level water*
> *One long track and trail of splendor,*
> *Down whose stream, as down a river,*
> *Westward, westward Hiawatha*
> *Sailed into the fiery sunset,*
> *Sailed into the purple vapors,*
> *Sailed into the dusk of evening.*[3]

Judging from Parkman and Longfellow, the great
drama of westering was over before Remington had
drawn a breath. But at least Remington had been
around to see the tail end of things.

Parkman, in his preface to the Remington-
illustrated edition of *The Oregon Trail*, observed
that change in the Far West had "grown to meta-
morphosis." Towns and cities had replaced the
tepee villages of his youthful wanderings, and
"tame cattle and fences of barbed wire" the buffalo
that once grazed upon the boundless plains.
The "wild Indian" had been "turned into an
ugly caricature of his conqueror," and the "slow
cavalcade of horsemen armed to the teeth" had
"disappeared before parlor cars and the effeminate
comforts of modern travel." The Old West was
gone. The "all-daring and all-enduring trapper"
had yielded place to the cowboy, "and even his
star begins to wane." "The Wild West is tamed,"
Parkman concluded,

> *and its savage charms have withered. If this*
> *book can help to keep their memory alive, it will*
> *have done its part. It has found a powerful*
> *helper in the pencil of Mr. Remington, whose*
> *pictures are as full of truth as of spirit, for they*
> *are the work of one who knew the prairies and*
> *the mountains before irresistible commonplace*
> *had subdued them.*[4]

Within a year of illustrating *The Oregon Trail*, Remington was confessing that a remote ranch in Mexico reminded him of Parkman's Fort Laramie, so strong was the impression of evanescence it imparted.[5]

Eventually Remington, too, would be pronouncing eulogies on *his* West. In 1905 he told a prophetic tale about his first experiences in Montana when, as a fresh-faced youth of nineteen, still full of wonder at the novel scenes about him, he met an old freighter who declared the West long dead. Remington had sensed "a heavy feel in the atmosphere," and now he knew why: "The old man had closed my very entrancing book almost at the first chapter." Remington had just arrived, and the party was already over. "Without knowing exactly how to do it, I began to try to record some facts around me, and the more I looked the more the panorama unfolded."[6] The Roosevelt commission in 1887 had allowed Remington to report some of those facts; *The Song of Hiawatha* and *The Oregon Trail* gave him the opportunity to demonstrate his versatility, drawing on imagination and research as well as experience.

Remington welcomed the Longfellow commission. Indeed, when he left for Boston on December 3, 1888, to negotiate terms with the publisher, Houghton, Mifflin & Company, Eva wrote that he had always "dreamed about doing" *The Song of Hiawatha*.[7] It seems odd; as a cadet at the Highland Military Academy in 1877 Remington observed, "There is nothing poetical about me"[8]— and his self-assessment rings true. He invested his moody, late-life paintings with a poetry of sorts, but even when he was experimenting with Tonalist principles he insisted, "I haven't a bit of that decorative feeling."[9] And certainly in 1888, when he accepted the commission to illustrate *The Song of Hiawatha*, his work was noted neither for poetry nor decorativeness, but for its unsparing realism. He thought the assignment would take him about six months, and he devoted most of the summer of 1889 to it. As always, he was an amazingly disciplined professional, completing twenty-two black and white paintings intended to capture the spirit of the poem, and 379 pen-and-ink sketches of Indian artifacts, animals and the like to decorate the margins. These made no pretension to poetry, and simply "recorded some facts." Anticipating criticism that few of the objects shown were directly related to *Hiawatha*'s time or place, the publisher explained:

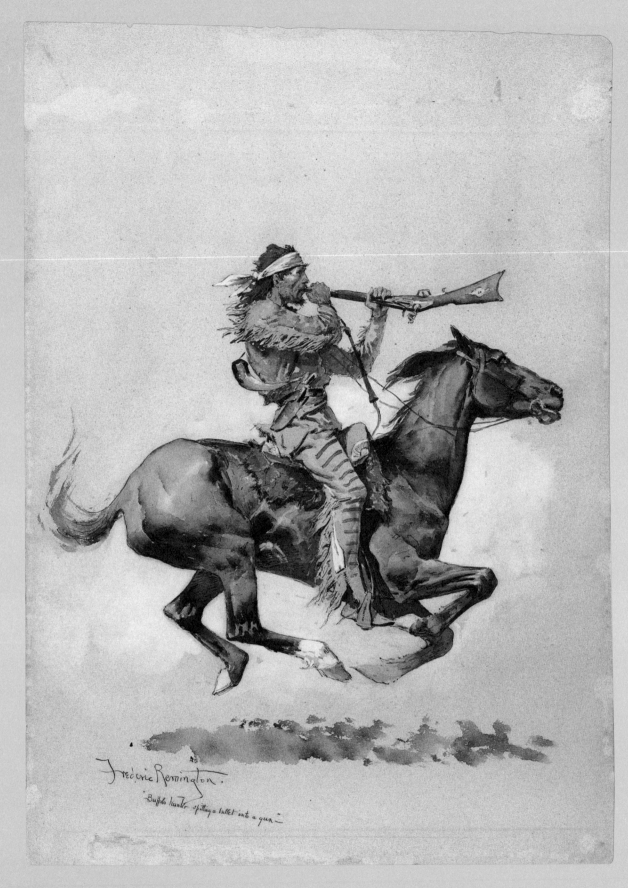

Buffalo Hunter Spitting a Bullet into a Gun 1892
Ink wash and brown watercolor on paper, 21⅛ x 15½" (53.7 x 39.4 cm.)
Signed lower left: Frederic Remington. / "Buffalo hunter spitting a bullet into a gun"—
Museum purchase, 1973; Ex-collection, James R. Clarke; FRAM 73.13, CR 1390

Most of these objects are mentioned in the poem, but many are not, for the artist was desirous of making this collection of drawings a museum of Indian curiosities, and in pursuit of his object he has drawn both from his own large accumulation of material obtained in observations made during frequent intercourse with Indian tribes, and from a diligent study of objects as stored in museums or pictured by trustworthy artists. A few of the objects… are later in date than the time of the poem, and show the presence of the white man. The artist, in a word, has studied to depict actual objects, indifferent to the possible criticism that in so doing he has departed from a strict regard to the time of the poem. His larger purpose has been to make these pen-and-ink sketches a storehouse of information regarding Indian life in its varied details.[10]

His mentor and guide in the exercise was the dean of American painters of Indian life, George Catlin, whose *Letters and Notes on the Manners, Customs, and Conditions of the North American Indians* (1841) had found its way into Remington's library. Several plates illustrating relics in Catlin's collection anticipate Remington's sketches.

The new edition of *The Song of Hiawatha* appeared in 1891, and was soon followed by the commission from another Boston firm, Little, Brown & Company, to illustrate *The Oregon Trail*. It was the last edition that would be published in Parkman's lifetime, and a project well suited to Remington's talents. "I am very glad that you are to illustrate the 'Oregon Trail,' for I have long admired your rendering of western life, as superior to that of any other artist," Parkman wrote Remington on January 7, 1892. Proceeding rapidly, Remington finished the eight full-page plates and sixty-seven pen-and-ink and wash illustrations for the text by the end of February.[11] Proof that he found the commission congenial was the quality of his work. *Buffalo Hunter Spitting a Bullet into a Gun* (published as *Buffalo Hunter Loading from the Mouth*) illustrated Parkman's observation:

The chief difficulty in running buffalo… is that of loading the gun or pistol at full gallop. Many hunters, for convenience' sake, carry three or four bullets in the mouth; the powder is poured down the muzzle of the piece, the bullet dropped in after it, or spit from the mouth into the barrel, the stock struck hard upon the pommel of the saddle, and the work is done.[12]

Remington conveys the dexterity required by showing the hunter's horse at full gallop. The horse, in turn, is a good example of Remington's use of Eadweard Muybridge's stop-action photographs, which revolutionized the way artists portrayed the horse in motion. Line drawings based on the photographs had appeared in *Century Magazine* in 1882, permitting general access to Muybridge's work.[13]

Remington still occasionally fell back on convention and depicted a galloping horse with front and back legs kicked out in rocking-horse fashion—for example, in *A Peril of the Plains*, published in 1890, where the racing pony flies through the air, demonstrating its rider's skill to full advantage.[14] By 1908 when he painted *The Lost Warrior* Remington was consistent in following Muybridge. His running horses now create a splendid rhythmic frieze, proving that the artistic concession to naturalism was not, as some contemporaries had feared, at the expense of aesthetic appeal.

1. Julian Ralph, "Frederic Remington," *Harper's Weekly*, February 2, 1895, p. 688.
2. Francis Parkman, *The Oregon Trail: Sketches of Prairie and Rocky-Mountain Life* (Boston: Little, Brown, and Co., 1892), p. 104.
3. Henry Wadsworth Longfellow, *The Song of Hiawatha* (Boston: Houghton, Mifflin & Co., 1890), p. 225.
4. Parkman, *The Oregon Trail*, pp. vii–ix.
5. FR, "An Outpost of Civilization," *Harper's Monthly*, December 1893; *Collected Writings*, p. 115.
6. "A Few Words from Mr. Remington," *Collier's Weekly*, March 18, 1905, p. 16.
7. Eva Remington to Horace D. Sackrider, December 3, 1888, quoted in Peggy and Harold Samuels, *Frederic Remington: A Biography* (Garden City, NY: Doubleday & Company,1982), p. 121.
8. FR to Scott Turner, [1877], *Selected Letters*, p. 14.
9. FR to Edwin W. Deming, [1909], in Therese O. Deming, comp., ed. by Henry Collins Walsh, *Edwin Willard Deming* (New York: The Riverside Press, 1925), p. 25.
10. Longfellow, *The Song of Hiawatha*, pp. xi–xii.
11. Francis Parkman to FR, January 7, 1892, and FR to Parkman, February 29, 1892, in Wilbur R. Jacobs, ed., *Letters of Francis Parkman*, 2 vols. (Norman: University of Oklahoma Press, in co-operation with The Massachusetts Historical Society, 1960), II, pp. 252, 257.
12. Parkman, *The Oregon Trail*, p. 357.
13. George E. Waring, Jr., "The Horse in Motion," *Century Magazine* 24 (July 1882): 381–88. For two positions on Remington's use of the Muybridge photographs, see Estelle Jussim, *Visual Communication and the Graphic Arts: Photographic Technologies in the Nineteenth Century* (New York: R. R. Bowker Company, 1974), pp. 218–35, and Peter H. Hassrick, "Remington: The Painter," in Michael Edward Shapiro and Hassrick, *Frederic Remington: The Masterworks* (New York: Harry N. Abrams, for the Saint Louis Art Museum, in conjunction with the Buffalo Bill Historical Center, Cody, WY, 1988), pp. 96–7, 109.
14. See John Bidwell, "The First Emigrant Train to California," *Century Magazine* 41 (November 1890): 106, for *A Peril of the Plains*.

Outline sketch based on an Eadweard Muybridge photograph of a running horse,
Century Magazine 24 (July 1882): 382, Fig. 9

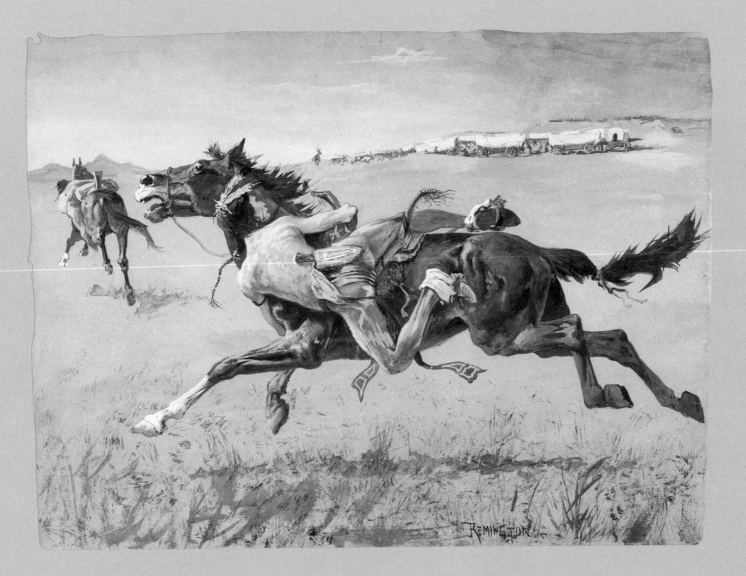

A Peril of the Plains ca. 1890
Gouache on paper, 18 ⅝ x 25" (47.3 x 63.5 cm.)
Signed lower right: REMINGTON
Bequest of Robert W. Purcell, New York, NY;
FRAM 92.4, CR 419

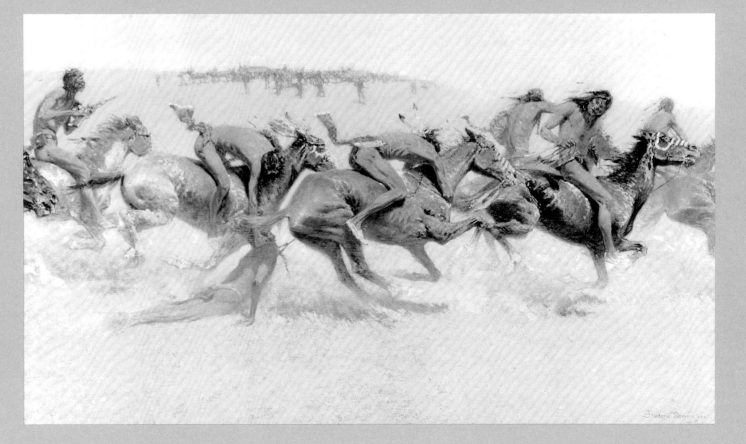

The Lost Warrior 1908
Oil on canvas. 29 ½ x 50" (74.9 x 127 cm.)
Gilcrease Museum, Tulsa, OK
CR 2861

A Comanche 1888–1889

Ink wash and gouache on paper, 18¼ x 17¼" (46.4 x 43.8 cm.)
Signed lower left: —FREDERIC REMINGTON— / FORT SILL. I. Ty.—
Inscribed lower right: A Commanche buck
Museum purchase with funds from the members of the International Advisory Board; FRAM 93.5, CR 475

Waiting for the Beef Issue 1888–1889

Ink wash on paper, 26 x 18¼" (66 x 46.1 cm.)
Signed lower left: FREDERIC RemingTON— / FORT RENO.—I.T.
Inscribed lower left margin: Sketch of a group of Indians before the beef issue corral, Indian article. no. 2.—
Bequest of Mr. Robert Purcell, New York, NY; FRAM 92.3, CR 500

In 1889 Remington established himself as a two-way threat. Having "beguiled" the editor of *Century Magazine* to send him on a "tour through the Indian Territory and into Arizona" in 1888, he wrote and illustrated three articles describing his experiences.[1] The trip was a demanding one for him, particularly a two-week scout with the Tenth Cavalry out of Fort Grant, Arizona, that exposed him to some of the harshest and most beautiful areas in Apache land. He participated in ration day at San Carlos, and came back twenty pounds lighter, thoroughly exhausted, and with a head full of new ideas for pictures. "It is a very successful trip and will help me professionally very greatly," he wrote Eva on June 22, shortly before departing for Texas and the second stage of his tour, an inspection of the Indian reservations.[2] He was tired of it all when he wrote her from Henrietta, Texas, on July 1:

> —there is not a square inch of my body that is not [mosquito] bitten—and oh oh oh how hot it is here—I have sweat and sweat my clothes full—I can fairly smell myself—I am dirty and look like the devil and feel worse and there is no help for me. Well you can bet I am going to make the dust fly and get through as soon as I can— … all this is very discouraging but its an artist life. I have no idea how long this thing will take for these Indians are scattered all over the earth but I "touch and go" and you can bet I wont spend the evening with them—still I came to do the wild tribes and I do it.[3]

In the end it was all worthwhile. His patrol with the Tenth Cavalry made for an article in the April 1889 *Century*, while the tour of the Indian reservations offered enough material for a two-part feature in the July and August issues. These served to cement Remington's reputation as America's foremost Western illustrator.

A Reservation Indian 1897
Ink wash on paper, 19 x 17¾" (48.3 x 45.1 cm.)
Signed lower right: —FrEderic Remington.—;
inscription lower center: Copyrighted 1897 / R. H. Russell & Son
FRAM. 86.7, CR 2195

Colorado Ute
FRAM, photograph album 71.830 (Book of Animals), p. 88
The caption is Remington's.

AN AGENCY POLICEMAN.

An Agency Policeman
Century Magazine 38 (August 1889): 541

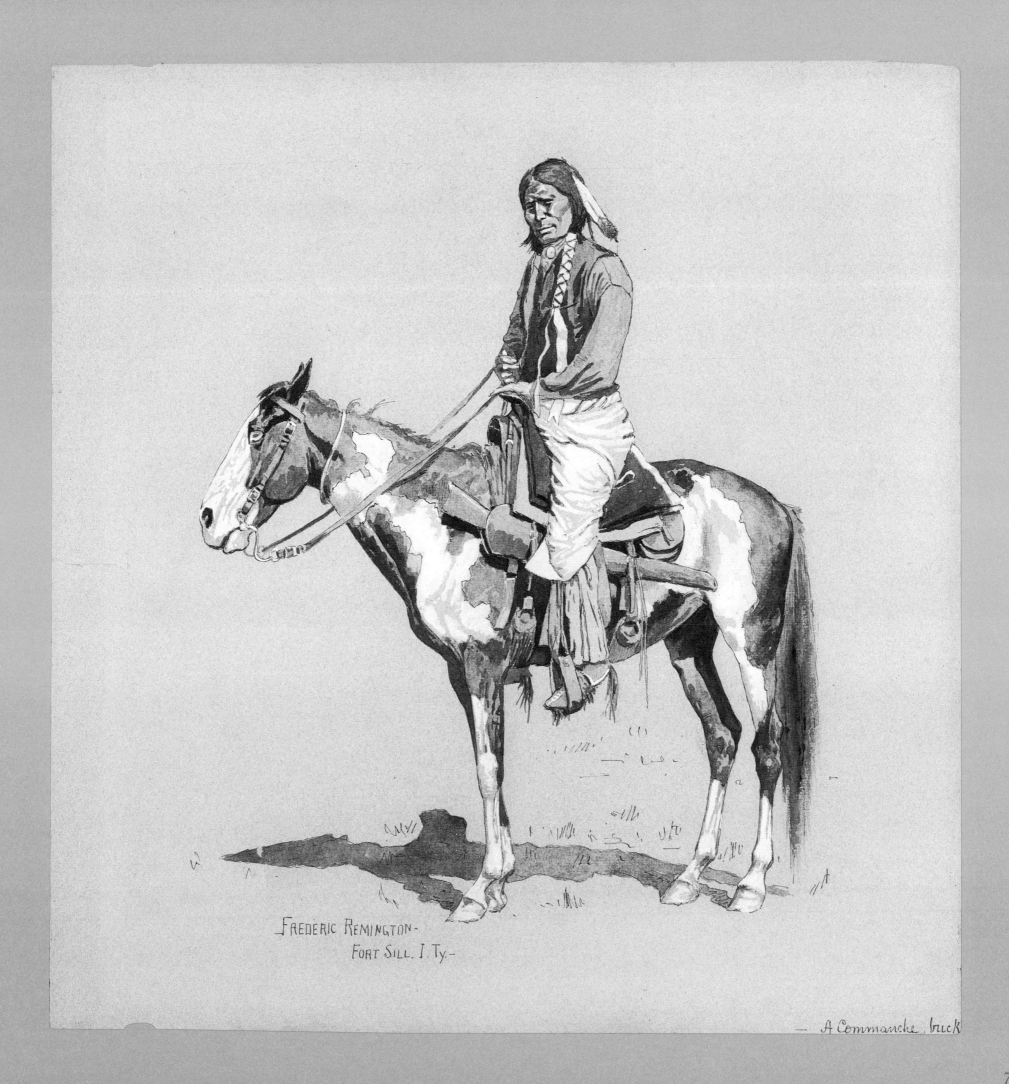

FREDERIC REMINGTON-
FORT SILL. I. TY.-

A Commanche buck

Remington's 1888 tour among the Apaches, Comanches, Kiowas and Cheyennes proved perhaps his most productive visit to Indian country. He brought back both sketches and photographs, and in later years reworked much of this material. The Comanches impressed him as "a jolly, round-faced people, who speak Spanish, and often have Mexican blood in their veins…. They breed [their horses] intelligently, and produce some of the most beautiful 'painted' ponies imaginable." His description fits the rider and horse in *A Comanche*, an expert equestrian study which, appearing in the July 1889 *Century*, showed how rapidly Remington had progressed in his craft in a matter of a few years.[4] He relied heavily on photographs at this time, and they are a part of the mixture of what was emerging as "Remington's West." For example, he published another single-figure equestrian study in the next issue of *Century* as *An Agency Policeman*; the drawing owes much to a photograph in one of his albums labeled "Colorado Ute." Subsequently, elements of both *A Comanche* and *An Agency Policemen* were amalgamated in his 1897 wash drawing *A Reservation Indian*. It was precisely by such transformations that Remington surmounted observed (and borrowed) particulars and made of them his own distinctive art.

Another Remington wash drawing, *Waiting for the Beef Issue*, makes this point as well. "In twos, and threes, and groups, and crowds, came Indians, converging on the beef corral," Remington wrote, and his illustration was faithful to what he saw.[5] It was intended as a factual representation of the sort that established his reputation. But he reworked the same group of riders in a late-life nocturne, *Who Comes There?*, which by shifting the scene from day to night transforms the entire mood. Now there is apprehension here, and an element of mystery that denies the mundane a place in Remington's great creation, *his* West.

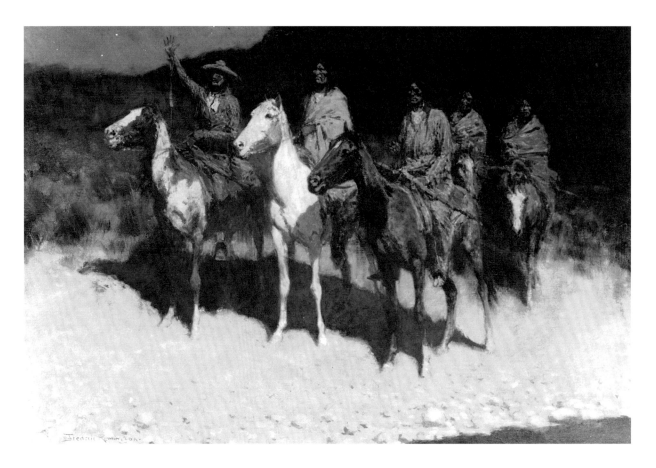

Who Comes There? (*Moonlight Scouting Party*) 1906
Gilcrease Museum, Tulsa, OK
CR 2803

1. FR to Powhatan Clarke, April 11, 1888, *Selected Letters*, p. 49.
2. FR to Eva Remington, June 22, [1888], *Selected Letters*, pp. 56–59.
3. FR to Eva Remington, July 1, 1888, *Selected Letters*, p. 60.
4. FR, "On the Indian Reservations," *Century Magazine* 38 (July 1889): 400–01; *Collected Writings*, p. 36.
5. FR, "Artist Wanderings among the Cheyennes," *Century Magazine* 38 (August 1889): 543; *Collected Writings*, p. 45.

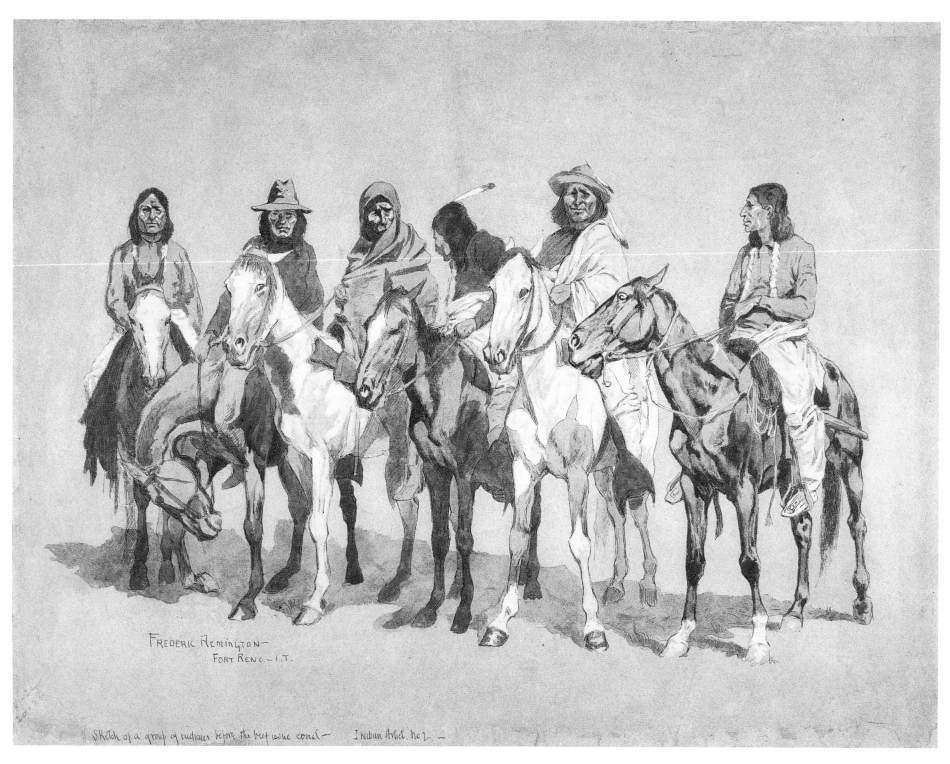

Waiting for the Beef Issue 1888–1889

Ink wash on paper, 26 x 18 ¹/₄" (66 x 46.4 cm.)

Signed lower left: FREDERIC RemingTON— / FORT RENO.—I.T.—

Inscription lower left margin: Sketch of a group of Indians before the beef issue corral, Indian article. no. 2.—

Bequest of Mr. Robert Purcell, New York, NY; FRAM 92.3, CR 500

Lieutenant Powhatan H. Clarke, Tenth Cavalry 1888

Oil on canvas, 10¼ x 12¾" (26 x 32.4 cm.)
Signed upper right: F. REMING / Study of a U.S. [surviving upper portion
of an oil originally signed lower left: —FREDERIC REMINGTON— / Fort Grant.]
FRAM 66.73, CR 1033

Remington liked cockiness and swagger in his soldiers. Generals were fine and all that, but he preferred the junior officers who still had something to prove. They were young, vigorous, athletic, "made of whalebone and rubber," as he put it, and spoiling to practice the art and science in which they had trained. When he met Lieutenant Powhatan H. Clarke, who was a year his junior, at Fort Grant, Arizona, in 1886, he found the personification of his ideal. Wasp-waisted, smug to the point of arrogance, and fearless, Remington believed, beyond ordinary mortals, Clarke was "altogether one of those old-time kind of 'ride into battle with his life on his sleeve' soldiers, and one not to be particularly commended for bravery, since trepidation would be quite a novel experience for him." Clarke had proved himself in battle against the Apache, pulling a wounded corporal to safety under a hail of enemy bullets, and that was proof enough for Remington.[1]

They carried on an animated correspondence, Remington wanting material and photographs he could use in his work, Clarke wanting entree into the world of publishers and top brass not ordinarily available to a lowly lieutenant. They swapped attitudes—both could be arch—and indulged in the manly art of superciliousness. There was something of the snob in the Virginian that appealed to the snob in Remington, and while Clarke disdained military rules and was indiscreet in the extreme, his unruly streak simply made him the more irresistible to his friend:

He is adored by his men, and universally
popular. He rides the horses which no one else
can, and chases the festive jack-rabbit with his
pack of hounds right into the parade…. Some of
the old commanders in the department regard

Powhatan H. Clarke
Photograph by Havens, Jacksonville, FL
FRAM 1918.76.157.37

Clarke as a "broncho" in
barracks, but they all have a
kindly regard for the soldierly
qualities of the young man….[2]

Clarke died young, by drowning in 1893. His men may have adored him, but they barely lifted a hand to save him. Remington, who had happily promoted him in life, mourned him in death:

Clark was a fellow who
appealed to my imagina-
tion—he was also a good
friend to me and I grew to be
very very fond of him—in fact
he entered into my life to the
extent that I can hardly make
it seem that I have got to get
along without him. I know of
no soldier in the U.S.A. who can take his part—
who has verve *and force and ability to act his*
part.[3]

Remington's standing portrait of Clarke, painted in 1888, intended for exhibition in 1890 and reproduced in *Harper's Weekly* that year, was partly destroyed in a later fire. It survives, as truncated as the young officer's life.[4]

A photograph of Remington at work in his studio in 1896 shows four paintings lining the walls above his collection of western curios. One is *Banff, Cascade Mountain* (p. 111); while the two on the left are his tributes to Clarke—*Arrival of a Courier* (1890; see p. 55) and the full-length portrait. Three years after his death, Clarke, poised overhead, still served as Remington's muse.[5]

1. FR, "Two Gallant Young Cavalrymen," *Harper's Weekly*, March 22, 1890; *Collected Writings*, pp. 48–49. With Remington boosting his case, Clarke was awarded the Medal of Honor for his act of heroism: Peggy and Harold Samuels, *Frederic Remington: A Biography* (Garden City, NY: Doubleday & Company, 1982), pp. 106–07, chap. 16.
2. FR, "Two Gallant Young Cavalrymen" (1890); *Collected Writings*, p. 49.
3. FR to Dr. Clarke, October 3, 1893, *Selected Letters*, p. 176. Remington tried unsuccessfully from 1891 on to get Clarke's story of an Apache pursuit published in *Harper's*; it did appear at last, illustrated by Remington (and with a mounted Clarke shown in profile, as in Remington's earlier portrait), as a memorial to him after his death: Powhatan Clarke, "A Hot Trail," *Cosmopolitan* 17 (October 1894): 706–16.
4. FR to Powhatan Clarke, October 31, 1888, January 30, April 9, September 1, 1890, *Selected Letters*, pp. 64, 91, 93, 97–98; and Samuels and Samuels, *Frederic Remington*, p. 159. A variation on Clarke's pose in the portrait appeared in *The Branding Chute at the Beef Issue* (*Century Magazine* 38 [August 1889]: 542), apparently showing Clarke supervising the beef issue at the San Carlos Agency.
5. The photograph illustrated C. M. Fairbanks, "Artist Remington at Home and Afield," *Metropolitan Magazine* 4 (July 1896): 447.

Frederic Remington painting in studio, 1896
Photograph compliments of *The Metropolitan Magazine*
FRAM 1918.76.65

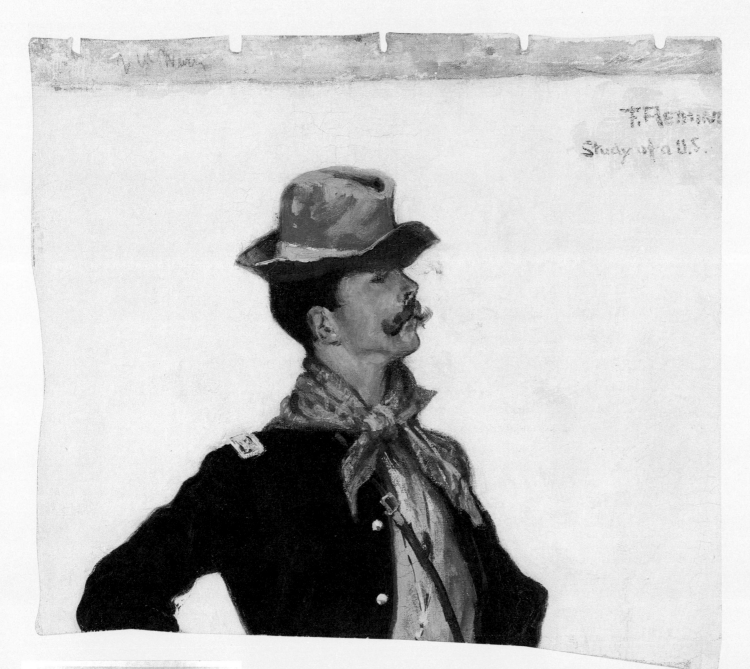

Lieutenant Powhatan H. Clarke,
Tenth Cavalry 1888

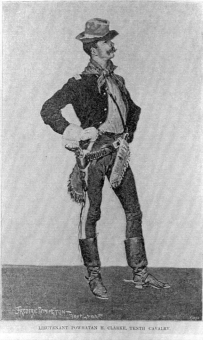

Lieutenant Powhatan H. Clarke, Tenth Cavalry
Harper's Weekly, March 22, 1890, p. 216

Lieutenant Casey, Commandant of Cheyenne Scouts 1890

Watercolor on paper, 16¾ x 17½" (42.6 x 44.5 cm.)
Signed lower left: FREDERIC REMINGTON.—; inscription lower right: Lieut. Edward Casey.—/ Chief Cheyenne Scouts–/ Fort Keough. Montana,—/ Oct. 1890. / Killed that winter, Jan. 91– on White Clay Creek,—/ by Sioux indian.—.
FRAM 66.71, CR 1127

Lt. Hardie—The Hero of "The West from a Car Window" 1894

Watercolor on paper, 17½ x 11" (44.5 x 27.9 cm.)
Signed lower right: Frederic Remington. / Chicago—;inscription across bottom: Lt. Hardie—the hero of "The West from a Car window."—The dragoon dude of 'Zapata City.'
FRAM 66.66, CR 1780

The Charge 1897

Inkwash and gouache on paper, 26 x 38¼" (66 x 97.2 cm.)
Inscribed lower right: To my friends Mr. & Mrs. Cox— / from— / FrEderic Remington.—
Museum purchase, 1962; Ex-collection: Jennings S. Cox, New Rochelle; FRAM 66.68, CR 2159

Powhatan H. Clarke was gone, but his insouciance lived on in Remington's portrayal of soldiers. Remington always favored jaunty, devil-may-care types, and was pleased when a reporter asked him how he captured that look in his cowboys and soldiers:

> *His face lighted up, and a deep twinkle came into his eyes. He glanced across the room at just such a picture as I had described....*
>
> *"Kipling says that, 'a single man in a barrack is not a plaster saint,' and that is about it...."*[1]

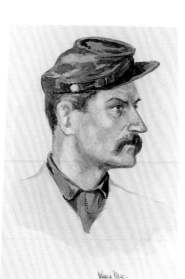

Johnnie Mac [1886]
Watercolor on paper. Unsigned; inscribed bottom center: Johnnie Mac.
FRAM 72.19.1, CR69a

Remington's American soldiers ran the gamut from individual portraits to generic types (in contrast to his Mexican soldiers, which in Remington's art began and ended with types—see pp. 56–57). Indeed, the specific set up the general. By showing individual officers in set poses—mounted and standing—he established conventions that he then applied to *all* soldiers. Thus the particular became the "typical." As Owen Wister observed appreciatively, Remington "with his piercing and yet imaginative eye has taken the likeness of the modern American soldier and stamped it upon our minds with a blow as clean-cut as is the impression of the American Eagle upon our coins in the Mint. Like the Mint, he has made these soldiers of ours universal currency, a precious and historic possession."[2] In exactly the same fashion did Remington fuse observation and imagination to create a pictorial record, instantly recognizable as his own, of the winning of the West. Because he showed particulars so well, he generalized convincingly. A Remington cavalry charge appeared to be a document, and not an imaginary creation. Since it presumably faithfully mirrored observed reality, it could be accepted as depicting a *typical* historical event. That was the power of Remington's work: just as his illustrations paved the way for his generic Western oils, the specifics in his illustrations validated a larger imaginary structure— *his* West. He created a reality of his own that became reality for others.

In October 1890 Remington painted an equestrian portrait of Lieutenant Edward W. Casey. Likely based on a photograph, it is more compelling than a photograph.[3] No background distracts the eye. Its clean lines and expert draftsmanship make it a tribute to an individual and to an ideal: the cavalry officer, an American hero. In this instance, the ideal was given added force by Casey's own fate. The leader of a contingent of Cheyenne scouts

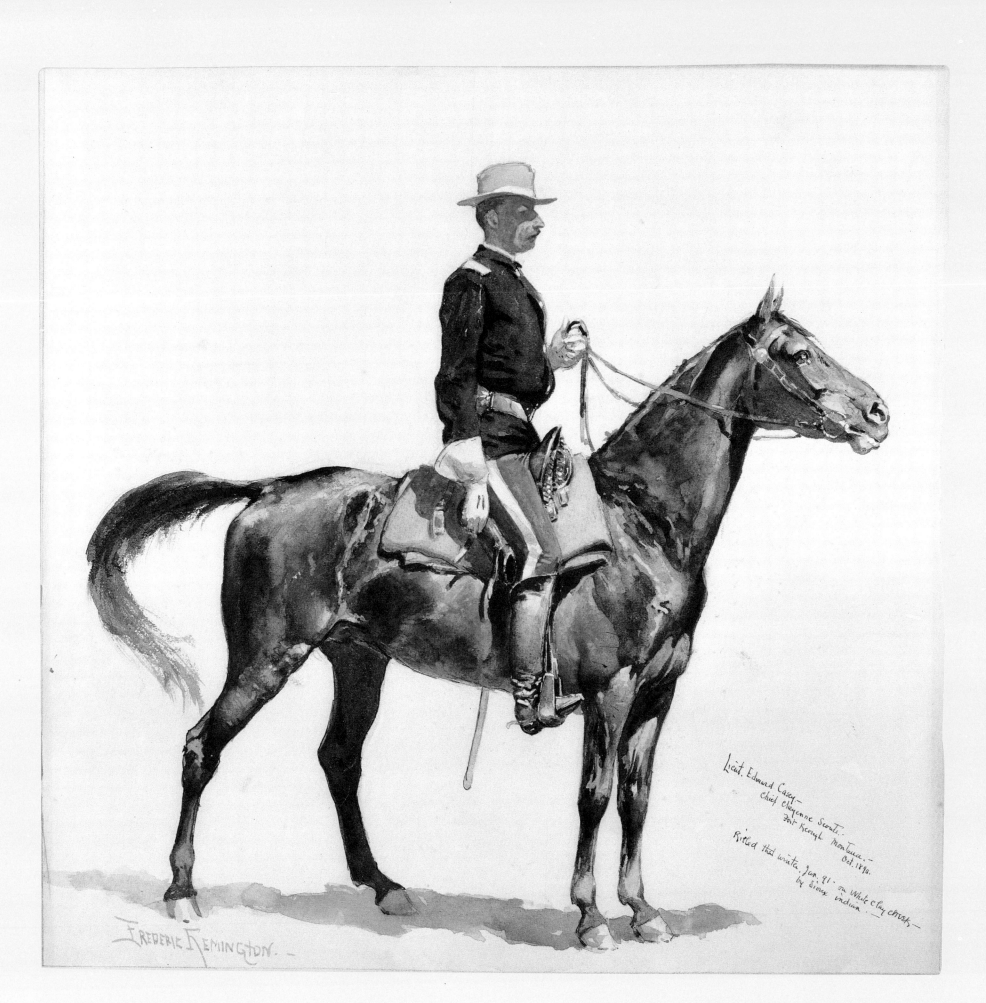

Lieut. Edward Casey —
chief Cheyenne Scouts. —
Fort Keough Montana. —
Oct. 1890.
Killed that winter, Jan. 91. on White Clay creek. —
by Sioux indian. —

FREDERIC REMINGTON. —

Lieutenant Casey, Commandant of Cheyenne Scouts 1890

in the Sioux Ghost Dance War of 1890–1891, he was killed by a young Lakota on January 7, 1891—just eleven days after his portrait appeared in *Harper's Weekly*. Remington wrote a formal tribute to Casey ("an accomplished man; the best friend the Indians had; a man who did not know 'fear'"[4]), but more telling was the tribute he sent to Powhatan Clarke: "Dont forget to paste Lieut. Casey's name on your hat—he was a soldier—from the ground up and for 7 miles on every side."[5]

In 1892 Remington illustrated "The West from a Car Window," a travelogue by journalist Richard Harding Davis published in *Harper's Weekly*. Davis devoted three months to his tour, and confessed, "All that I may hope to do is to tell what impressed an Eastern man in a hurried trip through the Western states." He spent time with the army in the field and at the post, and with cowboys on the ranch and Indians on the reservation. What he saw and reported was old hat to Remington, who could have illustrated the weekly installments off the top of his head. However, Davis provided him with photographs that Remington chose to use. *Water*, for example, was published with Remington's notation "after photo." It served as an ironic counterpoint to Davis's text, which described the ardors of patrolling in a parched land

where there are no roses, but where everything
that grows has a thorn. Where the cattle die of
starvation, and where the troops had to hold up
the solitary train that passes over it once a day,
in true road-agent fashion, to take the water
from its boilers that their horses might not drop
for lack of it…. Where there are no trees, nor
running streams, nor rocks nor hills, but just an
ocean of gray chaparral and white, chalky
cañons or red, dusty trails.[6]

Patrolling the Texas-Mexico border was hardship duty, in short, and Davis admired the dedication of Captain Francis H. Hardie and his Third Cavalry troopers. Remington sketched the captain's likeness from, he noted, "a bad photograph." Subsequently he met Hardie—probably in Chicago in 1894 when the Third Cavalry was called in to help break up a major labor protest—and sketched him from life.[7] His watercolor likeness combined portraiture and posturing of the sort Remington always favored in his army types.

The (sometimes literally) photographic realism of Remington's illustrative work—his Caseys and Hardies and scenes like *Water*—set the stage for his types and their typical activities. Thus a generic trooper like *Johnnie Mac*, with firm-set jaw, stern gaze, and fighting demeanor; and generic cavalrymen like the one shown in *The Guidon Bearer*. The rider reining his horse—man and animal rigid, expectant—could serve as a companion to the soldiers in some of Remington's major oils caught responding to *something* that may mean action in the offing. With his guidon snapping in the wind, he anticipates something as well—those Hollywood Westerns in which the cavalry charged to the rescue that drew so knowingly on Remington to create their own formulaic myths. In his sketch, Remington applied ink and watercolor freely to create a "snapshot" notable for its spontaneity and its effortless mastery.

Each individual study of a typical soldier bears the cumulative weight of the Remington tradition. String thirty-five of them across a page at full gallop and you have *The Charge*. It was one of forty "original full-page drawings" that Remington contracted to produce for a New York publisher on December 7, 1896.[8] He saw the task as a chance to provide a summation of many of his favorite Western themes, producing sixty-two works in all that R. H. Russell published in 1897 as *Drawings*. None was more theatrical—or more ambitious—than *The Charge*. Jennings S. Cox, the artist's friend and neighbor, was enthralled when Remington presented the painting to him. It was "*blood-stirring*," Cox wrote, "'brimming o'er' with *action*," impressing all who saw it with its "*vigor* and *dash*."[9] *The Charge* deserved such an emphatic endorsement. It transcends particulars to make a larger statement. Owen Wister, in introducing *Drawings*, noted that Remington "has caught alive not only the roped calf, or the troop cook sucking his comfortable corn-cob, the day-by-day facts of the wilderness, but the eternal note also, the pity and the awe of that epic life…. he has made a page of American history his own."[10] *The Charge* is a case in point. Its narrative is deceptively simple. The scouts, their work done, ride behind a solid line of men in blue, whose work is before them. But there is more. Time has been suspended, the moment made perpetual. Those Remington cavalrymen will charge forever across that endless space, permanent fixtures in the American imagination.

The Guidon Bearer 1907
Watercolor and ink on paper
16 x 12" (40.6 x 30.5 cm.)
Signed lower right: FrEderic Remington, / —1907.
FRAM 66.103, CR 2819

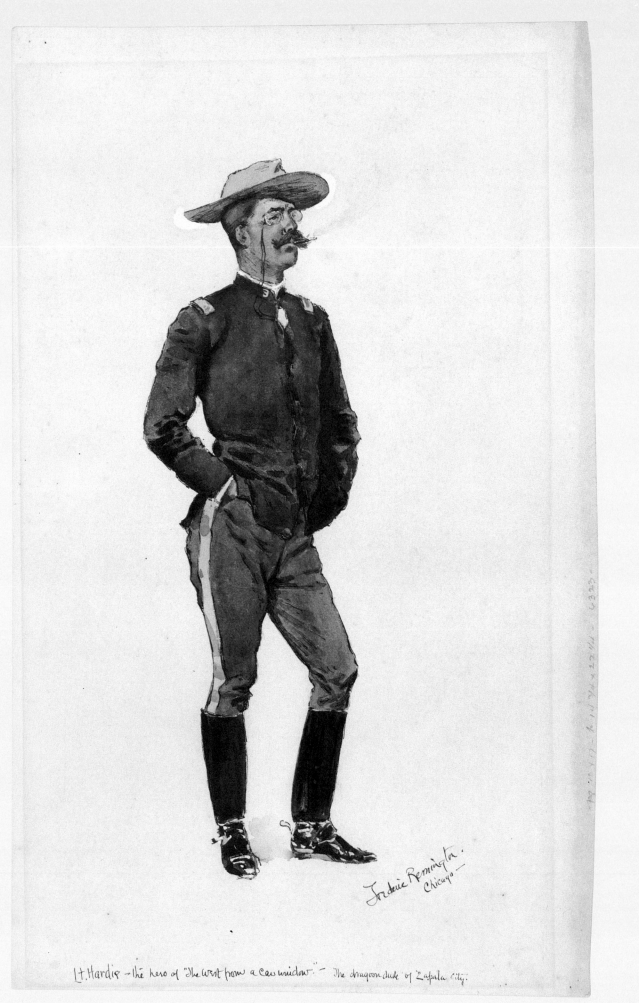

Lt. Hardie—the hero of "The West from a Car window."— The dragoon dude of 'Zapata City.'

Lt. Hardie—The Hero of "The West from a Car Window" 1894
Watercolor on paper, 17½ x 11" (44.5 x 27.9 cm.)
Signed lower right: Frederic Remington. / Chicago—, inscription
across bottom: Lt. Hardie—the hero of "The West from a Car
window."—The dragoon dude of 'Zapata City.'
FRAM 66.66, CR 1780

1. Charles H. Garrett, "Remington and His Work," *Success*, May 13, 1899; in Orison Swett Marden, ed., *Little Visits with Great Americans; or, Success Ideals and How to Attain Them*, 2 vols. (New York: The Success Company, 1905), I, pp. 328–29.

2. Owen Wister, Introduction to FR , *Done in the Open* (New York: P. F. Collier & Son, 1902).

3. Remington always altered what was in front of him—he made his figures taller, straighter and slimmer than their photographs show them, smoothed out the wrinkles in their trousers, and changed details of uniform and equipment if what they were actually wearing failed to meet his standards. For some interesting comparisons between Remington's drawings from 1890 and the photographs upon which they were based, see Richard Upton, compiler, *The Indian as a Soldier at Fort Custer, Montana* (El Segundo, CA: Upton and Sons, 1983), especially pp. 50–51.

4. FR, "Lieutenant Casey's Last Scout: On the Hostile Flanks with the Chis-chis-chash," *Harper's Weekly*, January 31, 1891; *Collected Writings*, p. 77. Remington first introduced Casey and his Cheyenne scouts in "Indians as Irregular Cavalry," *Harper's Weekly*, December 27, 1891; *Collected Writings*, pp. 64–65.

5. FR to Powhatan Clarke, January 27, 1891, *Selected Letters*, p. 113.

6. Richard Harding Davis, *The West from a Car-Window* (New York: Harper & Brothers, 1892), pp. 4, 42. The reports were first carried in *Harper's Weekly*, March 5 – May 28, 1892. It is quite possible that *Water* was actually based on photographs Remington made in Arizona in 1888; he may also have made the drawing at that time, though it is more likely he reworked his earlier material. He wrote his wife (FR to Eva Remington, Sunday [June 10, 1888], FRAM) from Fort Grant, Arizona Territory, just before leaving on a scout with Lieutenant Powhatan Clarke: "I am enjoying myself beyond all question or anticipation—I am getting material such as will make your eyes open—You know my picture on 'Water'—They turned out a troop with pack mules— went through the coming to water—and I photoed them six times." Remington's account, "A Scout with the Buffalo-Soldiers," *Century* 37 (April 1889), included an illustration titled *A Pool in the Desert* (p. 910) that merits comparison with *Water*.

7. Hardie and Remington met again in 1898 in Tampa, Florida, where Hardie's regiment was training prior to embarking for Cuba. This portrait could date from that period. See C. A. Secane, "Remington's Cavalryman," *Cavalry Journal* 52 (November–December 1943).

8. Agreement between Robert Howard Russell and Frederic Remington, December 7, 1896, FRAM.

9. Jennings S. Cox to FR, October 12, 1897, FRAM.

10. Owen Wister, "Concerning the Contents," in FR, *Drawings* (New York: R. H. Russell, 1897).

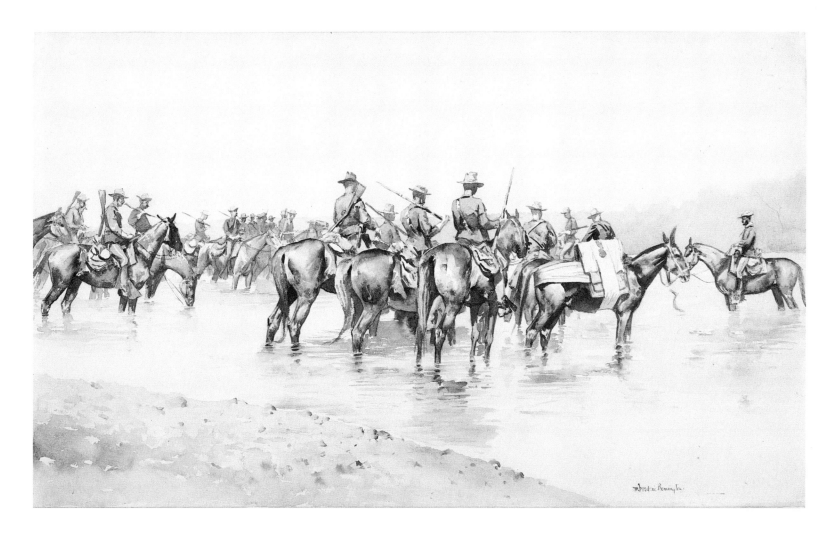

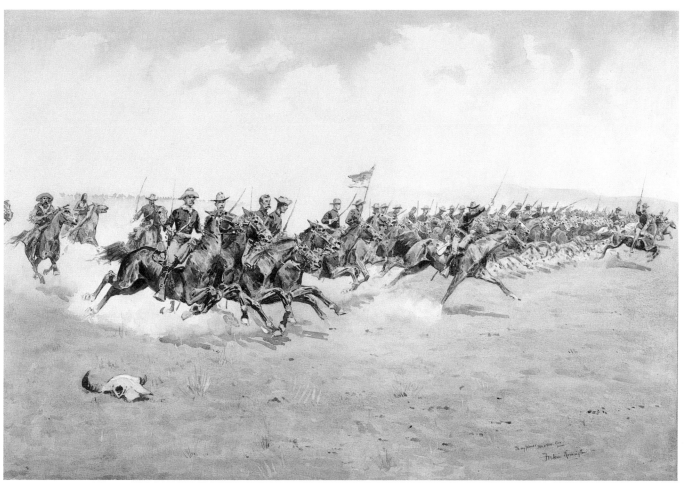

Top:
Water 1892
Ink wash and gouache on paper
18 x 30¹/₈" (45.7 x 76.5 cm.)
Signed lower right: FredEric Remington- / ["after
photo.——" now obliterated]
Museum purchase, 1980; FRAM 80.3, CR 1498

Right:
The Charge 1897
Ink wash with gouache on paper,
26 x 38¹/₄" (66 x 97.2 cm.)
Inscribed lower right: To my friends Mr. & Mrs.
Cox— / from— / Frederic Remington.—.
Museum purchase, 1962; Ex-collection: Jennings
S. Cox, New Rochelle; FRAM 66.68, CR 2159

Antoine's Cabin 1890

Oil on canvas, 28 x 20" (71.1 x 50.8 cm.)
Signed lower right: FREDERIC REMINGTON.
FRAM 66.37, CR 966

"Ten days before Xmas another man who was also insane and I started to make a dash for the North Pole," Frederic Remington wrote to a friend in January 1890. He and the New York *Sun* journalist Julian Ralph had been commiserating over cigars and wine at The Players Club in Manhattan. They were both mentally fatigued—burned out, bone tired and looking for respite. It was Remington who hit upon the solution: they would leave the next morning for Canada "to hunt the 'festive moose.'"[1] "Think of it!," he exclaimed. "In twenty-four hours we shall be tracking moose near Hudson Bay…." From Montreal they proceeded to Matawa, Ontario, hired two Indian guides and a teamster to drive the portage sleigh, and in short order were bumping their way along a path through the woods over tree stumps, rocks, deadfalls, and steep ravines, en route to Antoine's moose-yard ("a moose yard," Ralph explained, "is the feeding ground of a herd of moose, and our head Indian, Alexandre Antoine, knew where there was one"). They spent one night out-of-doors before they reached Antoine's cabin, a log hut "built for a hunting camp. It was very picturesque and substantial," Ralph wrote, "built of huge logs, and caulked with moss. It had a great earthen bank in the middle for a fireplace, with an equally large opening in the roof, boarded several feet high at the sides to form a chimney."[2] (Remington was blunter: "We slept in a log camp with half the roof off and as the Western man said 'd— us we like it too.'")[3] The conditions were unconducive to hunting, but on the fifth day Remington and Ralph got their moose. They had also got a story—Ralph to write it, Remington to illustrate it, inaugurating what would prove a profitable partnership in *Harper's Monthly*.

Remington's illustrations for "Antoine's Moose-yard" were a mixed bag. Three were directly worked up from photographs of Ralph and himself

Remington in tuque and capote
Photograph by William Notman & Son, Montreal
FRAM 1918.76.6

in full moose-hunting apparel. Ralph described Montreal as "the gayest city on this continent," and both men, smitten with the colorful winter clothing available there, headed into the woods "clad for arctic weather" and looking very picturesque:

We each wore two pairs of the heaviest woollen stockings I ever saw, and over them ribbed bicycle stockings that came to our knees. Over these in turn were our "neaps" and then our moccasins, laced tightly around our ankles. We had on two suits of flannels of extra thickness, flannel shirts, reefing jackets, and "capeaux," as they call their long hooded blanket coats… On our heads we had knitted tuques, and on our hands mittens and gloves.

Antoine's Cabin was Remington's best effort. He may have worked it up from an oil sketch made on the spot. It shows the rustic cabin, the axe that was indispensable to the Indian guides, their traps, the sled that figured in what Remington conceded was "the roughest traveling he had ever experienced," the artist in his north woods costume, and, most effectively, the woods themselves—"the undisturbed primeval forest where the trees shoot up forty feet before the branches begin," as Ralph put it. *Antoine's Cabin* is literal, like all Remington's work of this period, but effectively captures the poetry of Ralph's imagery: "All around us rose the motionless regiments of the forest, with the snow beneath them, and their branches and twigs printing lace-work on the sky."[4]

1. FR to Powhatan Clarke, January 9, 1890, *Selected Letters*, p. 87.
2. Julian Ralph, "Antoine's Moose-yard," *Harper's Monthly* 81 (October 1890): 651–52; 656; 662.
3. FR to Clarke, January 9, 1890, *Selected Letters*, p. 87.
4. Ralph, "Antoine's Moose-yard," pp. 653, 656, 658, 660.

"Give me a light, Ralph": Frederic Remington and Julian Ralph, December 1889
Photograph by William Notman & Son, Montreal
FRAM 1918.76.160.638

First study for *Antoine's Cabin* 1889–1890
Oil on paper, 28 x 20" (71.1 x 50.8 cm.)
Unsigned
FRAM 66.272, CR 966a

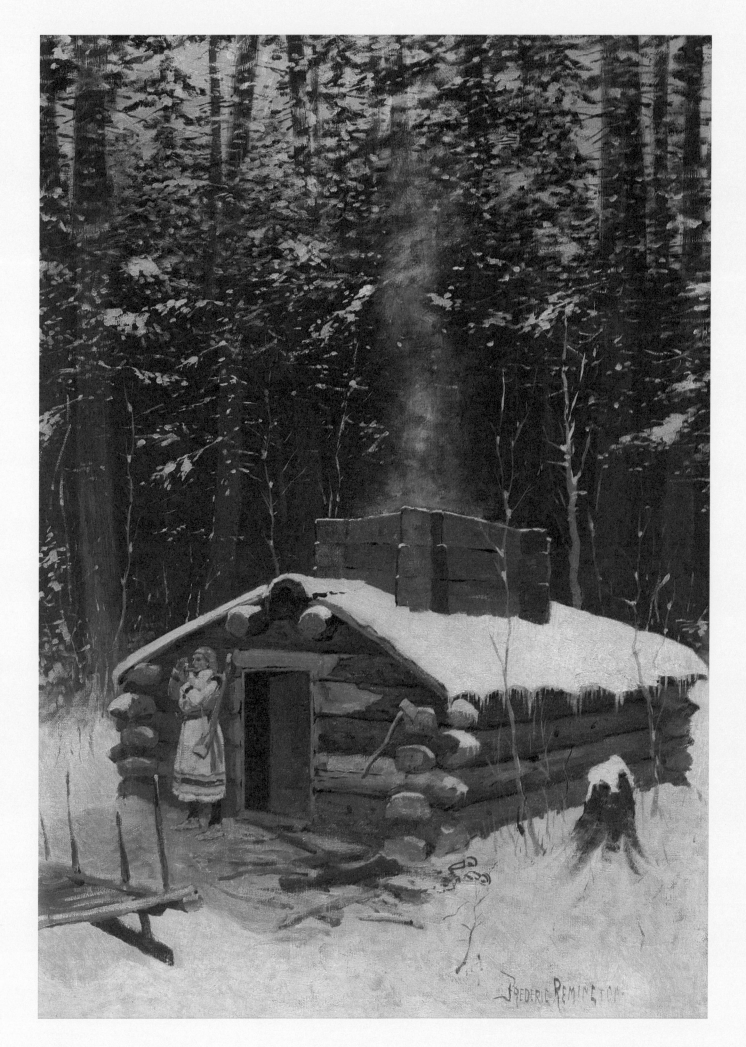

Antoine's Cabin 1890

The Frontier Guard and the Custom-House 1892
Ink wash with gouache on paper, 21⅜ x 32¾" (54.3 x 83.2 cm.)
Signed lower left: FrEderic Remington / Schmelkin—
Inscribed bottom center: Why we left Russia The frontier guard & the custom house
Museum purchase, 1946; Ex-collection: John Brendel, Bronx, NY; City Book Auction, New York; FRAM 66.65, CR 1547

Shoeing Cossack Horses 1892
Pen and ink wash and watercolor on paper, 21⅞ x 29" (55.6 x 73.7 cm.)
Signed lower left: FrEderic Remington
Museum purchase, 1991; Ex-collection: Eppich family; FRAM 91.5, CR 1565

The Emperor's Hunting-Lodge 1892
Ink wash and watercolor on paper, 14 x 13½" (35.6 x 34.3 cm.)
Signed lower right: FrEderic Remington / Rominten / June 16-'92
Museum purchase, 1983; Ex-collection: Andrew and Andrea Schrader, North Bangor, NY; FRAM 66.551, CR1611

Arab Method of Picketing a Horse 1894
Ink wash on paper, 22 x 21" (55.9 x 53.3 cm.)
Signed lower right: FrEderic Remington / Algiers.—
signed bottom center: FrEderic Remington / Algiers.—
Museum purchase, 1978; Ex-collection: Robert G. Butler, Hamilton, NY; FRAM 78.17, CR 1901

After 1891, Remington's career was at a crossroads. Whether or not he recognized the fact, his services as an Indian wars correspondent had come to an end. He would still go on assignment to the West, to Canada and Mexico, accompanying journalists or producing his own texts to illustrate. And there would always be reminiscent pieces about the Indian wars requiring illustration—a slew of them through the 1890s, from magazine articles to book-length memoirs. This was equivalent to working, like the estimable Howard Pyle, as a historical illustrator. Remington was not unwilling. An 1891 biographical notice by Julian Ralph had remarked on the wide range of interests indicated by Remington's surprisingly well-stocked—and surprisingly diversified—library. At the time Ralph simply hinted at other areas of competence: "His quiver is as full as ever warrior wore. His arrows are of many kinds. He must live long and work fast to leave himself empty-handed."[1] Four years later he identified one of the unexpended arrows: "I know—and here comes private knowledge again, with its persistent sacrilege—that Mr. Remington cherishes the hope of some day extending his bold and stirring panorama to include the French settlement of Canada also, with all the color and glitter and romance and picturesqueness that went with its beginning. He loves these phases of history."[2] It made sense that the illustrator of Francis Parkman's *Oregon Trail* would follow the master's tracks into the early history of French exploration and settlement in North America. But was there any future save the past for the "special correspondent" who had covered the final phase of America's Indian wars?

From his boyhood sketches to his formal studies of Mexican soldiers, Remington had always exhibited the instincts of a military artist. The West had simply been America's particular theater for war in his time. And if, that theater having closed forever, one could cover only so many military exercises, and depict only so many mock battles and practice skirmishes and displays of horsemanship and precision marching at home, one could always go abroad, where there were armies to see and the whiff of real battle in the air. Remington's opportunity came in 1892. Poultney Bigelow, a Yale classmate who was editing the student newspaper when Remington published his very first sketch and was editor of *Outing* magazine in 1887 when Remington published his very first illustrated article about his Western experiences, was planning a canoe trip down the Volga River, and needed an artist. Well-travelled and sophisticated, Bigelow would compensate for Remington's inexperience. He would write up their travels for *Harper's*, and Remington would illustrate them. It seemed an ideal arrangement, though the itinerary had to be altered to a canoe trip down the Baltic coast from St. Petersburg to Berlin.

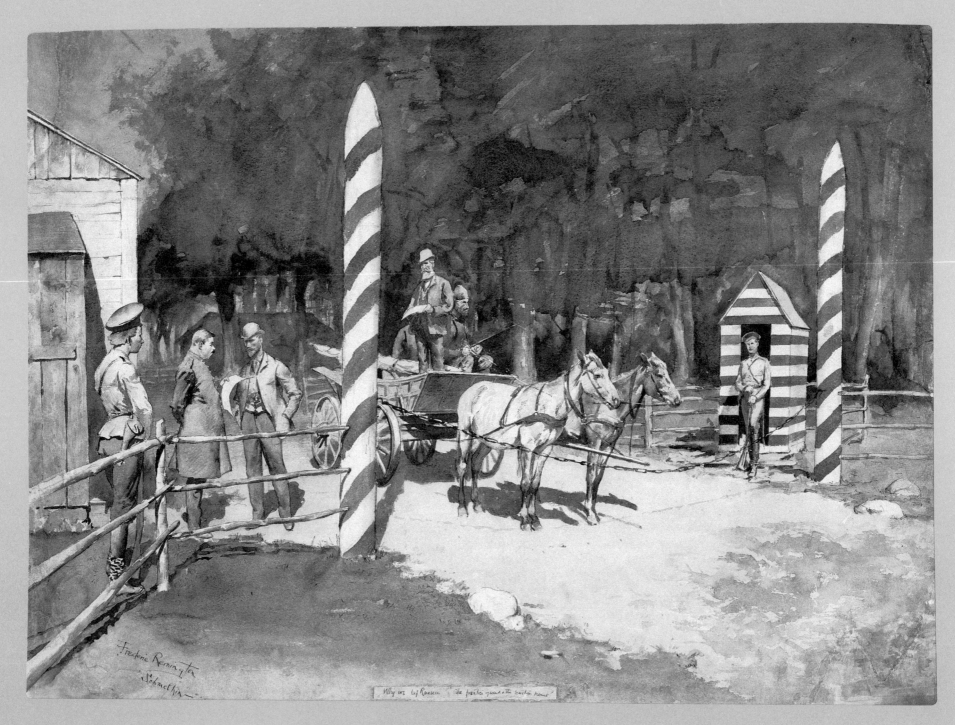

The Frontier Guard and the Custom-House 1892

Bigelow's close friendship with the German emperor, William II, provided an entrée when they arrived in Berlin in May 1892. The problem was that Bigelow's friendship with the emperor was *too* close, which did their cause no good at all in Russia. Indeed, acting like the spy he evidently was, Bigelow disappeared for three days while they were in St. Petersburg, leaving Remington, who was not the most worldly of men, to stew about what the Russians were going to do to him in Bigelow's absence—prison at least, which would be worse than facing a firing squad, he reasoned. Thus he was mightily relieved when his traveling companion returned and the two, denied permission to canoe down the coast, were unceremoniously escorted out of Russia. Back on German soil, they visited the Emperor's horse farm at Trakehnen and his hunting lodge at Rominten before parting company in Berlin. Remington continued alone to Paris, and the Hotel Continental, where his provincial suspicion of foreigners and his inability to communicate except in English curtailed the pleasure of looking at art.[3] His crib list of French phrases and their pronunciation has survived, giving a wonderful insight into his principal concerns:

I want to go to— *deseer allé à Place*
Where is the— *"wa la hotel Cont.*
a ticket to— *se vou pla a billet a un—bea*
how much money— *com-bien d'argent es* ce que *cella coute*
water, if you please— *de l'eaux*
I do not talk French— *Jena com prand pas l'France—*
water closet— *la cabinée*
to the station— *a la gare*
first class— *premier classe*
baggage— *bag gage*
sleepler [sleeper]— *wag gon lee—*

England was a decided relief. "In Russia one cannot even read the signs over the shops," Remington observed. "In Berlin he can spell out the signs and at Paris he is able to read the bill of fare. At last in England he can with some difficulty understand the language and it is only in Ireland that a New Yorker begins to feel at home—."[4] A visit to Buffalo Bill's Wild West touring in London was like a fresh breeze from America that made Remington all the happier when he boarded a steamer on July 2 bound for "God's country."[5]

Nevertheless, the Russian adventure left its impress on Remington's art. He had seen the armies of Europe (French and English, as well as German and Russian) and had expanded his repertoire. Subsequently, he exhorted Bigelow to write up their experiences so he would have something to illustrate—reaffirming the melancholy reality that the writer was primary, the illustrator only secondary. Still, Remington lectured Bigelow, each had his job to do, so "Do not please make suggestions to Harpers of what illustrations I am to make since it only embarrasses me as I can best judge how to use my material."[6] Upon his return, from July through November, Remington worked on his pictures.

The Frontier Guard and the Custom-House illustrated Bigelow's first article, "Why We Left Russia," and was an appropriate accompaniment to a rather dreary litany of complaints about diplomatic snubs, bureaucratic obstructionism, tourist gouging, and a tense border-crossing following their expulsion from Russia.[7]

Shoeing Cossack Horses illustrated Bigelow's "In the Barracks of the Czar." For all their problems in Russia, Bigelow and Remington did get outside St. Petersburg to see something of the Russian army. Remington thought the country and its people drab ("the sad gray land"), but admired the Cossacks' way with horses. "The Russian is a poor horseman," an officer explained, "and drill cannot make a cavalryman…. The Cossack is otherwise; he loves his horse, he is full of resources, and is worth all the rest of the cavalry put together."[8] *Shoeing Cossack Horses* is more than simply competent. It is a charming illustration that captures Remington's own love of horses (a photograph shows him inspecting the shoe of his riding horse at New Rochelle with his stablehand Jim), and confirms his opinion that his illustrations for "In the Barracks of the Czar" were "as good or better than anything I have produced yet."[9]

The Emperor's Hunting Lodge has no such pretensions. It appeared with the last of Bigelow's articles on their Russian trip, in 1894, though the drawing is dated June 16, 1892, and was among the earliest illustrations Remington completed for Bigelow's promised essay on "Emperor William's Stud-Farm and Hunting Forest." After their snubbing in Russia, Remington and Bigelow were grateful for German hospitality, including the opportunity to inspect the emperor's new hunting lodge at Rominten, near the Russian border. Remington sketched it from their inn room window, and Bigelow described it in detail:

Remington inspects a horse-shoe, New Rochelle
FRAM 1918.76.152.68

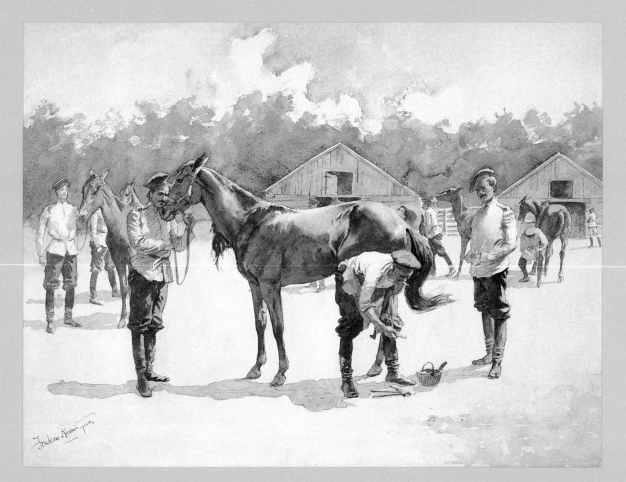

Shoeing Cossack Horses 1892
Pen and ink wash and watercolor on paper, 21⅞ x 29" (55.6 x 73.7 cm.)
Signed lower left: FrEderic Remington.
Museum purchase, 1991; Ex-collection: Eppich family; FRAM 91.5, CR 1565

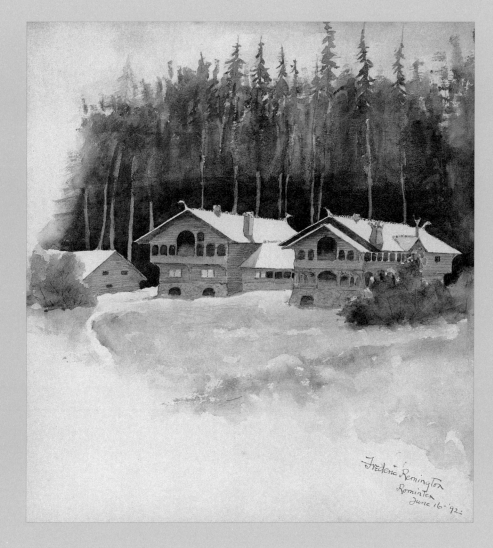

The Emperor's Hunting-Lodge 1892
Ink wash and watercolor on paper, 14 x 13½" (35.6 x 34.3 cm.)
Signed lower right: FrEderic Remington / Rominten / June 16-'92.
Museum purchase, 1983; Ex-collection: Andrew and Andrea Schrader, North Bangor, NY;
FRAM 66.551, CR1611

This hunting-lodge of the Emperor's is a cross between the typical Swiss chalet and an American log house; there is a striking amount of quaint Norwegian carving about it, and the rafters of the roof come to a point in the shape of grinning dragons' heads…. It is, of course, unpainted, and finished in the most severe style, as befits the purpose for which it was originally designed.[10]

This rustic style, which would characterize the architecture in many of America's Western parks in the early years of the twentieth century, appealed to the so-called sportsmen-conservationists of Remington and Roosevelt's generation, who believed that roughing it out-of-doors was a last vital link to the pioneering past that had forged the nation's character.[11]

Though Remington continued to dismiss Europe and reaffirm his preference for America, his appetite had been whetted in 1892, and he was quick to seize the opportunity to join Bigelow on another excursion in March 1894. This time, the two men hooked up for a trip to inspect the French soldiers stationed in North Africa and to check out first hand the Arabs of the Sahara who were so often compared to the Western Indians Remington had made his specialty. Judging from his illustrations for Bigelow's essay "An Arabian Day and Night," he was not disappointed. His drawings of a camel caravan and Arab riders were full of dash and verve—he rendered them as he would Apache and Sioux, and thus Americanized "types" who had figured prominently in Europe's "orientalist" vogue. Remington was especially eager to see Arabian horses. Five years before his visit, he had observed: "To men of all ages the horse of northern Africa has been the standard of worth and beauty and speed. It was bred for the purpose of war and reared under the most favorable climatic conditions, and its descendants have infused their blood into all the strains which in our day are regarded as valuable."[12] *Arab Method of Picketing a Horse* was one of his quieter studies of the camp of El Hadj Mohammed which, Bigelow wrote, "consisted of about a dozen round tents made of brown camel's hair cloth…. along the front of the tents was a thick rope of camel's hair, to which the horses were hobbled."[13] Remington made sketches on the spot, but relied on a group of photographs in working up his illustrations.

1. Julian Ralph, "Frederic Remington," *Harper's Weekly*, January 17, 1891, p. 43.
2. Julian Ralph, "Frederic Remington," *Harper's Weekly*, February 2, 1895, p. 688.
3. FR to Powhatan Clarke, July 19, [1892]; also to Owen Wister, April 1, [1894], *Selected Letters*, pp. 143, 207.
4. Sketchbook (Frederic Remington / "Endion" / New Rochelle), FRAM 69.759; and see FR to Julian Ralph, June 11, 1892, *Selected Letters*, pp. 137–38.
5. FR to Poultney Bigelow, June 27, 1892, *Selected Letters*, p. 140.
6. FR to Poultney Bigelow, August 24, 1892, *Selected Letters*, p. 147.
7. Poultney Bigelow, "Why We Left Russia," *Harper's Monthly* 86 (January 1893): 294–307.
8. Poultney Bigelow, "In the Barracks of the Czar," *Harper's Monthly* 86 (April 1893): 777–78, 780. Writer and artist were impressed enough by the Cossacks to collaborate on another piece devoted to them: "The Cossack as Cowboy, Soldier, and Citizen," *Harper's Monthly* 89 (November 1894): 921–36.
9. FR to Poultney Bigelow, November 16, [1892]; also September 27, 1892, *Selected Letters*, pp. 153, 149.
10. Poultney Bigelow, "Emperor William's Stud-Farm and Hunting Forest," *Harper's Monthly* 88 (April 1894): 750, 753–54.
11. See Anne Farrar Hyde, *An American Vision: Far Western Landscape and National Culture, 1820–1920* (New York: New York University Press, 1990), chap. 6.
12. FR, "Horses of the Plains," *Century Magazine*, January 1889; *Collected Writings*, p. 15.
13. Poultney Bigelow, "An Arabian Day and Night," *Harper's Monthly* 90 (December 1894): 6, 10.

Above:
Sketch of an Arabian rider, a Spahi; sketchbook
(Frederic Remington / Endion / New Rochelle)
FRAM 70.753.30

Right:
Arabian horses, 1894
FRAM 1918.76.160.21, 1918.76.160.20

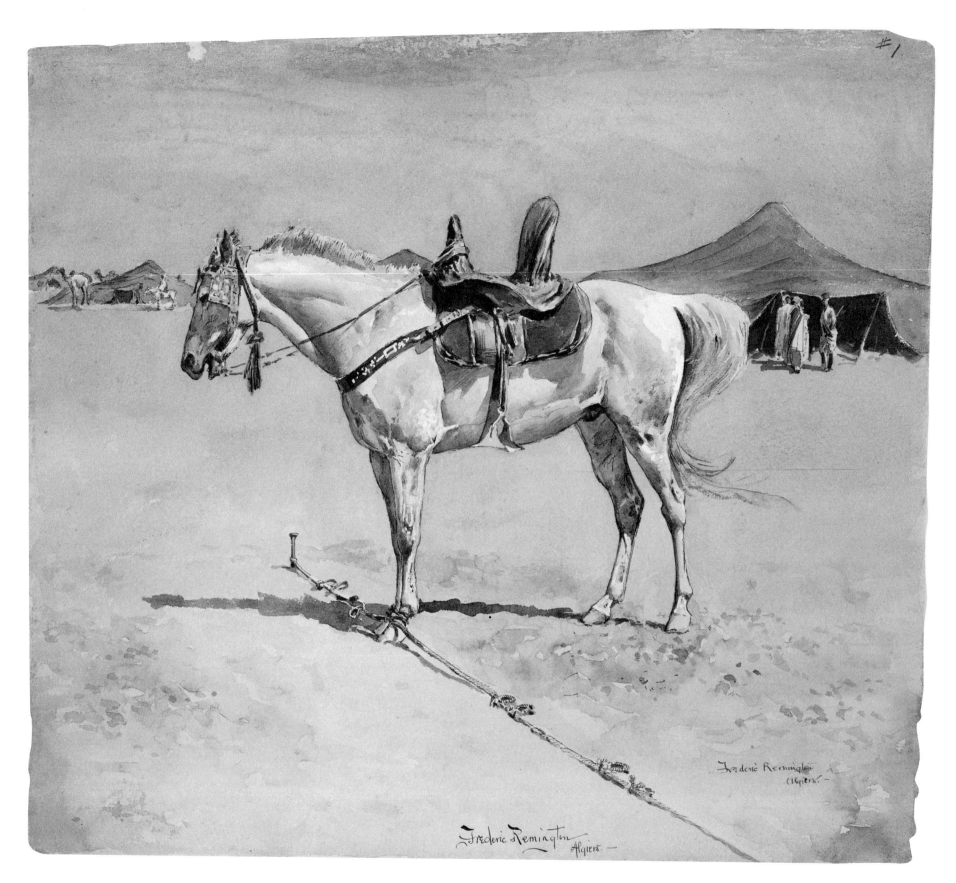

Arab Method of Picketing a Horse 1894
Ink wash on paper, 22 x 21" (55.9 x 53.3 cm.)
Signed lower right: FrЕderic Remington / Algiers.—
Signed bottom center: FrЕderic Remington / Algiers.—
Museum purchase, 1978; Ex-collection: Robert G. Butler, Hamilton, NY; FRAM 78.17, CR 1901

The Bicknell Rips Party early 1880s
Pencil on paper, 11½ x 8½" (29.2 x 21.6 cm.)
Inscribed lower left: The Bicknell Rips Party; below heads,upper left: Harding; upper right: Cleveland;
lower left: Gale.-Guide; lower right: Hale.
FRAM 66.317.14, CR 35b

Dan Dunn on His Works 1890–1891
Black and white wash drawing on paper, 15¼ x 8⅜ " (38.7 x 21.3 cm.). Signed lower left:—Remington—
Bequest of Miss Adelaide Emory, FRAM 99.3, CR 1170

The Old Tavern in the Valley 1893–1894
Ink wash on paper, 13⅝ x 17" (34.6 x 43.2 cm.)
Signed lower right: FrEderic Remington. / — West Virginia.
FRAM 66.79, CR 1861

A Foot-Bridge, West Virginia 1893–1894
Ink wash and gouache on paper, 14 x 17" (35.6 x 43.2 cm.)
Signed lower left: FrEderic Remington. / West Virginia.—
FRAM 66.79, CR 1855

High Finance at the Cross-Roads 1897
Ink wash on paper, 21¾ x 27¼" (55.3 x 69.2 cm.)
Signed lower left: —FrEderic Remington-
Museum purchase, 1946; FRAM 66.62, CR 2177

Among the unexpended arrows in Remington's quiver (to use Julian Ralph's image from 1891) were colorful types in addition to soldiers and Westerners. Remington might have vied with his friends Arthur B. Frost and Edward W. Kemble in illustrating rural types, for example, had he not already staked out his own lucrative claim. (Kemble paid him teasing tribute when he published some humorous Western sketches in 1891 and on the first crossed out "Reming" and signed his own name below.) But if Remington had become America's preeminent Western (and army) illustrator by the 1890s, his early interests covered a broader spectrum. When he lined up an exchange of drawings with another budding schoolboy artist in 1877, he was explicit about what he wanted: "Don't send me any more women or any more dudes. Send me Indians, cowboys, villains or toughs. These are what I want."[1] In his early career as an illustrator, Remington did his share of football players and working men. He could depict workers sympathetically—when he illustrated Hamlin Garland's "At the Brewery" in 1892, for example[2]—though he was without sympathy when it came to labor protesters. A collection of sketches he made in 1878 included four caricatures of "pugs" that he labeled

"Specimen Bricks of the Labor Movement," and when he covered violent strikes in Chicago in 1894 for *Harper's*, his sympathy was entirely with the soldiers sent in to control the situation. He typecast the strikers individually as foreign anarchists, and collectively as "the mob" (see p. 96).

(see p. 96).

Ironically, the Western types Remington had popularized—trappers, miners, even cowboys— were working men themselves. Kemble's sly take-offs on Remington's types made that very point: stripped of their heroic aura, they would fit squarely within the rustic tradition. The Remington drawing *Dan Dunn on His Works* makes this point. It illustrated an 1891 essay by Julian Ralph in which Dunn, general foreman on one section of a railroad under construction in British Columbia, was described as

over six feet in height, broad-chested, athletic, and carrying not an ounce of flesh that could be spared,… a striking figure even where physical strength was the most serviceable possession of every man. From never having given his personal appearance a thought… he had so accustomed himself to unrestraint that his habitual attitude was that of a long-bladed jack-knife not fully opened. His long spare arms swung limberly before a long spare body set

Edward W. Kemble *Trading with the Indians, Century Magazine* 43 (November 1891): 61

The Bicknell Rips Party early 1880s

Dan Dunn on His Works 1890–1891

Two North Country types
Bottom photograph by A. J. Runions, Canton, NY
FRAM 1918.76.160.19, 1918.76.160.18

*upon long spare legs. His costume… consisted of
a dust-coated slouch felt hat, which a dealer once
sold for black, of a flannel shirt, of homespun
trousers, of socks, and of heavy "brogans."
In all his dress was what the aesthetes of
Mr. Wilde's day might have aptly termed a
symphony in dust.*

Likely working from a photograph, Remington
depicted not the imposing, broad-chested, athletic
Dan Dunn, but the symphony in dust, suggesting
that the Westerner, viewed objectively, could be
considered just another rustic.[3]

Rustics (or "hicks") were popular fixtures
in the folklore of an urbanizing nation. Cracker-
barrel philosophers and their country cousins from
Maine to Georgia, or even from Upstate New York,
proved irresistible, and Remington let an occasional
arrow fly in their direction. His research files bulged
with photographs of soldiers and Mexicans and
Indians, of course, and also some rustic characters.
In 1892 he illustrated Irving Bacheller's poem
"The Rustic Dance" and showed among the folksy
types a big, raw-boned bumpkin with unruly hair
stomping out a jig.[4] Remington had honed his skills
on Adirondack hunting companions and guides in
sketches such as *The Bicknell Rips Party* (see also
pp. 34–40). Like his Westerners, he depicted them
as outdoorsmen, and thus admirable. At play, how-
ever, they were just country boys, bashful or oafish
depending on the situation.

Late in 1893 Remington set off with Julian
Ralph on a two-week hunting trip that took them
to West Virginia in search of deer and "relics of a
by-gone era." They got their fill of the rustic. Ralph
wrote up their experiences in an article titled
"Where Time Has Slumbered." Of the mountain
folk, he wrote that "to find them all so backward
and simple, all so tall and spare and angular, all
speaking so nearly the same dialect, all living in
cabins of nearly one pattern," was to erase a century
and encounter an old-time America "as simple
and genuine as fresh air." Remington kept busy
capturing the types—*The Circuit Rider*, *Mountain
Women*, *The United States Mail in the Mountains*, *A
Private Hunter*, *A Native Sportsman*, *Old Mountain
Type*. He also made wash drawings of some of the
local architecture, including *The Old Tavern in the
Valley* and *A Foot-Bridge, West Virginia*, in which
he adjusted his style to match the subject. His
treatment is uncharacteristically delicate, as befits
an arcadian idyll:

Specimen Bricks of the Labor Movement 1878
"Sketches of Highland Military Academy. / Fred. Remington /
Ogdensburg N.Y. / Cadet H.M.A." (1878)
FRAM 70.758.57

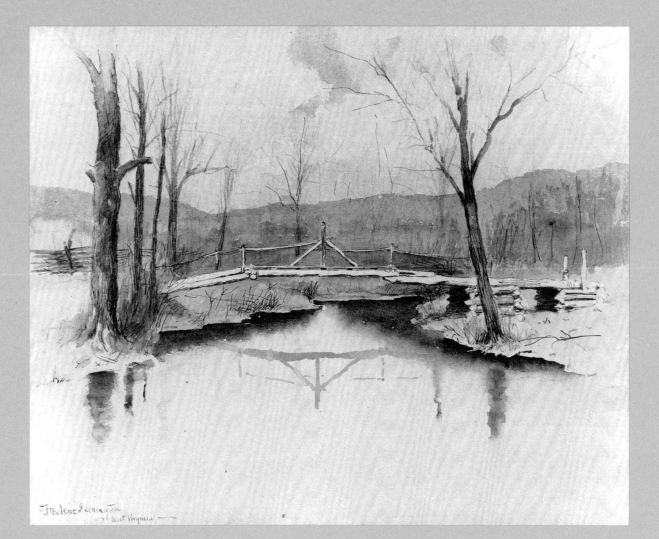

A Foot-Bridge, West Virginia 1893–1894
Ink wash and gouache on paper, 14 x 17" (35.6 x 43.2 cm.)
Signed lower left: FrEderic Remington. / West Virginia.—
FRAM 66.79, CR 1855

The Old Tavern in the Valley 1893–1894
Ink wash on paper, 13⅝ x 17" (34.6 x 43.2 cm.)
Signed lower right: FrEderic Remington. / — West Virginia.
FRAM 66.80, CR 1861

… the rule, over the entire mountain system, is for the horses and wagons to cross the streams by means of fords over "branches" and creeks that are floored with great thicknesses of shaley, flat, smooth stones. The pedestrians get over the streams by means of foot-bridges, some of which are mere tree trunks resting on cross-bucks, and some of which are quite ornamental though simple suspension-bridges, with certainly one hand-rail, if not two, beside the planking.

There was class consciousness in all this doting on common folk who still wore home-spun and lived in "picturesque little cabins" like "the founders of our republic."[5] Inevitably, there was the trace of a smirk and a touch of condescension. Rustics made for good stories around the mahogany table at a tony Manhattan club.

Still, there was genuine affection in some of Remington's rustic portrayals. *Grandfather Sackrider* is both a simple watercolor portrait of his maternal grandfather, Henry L. Sackrider, who died in 1895 about the time it was painted, and a homage to an ideal. Grandfather Sackrider, a Presbyterian elder in Canton known to his family as "The Deacon," commanded his irreverent grandson's devotion. "Now I always liked Grandpa and would do anything for him or let him do anything for me, but name a baby," Remington wrote in 1877. "He might name it after 'Obadiah, or Zacharias' which worthy gentlemen were passionately fond of attending church…"[6] Remington did not share his grandfather's religious zeal, but he did share his zealous loyalty to the Republican Party. Henry Sackrider's generation represented real Americanism to him. They might be as hopelessly out of date as Old Testament names, but they were the shrewd, small-town types who calculated and jaw-boned at every cross-roads gathering place in America—the very backbone of the Republic. In 1897, he paid them tribute in *High Finance at the Cross-Roads*. Though Remington boasted that his work in *Drawings* was "Away from the Kodac," this portrait gallery of rural types is closely based on at least one photograph.[7] Remington described the locale as Kansas when he exhibited *High Finance* in Boston that December, but the three figures on the right absorbing the lecture all appear in a snapshot made in front of Bush Shoe Store on Main Street in Canton, New York, about 1895.[8]

Grandfather Sackrider ca. 1890s
Watercolor on paper, 9 x 7" (22.9 x 17.8 cm.)
Unsigned. FRAM 66.278

John Morrow, Ben Bush and Dave O'Brien outside the Bush
Shoe Store, Main Street, Canton, NY, about 1895
Atwood Manley Collection

1. FR to Scott Turner, [1877], *Selected Letters*, p. 15.
2. Hamlin Garland, "At the Brewery," *Cosmopolitan* 13 (May 1892): 34–42.
3. Julian Ralph, "Dan Dunn's Outfit," *Harper's Monthly* 83 (November 1891): 887, 891.
4. Irving Bacheller, "The Rustic Dance," *Cosmopolitan* 12 (April 1892): 650–52; and see Marta Jackson, ed., *The Illustrations of Frederic Remington* (New York: Bounty Books, 1970), pp. 61–82, for a selection of his "people."
5. Julian Ralph, "Where Time Has Slumbered," *Harper's Monthly* 89 (September 1894): 613–29; and see FR to Poultney Bigelow, [late 1893], *Selected Letters*, p. 200.
6. FR to Robert Sackrider, November 13, [1877], *Selected Letters*, p. 16. Remington also did a profile sketch of *The Deacon* with reading glasses perched atop his hawk-nose, and a cigar instead of a pipe clenched between his teeth (ibid., p. 254); and an oil *Portrait of Deacon Sackrider* (ca. 1886), again a profile facing left (Atwood Manley and Margaret Manley Mangum, *Frederic Remington and the North Country* [New York: E. P. Dutton, 1988], picture section). For Henry Sackrider, see Peggy and Harold Samuels, *Frederic Remington: A Biography* (Garden City, NY: Doubleday & Company, 1982), pp. 7–8, 18.
7. FR to Owen Wister, [June 1896], *Selected Letters*, p. 217. The date should be 1897.
8. *Paintings and Drawings by Mr. Frederic Remington* (Boston: Hart & Watson, [1897]), #30; Atwood Manley, *Some of Frederic Remington's North Country Associations* (Ogdensburg: Northern New York Publishing Company, for Canton's Remington Centennial Observance, 1961), p. 42; and Manley and Mangum, *Frederic Remington and the North Country*, picture section.

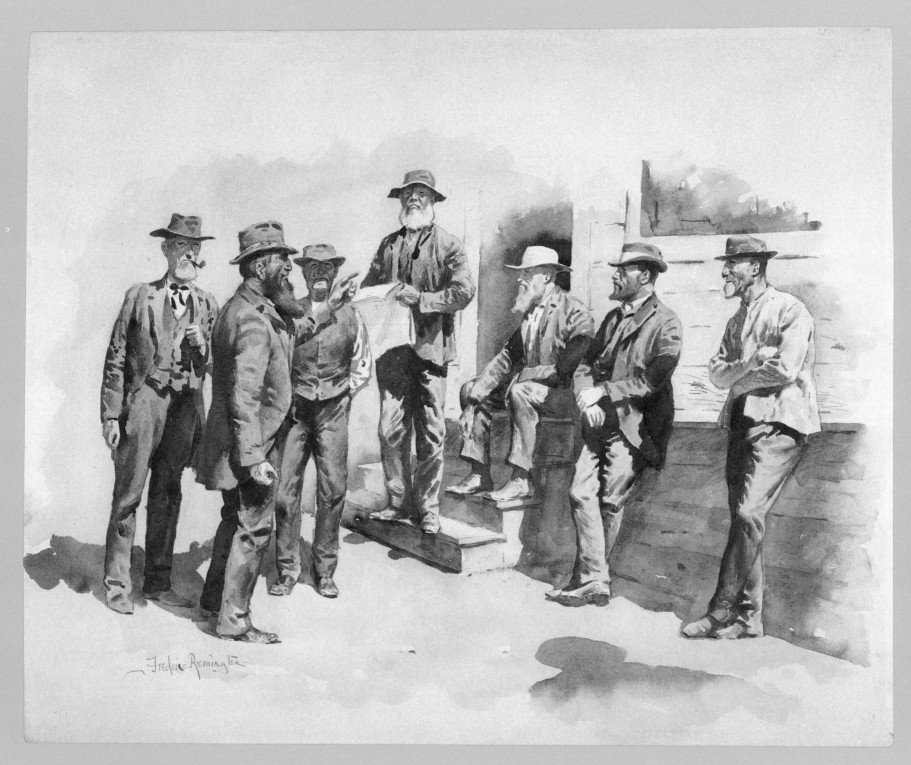

High Finance at the Cross-Roads 1897
Ink wash on paper, 21³/₄ x 27³/₄" (55.3 x 69.2 cm.)
Signed lower left: —FrEderic Remington-
Museum purchase, 1946; FRAM 66.62, CR 2177

On the Skirmish Line 1894

Ink wash on paper, 17 x 22" (43.2 x 55.9 cm.)
Signed lower right: FrEderic Remington.
FRAM 66.64, CR 1834

Illinois National Guards Picket in Streets of Chicago at Night 1894

Ink wash and gouache on paper, 17¹⁄₂ x 22" (44.5 x 55.9 cm.)
Signed lower left: FrEderic Remington / Chicago.—; lower right: Illinois national guards picket in the streets of Chicago at night.—
Museum purchase, 1982; Ex-collection: John W. Harper, New York; Mrs. John W. Harper, New York; Graham Gallery, New York; FRAM 82.1, CR 1839

In the early 1890s Remington was evidently ill at ease with his artistic progress. Western subject matter was in danger of drying up. There were no Indian wars to cover, and army routine could be made only so interesting to the lay reader in the absence of any prospect of military action. *On the Skirmish Line* accompanied a short essay he published in *Harper's Weekly* on July 7, 1894 describing the weekend maneuvers of a New York state cavalry troop. Remington tried to pep things up with an injection of his own enthusiasm ("I opine that the greatest and best thing in this world is a boy twenty-one years old who is in the cavalry."), but the topic was pretty dreary.[1] His trips abroad had not been especially encouraging, either—more soldiers drilling, more uniforms to show, but no battles in the offing. He could keep himself busy only if Western material continued to roll into the periodicals. He had badgered army friends to write up their reminiscences, had virtually ordered Owen Wister to keep churning out Western stories, throwing in suggestions for subjects to prime the Wister pump, and had become a prolific writer himself, all in the name of keeping himself employed. But his long-range prospects were not encouraging.

Consequently, Remington welcomed the violent labor strikes that broke out in Chicago in 1894 during a time of severe economic depression. They gave him a chance to vent his spleen over the "anarchistic foreign trash" that was ruining America, and for employment by *Harper's Weekly* as a special correspondent assigned to cover the army's activity in controlling the "scum."[2] "Just back from Chicago—mob and soldiers—hot stuff," he wrote Poultney Bigelow on July 27, 1894. "Got to have a big killing in this country.... You may have to come out here and help us lick the lice from Central Europe."[3] Bigelow and Owen Wister always brought out the worst in Remington. He shared their conservative views, and ranted freely in his letters to them. But he also believed what he said. His notebook

from Chicago recording his impressions at the time shows him entirely in sympathy with the soldiers. They represented law and order, the strikers, anarchy. He had heroes and villains—cowboys and Indians—once again, but his heroes in Chicago were tethered, and that worried Remington. Soldiers were meant to fight, not philosophize. It was detrimental to good order and discipline to restrain them from doing what they were trained to do:

> The U.S. regulars are spoiling for a fight literaly getting rotten & disorganized for lack of it. The mob has the moral[e] on them on account of it—thus showing that it is never good to appeal to force unless you mean to use it.—like a "tender-foot" hauling a gun when he does not intend to use it: The bluff dont go.—... This is civil war—right now and the President and those who are loyal to the govt. should do business on that basis.[4]

In his published reports on the strike, Remington played down his worries, played up the ease with which the soldiers scattered the "mob" when blow came to blow, and left an overall impression that things were in good hands.

His wash drawing *Illinois National Guards Picket in Streets of Chicago at Night*, published in *Harper's Weekly* for July 21, 1894, is typical of the work he did for the *Weekly*, and in line with the reports he chose to file. But his real desire found expression in a story he published in the *Weekly* the next year, "The Affair of the -th of July," setting up an imaginary scenario in which mob violence broke loose and anarchy reigned in America until the army waded in with seven-league boots and stomped out the revolution. Remington indulged such fantasies whenever actuality failed to satisfy him—when he reported on the war dreams of officers aboard ship awaiting decisive action in Cuba in 1898, for example. It was Remington's dream as well. In the end, Cuba would provide him all the reality he wanted.[5]

1. FR, "Troop A with the Dust On," *Harper's Weekly*, July 7, 1894; *Collected Writings*, p. 151.
2. FR, "Chicago Under the Mob," *Harper's Weekly*, July 21, 1894, and "Chicago Under the Law," *Harper's Weekly*, July 28, 1894; *Collected Writings*, pp. 152, 156. Remington reported the story entirely from the military perspective; see his Special Pass, Headquarters of U.S. Troops, Camp on Lake Front, Chicago, July 8, 1894, FRAM 96.8.10.
3. FR to Poultney Bigelow, July 27, 1894, *Selected Letters*, p. 212.
4. Sketchbook, FRAM 71.774.
5. FR, "The Affair of the -th of July," *Harper's Weekly*, February 2, 1895, and "The War Dreams," *Harper's Weekly*, May 7, 1898; *Collected Writings*, pp. 176–83, 301–03.

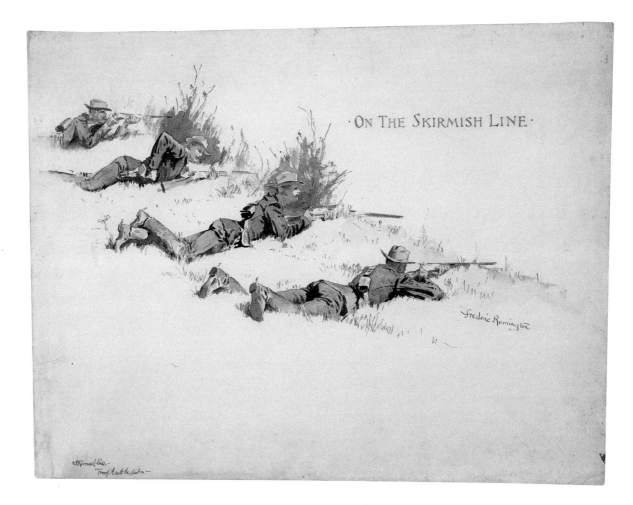

On the Skirmish Line 1894

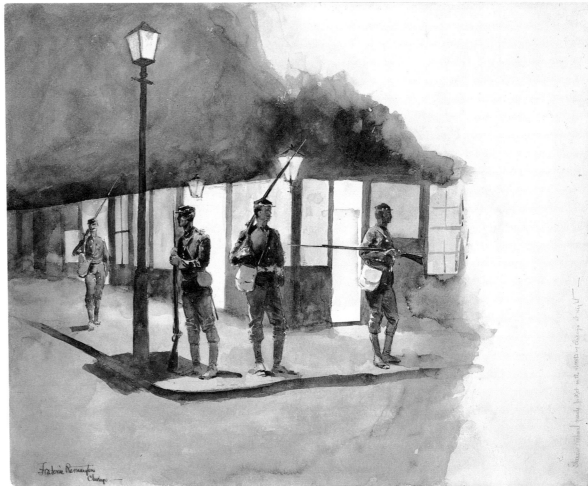

Illinois National Guards Picket in Streets of Chicago at Night 1894

Prospectors Making Frying-Pan Bread ca. 1893–1897

Black and white oil on canvas, 27 x 40" (68.6 x 101.6 cm.)
Signed lower left: Frederic RemingtoN- / to Santa Barbara Club;
inscribed on reverse: Prospectors Making Frying-Pan Bread.
Ex-collection: Santa Barbara Club, Santa Barbara, CA; Gift of Floyd and Libby Gottwald, 1991; FRAM 91.1, CR 1772

Frederic Remington was a consummate professional. He made his living as an illustrator, and took himself and his craft seriously. He was prolific, efficient, and hard-working. Not every illustration was a masterpiece, but he delivered the goods on time. In return, he expected and received top rates. He required that publishers return his originals, unmarked, for sale at the auctions he held in 1893 and 1895 and through the galleries that beginning in 1897 exhibited his work. Under exceptional circumstances he would make a gift of a painting to an officers' mess, his old alma mater, Yale (which awarded him an honorary degree), and, apparently, the Santa Barbara Club.[1] The Remingtons traveled to California in 1893 and again early in 1903.[2] Just when they incurred a debt to the Santa Barbara Club is unclear, but the oil painting inscribed to the club could have been done at any time in the 1890s. Likely the Remingtons were hosted at a luncheon or a dinner at the club, making the painting, which became known as *Meal Time*, an appropriate gift.

Remington's own title, *Prospectors Making Frying-Pan Bread*, is equally prosaic but more descriptive. A traveler in western Canada in 1880 recounted the procedure:

> *When making bread on the prairie, you may be said to work at a disadvantage, your apparatus being of the most limited kind. Of course we have a bag of flour and some baking powder; but now we must have a dish of some kind in which to mix them. A wash-bowl of granite ironware… does not seem just the thing to mix bread in. Fortunately, we have a spare tin dish, which, though small, will answer our purposes. Some flour, salt, and baking powder are thrown in, and sufficient water to reduce all to the proper consistency; and then we discover that we have no kneading-board. "Necessity," however, "is the mother of invention." The cart, standing near by, has a tail-board, which, though still in the rough, and not much improved by its passage through sundry sloughs and creeks, presents, nevertheless, a solid foundation. This board Sam [the cook] appropriates, and in a very few*

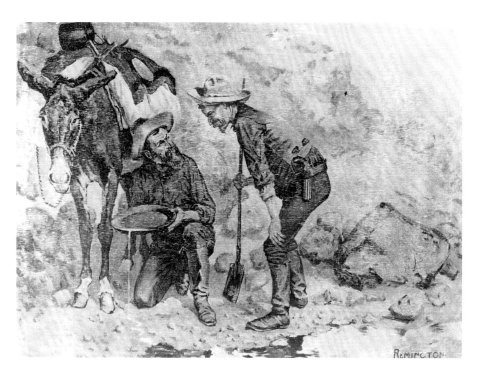

Miners Prospecting for Gold
John Muir, ed., *Picturesque California*
(San Francisco: The J. Dewing Publishing Company, 1888), facing page 236

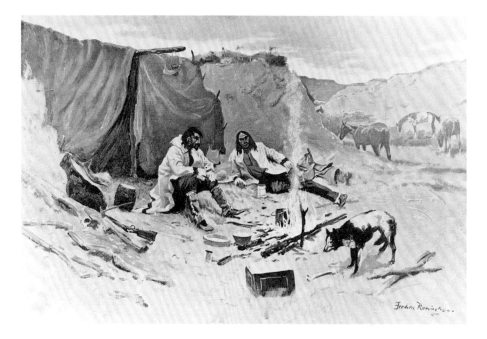

Half-Breed Horse Thieves of the Northwest
Frederic Remington, *Drawings* (New York: R. H. Russell 1897)

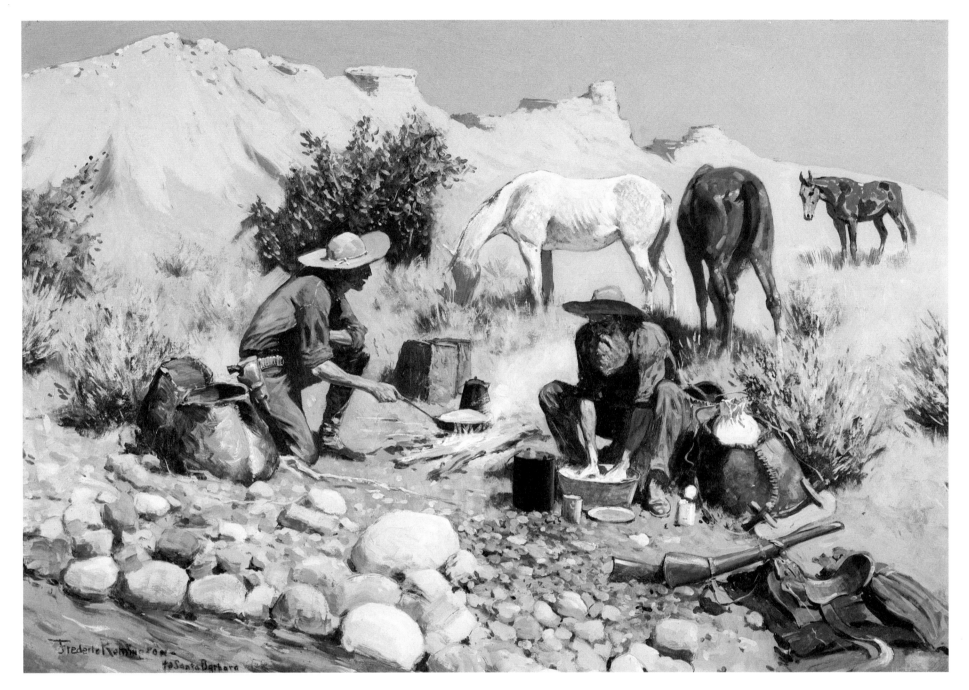

Prospectors Making Frying-Pan Bread ca. 1893–1897

minutes has his "bannocks" ready for the oven.
Alas! we have no oven; but no matter. Sam
seizes the frying-pan, throws in a bannock, tilts
the pan at an angle of seventy degrees, facing the
fire, rakes some glowing embers behind it, and in
a wonderfully short space of time we have some-
thing which, if it would hardly pass inspection
in a city bakery, is not to be despised by those
who sit down to supper with a prairie appetite.[3]

In Remington's painting there is a hint of danger in
the holstered revolver and the rifle at ready, but the
point seems to be that even tough Western hombres
had to eat.[4]

Prospectors Making Frying-Pan Bread is a
large-scale demonstration of Remington's skill in
black and white. The qualities that made him a
successful illustrator are all evident here: clean
line, strong contrast, crisp detail—the very qualities
he would labor to overcome in the process of
transforming himself into a pure artist. "*The thing* to
which I am going to devote two months is '*color*',"
he wrote Owen Wister in 1896 before departing on
a Western excursion: "I have studied *form* so much
that I never had a chance to '*let go*' and find if I can
see with *the wide open eyes of a child* what I know
has been pounded into me I *had* to know it—now I
am going to see."[5] *Prospectors Making Frying-Pan
Bread* may have been painted about this time. The
general composition, with the background rising to
the left and one figure shown face on, the other in
profile, is reminiscent of an 1888 illustration *Miners
Prospecting for Gold*. But the modeling of the figures
and the attention to setting (and, for that matter,
the signature) are suggestive of some of the paint-
ings Remington produced for his 1897 book *Draw-
ings*—*The Sheep Herder's Breakfast*, *The Gold Bug* and,
particularly, *Half-Breed Horse Thieves of the Northwest*,
where two men loll by a campfire with a rifle at
ready, for good reason.

1. See A. K. Arnold to FR, September 11, 1894 (Resolution
of thanks, Officers Club, First U.S. Cavalry, Fort Grant,
Arizona); W. Lacy Kenly to FR, December 28, 1898 (for
Officers Club, Jefferson Barracks, Missouri); John F. Weir
to FR, July 15, 1900 (for Yale University School of the Fine
Arts); and H. R. Scott to FR, February 27, 1907, (for the
U. S. Military Academy, West Point), and A. S. Bottoms,
March 7, 1907 (for the West Point Army Mess) all FRAM.
Remington also made exchanges with other artists, includ-
ing Howard Pyle and Homer Davenport.

2. For the 1893 visit to California, see Peggy and Harold
Samuels, *Frederic Remington: A Biography* (Garden City, NY:
Doubleday & Company, 1982), p. 181; and for the 1903
visit, Eva Remington, "A Snow-Shoe Trip to California in
Winter of 1903" (photograph album, FRAM 71.834).

3. A. Sutherland, *A Summer in Prairie-land: Notes of a Tour
through the North-West Territory* (Toronto: Methodist Book
and Publishing House, 1881), pp. 174–75.

4. Reproduced on the cover of the periodical *Northwestern
Miller* (date unknown), Remington's painting was intended
to illustrate the use of flour in a rugged Western setting.
As Randolph Edgar (Preface to *The Miller's Holiday: Short
Stories from The Northwestern Miller* [Minneapolis: Miller
Publishing Company, 1920]) noted: "The Holiday
Numbers of The Northwestern Miller were published at
twelve Christmas seasons between 1883 and 1904, the
intervals between these special issues being irregular.
Unprecedented and never imitated in trade-journalism,
The Northwestern Miller secured for the exclusive use
of its columns the merited work of the best writers and
illustrators of the day." Remington was a case in point.

5. FR to Owen Wister, [before February 1, 1896], *Selected
Letters*, pp. 280–81.

Opposite page, detail:
Prospectors Making Frying-Pan Bread
ca. 1893–1897

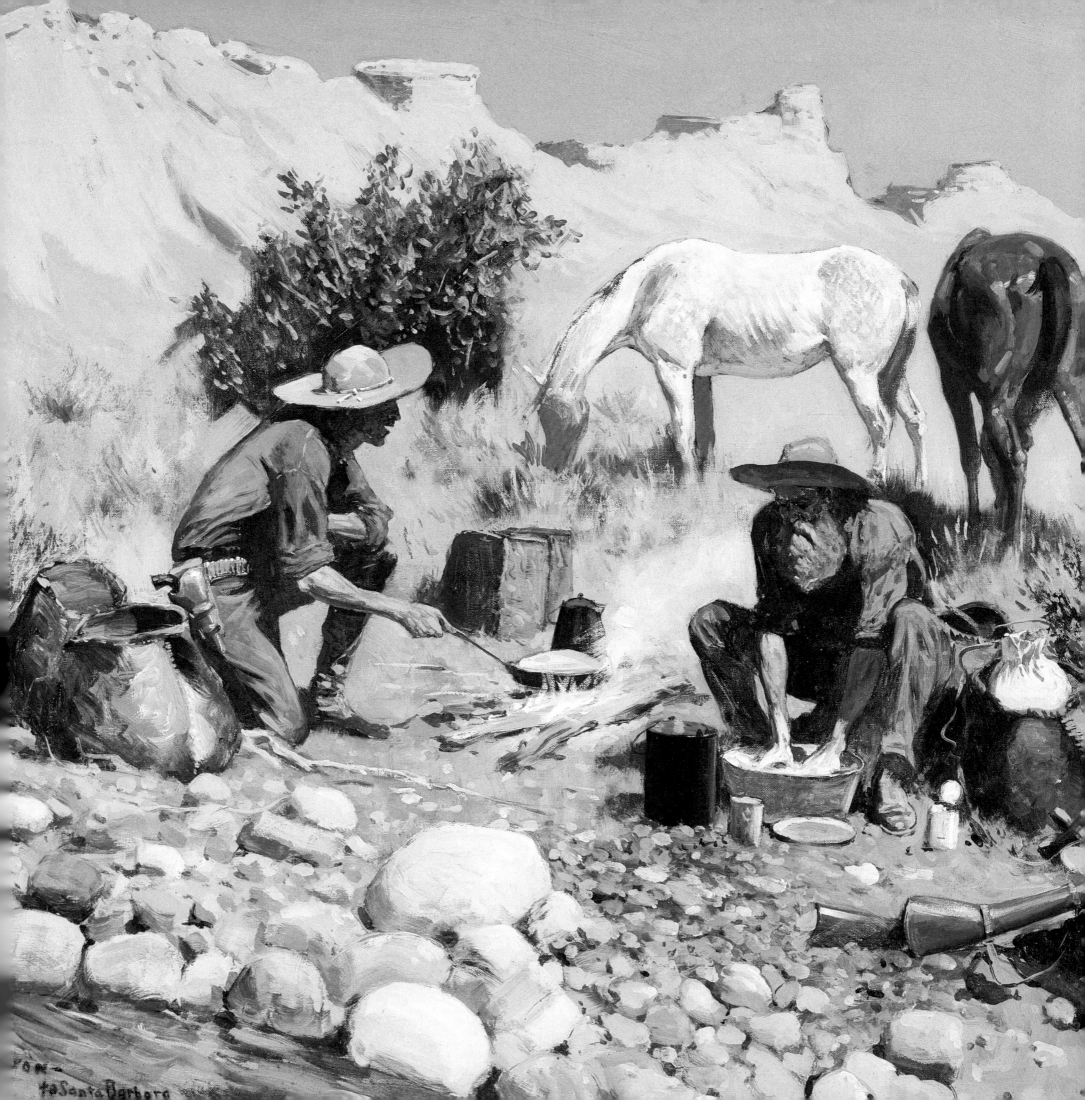

The Meeting with the United States Cavalry 1895
Ink wash and gouache on paper, 18 x 29" (45.7 x 73.7 cm.)
Signed lower left: —FrEderic Remington.—
Museum purchase, 1947; FRAM 66.67, CR 1982

Then He Grunted, and Left the Room 1894
Ink wash and gouache on paper, 21⅛ x 21¾" (53.7 x 55.3 cm.)
Signed lower right: FrEderic Remington—
Museum purchase, 1948; FRAM 66.63, CR 1821

It was a central irony of Remington's career that he commanded higher payment than the writers he illustrated, but his drawings were necessarily subservient to their words. Illustration was least agreeable when it bound him most tightly to someone else's ideas—a Poultney Bigelow essay brought the criticism that it was "d— abstract."[1] In fiction, the author created characters and situations and the illustrator attempted to give them visual form. Remington could always fall back on his familiar types for the characters, but the author's contrived situations were another matter. Plot requirements dictated the illustrations in, for example, *The Meeting with the United States Cavalry*, which illustrated Dan De Quille's "An Indian Story of the Sierra Madre" in the June 1895 *Cosmopolitan*. Three American prospectors outwit and kill five Apaches and decide to fool their tribesmen by masquerading as Apaches. "They were all soon clean-shaven," De Quille wrote, "and, having made a decoction of two or three kinds of bark, they stained their hands and faces a good and durable Apache color. When they had donned their Indian dress, they would have passed in any frontier town as genuine braves."[2] Their adventure ended with the welcome arrival of a U.S. Cavalry detachment, and it was this meeting Remington chose to depict. He produced a crisp study of horses and riders (a grouping he would utilize to generic ends two years later in *The Borderland of the Other Tribe*); but, perhaps impatient with the necessity of observing plot contrivances, forgot that the prospectors were supposed to be clean-shaven and dark-skinned.

Such assignments suggest why Remington, who saw himself as an artist, found illustration increasingly distasteful. But he liked the comforts his success had brought him, and that meant continuing to illustrate and, more to the point, assuring that there were assignments suitable to his talents. Thus he formed mutually beneficial partnerships with Julian Ralph and Poultney Bigelow and (he hoped) Powhatan Clarke. Their

The Borderland of the Other Tribe
Frederic Remington, *Drawings* (New York: R. H. Russell, 1897)

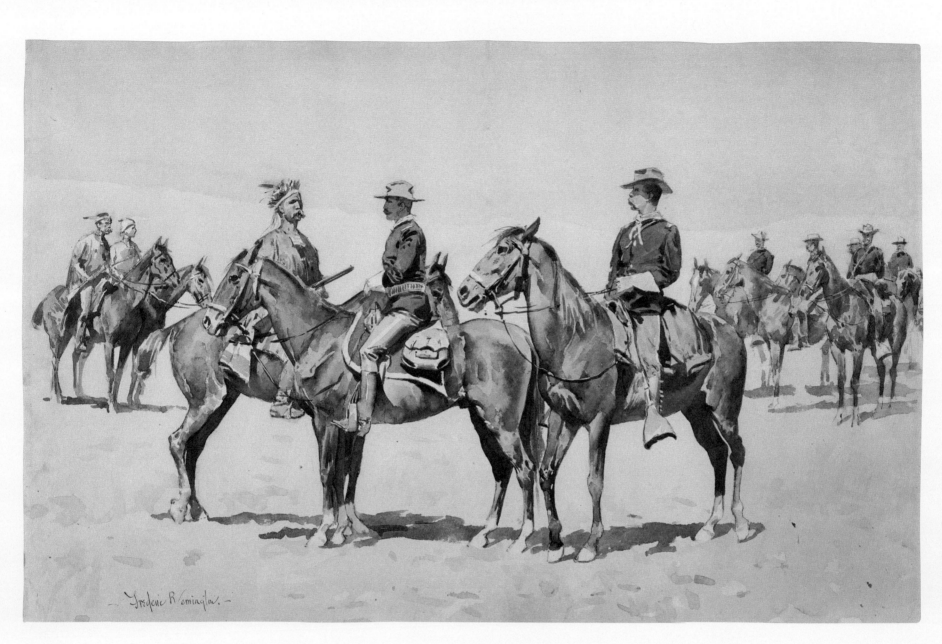

The Meeting with the United States Cavalry 1895

job was to produce copy that he could illustrate. (He took up writing himself, he claimed, in order to ensure a continuing demand for his illustrative services, and not for the paltry sums his stories and novels commanded.) But in the early 1890s Remington was in need of a writer-collaborator who saw what he saw in the West—the death throes of a great American epic. He found his man in Owen Wister, a Harvard-educated Philadelphia lawyer (and a friend of Theodore Roosevelt) who first journeyed to Wyoming in 1885 to escape the insufferable boredom of an uncongenial profession. Wister gloried in his new-found freedom. Social constraints went out the window, and Philadelphia (like Parkman's Fort Laramie in recollection) faded into improbability: "This life has a psychological effect on you," he wrote his domineering mother. "To ride 20 miles and see no chance of seeing human traces; to get up on a mountain and overlook any number of square miles… and never a column of smoke or a sound except the immediate grasshoppers….

Portrait of Owen Wister
FRAM 1918.76.157.35

You begin to wonder if there is such a place as Philadelphia anywhere."[3] The West was in Wister's blood, and he returned to Wyoming most summers. He first put his experiences into fiction in 1892, and the next year, on a cold September day in Yellowstone Park, met the man *Harper's* had already chosen as his illustrator. Remington and Wister hit it off immediately. "Remington is an excellent American," Wister noted in his journal: "that means he thinks as I do about the disgrace of our politics and the present asphyxiation of all real love of country." For both men, the West was literally a breath of fresh air that would reinvigorate an America rapidly becoming "merely a strip of land on which a crowd is struggling for riches."[4] Wister remained one of those Remington privileged with his diatribes on immigrants, labor protesters, and the other undesirable "rats" infesting America, and Wister echoed them in patrician prose. In an essay on the evolution of the cowboy that Remington virtually commissioned him to write— urging him on, cajoling him, suggesting ideas, anything to get it written so that he could "make some pictures of the ponies going over the hell

roaring mal-pai [badlands] after a steer on the jump"[5]—Wister advanced his thesis that the cowboy represented the *real* American, and the West the last bastion of the pure Anglo-Saxon ideal that, to the nation's detriment, was being crowded out in the East's teeming cities.[6]

These attitudes informed all of Wister's writing about the West. In his story "A Kinsman of Red Cloud," published in *Harper's Monthly* for May 1894, he told of a man named Toussaint, "by a French trapper from Canada out of a Sioux squaw, one of Red Cloud's sisters," whose "heart beat hot with the evil of two races, and none of their good." Wister may have named the mixed-blood Toussaint as a mocking reference to Toussaint L'Ouverture, the mulatto who led the slaves to freedom in the bloody Haitian uprising of the 1790s. *Then He Grunted, and Left the Room* illustrated the story's climactic scene. Hunted down and wounded outside Fort Robinson, and facing the death penalty as a murderer, Toussaint hoped his brother-in-law would rescue him from the white man's justice. With the scout who shot him standing at the foot of the bed and an officer and ambulance-boy in attendance, Toussaint pled his case to Red Cloud. But his "mongrel strain of blood" got the best of him, and he

> *poured out a chattering appeal, while Red Cloud… waited till it had spent itself. Then he grunted, and left the room. He had not spoken….*
>
> *Red Cloud came back to the officers, and in their presence formally spoke to his interpreter, who delivered the message: "Red Cloud says Toussaint heap no good. No Injun, anyhow. He not want him. White man hunt pretty hard for him. Can keep him."*

And so the Indian renders Wister's own judgment on race-mixing. Remington passed on portraying Red Cloud's distinctive features, which were well recorded, but did suggest the ceremonial outfit and long feather bonnet the Oglala chief wore on a visit to the President in 1870.[7]

Opposite page:
Then He Grunted, and Left the Room 1894
Ink wash and gouache on paper
21⅛ x 21¾" (53.7 x 55.3 cm.)
Signed lower right: Frederic Remington—
FRAM 66.63, CR 1821

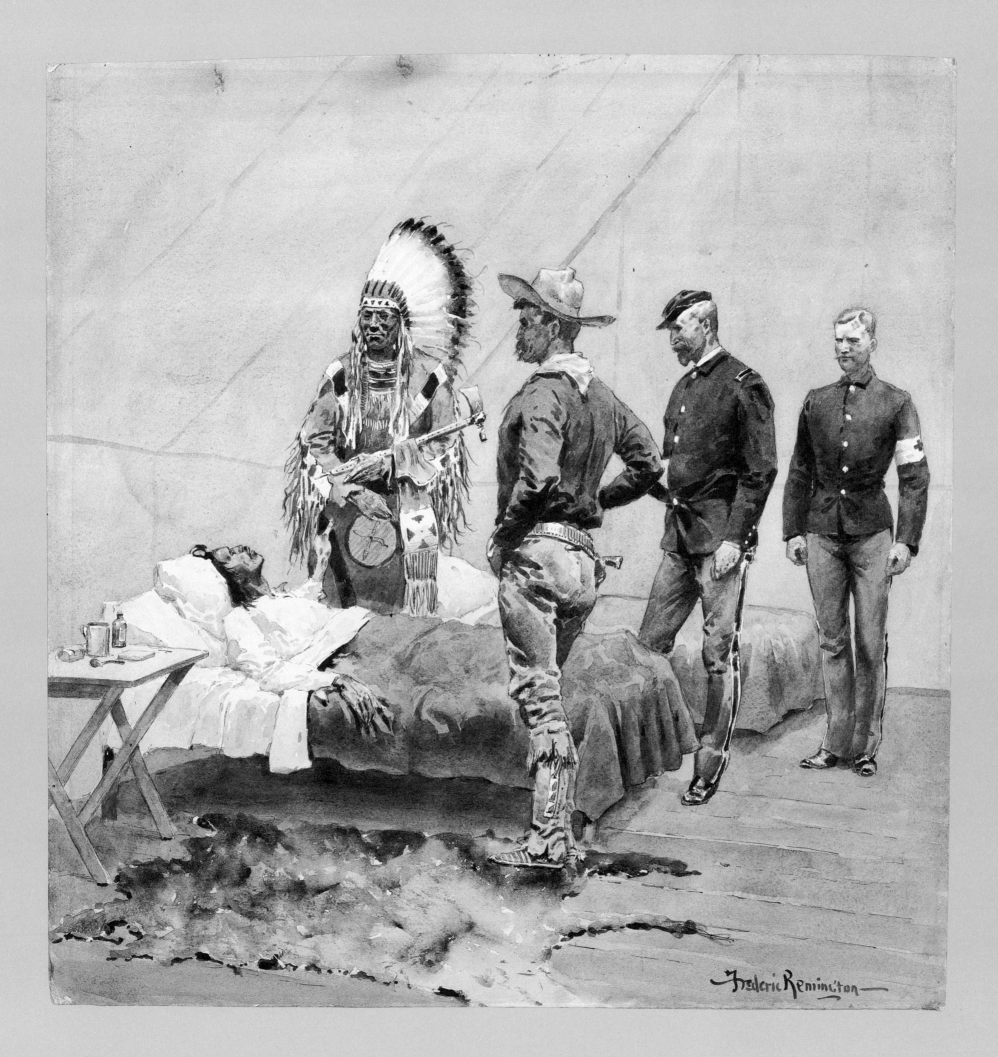

Remington and Wister collaborated on eleven pieces for *Harper's Monthly* in 1894–1895, and thereafter occasionally obliged one another with illustrations or a prose puff. But they were never again a close "team," as Wister called them in 1895.[8] Ego entered into it, and competing agendas. Remington made it increasingly clear that he did not consider illustration his higher destiny, and could be churlish about his role. "I am meanwhile tussling with your d— subjectives in '*The Game and the Nation*,'" he complained on September 1, 1899. "You get harder all the while for the plastic man."[9] Another story he returned to Wister "because it dont need illustration—its all there—I wouldn't care to interfere."[10] Wister, in turn, tired of providing introductory tributes to Remington's published portfolios, and complained to his mother in 1902, "I am doing some doggerel for an album of Remington's pictures…. He is the most uneven artist I know, which you find out very much when you come to extract verse from each drawing. Some are full of meaning and some empty as old cartridges."[11] But they both were aware of what their collaboration had meant to one another—and to the creation of a particular version of the American West. In the jocular tone he often assumed when addressing Wister, Remington in 1899 remarked, "You are the only 'good thing' that ever came my way."[12] And after the artist's death, Wister wrote his widow: "I think I did understand Remington's inspiration & purpose very intimately—& I felt his loss very deeply, as a national one—being thankful that he had done so much."[13]

1. FR to Poultney Bigelow, [May 1893], *Selected Letters*, p. 171.
2. Dan De Quille [William Wright], "An Indian Story of the Sierra Madre," *Cosmopolitan* 19 (June 1895): 189.
3. Quoted in G. Edward White, *The Eastern Establishment and the Western Experience: The West of Frederic Remington, Theodore Roosevelt, and Owen Wister* (New Haven: Yale University Press, 1968), p. 123.
4. Owen Wister, Journal, September 8, 1893, in Fanny Kemble Wister, ed., *Owen Wister Out West: His Journals and Letters* (Chicago: University of Chicago Press, 1958), pp. 181–82.
5. FR to Owen Wister, [October 1894], and passim., *Selected Letters*, pp. 255–66, 271, 274–75.
6. Owen Wister, "The Evolution of the Cow-puncher," *Harper's Monthly* 91 (September 1895): 602–17.
7. Owen Wister, "A Kinsman of Red Cloud," *Harper's Monthly* 88 (May 1894): 909, 917. Remington's photographic files included a portrait of Red Cloud made a few years later, in 1898; but he would have seen earlier images of the often-photographed chief.
8. Owen Wister to FR, October 26, 1895, *Selected Letters*, p. 276.
9. FR to Owen Wister, September 1, 1899, *Selected Letters*, p. 233.
10. FR to Owen Wister, [late August 1902], *Selected Letters*, p. 302.
11. Owen Wister to Sarah B. Wister, August 2, 1902, quoted in Ben Merchant Vorpahl, *My Dear Wister—: The Frederic Remington-Owen Wister Letters* (Palo Alto: The American West Publishing Company, 1972), p. 309. Earlier, Wister had provided commentaries for *Drawings* (New York: R. H. Russell, 1897) and *A Bunch of Buckskins* (New York: R. H. Russell, 1901); his irritation with the task of introducing and poetically interpreting the pictures in *Done in the Open* (New York: P. F. Collier & Sons, 1902) is evident from *Selected Letters*, pp. 299–304. Remington was too busy in 1902 to illustrate for Wister—and Wister was just finishing his novel *The Virginian*. It became a publishing sensation that year and put him, in terms of importance as an interpreter of the West, on an equal plane with Remington. When Wister's publisher decided to issue an illustrated edition in 1911, two years after the artist's death, ten Remington illustrations were used as embellishments. They were not directly related to the story (Charles M. Russell was contracted to provide textual illustrations), but were purposely intended as a tribute to a partnership that had permanently shaped public perceptions of the West. "I hope the book will be such as Mr. Remington would have approved," Edward C. Marsh wrote Eva Remington, "and it is certainly fitting that Mr. Wister's book should at last have this association with some of Mr. Remington's work." (April 11, 1911, FRAM 96.8.1.)
12. FR to Owen Wister, [December 1899], in Vorpahl, *My Dear Wister—*, p. 282.
13. Owen Wister to Eva Remington, April 18, 1910, FRAM 96.8.5.

Opposite page, detail:
The Meeting with the United States Cavalry 1895

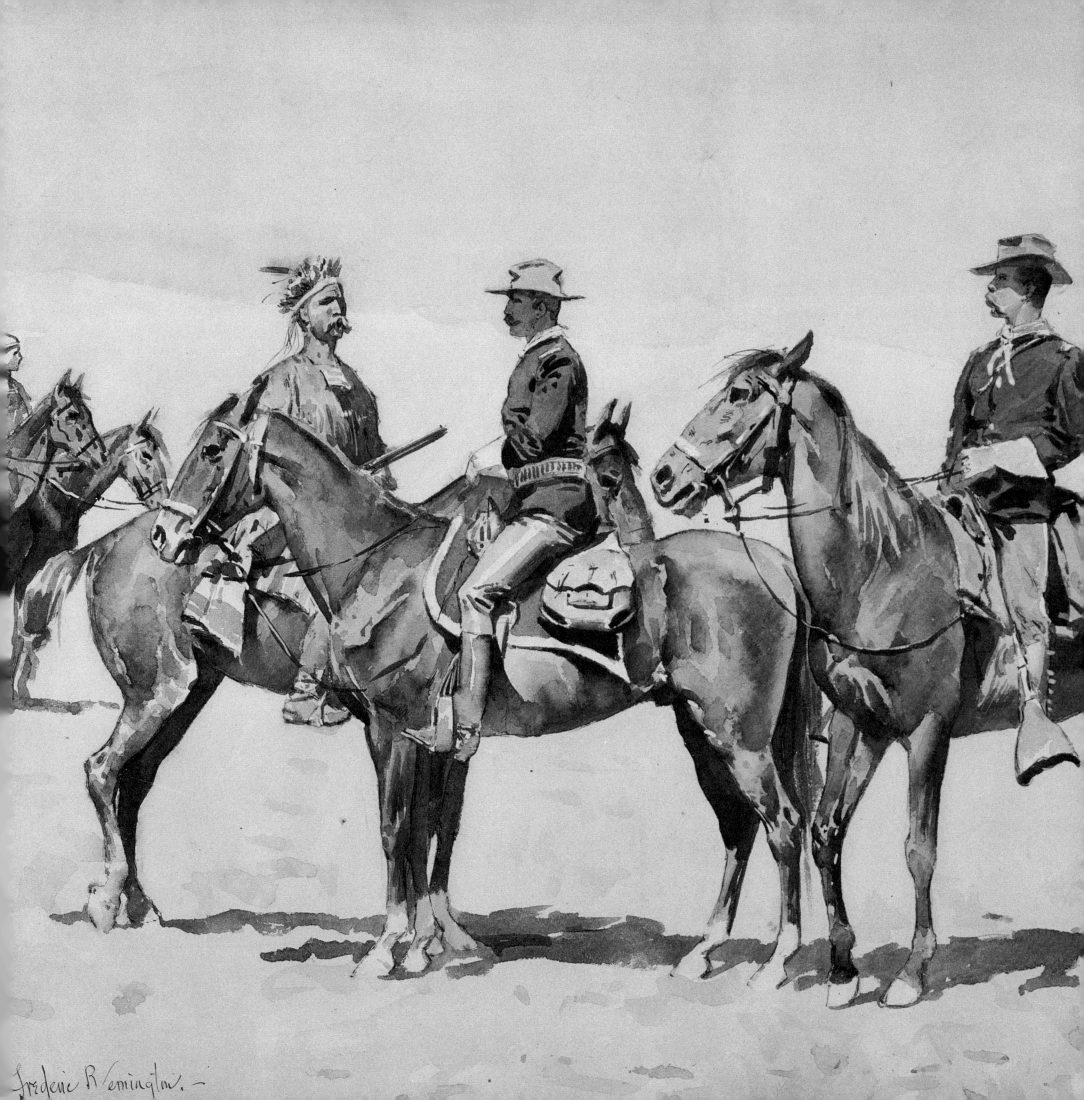

Frederic Remington.

Recent Uprising among the Bannock Indians—A Hunting Party Fording the Snake River Southwest of the Three Tetons (Mountains) 1895

Ink wash on paper, 21 x 28½" (53.3 x 72.4 cm.)
Signed lower right: FrEderic Remington.—
Donated by Mr. and Mrs. Donald Leary, Manteo, NC; FRAM 86.5, CR 1999

Banff, Cascade Mountain ca. 1890

Oil on academy board, 30 x 18" (76.2 x 45.7 cm.)
Unsigned
FRAM 66.41, CR 987

Mountains, to those who love them, are as individual as people. They have distinct personalities, a fact known to Remington, who collected photographs of their likenesses even though he ordinarily portrayed a Southwestern landscape where the issue never arose. But when he set his scenes in the Northwest, mountains often figured into the calculation. On an excursion that took him to Banff, Alberta, in 1890, he painted Cascade Mountain, which towers over the town. (He bought a photograph of it that shows how he stretched and tapered it, just as he did people, in painting its portrait.[1]) An illustration like *Recent Uprising among the Bannock Indians—A Hunting Party Fording the Snake River Southwest of the Three Tetons (Mountains)* featured the distinctive peaks that established place, leaving Remington free to deal with the temporal activity at which he excelled. Much of his early work downplayed identifiable landmarks. He preferred a flat surface—desert, plains—as a stage for violent action where nothing interfered with his focus on the human drama, though in 1892 he wrote Francis Parkman that one of his illustrations for *The Oregon Trail* aspired to something more: "I have made one picture which I call the 'Mountains.' It has the Indians coming down the defile. I did [it] for variety—a landscape—it foils the figures of which I am too fond."[2]

In *Recent Uprising among the Bannock Indians*, Remington combined his fondness for figures with a salute to the celebrated landscape of Jackson Hole. Indian disturbances were passé by 1895, but the Bannocks had been restive that summer, and *Harper's Weekly* called on Remington for an illustration. The so-called "Jackson Hole War" was a sad affair. The Bannock and Shoshone Indians at Fort Hall Reservation in southern Idaho enjoyed the right by treaty to hunt on unoccupied federal lands. On July 15 a posse formed at the instigation of local white guides arrested nine

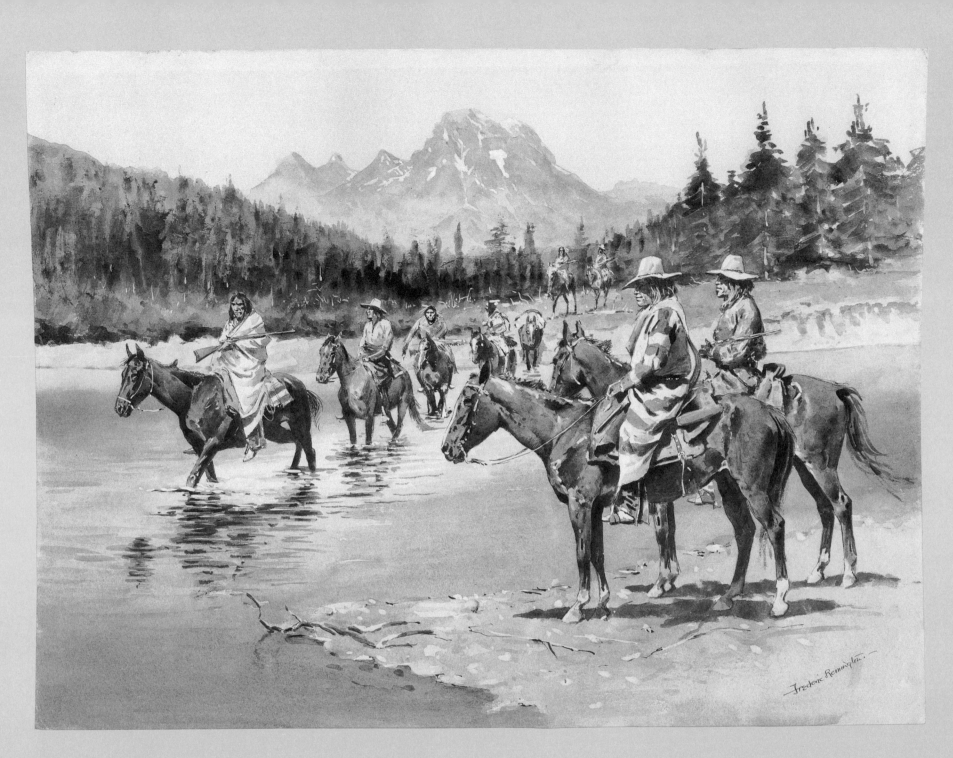

Recent Uprising among the Bannock Indians—A Hunting Party
Fording the Snake River Southwest of the Three Tetons (Mountains) 1895

Bannocks hunting elk in the Jackson Hole area. One of the Bannocks was killed in an escape attempt purposely precipitated by the posse, while the others fled back to their agency. Threats of retaliation brought in the troops. The "war," historian Brigham D. Madsen writes, was "taken up with gusto by the eastern press, which had not had the pleasure of covering an Indian outbreak for some years."[3] Predictably, the affair ended in court with the whites unpunished and the Indians losing their hunting rights. Remington's illustration is a calculated combination of the specific (he owned a print of an F. Jay Haynes photograph of the Tetons) and the generic (one Indian sports a blanket and hat reminiscent of a William H. Jackson photograph of Shoshones, but the others are nondescript).[4] His most arresting touch is the number in the group— eight Indians and a packhorse, suggesting a hunting party of nine depleted by one death. Brandishing their rifles, they appear to be more menacing aggressors than unoffending victims. Remington had not forgotten the politics of Indian wars coverage.[5]

1. See FR to Powhatan Clarke, January 9, August 7, 1890, and Eva Remington to Clarke, September 13, 1890, *Selected Letters*, pp. 87, 97, 101, for reports (Eva was along) of the cross-Canada trip.

2. FR to Francis Parkman, February 24, 1892, in Wilbur R. Jacobs, ed., *Letters of Francis Parkman*, 2 vols. (Norman: University of Oklahoma Press, in co-operation with The Massachusetts Historical Society, 1960), II, p. 257.

3. Brigham D. Madsen, *The Northern Shoshone* (Caldwell, ID: The Caxton Printers, 1980), p. 137. Madsen offers a thorough discussion of the entire affair.

4. See ibid., pp. 67, 84.

5. The illustration was reproduced in *Harper's Weekly*, August 10, 1895, p. 749.

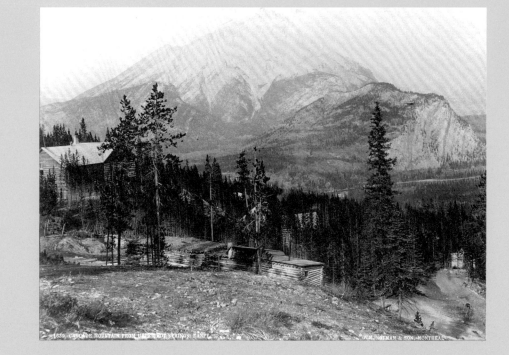

Cascade Mountain from Upper Hot Springs, Banff
Photograph by Wm. Notman & Son, Montreal;
FRAM 1918.76.160.99

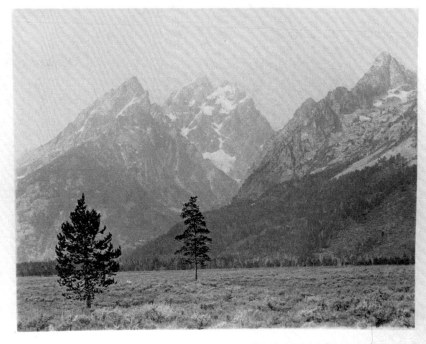

Teton Mountains
Photograph by F. Jay Haynes, St. Paul, MN
FRAM 1918.76.160.111

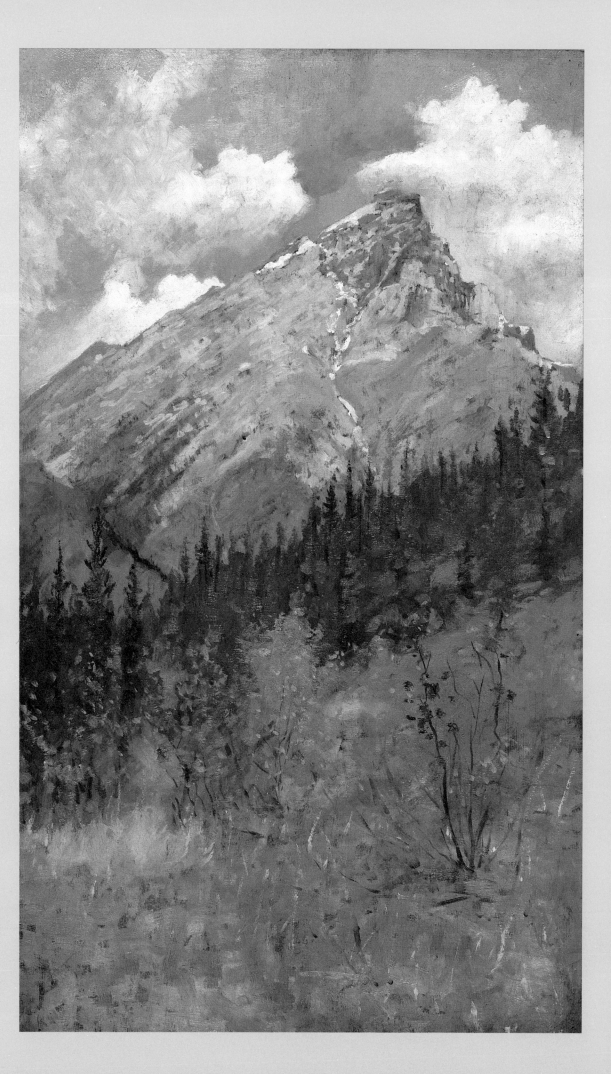

Banff, Cascade Mountain ca. 1890
Oil on academy board, 30 x 18" (76.2 x 45.7 cm.).
Unsigned
FRAM 66.41, CR 987

The Broncho Buster © October 1, 1895

The Henry-Bonnard Bronze Company cast no. 23 (1896) 23⁷/₈ H x 20⁷/₁₆ W x 10⁷/₁₆" D (59.5 H x 51.9 W x 26.5 D cm.)
Museum purchase, 1990; Ex-collection: Lindsey & Company, Philadelphia, PA; FRAM 90.7

W hen Remington was at his acme as an illustrator, he knew he worked mostly in black and white at a price. Illustration cost him his color sense. He would cultivate it in the twentieth century by repudiating illustration and making himself over into a painter. But first he discovered a different release from the monochromatic prison of illustration: the joy of modeling.

In the fall of 1894, the story goes, Remington wandered over to his New Rochelle neighbor Augustus Thomas's house and watched entranced as Thomas's guest, the established sculptor Frederick W. Ruckstull, worked on a fourth-sized model for an equestrian monument. Each afternoon Remington returned to see Ruckstull's progress. Subsequently, Thomas looked on while Remington mapped out an illustration, effortlessly repositioning a figure for storytelling effect. "Fred, you're not a draftsman; you're a sculptor," Thomas remarked. "You saw all round that fellow, and could have put him anywhere you wanted him. They call that the sculptor's degree of vision."[1] Remington dismissed Thomas's observation with a laugh, but was intrigued by the notion and, with Ruckstull as well encouraging him, began an equestrian model of his own—though an equestrian with a difference. Remington had always been impressed by the feisty nature of the Western bronco. "Every one knows that he 'bucks,' and familiarity with that characteristic never breeds contempt," he observed in 1889:

> *Only those who have ridden a bronco the first time it was saddled, or have lived through a railroad accident, can form any conception of the solemnity of such experiences. Few Eastern people appreciate the sky-rocket bounds, and grunts, and stiff-legged striking....*[2]

For his first model, he would sculpt a bucking bronco.

Modeling gave scope to Remington's skill at form and contour while challenging him with the perplexing problem of volume and a world of technical complexities to master. Remington approached the challenge directly, learning as he went along and crowing over his success. "I am

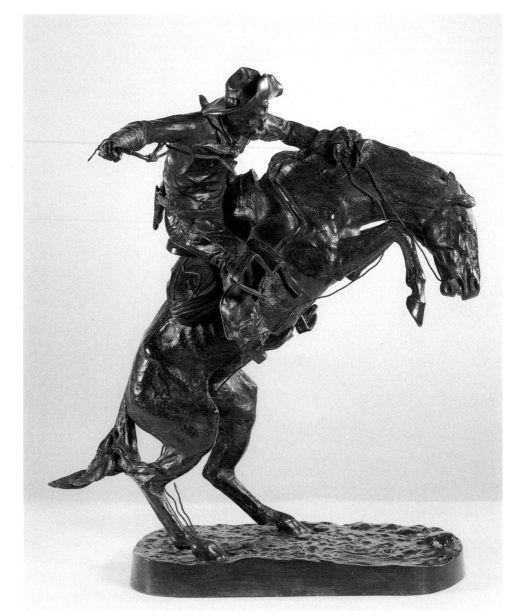

The Broncho Buster © October 1, 1895
Roman Bronze Works cast no. 275 (ca. 1918–1919)
22¹/₈ H x 21¹/₄ W x 10¹/₄" D (56.2 H x 60 W x 26 D cm.)
Estate casting according to Eva Remington's will; FRAM 66.6

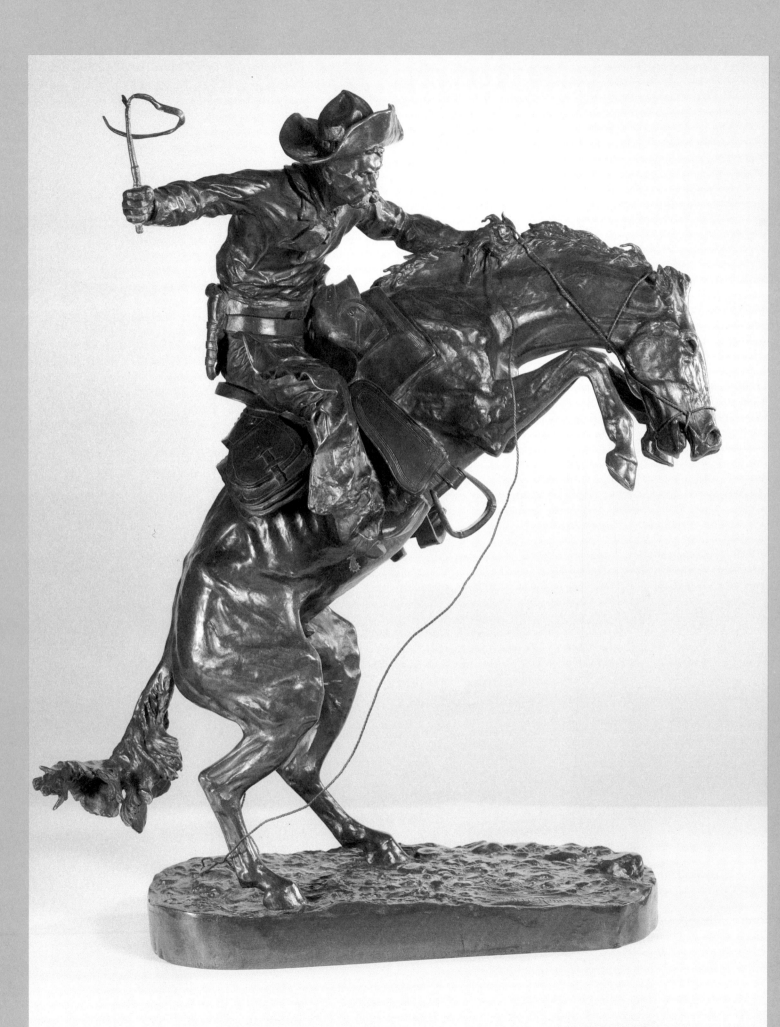

The Broncho Buster © October 1, 1895
The Henry-Bonnard Bronze Company,
cast no. 23 (1896)

modeling," he informed Owen Wister in January 1895:

—I find I do well—I am doing a cow boy on a bucking broncho and I am going to rattle down through all the ages….

I have simply been fooling my time away— I can't tell a red blanket from a grey overcoat for color but when you get right down to facts— and thats what you have got to sure establish when you monkey with the plastic clay, I am there—therere in double leaded type—[3]

In his major oil paintings of riders on bucking horses—for example, *Turn Him Loose, Bill!* (ca. 1893) and *Blandy* (ca. 1900)—Remington established a context for the action and showed other cowboys looking on.[4] In making illustrations, however, he routinely lifted figures from their settings. It was part of his reworking of photographs, whose reality was too all-encompassing for effective reproduction, where the rule of thumb was ever simplicity, clarity, and contrast. Sculpting for him was a similar process of paring away the nonessential.

Lieutenant Alvin R. Sydenham, an officer who first met Remington while he was covering the Ghost Dance war for *Harper's* in 1890, likely had his portraits of Lieutenant Edward W. Casey (p. 77) and others in mind when he observed:

One thing peculiar to his drawings is the absence of detail of background. The figures stand out upon the page, and the eye is not distracted by painfully wrought foliage and blunt cliffs. Only the figure fills the eye; the background is open, dim, evanescent, just as it becomes when we fix our eye upon an object and the background fades, because the lens has ceased to focus upon it. This perhaps is the trick which gives the figure what appears to be aggressive life. We must look at it whether we will or no, for there is nothing else to look at. It is like the lines of beauty in nude sculpture, which because destitute of color, and background, and raiment, we are forced to regard attentively for lack of other features to check the eye.[5]

Sydenham's observation was acute. Remington's earliest Western illustrations were cluttered partly because he wanted to get everything in to prove that he had been *out there* and knew whereof he drew. Simplification was the hallmark of his mature illustrative art and of his sculpting as well. He had

Cowboy on a bucking horse
FRAM 71.834

A Bucking Broncho
Frontispiece, Richard Harding Davis, *The West from a Car Window* (New York: Harper Brothers, 1892)

to extract his figures from their contexts and reconceive them free-floating, in the round, while retaining that vigor, that movement, that "aggressive life" Sydenham spoke of. His reference files included a photograph of a cowboy on a bucking horse that resembles his 1892 illustration *A Bucking Broncho*. The illustration liberated horse and man from the photograph's distracting background; *The Broncho Buster* carried the process the logical next step, liberating horse and man from two-dimensionality as well. "I was impelled to try my hand at sculpture by a natural desire to say something in the round as well as in the flat," Remington told a journalist in 1907. "Sculpture is the most perfect expression of action. You can say it all in clay."[6]

There is an irony worth noting. Sculpting delivered Remington from illustration—and illustration's accursed middlemen, the engravers—at the very time the technology of reproduction was making direct photographic reproduction possible.[7] Of course, that same development would eventually render illustration itself secondary to photography. But modeling would always involve an essential middleman, the foundry, where the plaster that was itself a technician's creation from the artist's original model was cast in bronze. Without a sympathetic bond between sculptor and foundry, success was unattainable. Relying on Ruckstull's advice, apparently, Remington chose the Henry-Bonnard Bronze Company of New York to cast *The Broncho Buster*. He had completed his model—"a long work attended with great difficulties on my part"—by the third week of August 1895, and followed it through the various stages of the sand-casting process until a finished bronze was in hand by October 20.[8] Sand-casting was a laborious process that produced superbly detailed bronzes, and *The Broncho Buster* realized Remington's every hope. With his right stirrup swinging free, a quirt in one hand and a fistful of mane and reins in the other, a cowboy fights to stay aboard a rearing, plunging horse. From every perspective, the group convincingly portrays a tense struggle for mastery. "Breaking away from the narrow limits and restraints of pen and ink on flat surface," a contemporary wrote, "Remington has stampeded, as it were, to the greater possibilities of plastic form in clay, and in a single experiment has demonstrated his ability adequately to convey his ideas in a new and more effective medium of expression."[9]

If Remington's bronzes are thematically consistent with his published illustrations, no

"Turn Him Loose, Bill!" ca. 1893
Anschutz Collection, Denver, CO
CR 1658

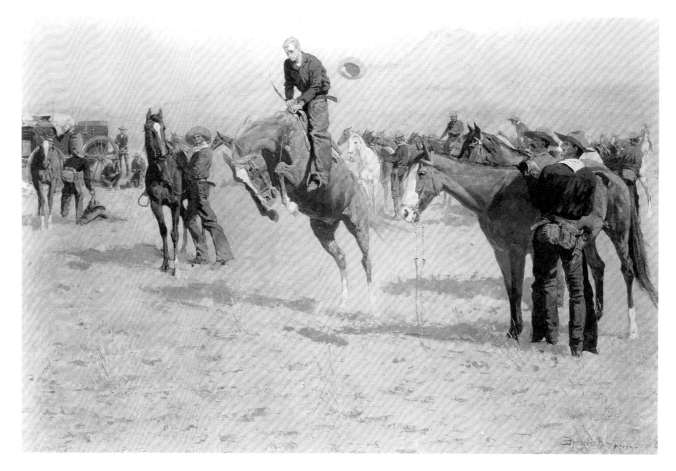

Blandy ca. 1900
The R. W. Norton Art Gallery, Shreveport, LA
CR 2479

wonder. "Painting and modeling are about the same," Remington explained. "You must know anatomy in both."[10] The fact that he had already established a repertoire of Western types eased his transition to sculpture. His sculpted figures required no context to identify them. That was part of their appeal: they were instantly accessible. As he put it, "I am d— near eternal if people want to know about the past and above all I am so simple that wise-men & fools of all ages can 'get there' and know *whether or not*."[11] In an article published in 1896, C. M. Fairbanks observed that, until Remington went West,

No one had ever before told us so truly what manner of man was the cowboy, no one else had so literally brought us face to face with the poor Indian, and never before had we of the East had such a realistic view of the lives of our soldiers in camp and in action. That four-footed quintessence of all that is vicious and ugly, the broncho, found his first glorification in Mr. Remington's pictures.

… In a word, he has fixed on the dial of time types that are disappearing from our Western borders and of which we shall have no other equally satisfactory likenesses.

After praising Remington sketches of the types in question—a cow pony, a herd of steers, a U.S. Infantry officer in field equipment ("truer than a tintype"), a drummer boy ("the true type of the so-called 'wind-jammer'")—Fairbanks turned to *The Broncho Buster*. "It demonstrates more surely than his drawings, even, his absolute knowledge of the external horse, and suggests a familiarity with horse nature, or ill-nature, as well. It is an extraordinary representation in bronze of wild and violent action, and… encourages the hope that we have in Mr. Remington an American Barye."[12]

Fairbanks' comment was typical of the acclaim that greeted *The Broncho Buster*. Remington often complained about critical neglect, but his sculptural debut was enthusiastically reviewed in two of the popular journals that featured his illustrations. In *Harper's Weekly*, Arthur Hoeber expressed astonishment that Remington should have "overcome so readily and with such excellent results" the "difficulties of technique in the modeling in clay," and in *Century Magazine* William A. Coffin observed that "the movement and force of both horse and rider are given with a strength and grasp that impress by their truth at first glance. The group is so good, and its aspect so attractive, that it

deserves praise not only for its technical qualities, but also for its power to please those who care as much for subject as for treatment."[13] Their numbers were sufficient to make *The Broncho Buster* "the most popular American bronze statuette of the nineteenth and early twentieth centuries."[14] The Henry-Bonnard Company apparently produced sixty-four castings by 1900, when Remington switched his loyalties to a rival foundry, the Roman Bronze Works, where the lost-wax casting process gave a whole new vitality to the group.[15] Remington was able to swing the right stirrup outward, alter the angle of the cowboy's hat, rotate his wrist and quirt hand, and rework the horse's mane and tail, further unifying the composition while augmenting its dynamic action. Perhaps another ninety casts of *The Broncho Buster* were produced by the Roman Bronze Works in Remington's lifetime, making it, quite simply, a phenomenon so clean in its lines (and outline) and so impressive in its energy that it became an instant classic and remains an icon of Western art. Appropriately, the Frederic Remington Art Museum has adopted a silhouette of *The Broncho Buster* as its symbol. So indelibly has the sculpture impressed itself on the popular imagination that the *New Yorker* in 1989 dismissed Remington's "bronzes of riders on horseback" as "clichéd."[16] That is a high honor indeed—Frederic Remington, creator of his own cliché!

1. Augustus Thomas, *The Print of My Remembrance* (New York: Charles Scribner's Sons, 1922), pp. 326–27. Thomas had offered a slightly different version of events in an earlier tribute, "Recollections of Frederic Remington," *Century Magazine* 86 (July 1913): 361. Besides such details as the size of Ruckstull's model (one-half instead of one-fourth) and the spelling of his name, Thomas offered a variant on his comments: "Frederic, you're not an illustrator so much as you're a sculptor. You don't mentally see your figures on one side of them. Your mind goes all around them."
2. FR, "Horses of the Plains," *Century Magazine*, January 1889; *Collected Writings*, p. 20.
3. FR to Owen Wister, [January 1895], in facsimile in Ben Merchant Vorpahl, *My Dear Wister—: The Frederic Remington-Owen Wister Letters* (Palo Alto: American West Publishing Company, 1972), pp. 160–61. The last "therere" is usually rendered simply "there" in printed transcripts of Remington's letter, but given its context was probably intentional—a visual-verbal pun.
4. *Turn Him Loose, Bill!* was featured in Remington's 1893 auction at The American Art Galleries in New York City. In the catalog it was titled *"Turn Him Loose!"—Breaking a Broncho*. Since the auction was held on January 13, the painting dates from before 1893. See *Catalogue of a Collection of Paintings, Drawings and Water-colors by Frederic Remington, A.N.A.* (New York: The American Art Galleries, 1893), #53.
5. Alvin R. Sydenham, "Frederic Remington" (ca. 1892), *Selected Letters*, p. 181.
6. Perriton Maxwell, "Frederic Remington—Most Typical of American Artists," *Pearson's Magazine* 18 (October 1907): 407.
7. Maxwell, "Frederic Remington—Most Typical of American Artists," p. 403; and Estelle Jussim, *Visual Communication and the Graphic Arts: Photographic Technologies in the Nineteenth Century* (New York: R. R. Bowker company, 1974). Remington drew a clear distinction in his remarks to Maxwell about the "infernal wood engravers": "Do not misunderstand me, I have no quarrel with the good engravers of the block, the men who are as much artists as those whose drawings they interpret. But those clumsy blacksmiths, turned wood-choppers, who invariably made my drawings say things I did not intend them to say—those were the fellows who made my youthful spleen boil."
8. William A. Coffin, "Remington's 'Bronco Buster,'" *Century Magazine* 52 (June 1896): 319; and Michael Edward Shapiro, *Cast and Recast: The Sculpture of Frederic Remington* (Washington, DC: Smithsonian Institution Press, for the National Museum of American Art, 1981), pp. 41–42. Shapiro also provides an excellent description of the sand-casting process, pp. 13–26.
9. Arthur Hoeber, "From Ink to Clay," *Harper's Weekly*, October 19, 1895.
10. Charles H. Garrett, "Remington and His Work," *Success*, May 13, 1899; in Orison Swett Marden, ed., *Little Visits with Great Americans; or, Success Ideals and How to Attain Them*, 2 vols. (New York: The Success Company, 1905), I, p. 332. For the influence of Antoine Barye on Remington's sculpture, see Shapiro, *Cast and Recast*, pp. 42–43.
11. FR to Owen Wister, October 24, [1895], *Selected Letters*, p. 275.
12. C. M. Fairbanks, "Artist Remington at Home and Afield," *Metropolitan Magazine* 4 (July 1896): 448, 450; and see Michael Edward Shapiro, "Remington: The Sculptor," in Shapiro and Peter H. Hassrick, *Frederic Remington: The Masterworks* (New York: Harry N. Abrams, for the Saint Louis Art Museum, in conjunction with the Buffalo Bill Historical Center, Cody, 1988), pp. 186–87.
13. Hoeber, "From Ink to Clay"; Coffin, "Remington's 'Bronco Buster,'" p. 319; and see the invitation to view *The Broncho Buster* from Tiffany & Co., London, February 3, 1896 (FRAM 98.8.12), which noted that the bronze "has been highly commended by the New York press." Coffin quoted Remington, revealingly: "I propose to do some more, to put the wild life of our West into something that burglar won't have, moth eat, or time blacken. It is a great art and satisfying to me, for my whole feeling is for form."
14. Shapiro, *Cast and Recast*, p. 43, and, for the casting estimates that follow, pp. 63–69, and Shapiro and Hassrick, *Frederic Remington: The Masterworks*, Appendix A, p. 266.
15. I am indebted to Michael Greenbaum for the information on the number of Henry-Bonnard castings.
16. "Goings on About Town," *New Yorker*, March 6, 1989, p. 14.

Opposite page, detail:
The Broncho Buster © October 1, 1895
Henry-Bonnard Bronze Company cast no. 23 (1896)

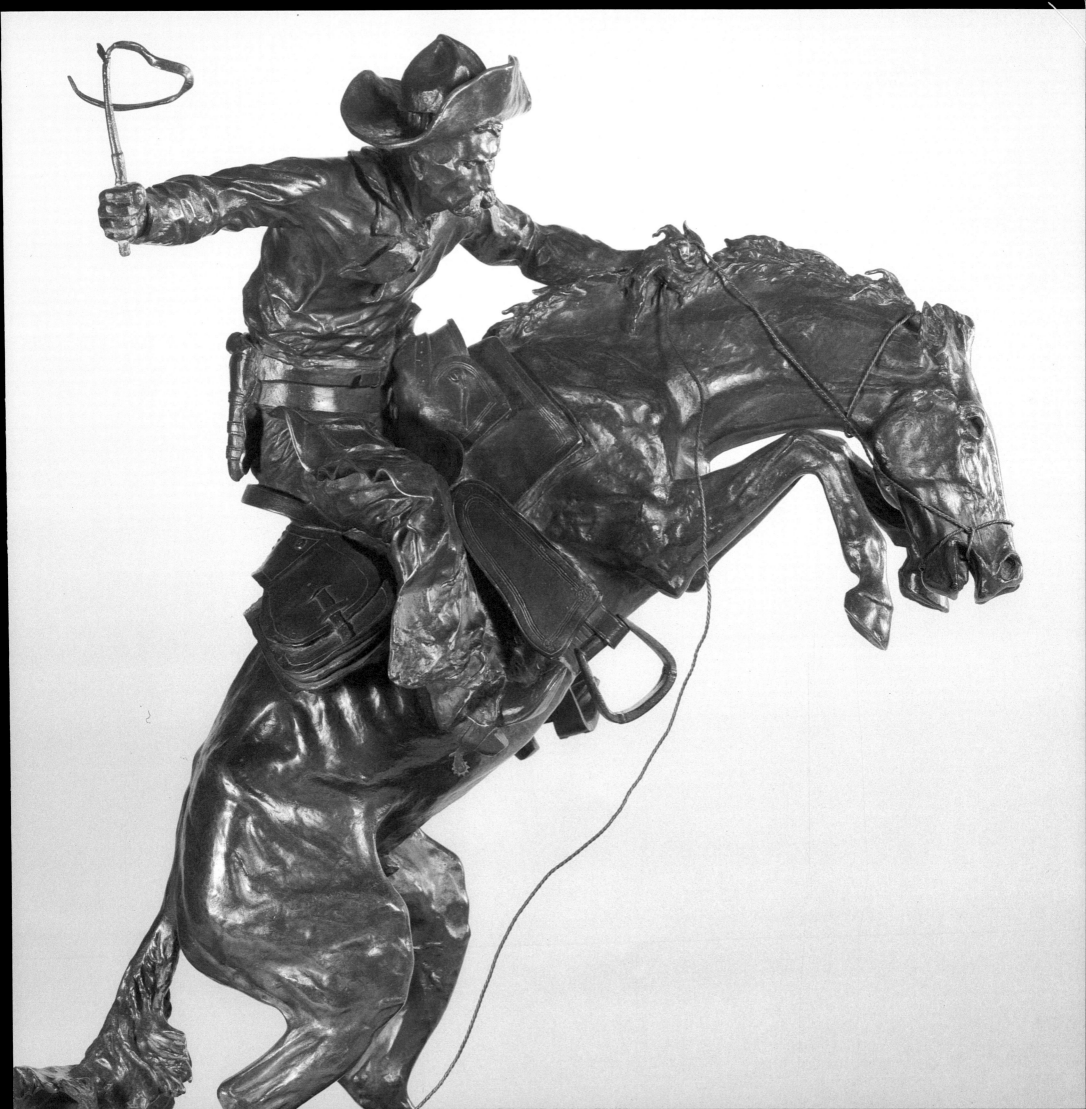

United States Troops Practising Marching in the Palmetto 1898

Ink wash on paper, 19^1/$_2$ x 29^1/$_2$" (49.5 x 74.9 cm.)
Signed lower left: FrEderic Remington.—
Museum purchase, 1947; FRAM 66.69, CR 2306

Remington had never made a secret of his desire to see a war. He had toured abroad and sketched the armies of Europe, building up his portfolio and establishing his credentials in the event there would be an outbreak of fighting. "I live in the hope of a war," he wrote Poultney Bigelow in 1894,[1] and he relished the taste of action when troopers faced "the mob" in Chicago that year. But by 1898 he had about given up. "There was a time when I, too, regarded not the sketches in this [martial] art," he wrote, "but yearned for the finished product. That, however, is not exhibited generally over once in a generation."[2] In 1898, it was his generation's turn.

Remington had long suspected (and hoped) that Cuba would be the scene of active hostilities involving the United States Army in defense of the rights of ordinary Cubans against their Spanish rulers, routinely characterized in the American press as "despots."[3] Early in 1896 he predicted "a big war with Spain,"[4] and he got himself assigned as one of the New York *Journal*'s special correspondents before the year was out. It did not add up to much—a two-week visit to Cuba to interview the Spanish overlord, General Weyler, as he was known, and to assess the impact of the Cuban insurgents. But the assignment put him in position to cover the fighting when the United States formally declared war on Spain on April 25, 1898. It took time to organize an invasion, and Remington, along with the other correspondents gathered at the assembling point in Tampa, Florida, chafed at the inactivity and boredom. He was experienced in the preliminaries to the main event, however—his had been a career of preliminaries—and was confident, as he wrote Owen Wister in June, that there would be "a lovely scrap around Havana—a big murdering—sure—."[5] Meanwhile he bided his time, sketching the military preparations that would make the payoff possible. He was still an accredited correspondent for the *New York Journal*,[6] and in that capacity did the wash drawing *United States Troops Practising Marching in the Palmetto*. Redrawn as a pen sketch and published on May 17, it is in keeping with the work Remington produced for the *Journal*—

professionally competent, but not terribly inspired, reflecting perhaps his awareness that newspaper printing was "too bad" to do much more.[7]

The Spanish-American War brought a number of old soldiers into the limelight again. Major General James F. Wade, like several other officers, had served against the Apache, while Major General Joseph Wheeler, commander of the Cavalry Division, was a Confederate veteran of the Civil War. Remington, who usually shied away from portraiture, rendered both men's likenesses for a June 4 *Harper's Weekly* spread, "Some Notable General Officers at Tampa, Florida."

1. FR to Poultney Bigelow, [1894]; also, FR to Bigelow, October 23, 1894, *Selected Letters*, pp. 204, 213.
2. FR, "The Essentials at Fort Adobe," *Harper's Monthly*, April 1898; *Collected Writings*, p. 287.
3. For a useful compendium of pictures and text see Douglas Allen, *Frederic Remington and the Spanish-American War* (New York: Crown Publishers, 1971).
4. FR to Owen Wister, [early April 1896], *Selected Letters*, p. 216.
5. FR to Owen Wister, [June 1898], in Ben Merchant Vorpahl, *My Dear Wister—: The Frederic Remington-Owen Wister Letters* (Palo Alto: American West Publishing Company, 1972), p. 233.
6. War Correspondent's Pass, No. 11, issued by the Navy Department, April 30, 1898, FRAM 96.8.10. It is worth noting that the *New York World* tried to woo Remington from the *Journal*, and he signed an agreement with them on February 19, 1897 (FRAM) that was obviously revoked, since he continued to work on assignment for the *Journal*.
7. FR to Poultney Bigelow, January 28, 1897, *Selected Letters*, p. 219. Compare the similar Remington illustrations *A Practice March in Texas*, *Harper's Weekly*, January 4, 1896, and *With the Regulars at Fort Tampa, Florida: 9th U.S. Cavalry Skirmishing Through the Pines*, *Harper's Weekly*, May 21, 1898.

Major-General Joseph Wheeler, U.S. Vols., Commanding Cavalry Division, Tampa 1898
Ink and gouache on paper, 15 x 11^1/$_8$" (38.1 x 28.3 cm.)
Signed lower right: FrEderic Remington. / drawn from life.—
FRAM 66.95, CR 2356

Major-General James F. Wade, U. S. Vols., Now Commanding 3rd Army Corps, Chickamanga 1898
Ink and gouache on paper, 15 x 11^1/$_8$" (38.1 x 28.3 cm.)
Signed lower right: FrEderic Remington / Tampa.—
FRAM. 66.95.2, CR 2355

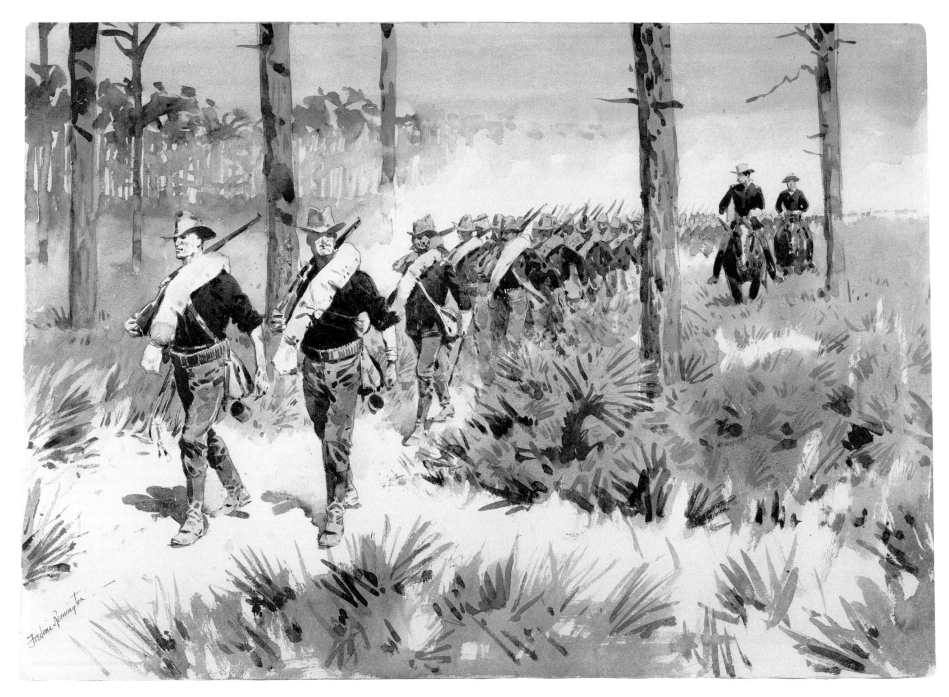

United States Troops Practising Marching in the Palmetto 1898

The Charge of the Rough Riders (Charge of the Rough Riders at San Juan Hill) 1898

Oil on canvas, 35 x 60" (88.9 x 152.4 cm.)
Signed lower right: —Frederic Remington— / '98 / COPYRIGHTED BY FREDERIC REMINGTON 1898
FRAM 66.52, CR 2397

Ten years after he illustrated Theodore Roosevelt's articles on ranching in Dakota, Remington illustrated Roosevelt's own account of his fabled charge with a regiment of western "Rough Riders" up a hill in Cuba. As lieutenant colonel of the First United States Volunteer Cavalry—the Rough Riders—Roosevelt had converted noisy jingoism into action, and cemented his link with the West in the bargain. The war was an important stepping stone in his political career. While serving as Assistant Secretary of the Navy in the McKinley administration, he had become the public figure as good as his word. Thereafter, whenever he trumpeted the virtues of the strenuous life, he could offer himself as a perfect exemplar. In Cuba, a contemporary wrote, Roosevelt had crossed a personal dividing line and found "the coolness, the calm judgment, the towering heroism" that would make him a national idol.[1]

Remington, too, had gone to Cuba to satisfy "a life of longing to see men do the greatest thing which men are called on to do," and he was prepared to enjoy himself:

The creation of things by men in time of peace is of every consequence, but it does not bring forth the tumultuous energy which accompanies the destruction of things by men in war. He who has not seen war only half comprehends the possibilities of his race….

Remington came back a chastened man, aware of war's reality. "All the broken spirits, bloody bodies, hopeless, helpless suffering which drags its weary length to the rear, are so much more appalling than anything else in the world that words won't mean anything to one who has not seen it," he observed in his article "With the Fifth Corps" published in the November 1898 *Harper's Monthly*.

Ironically, for all the disillusionment Remington experienced in Cuba, his best-known painting of the Spanish-American War would be his most heroic. It showed the final rush of the Rough Riders as Roosevelt, mounted and with pistol in hand, encouraged them on. There was no charge for Remington personally. When, through binoculars,

he could see "the white lines of the Spanish intrenchments," his customary prudence, which he always cheerfully acknowledged, took over. He "got back into the safety of a low bank" and stayed there while the soldiers let out a yell and began their advance:

Then the Mausers came in a continuous whistle. I crawled along to a new place and finally got sight of the fort, and just then I could distinguish our blue soldiers on the hill-top, and I also noticed that the Mauser bullets rained no more. Then I started after….

San Juan was taken by infantry and dismounted cavalry of the United States regular army without the aid of artillery. It was the most glorious feat of arms I ever heard of, considering every condition. It was done without grub, without reserves of either ammunition or men, under tropical conditions. It was a storm of intrenched heights, held by veteran troops armed with modern guns, supported by artillery, and no other troops on the earth would have even thought they could take San Juan heights, let alone doing it.

I followed on and up the hill.[2]

Thus Remington's painting of Roosevelt's charge appeared to be an eyewitness record. It was not. Roosevelt led a volunteer regiment, not regulars, and *he did not charge up San Juan Hill.* This would prove a problem when Roosevelt wrote up his war experiences for *Scribner's Magazine* and Remington's painting served as an illustration. Roosevelt's text was precise about what he had and had not done that day. There were two hills on the army's front, Roosevelt wrote, "the hill on the left, which contained heavy block-houses, being farther away from us than the hill on our right, which we afterward grew to call Kettle Hill, and which was surmounted merely by some large ranch buildings or haciendas, with sunken bricklined walls and cellars." It was up Kettle Hill that Roosevelt charged. Remington had him positioned correctly, mounted and at the head of the Rough Riders intermingled with regulars from the First and Ninth Cavalry, the latter a black regiment. As Roosevelt

described the critical phase of the charge, he "galloped toward the hill, passing the shouting, cheering, firing men." Little Spanish resistance was met, and "almost immediately" Kettle Hill was covered by Rough Riders and members of the Ninth, each claiming priority in reaching the top.[3]

Of course Remington knew that Roosevelt's Rough Riders did not charge up San Juan Hill, and it annoyed him when the *New York Sun* as late as 1908 chastised him for his error.[4] He had copyrighted the work in 1899 simply as *The Charge of the Rough Riders*, and it was reproduced as a print under that title.[5] But it appeared with Roosevelt's article that same year titled *Charge of the Rough Riders at San Juan Hill*, thereby contributing to the public's enduring confusion. Roosevelt will always be the American president who led the charge up San Juan Hill. Asked by a reporter about his painting, Remington explained that he "saw Roosevelt just before but not during the charge:"

But when you see one, you see all. The fighting to-day is done in long, thin lines; the solid formations are no longer used. It makes too great a target. You are never out of range, for the bullets carry a mile and a half. Most of the fighting is done lying down, the front line advancing, and the others harassing the enemy. To me there was nothing enjoyable about it…. in my younger days, I actually enjoyed being in the midst of an Indian fight. The climate is so different, and entirely to my liking, out west.[6]

Why, then, paint such an old-fashioned tribute to heroism?

The Charge of the Rough Riders offers some interesting clues. The vivid greens of jungle and grass ("pea-green guinea-grass," Remington noted) establish that this is Cuba, not the West.[7] Indeed, when he was out West, Remington fussed if things were too springlike and verdant, since he had no use for color studies of a green landscape when his own set Western palette ran to sere tones.[8] He made the adjustment to tropical colors reluctantly. "I dont care for Cuba," he wrote a fellow correspondent on his return. "Its all green paint and I hate green—it dont go with any thing else, especially our

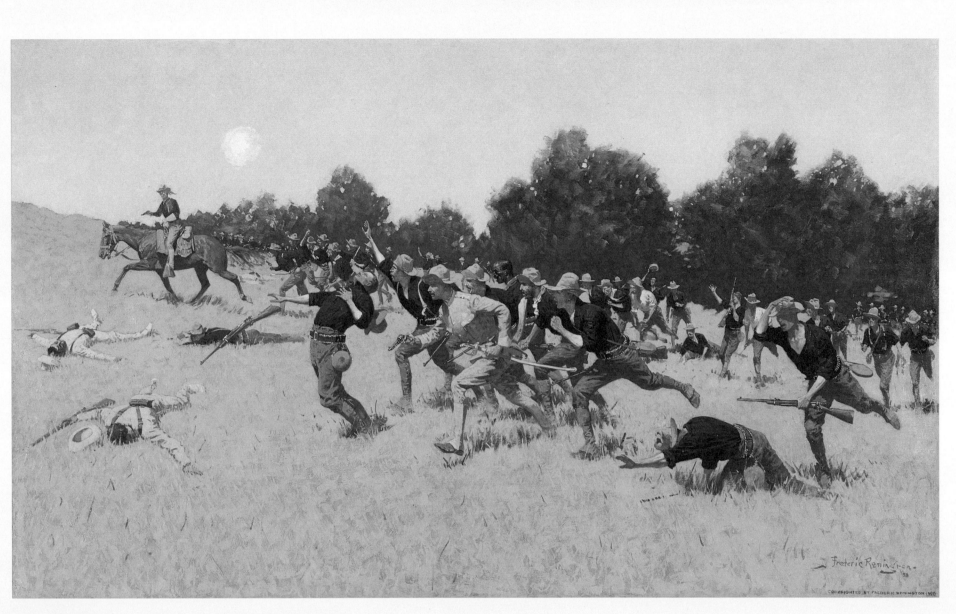

The Charge of the Rough Riders (*Charge of the Rough Riders at San Juan Hill*) 1898

army blue."[9] But he did his best in *The Charge of the Rough Riders*. A steamy haze hangs over the land. It is a day made for a splendid little charge. In his reportage, Remington commented tellingly on the impersonal nature of modern warfare. "The guerilla is out of date," he wrote. Now a soldier might "be in a dozen battles, and survive a dozen wounds without seeing an enemy."[10] The last phase of the fighting near San Juan Hill was different. The soldiers, for once, were able to stand and charge. The fallen Spaniards sprawled in the grass seem oddly small, as though all resistance is literally shrinking away before the onrushing Americans. The artist's vantage point is that of a spectator on the sidelines at a football match watching the action sweep past. In his essay on the battle, Roosevelt described his "crowded hour" as an exhilarating contest: "... we were all in the spirit of the thing and greatly excited by the charge, the men cheering and running forward between shots, while the delighted faces of the foremost officers... will always stay in my mind."[11] Remington's painting captures this mood. The reality of war in Cuba may have sobered him considerably, but he still thought of fighting in boyhood terms, as gallant soldiers rushing at the enemy.

The painting bears striking similarities to a youthful sketch Remington made of the Civil War, *A Battle Scene*. The running figures in the drawing anticipate those in the later oil; indeed, the officer on the right whose knees appear to be buckling from a wound parallels the collapsing soldier in the painting's left foreground. (Even the half-buried cannon ball in the sketch is echoed in the artillery shell bursting in the air over Roosevelt's charging men!) This was the way war was supposed to be—not men inching forward on their bellies, but upright figures dashing at the enemy, all eager exuberance. The image of running men was a Remington staple; in 1889 he illustrated a Roosevelt article on "Buffalo-Hunting" with a drawing, *They Were in Good Training, and They Did Not Have to Halt*, showing Roosevelt's brother and cousin trailing four buffalo on the Texas plains; the two young Easterners made a trot of several miles, and were rewarded with success. Thus they served Roosevelt as models of the types who "frequently drift to the frontier": "hardy, vigorous fellows eager for excitement and adventure."[12] Such were the pioneering (read *Anglo-Saxon*) traits that Roosevelt's generation believed had made the United States a great nation. For them, the West was the last bastion of pure Americanism. That is why the Rough Riders and two other regiments of mounted riflemen from the West were recruited in

the first place. As Westerners, they were expected to bring into battle that rugged Americanism celebrated in Buffalo Bill Cody's Wild West show and Frederic Remington's art. "I am proud of this regiment, because it is a typical American regiment, made up of typical American men," Roosevelt stated after the Rough Riders' triumphant return from Cuba. "The men of the West and the men of the Southwest, horsemen, riflemen, and herders of cattle, have been the backbone of this regiment...."[13] (Noteworthy, too, was the fact that one of the twelve troops of Rough Riders was recruited primarily in New York and represented several prominent Eastern families, confirming Roosevelt's point that old America and the West were of a kind.) Seen in this light, *The Charge of the Rough Riders* is more a throwback to Remington's master theme, the winning of the West, than it is about the war in Cuba. Perhaps that explains the unabashedly (and anachronistically) heroic treatment.

1. Edward Marshall, *The Story of the Rough Riders* (1899), quoted in G. Edward White, *The Eastern Establishment and the Western Experience: The West of Frederic Remington, Theodore Roosevelt, and Owen Wister* (New Haven: Yale University Press, 1968), p. 168. White offers an exemplary discussion of the cultural significance of the Rough Riders.
2. FR, "With the Fifth Corps," *Harper's Monthly* 97 (November 1898): 962, 972–75; *Collected Writings*, pp. 338, 346–48. The original article, with its downbeat illustrations in place, best conveys the spirit of Remington's essay.
3. Theodore Roosevelt, "The Rough Riders: The Cavalry at Santiago," *Scribner's Magazine* 25 (April 1899): 425–32. Remington's painting is reproduced full-page, p. 421.
4. Diary, April 24, 1908, FRAM 71.817.
5. Peggy and Harold Samuels, *Remington: The Complete Prints* (New York: Crown Publishers, 1990), p. 51, #44.
6. Charles H. Garrett, "Remington and His Work," *Success*, May 13, 1899; in Orison Swett Marden, ed., *Little Visits with Great Americans; or, Success Ideals and How to Attain Them*, 2 vols. (New York: The Success Company, 1905), I, pp. 330–31.
7. FR, "With the Fifth Corps," p. 974; *Collected Writings*, p. 346.
8. FR to Eva Remington, [April 7, 1907], *Selected Letters*, p. 307
9. FR to John Fox, Jr., [late August 1898], Fox Family Collection, Appalachian Center, University of Kentucky, Lexington.
10. FR, "With the Fifth Corps," p. 970; *Collected Writings*, p. 345 (though "guerilla" is rendered "gorrilla" in this reprint!).
11. Roosevelt, "The Rough Riders: The Cavalry at Santiago," pp. 428, 430.
12. Theodore Roosevelt, "Buffalo-Hunting," *St. Nicholas* 17 (December 1887): p. 137.
13. Roosevelt's farewell address to the Rough Riders, September 13, 1898, quoted in White, *Eastern Establishment and the Western Experience*, p. 169.

Photographs of Frederic Remington running, New Rochelle
FRAM 1918.76.152.97, 1918.76.152.104

A Battle Scene ca. 1876
Pencil and watercolor on lined
paper, 7½ x 13" (19.1 x 33 cm.)
FRAM 73.37

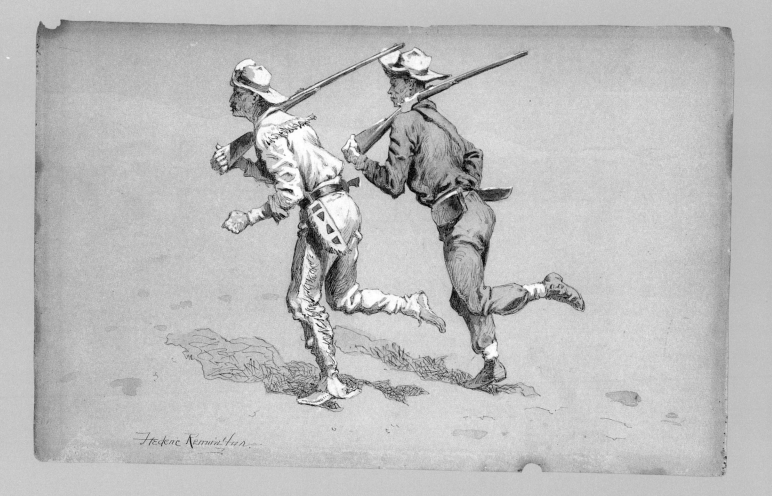

*"They Were in Good Training, and They Did
Not Have To Halt"* 1889
Ink wash on brown paper,
12 x 18½" (30.5 x 47 cm.)
Signed lower left: FrΕderic Remington.-.
Museum acquisition, 1961; Ex-collection
Mr. Margaret Lujan, Los Angeles, CA;
FRAM 66.92, CR 546.

Capt. Grimes's Battery Going Up El Poso Hill 1898
Black and white oil on canvas, 26½ x 39¾" (67.3 x 101 cm.)
Signed lower right: Frederic Remington
Bequest of Mr. Robert Purcell; FRAM 92.2, CR 2381

There is dash and vigor in *Capt. Grimes's Battery Going Up El Poso Hill*—the only illustration for "With the Fifth Corps" that explodes with energy. The rest showed the waiting that so wore on men's nerves, the cautious advance, and the wounded. Remington wanted, he admitted, "the roar of battle," but never found it: only long-range sniping and "so little fuss, that a soldier is for hours under fire getting into the battle proper." Men "subject to wounds and death, before they had even a chance to know where the enemy was," became almost "apathetic." This did not make for good pictures. Remington required mass for his art—bodies of men in tight formation, or bunched by circumstance, where the echoing of poses gave rhythmic momentum to his composition. The running figures in *Charge of the Rough Riders* are a case in point. He achieved this same effect in *Capt. Grimes's Battery* through the plunging team of horses, straining mightily to top the rise, and the leftward lean of the soldiers. Together they create a surging flow that even the foliage complements. But Remington's accompanying text qualified the heroic impression:

> … the road [to Santiago] was jammed with troops, and up the hill of El Poso went the horses of [Captain George] Grimes's battery under whip and spur….
>
> The battery took position, and behind it gathered the foreigners, naval and military, with staff-officers and correspondents. It was a picture such as may be seen at a manoeuvre. Grimes fired a few shells toward Santiago, and directly came a shrill screaming shrapnel from the Spanish lines. It burst… and the manoeuvre picture on the hill underwent a lively change. It was thoroughly evident that the Spaniards had the range of everything in the country…. For myself, I fled, dragging my horse up the hill, out of range of Grimes's inviting guns. Some as gallant soldiers and some as daring correspondents as it is my pleasure to know did their legs proud there…. Directly came the warning scream of No. 2, and we dropped and hugged the ground like star-fish. Bang! right over us it exploded….

> And the next shell went into the battery, killing and doing damage. Following shell were going into the helpless troops down in the road, and Grimes withdrew his battery for this cause. He had been premature.[1]

Up the hill—and back down again. That, and the terrible casualties of war, were the realities Remington found in Cuba. But in *Capt. Grimes's Battery Going Up El Poso Hill* he had struck an unusually positive note, and had no trouble selling it for $150, to the disappointment of a friend who had coveted the painting.[2]

1. FR, "With the Fifth Corps," *Harper's Monthly 97* (November 1898): 968. The corresponding passage in *Collected Writings*, pp. 343–44, has been slightly scrambled. For a different take on the same event by a fellow artist, see Howard Chandler Christy, "An Artist at El Poso," *Scribner's Magazine 24* (September 1898): 283–84.
2. FR to Joel Burdick, November 15, 1898, *Selected Letters*, p. 231; and undated and December 15 [1898], FRAM 92.18.9, 92.18.17. Remington promised the "drawing" to Burdick in November, but subsequently sold it to another. At the time, perhaps in response to praise such as that he received from Clarence C. Buel of the *Century Magazine* (Buel to FR, October 28, 1898, *Selected Letters*, p. 232), he was contemplating a major oil on the same subject. Back in 1892 he wrote an artillery officer: "There is a great big aching void in oil for a painter who can do the Artillery. I had a nice commission to do some while back and couldn't because I don't know the difference between a Krupp and a Carrionade and then to do artillery one must be able to paint nuts & bolts and the artist who can draw a wagon wheel would have to be a person who had no immortal soul. Still human genius has no limits and a person will some day appear who can put sentiment into a gun carriage and make it look different from an advertisement for a wagon factory." (FR to Alvin H. Sydenham, August 31 [1892], typescript copy in the Helen E. and Homer E. Britzman Collection, Taylor Museum for Southwestern Studies of the Colorado Springs Fine Arts Center, c.13.77.) *Grimes's Battery* succeeded by minimizing the weaponry and accentuating the human and animal actors involved. Remington did not work the subject up into a major oil, however, but many of the same ingredients reappeared in his *Closing Up the Train* (1906), where the West replaced Cuba, and covered wagons the artillery. *Grimes's Battery* was in an established tradition. Works by the British military painter John Charlton come to mind, notably his *British Artillery Entering the Enemy's Lines at Tel-el-Kebir 13th September 1882* (1883) and his simplified treatment of the same theme, *Placing the Guns* (1893). Both are illustrated in Peter Harrington, *British Artists and War: The Face of Battle in Paintings and Prints, 1700–1914* (London: Greenhill Books, and Stackpole Books, Mechanicsburg, PA, in association with Brown University Library, Providence, RI, 1993), pp. 213, 228, along with p. 283, George Scott's *Final Crossing of the Tugela* (1900), which owes a self-evident debt to Remington's *Grimes's Battery*. Seen together, these works establish the cross-fertilization characteristic of military art.

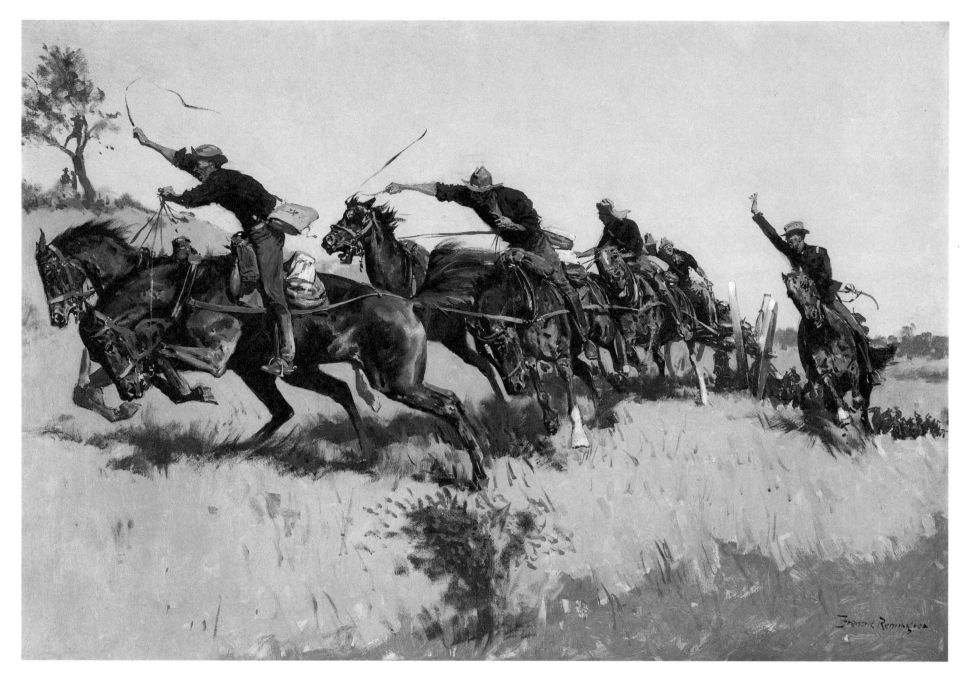

Capt. Grimes's Battery Going Up El Poso Hill 1898

Under Which King? 1899

Black and white oil on canvas, 27 x 40" (68.6 x 101.6 cm.)
Signed lower right: —Frederic Remington / Cuba.—.
Gift of Mr. Rudolf Wunderlich; Ex-collection: Museum of Fine Arts, Houston, TX; FRAM 80.9, CR 2417

Even after San Juan Hill was captured, Santiago taken, and the Spanish routed, Cuba was not over for America, or for Frederic Remington. Remington was never other than racially conservative. Though he persuaded himself that the Cuban insurgents' cause was right and American intervention necessary, he expressed his true feelings to Owen Wister in 1896: "*Cuba libre*. It does seem tough that so many Americans have had to be and have still got to be killed to free a lot of d— niggers who are better off under the yoke."[1] After peace was concluded on December 10, 1898, Remington's doubts moved to the forefront. The mass of Cubans were benighted, their leaders corrupt, and continued American involvement a risky proposition, since peace-keeping was a far less clear-cut activity than war-making.

In February 1899 Remington sailed to Cuba again as special correspondent for *Collier's Weekly*. "This time I did not go feeling like a thief in the night or an unbidden guest." Instead, he was one with the conquering army that patrolled the streets of Havana. The newly-librated Cubans wanted the Americans out—that much was clear. But could they fend for themselves? Even as he recorded "the haughty reserve" maintained by a passing soldier of the Army of Liberation on his "mice-like" pony, in contrast with a well-mounted American regular, he was dubious.[2] The habits of generations could not be eradicated in a few months, and his prediction for Cuba's future in *Under Which King?* was manifest in the cowering figures of the peasants on the right, accustomed to obedience, not freedom, and bewildered by the presence of two masters instead of one. (The background, it should be noted, drew on a photograph in Remington's collection, indicating his continuing use of such *aides-mémoires* in his illustrative art.)

Under Which King? about terminated Remington's interest in Cuba. "I was no longer a Cuban sympathizer," he admitted;[3] the issue now seemed to him a purely racial one ("they are, in the aggregate, the most ignorant people on earth"[4]), and while he wished them well, he was ready to wash his hands of the whole thing and return to his first love. After "a good time" in Montana and Wyoming over the summer, he reported back to Wister that September: "as Miss Columbia said to Uncle Sam 'That was my war'—that old cleaning up of the West—that is the War I am going to put in the rest of my time at."[5]

1. FR to Owen Wister, [early April 1896], *Selected Letters*, p. 216.
2. FR, "'Under Which King?,'" *Collier's Weekly*, April 8, 1899; *Collected Writings*, pp. 361, 358.
3. FR, "The Triumph of a Conqueror," *Collier's Weekly*, March 18, 1899, in Douglas Allen, *Frederic Remington and the Spanish-American War* (New York: Crown Publishers, 1971), p. 145. This article is not in *Collected Writings*.
4. FR, "'Under Which King?,'" *Collected Writings*, p. 361; and see "Triumph of a Conqueror," p. 150.
5. FR to Owen Wister, September 1, 1899, *Selected Letters*, p. 233.

Photograph of Cuban landscape
FRAM 1918.76.160.573

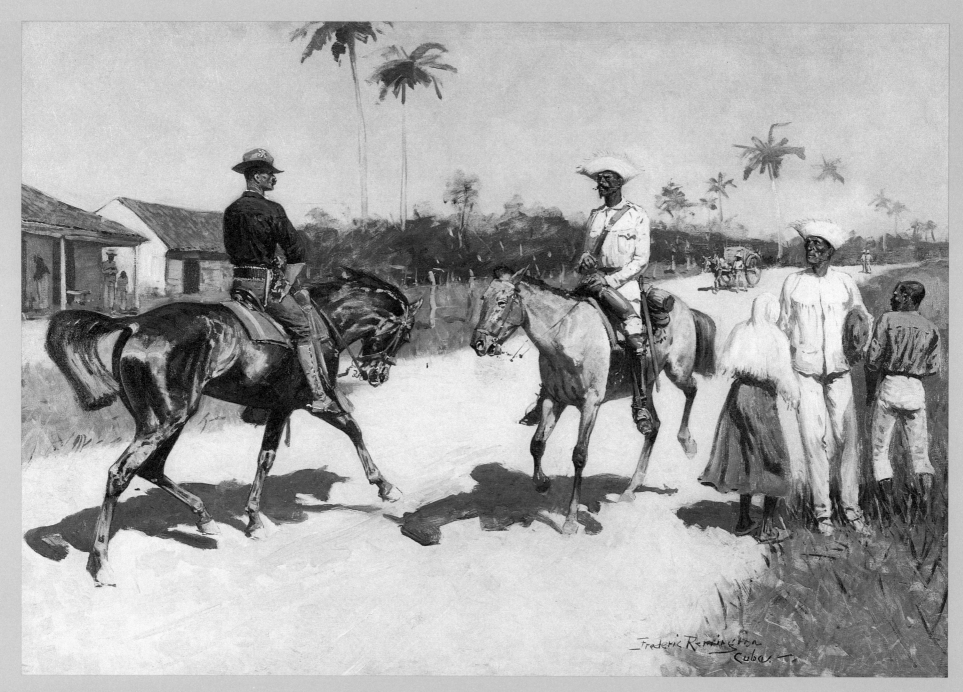

Under Which King? 1899

A Mining Town, Wyoming ©1899 as *Red Medicine*; altered 1904

Oil on canvas, 27 x 40" (68.6 x 101.6 cm.)
Signed lower left: —Frederic Remington-
FRAM 66.45, CR 2477

Remington had always been keen to gather facts, impressions, photographs and mementos in service of his art. His trips West, once made as artist-correspondent, increasingly were in the nature of refresher courses. As he told Owen Wister in 1899, he had spent the summer in Montana and Wyoming "trying to paint at the impossible."[1] There was nothing new to be seen that interested him, just the country itself, and while enduring bad food and discomfort on a swing through Colorado and New Mexico the next year, that did not seem compensation enough. "Shall never come west again," he wrote Eva on November 6, 1900 from Santa Fe: "It is all brick buildings—derby hats and blue overhauls—it spoils my early illusions—and they are my capital."[2] But he had found himself "dead on" as to color, and after returning home summed up the mixed results of his trip in a letter to the great illustrator Howard Pyle: "Just back…. Trying to improve my color. Think I have made headway. Color is great—it isn't so great as drawing and neither are in it with Imagination. Without that a fellow is out of luck."[3] It was imagination alone that would people *his* West, while the Western landscape set the stage.

How consciously the West served as backdrop to Remington's contrivances is apparent in *A Mining Town, Wyoming*. The substantial foreground seems like an empty stage; the backdrop is in place, but the actors are still waiting in the wings. In fact, the actors had already made an appearance on this particular stage. A drunken Indian man, passed out on the trail leading away from town, his wife seated by him, once occupied the foreground, and the painting, copyrighted in 1899 as *Red Medicine*, was known by its published title as *The Red Man's Load*.[4] An Owen Wister poem explained the meaning of the scene:

> *No more are sun and cloud his banners*
> *The Stars and Stripes above him wave,*
> *And he hath drunk the White Man's Burden*
> *Deep as is the grave*[5]

The drunken Indian stereotype reached back in time to the earliest years of the Republic, and

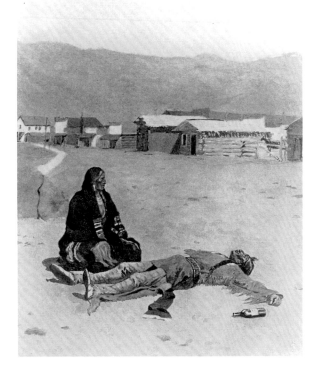

The Red Man's Load (*Red Medicine*)
Frederic Remington, *Done in the Open* (New York: P. F. Collier & Son, 1902)

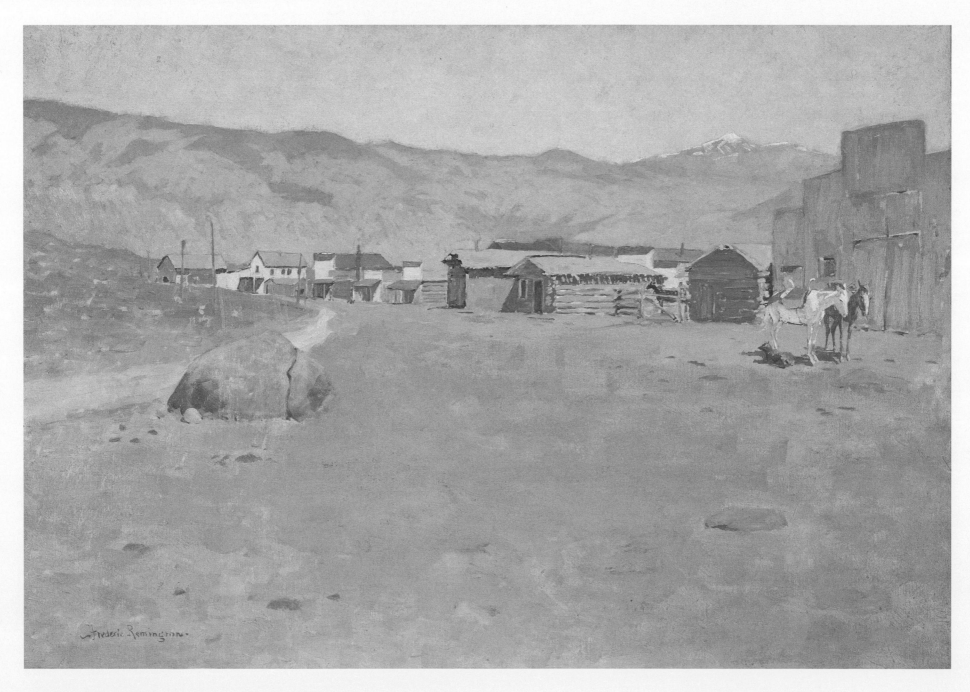

A Mining Town, Wyoming © 1899 as *Red Medicine*; altered 1904

helped sustain the theory that America's native race was doomed to extinction by civilized progress.[6]

Remington was inclined to accept the theory. In 1897 he painted an allegory titled *The Twilight of the Indian*, showing a plains Indian who had once chased the buffalo resting by his plow and gazing longingly into the distance. Remington had observed more than once that civilization was contrary to Indian nature, and a disaster for their picturesqueness. "Far be it from these quaint people ever to lose their blankets, their horses, their heroism, in order to stalk behind a plow in a pair of canvas overalls and a battered silk hat," he had commented after visiting the Kiowa and Comanche reservation in 1888.[7] But he also recognized that change was unavoidable: "The Indian suns himself before the door of his tepee, dreaming of the past. For a long time now he has eaten of the white man's lotos—the bimonthly beef issue."[8] And he had drunk of the white man's whiskey. In *The Red Man's Load* Remington took allegory to the next step, where unsparing realism offered its own uncolorful lesson. Recognizing that the subject had no sales appeal, he painted over the figures, effectively sweeping his stage clean for other actors to make their appearance in a more appealing drama.

The most distinctive feature remaining in *A Mining Town, Wyoming* is the large boulder beside the path. It is reminiscent of Turtle Rock, the subject of a Remington landscape study. But its position in the composition, and the prominent fissure, suggest a symbolic import. It is as though the Indian's way of life has cracked in two, and the path from the old to the new has proven a crooked trail. Even with the Indians removed, one can still see the boulder symbolizing a division between the past and the future, the horses on the right and the telephone poles on the left.

The Twilight of the Indian 1897
The R. W. Norton Art Gallery, Shreveport, LA
CR 2214

Turtle Rock ca. 1890s.
Watercolor on paper, 10⅛ x 13¾" (25.7 x 34.9 cm.)
Unsigned
FRAM 66.96

1. FR to Owen Wister, September 1, 1899, *Selected Letters*, p. 233.
2. FR to Eva Remington, November 6, 1900, *Selected Letters*, p. 318.
3. FR to Eva Remington, November 4, 1900, and to Howard Pyle, December 5, [1900], *Selected Letters*, pp. 317, 291, where the Pyle letter is misdated November 5, [1899].
4. I am grateful to Melissa Webster and Peter H. Hassrick of the Buffalo Bill Historical Center's Remington *catalogue raisonné* project for this information.
5. FR (with Owen Wister), *Done in the Open* (New York: P. F. Collier & Son, 1902), unpaginated.
6. See Brian W. Dippie, *The Vanishing American: White Attitudes and U.S. Indian Policy* (Lawrence: University Press of Kansas, 1982 [1991]), pp. 34–36.
7. FR, "On the Indian Reservations," *Century Magazine*, July 1889; *Collected Writings*, p. 38.
8. FR, "The Essentials at Fort Adobe," *Harper's Monthly*, April 1898; *Collected Writings*, p. 286.

Opposite page, detail:
A Mining Town, Wyoming ©1899 as *Red Medicine*; altered 1904

The Cheyenne © November 21, 1901
Roman Bronze Works cast no. 2 [1901–1902]
Promised by bequest of Charles R. Wood; Ex-collection: William Mountain Estate; DuMouchelles Art Galleries Co., Detroit, MI

The Cheyenne © November 21, 1901
Roman Bronze Works cast no. 12 (January 24, 1906), 20 H x 24⁵⁄₁₆ W x 7" D (50.8 H x 61.8 W x 17.8 D cm)
Gift of Mr. and Mrs. Robert Hollins; FRAM 85.5

Remington's first bronze group, *The Broncho Buster*, elicited admiration for his horses—and especially for their departure from convention. "Here was a man who gave us horses that differed from the old time inanities born of studio study and the plaster cast, and quite innocent of the stable," Arthur Hoeber wrote in 1895. "Here were beasts that had snap, go, life, and hot, quick-coursing blood in their veins."[1] *The Cheyenne* raises the same questions about Remington's use of photographs in modeling a running horse as do his illustrations and paintings. That is, the positioning of the horse's legs at full gallop relies on Eadweard Muybridge's stop-action photography (see p. 68), with the added difference that Remington shows *The Cheyenne*'s horse clearing some unseen obstacle while racing at full tilt—an "Indian & a pony which is burning the air," as he put it in a letter to Owen Wister in late April 1901.[2] Apart from the angle of the warrior's spear and the quirt instead of the shield in his hand, the model is directly related to Remington's black and white oil *Attacking Indian War Party*, painted in 1888 when he still viewed plains Indians as irredeemable and dangerous savages. By the time he began modeling *The Cheyenne*, admiration qualified this judgment. "They were fighting for their land—they fought to the death—they never gave quarter, and they never asked it," he wrote in 1899. "There was a nobility of purpose about their resistance which commends itself now that it is passed."[3]

So *The Cheyenne* is Remington's tribute to a conquered foe, and another bronze tour de force. The trailing buffalo robe supports the entire weight of horse and rider; suspended in air, they seem to skim the earth's surface. This impressive aerial effect was achieved by a partnership struck about 1900 between Remington and Riccardo Bertelli (1870–1955), founder of the Roman Bronze Works, where the revival of an old craft—the *cire perdue*, or lost-wax process—permitted artistic intervention between the plaster casting made off the original model and the finished bronze. The sculptor could actually modify the wax impression, working his

Attacking Indian War Party ca. 1888
'21' Club, New York, NY
CR 357

Riccardo Bertelli, 1906
Photograph by T. H. Lifskey, Brooklyn, NY
FRAM 1918.76.157.34

Opposite page:
The Cheyenne © November 21, 1901
Roman Bronze Works cast no. 2 [1901–1902]

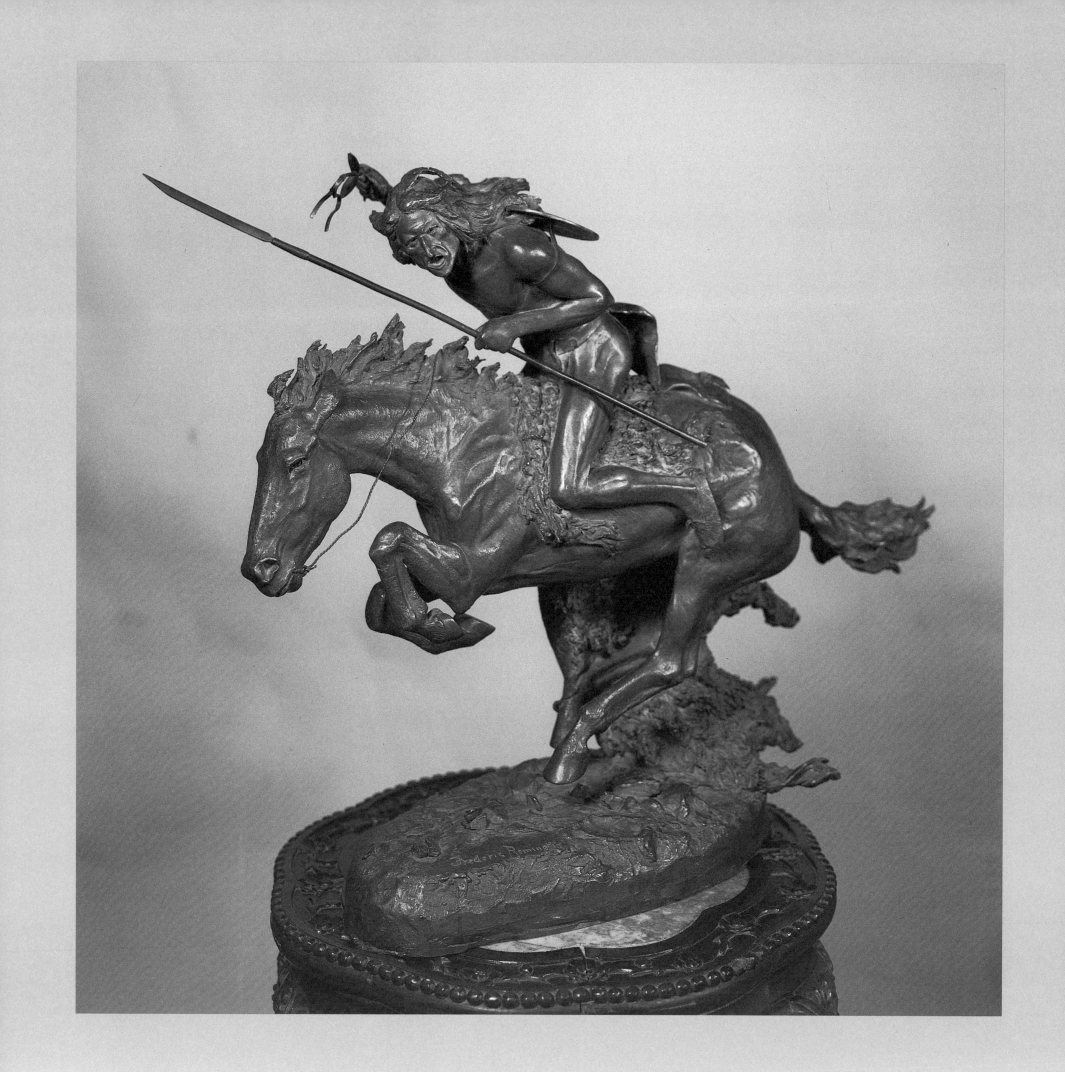

will to creative ends.[4] Bertelli became a key player in Remington's remaining years, fulfilling the artist's most outrageous hopes for bronze. The earliest casts of *The Cheyenne* were probably Bertelli's first Remingtons. Their exact detail, faithfulness to texture and exceptional finish must have persuaded Remington that he had found his maker ("Oh—Man of Metal," he would address Bertelli).[5]

Remington soon took advantage of the flexibility offered by the lost-wax process. After cast number 8 in 1904, Michael Greenbaum has noted,

> *he made a major change that became incorporated in all subsequent production. The warrior's shield was lowered from its previous location high on the rider's back to a more natural position, probably after Remington realized that the original height would create a wind drag…. Feathers were added to the shield, and Remington gave the warrior earrings. The Indian's face turned slightly to the left, rather than facing forward….[6]*

The effect of these changes can be seen by comparing cast number 2 to cast number 12.

Since the earliest casts of *The Cheyenne* were so fine, comparison with later casts provides a textbook study in differential bronze quality. Bertelli was a friend, but also a businessman. In her will, Eva Remington stipulated that "*All bronzes* done by my late husband, Frederic Remington must cease being reproduced after my death. The models must be broken, but before they are broken I want one made from each model, (not already in the Frederic Remington Collection) and added to the Frederic Remington Collection to be paid for out of my estate."[7] But after Eva died on November 2, 1918, Roman Bronze Works engaged in a Remington frenzy and, Michael Shapiro concludes from a close study of the foundry's ledgers, cast thirty-five additional *Cheyennes*. From as few as twenty-one casts in Remington's lifetime, the edition of *The Cheyenne* had reached eighty-nine, including the estate cast (number 79), before the mould was broken.[8] Compared to cast numbers 2 and 12, the estate cast shows less definition in the straining musculature of horse and man, and a general loss of crispness and detail, from the knife riding in its scabbard on the Indian's left hip (which disappears) to the textures of horse hair and trailing buffalo robe. What survives is the coiled energy that animates *The Cheyenne* and that made it one of Remington's most popular bronzes.

1. Arthur Hoeber, "From Ink to Clay," *Harper's Weekly*, October 19, 1895, p. 993.
2. FR to Owen Wister, [late April 1901], *Selected Letters*, p. 296 (the letter is misdated 1900). Michael Edward Shapiro, "Remington: The Sculptor," in Shapiro and Peter H. Hassrick, *Frederic Remington: The Masterworks* (New York: Harry N. Abrams, for the Saint Louis Art Museum, in conjunction with the Buffalo Bill Historical Center, Cody, WY, 1988), p. 199, notes that the horse replicates the animal on the left side of *The Wounded Bunkie* (see p. 138).
3. FR, "How Stillwell Sold Out," *Collier's Weekly*, December 16, 1899; *Collected Writings*, p. 397.
4. See Michael Edward Shapiro, *Cast and Recast: The Sculpture of Frederic Remington* (Washington, DC: Smithsonian Institution Press for the National Museum of American Art, 1981), pp. 26–35, 46–59.
5. FR to Riccardo Bertelli, undated, quoted in ibid., p. 47.
6. Michael D. Greenbaum, *Icons of the West: Frederic Remington's Sculpture* (Ogdensburg, NY: Frederic Remington Art Museum, 1996), p. 89.
7. Last Will and Testament of Eva A. Remington (probated December 23, 1918), copy, FRAM 97.3.
8. Shapiro, *Cast and Recast*, p. 76, and "Frederic Remington: Sculptor," p. 199. Bertelli explained his rather contradictory position on the posthumous castings in a letter to the curator of the Remington Art Memorial, Sarah Y. Raymond, August 12, 1927 FRAM 96.8.28:

> *As far as bronze castings are concerned, personally, I feel quite safe by saying that the words "original bronze" should be suppressed from the artistic conversation.*
>
> *All bronze castings made from a good mould, have the same intrinsic value as far as reproduction of the work, and it would be quite impossible for any expert eye to decide which one of these replicas could be called an "original."*
>
> *My opinion is that the words "original bronze" should be used only when an unique cast is made from a model of the sculptor, and then the mould and the model be completely destroyed. This, of course, would mean that the bronze cast should remain in your possession and be safely protected with copyright, so as to avoid any reproductions being made, which could be done from the bronze cast….*
>
> *In reference to Mr. Remington's bronzes [I] would say, that the work was executed under special circumstances, that involved quite and [an] expensive outlay of moulds, which we did to secure the best class of work that could be obtained in the market, with the freshness of the modeling of Mr. Remington, which he supervised himself, here at our foundry.*
>
> *For these circumstances, I feel that, if there is any reason of existence of the words "original bronze," that should be applied to the Remington bronzes.*

Michael Greenbaum has closely studied the various editions of Remington's bronzes, noting qualitative distinctions between the first eight castings of *The Cheyenne*, those numbered 9 through 20, and the rest of the edition which, in its entirety, "spans the spectrum from the finest examples of the cire perdue process to some of the poorest." (*Icons of the West*, p. 91.)

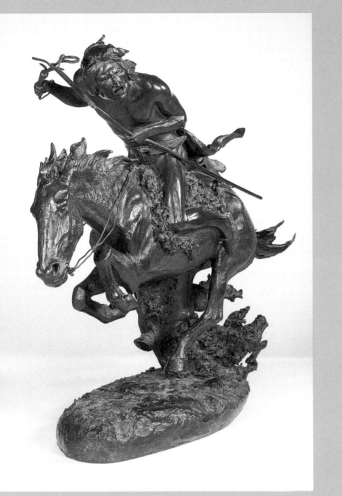

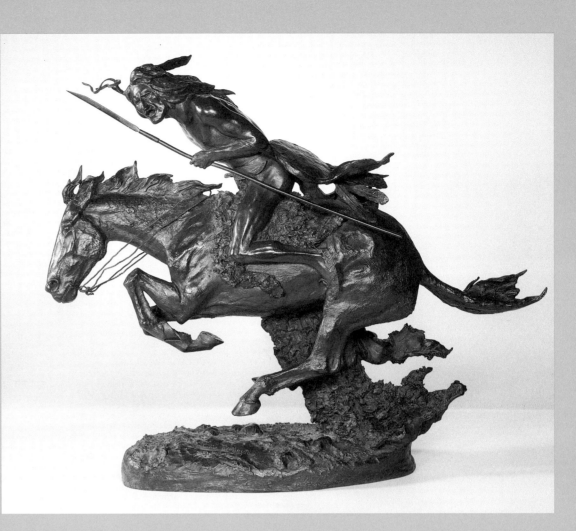

Above, left and right:
The Cheyenne © November 21, 1901
Roman Bronze Works cast no. 12 (January 24, 1906)
20 H x 24⁵⁄₁₆ W x 7" D (50.8 H x 61.8 W x 17.8 D cm.)
Gift of Mr. and Mrs. Robert Hollins; FRAM 85.5

Right:
The Cheyenne © November 21, 1901
Roman Bronze Works cast no. 79 (ca. 1918–1919)
20¹⁄₈ H x 22⁷⁄₈ W x 8¹⁄₁₆" D (51.1 H x 58.1 W x 20.8 D cm.)
Estate casting in accordance with Eva Remington's will
FRAM 66.9

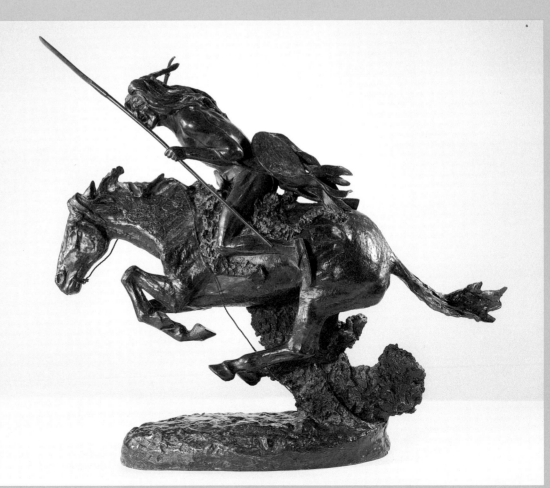

Coming Through the Rye © October 8, 1902
Roman Bronze Works cast no. 15 (ca. 1918–1919), 27$^{1}/_{16}$ H x 29 W x 27" D (68.7 H x 73.7 W x 68.6 D cm)
Estate casting in accordance with Eva Remington's will
FRAM 66.2

In his paintings, Remington favored a composition in which figures advance towards the viewer from right to left, but he occasionally ran the action straight at the viewer. This could be an effective narrative device. Illustrating a story in which a Texan mounted on a mule is chased by Apaches, Remington utilized a head-on perspective to show simultaneously flight, pursuit, one Apache shot and falling, and the Texan turning his revolver on another.[1] The charging animals run almost abreast, while the three figures are linked by the action into a single, integrated whole. Eliminate the background, tighten the grouping, and there is a sculpturesque unity to *My Second Shot Sent Him Lining Out after His Brother* of the sort Remington recognized in turning his 1888 pen sketch *Dissolute Cow-Punchers* into one of his most ambitious bronzes, *Coming Through the Rye*. The subject of cowboys on a spree was even older. Blazing pistols, galloping horses and shouting cowboys had all figured in Rufus F. Zogbaum's *Painting the Town Red* in 1886. But Remington made the subject his own when he added to *Dissolute Cow-Punchers* a more ambitious illustration, *Cow-Boys Coming to Town for Christmas*, in 1889, and then his bronze in 1902.[2] A contemporary remarked: "Here are four cowboys, wild, harum-scarum devils, shooting up a town from the mere joy of a healthy existence, plus the exhilaration produced by frontier rum! They are dashing down the street, the ponies at top speed, spurning the ground beneath their feet—and that is the marvelous part of it—only five [actually six] of those pattering hoofs touch the earth, and there are eight pairs of them!"[3] The technical feat pleased Remington as much as it did his critics as he pushed the limits of bronze and imbued his subjects with a naturalistic energy.

The key figure in *Coming Through the Rye* is the cowboy second from the left, who leans back in his saddle to let out a howl as he fires his pistol. He breaks the plane created by the other three riders, so that the bronze can be viewed pleasurably from the left side, and Remington's ultimate technical flourish appreciated—the horse and rider on the outside flying through the air. Remington accomplished this feat by having the inside rider lean back as the outside rider leans over and plants

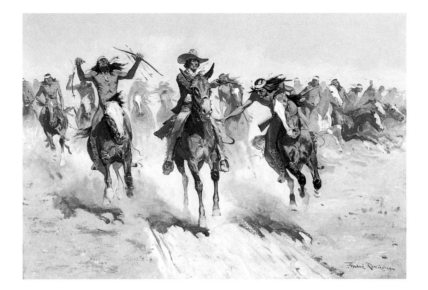

My Second Shot Sent Him Lining Out after His Brother 1901
Black and white oil on canvas, 27$^{1}/_{4}$ x 40" (69.2 x 101.6 cm.)
Signed lower right: Frederic Remington—.
Museum purchase 1973 through public donations; Ex-collection: Mrs J. Warren Joyce and
Mrs. Richard Lorraine; FRAM 73.4, CR 2594

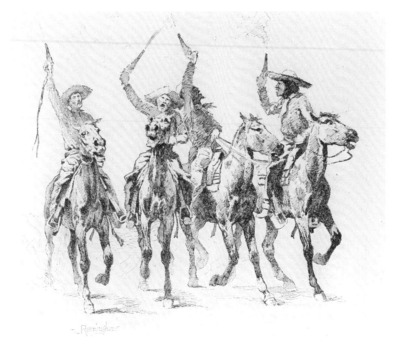

Dissolute Cow-Punchers
Century Magazine 36 (October 1888): 836

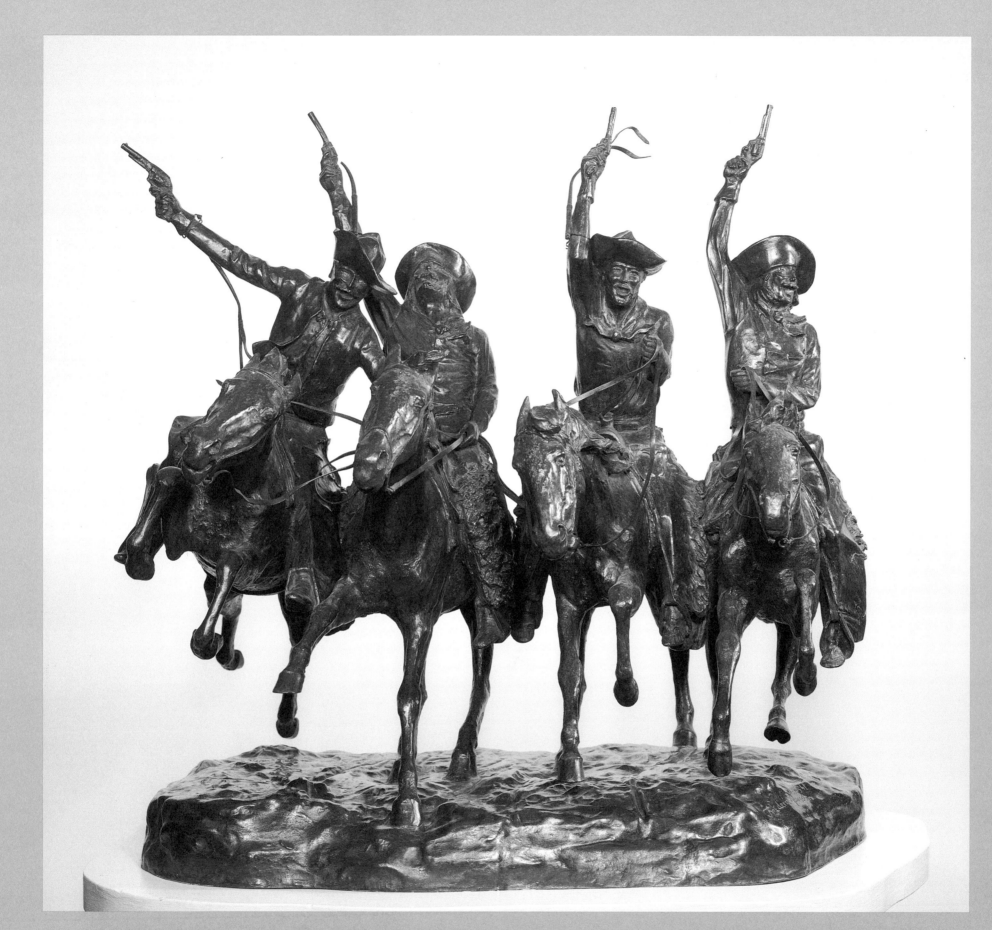

Coming Through the Rye © October 8, 1902
Roman Bronze Works cast no. 15 (ca. 1918–1919)

his hand on his horse's neck. He anticipated the pairing in his second bronze, *The Wounded Bunkie* (1896), in which a soldier shot in the saddle topples over into the arm of a comrade riding beside him.[4] The two cowboys balance one another, and the horse with three hooves on the ground supports the weight of both cowboys and the outside horse. In *Coming Through the Rye*, the four riders are joined at the knee; it might have been easier to suspend one of the inside riders in the air, letting points of contact with those on either side carry him, but the effect would have been nowhere near as dazzling.

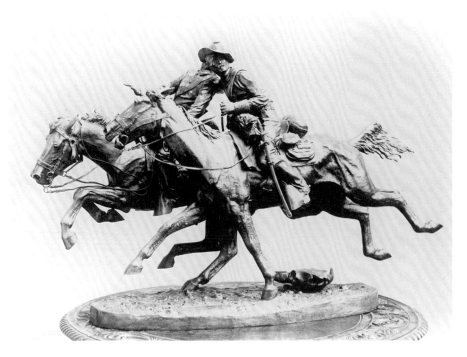

The Wounded Bunkie © July 9, 1896
FRAM 1918.76.160.249

1. *My Second Shot Sent Him Lining Out after His Brother* illustrated W. M. Edgar, "One Wagon-Train Boss of Texas," *Outing* 39 (January 1902): frontispiece.

2. See Michael Edward Shapiro and Peter H. Hassrick, *Frederic Remington: The Masterworks* (New York: Harry N. Abrams, for the Saint Louis Art Museum, in conjunction with the Buffalo Bill Historical Center, Cody, WY, 1988), p. 85. Zogbaum's *Painting the Town Red* appeared in *Harper's Weekly*, October 16, 1886, and Remington's *Cow-Boys Coming to Town for Christmas* in the *Weekly* for December 21, 1889. Still not satiated, the *Weekly* in 1900 carried Stanley L. Wood's *Cowboy Fireworks*. All three versions, along with Remington's *Dissolute Cow-Punchers*, are reproduced in John Meigs, ed., *The Cowboy in American Prints* (Chicago: The Swallow Press [Sage Books], 1972), pp. 14, 51, 59, 67. Charles M. Russell and Charles Schreyvogel also offered versions of the theme, which has become entrenched in Western lore, appearing as recently as 1993 in the motion picture *Tombstone*.

3. James Barnes, "Frederic Remington—Sculptor," *Collier's Weekly*, March 18, 1905, p. 21.

4. Notable is the fact that only two hooves touch the ground in *The Wounded Bunkie*, creating an astonishing effect without resorting to the self-conscious pyrotechnics of *Coming Through the Rye*; indeed, as a contemporary critic remarked, *The Wounded Bunkie* is notable for "the lines of the group" and its 'perfectly balanced' composition." (Charles Mason Fairbanks, "'The Wounded Bunkie,'" *Harper's Weekly*, November 28, 1896, p. 1177.) For comment on technical flaws in *Coming Through the Rye*, particularly the caricatured faces, see Michael Edward Shapiro, "Remington: The Sculptor," in Shapiro and Hassrick, *Frederic Remington: The Masterworks*, p. 207. *Coming Through the Rye* as a title was controversial. At a showing of his bronzes at Knoedler in New York City, January 1905, the title was listed as *"Comin thro' the Rye"* to emphasize its poetic source, Robert Burns (Invitation to Knoedler Gallery & Co. Exhibition, 1905); but the Corcoran Gallery in Washington, while pleased to have acquired a casting, thought the title in any form a mistake and, at Remington's suggestion, settled on *Off the Range* (F. B. McGuire to FR, February 2, 1905, FRAM 71.824.49). For the bronze and its titles, see Peggy and Harold Samuels, *Frederic Remington: A Biography* (Garden City, NY: Doubleday & Company, 1982), pp. 325–28.

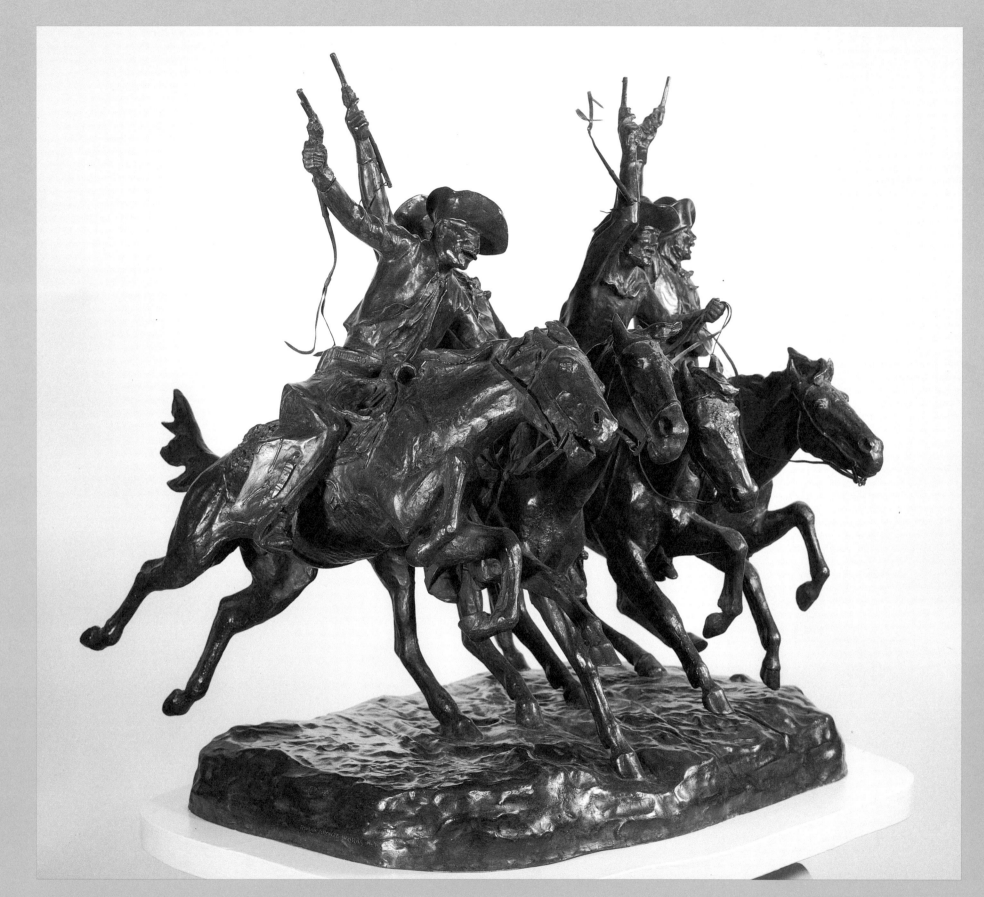

Coming Through the Rye © October 8, 1902

The Mountain Man © July 10, 1903

Roman Bronze Works cast no. 54 (ca. 1918–1919), 28½ H x 21 W x 11⅛" D (72.4 H x 53.3 W x 28.3 D cm.)
Estate casting in accordance with Eva Remington's will
FRAM 66.1

Frederic Remington favored two kinds of mountain men—the grizzled old-timer, looking bearlike in his buckskins and heavy beard, and the mixed-blood trapper, younger and smooth-faced. He gave memorable form to the second kind in an 1889 oil, *An Indian Trapper*—an ambitious painting for the time that early established his ability to nail down a "type." His passion for corroborating detail is apparent in the trapper's clothing and accoutrements, from the blanket coat and distinctive fur cap to the knife sheath, quirt, belt ax and trade rifle.

The French Trapper 1889
Pen and ink on paper,
14 x 10 ¾" (35.6 x 27.3 cm.)
Inscribed lower center: "—The French Trapper.—"
FRAM 66.254, CR 981a

In his model of *The Mountain Man*, copyrighted in 1903 and substantially modified in subsequent lifetime castings, Remington depicted a similar mixed-blood trapper—"one of these old Iriquois Trappers who followed the Fur Companies in the Rocky Mountains in the '30 & '40ties," he wrote.[1] Seen from front or side, the bronze conveys a dizzying sense of height, and stands as a tribute to the rider's risky profession as he makes his cautious descent of a dangerously steep slope. Some have read into *The Mountain Man* a comment on the precariousness of the West itself. Along with *The Broncho Buster*, it is Remington's most recognizable single-figure sculpture. In 1984 Thomas Hoving, director of the Metropolitan Museum, played agent provocateur by naming the thirty "sublime" works of art among the thousands held by American public institutions. "Although the choice will be pooh-poohed by the fashion-conscious art pundits (many of whom have not actually seen the sculpture)," he wrote, Remington's "impeccable and unforgettable" *The Mountain Man* belonged on the list.[2]

The image of a rider making a steep descent appealed to Remington's sense of the dramatic. It established the frontier milieu, where "men with the bark on" followed "crooked trails." His photograph files included pictures of European soldiers plunging down embankments, and he

worked related poses into his paintings.[3] But the obvious precedent for *The Mountain Man* is a Remington sketch of a black trooper that accompanied his 1889 account of "A Scout with the Buffalo-Soldiers," *A Study of Action*. The sharply-angled pose was even more appropriate for a tribute to a *mountain* man. In *An Indian Trapper* Remington showed his subject ascending into the high country; in *The Mountain Man*, picking his way down a precipitous slope. Together these two works (further linked by the rider's hand resting on his horse's rump, adding to the impression they are reversed images) bracketed Remington's career (with its ups and downs!). But he was not finished yet. The mixed-blood trapper reappeared in 1904 in the painting *An Old-Time Plains Fight*.

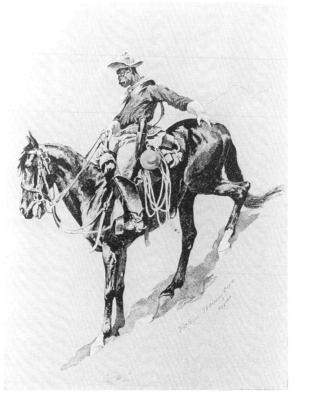

A Study of Action
Century Magazine 37 (April 1889): 905

1. Michael Edward Shapiro, *Cast and Recast: The Sculpture of Frederic Remington* (Washington, D.C.: Smithsonian Institution Press, for the National Museum of American Art, 1981), pp. 51, 77–81, which provides a casting history for *The Mountain Man* and quotes Remington's letter to the director of the Corcoran Gallery of Art, Frederick McGuire, January 29, 1905.
2. Thomas Hoving, "30," *Connoisseur* 214 (July 1984): 47.
3. See Michael Edward Shapiro, "Remington: The Sculptor," in Shapiro and Peter H. Hassrick, *Frederic Remington: The Masterworks* (New York: Harry N. Abrams, for the Saint Louis Art Museum, in conjunction with the Buffalo Bill Historical Center, Cody, WY, 1988), pp. 204, 210.

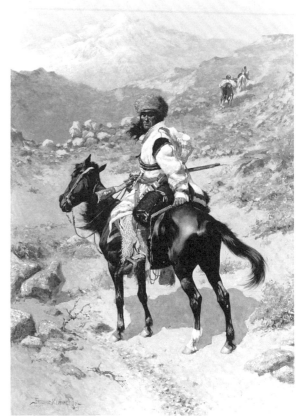

An Indian Trapper 1889
Amon Carter Museum, Fort Worth, TX
CR 981

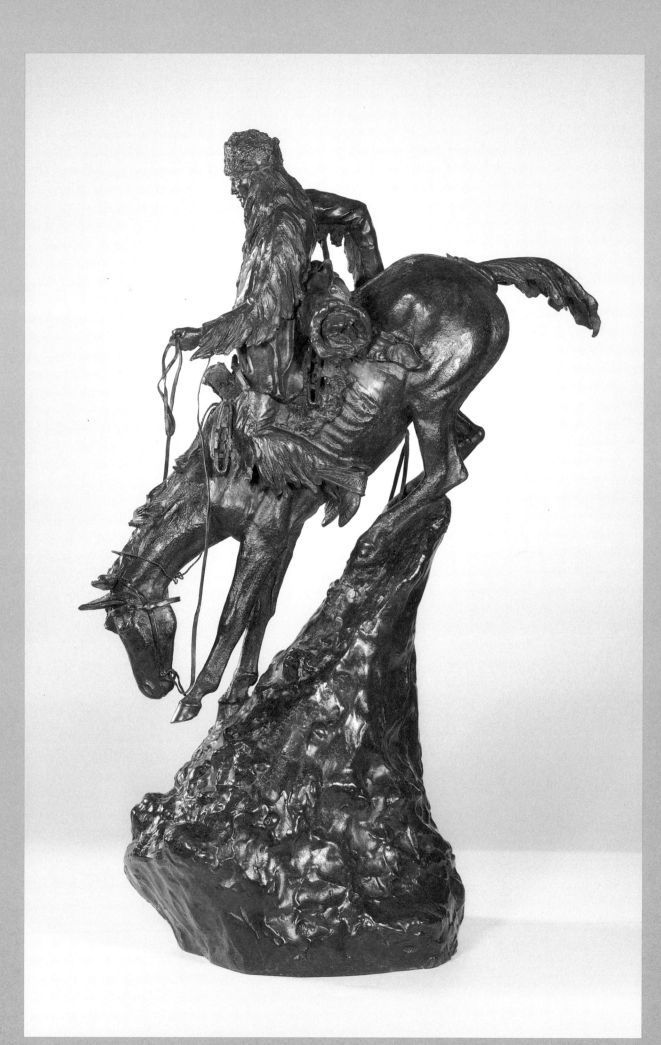

The Mountain Man © July 10, 1903
Roman Bronze Works cast no. 54 (ca. 1918-1919)

An Old-Time Plains Fight ca. 1904

Oil on canvas, 27 x 40" (68.6 x 101.6 cm.)
Signed lower right: Frederic Remington-;
lower left: copyright 1904 [1903?] by Century Co.
FRAM 66.43, CR 2721

Men at bay. Caught in the open. The desperate stand. Whatever it might be called, this was a defining Remington theme. He painted a dozen such stands—and some were last stands. He was capable of substituting a bear surrounded by hunters, or an Indian ridden down by tribal enemies. But mostly he was interested in white pioneers as symbols of the price of progress. Cowboys or soldiers were his usual representatives of besieged civilization, caught in the open—on a hill, or a plain, or by a waterhole. Sometimes he showed frontiersmen making a pellmell ride for safety with Indians in pursuit. But the theme was at its most powerful when at its starkest, when the representatives of civilization were dismounted, surrounded and vulnerable. In his world, each stand was *typical* of the sacrifices that won the West for white civilization; collectively, they justified the displacement of the natives by showing the whites as potential victims simply defending their lives, and the Indians as aggressors—a reversal of historical logic crucial to Remington's heroic vision. The set-up allowed him to admire the grim fortitude of the defenders without asking what they were doing on Indian land in the first place.

So desperate stands marked white advance across the continent, each step of the way—and rendering them marked Remington's progress, step by step. His boyhood sketches included versions of Custer's Last Stand; one, a generic *Indian Fight*, shows the cavalry riding to the rescue (thereby anticipating a slew of Hollywood Westerns!). His seminal illustrations for Theodore Roosevelt's articles on ranching life in the West published in *Century* included a full-page engraving of his 1887 painting *An Episode in the Opening Up of a Cattle Country*.[1] It was a dramatic composition in its own right, and Remington bore it in mind when, two

An Indian Fight 1878
Pen and ink sketch in "Sketches of Highland Military Academy. Fred. Remington Ogdensburg N.Y. Cadet H.M.A."
FRAM 70.758.47

years later, he submitted an oil in color to the Paris Universal Exposition (where Eiffel's Tower made its debut)—his first bid for international recognition as an artist. The new painting was titled *The Last Lull in the Fight*, and, but for a change in the setting and a reduction in the number of figures from six to four, it serves as an immediate sequel to *An Episode in the Opening Up of a Cattle Country*. Having painted a sequel—and having won praise for the unsparing realism of his work—he next painted a prelude of sorts, *A Dash for the Timber*, for exhibition at the National Academy of Design that fall. At four by seven feet, it was a crowd pleaser showing a group of riders rushing straight at the viewer, Indians in hot pursuit. The stand would follow, in the relative shelter of a wooded area.[2]

The next year Remington painted *The Last Stand*, which appeared as a double-page spread in *Harper's Weekly* for January 10, 1891. A dramatic pyramid of soldiers make their stand on a rocky hilltop. Not an Indian can be seen; but the bullets spewing up dust at their feet, and the odd Indian relic strewn in the foreground, attest to the deadly proximity of the foe. The tight cluster of troopers, their sabres planted to establish their defensive perimeter, and at ready for the final hand-to-hand struggle sure to follow; the wounded and dying men sinking to the ground, forming the base of the pyramid, with an officer and scout standing erect in the middle, their heads its apex; the dreary, heavy grey sky under which they wage their hopeless struggle; it all adds up to Remington's definitive statement on the theme of the winning of the West. Just days after the slaughter of the Lakota at Wounded Knee in Dakota Territory by an army bent on crushing the Ghost Dance—an event Remington was covering as artist-illustrator for *Harper's*—he had published his masterpiece of the *typical* honoring not the Indians, whose centuries-long war in defense of their

An Episode in the Opening Up of a Cattle Country 1887
Century Magazine 35 (February 1888): 497

The Last Stand 1890
Woolaroc Museum, Bartlesville, OK
CR 1134

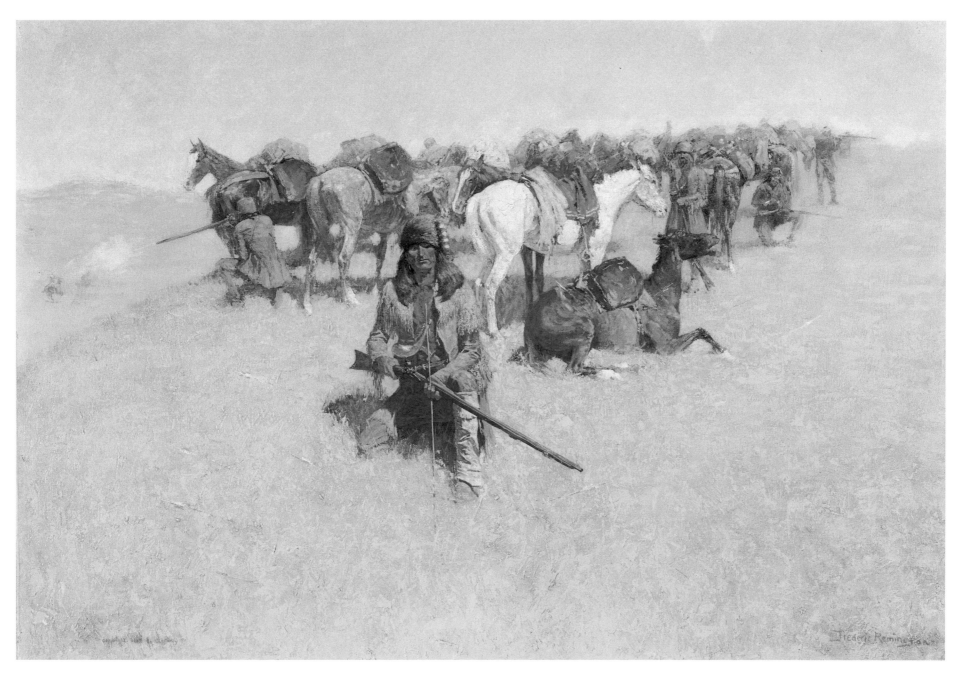

An Old-Time Plains Fight ca. 1904

homeland was over, but the soldiers who stood for the sacrifices made by all the white pioneers who had displaced them.

Other stands followed, including Remington's first appearance in full color in *Collier's Weekly*, on December 7, 1901. *Caught in the Circle* was a much simpler composition than those he had favored in the past. Essentially, it takes the pronounced pyramidical arrangement and four figures from *The Last Stand* and combines them with some of the wounded horses prominent in earlier versions to create a stark rendition of the theme. Remington would return to it again in two exceptional oils, *Fight for the Water Hole* (1903) and *An Old-Time Plains Fight* (ca. 1904). The men at bay in the one form a baseball diamond, in the other, an inverted triangle, and the geometric elegance of each composition underscores the impression of calm at the center of a storm.

An Old-Time Plains Fight was one of Remington's last major illustrations. He had longed to be free of the imperatives of embellishing another's words—indeed, had himself written essays and books to provide congenial subjects to illustrate—and in 1903 concluded an agreement with Robert J. Collier that put him on an annual retainer and freed him up to paint what he wanted, granting *Collier's Weekly* exclusive reproduction rights to his work.[3] But outstanding obligations had to be satisfied, and they included four illustrations for a history of the fur trade by Agnes Laut that appeared in the *Century Magazine* for April 1904. Three showed mountain men, including *An Old-Time Plains Fight*. It did not correspond to a specific passage in Laut's rather dry account, but represented the general situation after 1820 when fur traders entered Indian country in parties strong enough "to defy attack by hostiles or rivals."[4] The mixed-blood trapper in the foreground—a throwback to the figure in *An Indian Trapper* and the bronze *The Mountain Man*—is all businesslike competence, unperturbed by the arrows bristling in the grass, conserving his powder and coolly awaiting an opportunity to return fire.[5] His level gaze promises a lethal shot. He is a Remington ideal: the hero in charge of himself, and thus in charge of his own destiny. Self-mastery. Self-reliance. The Western myth in a single image.

Caught in the Circle
Collier's Weekly, December 7, 1901, pp. 20-21

Fight for the Water Hole ca. 1903
The Museum of Fine Arts, Houston
The Hogg Brothers Collection
Gift of Miss Ima Hogg; CR 2703

A Citadel of the Plains
Frederic Remington, *Drawings* (New York: R. H. Russell, 1897)

1. Theodore Roosevelt, "Ranch Life in the Far West: In the Cattle Country," *Century Magazine* 35 (February 1888): 497.
2. Peter H. Hassrick, "Remington: The Painter," in Michael Edward Shapiro and Peter H. Hassrick, *Frederic Remington: The Masterworks* (New York: Harry N. Abrams, for the Saint Louis Art Museum, in conjunction with the Buffalo Bill Historical Center, Cody, WY, 1988), pp. 69–73.
3. Harold McCracken, *Frederic Remington: Artist of the Old West* (Philadelphia: J. B. Lippincott Company, 1947), p. 115, quoting a letter of agreement in Robert J. Collier's hand, dated May 1, 1903. The location of the original is unknown.
4. Agnes C. Laut, "The Fights of the Fur Companies: A Chapter of Adventure in the Louisiana Purchase," *Century Magazine* 67 (April 1904): 812.
5. For *An Indian Trapper* see p. 140. A precedent for *An Old-Time Plains Fight* is a painting Remington later burned, *A Citadel of the Plains*, which appeared in *Drawings* (New York: R. H. Russell, 1897). The strength of the later version is especially evident in comparing the two.

Opposite page, detail:
An Old-Time Plains Fight ca. 1904

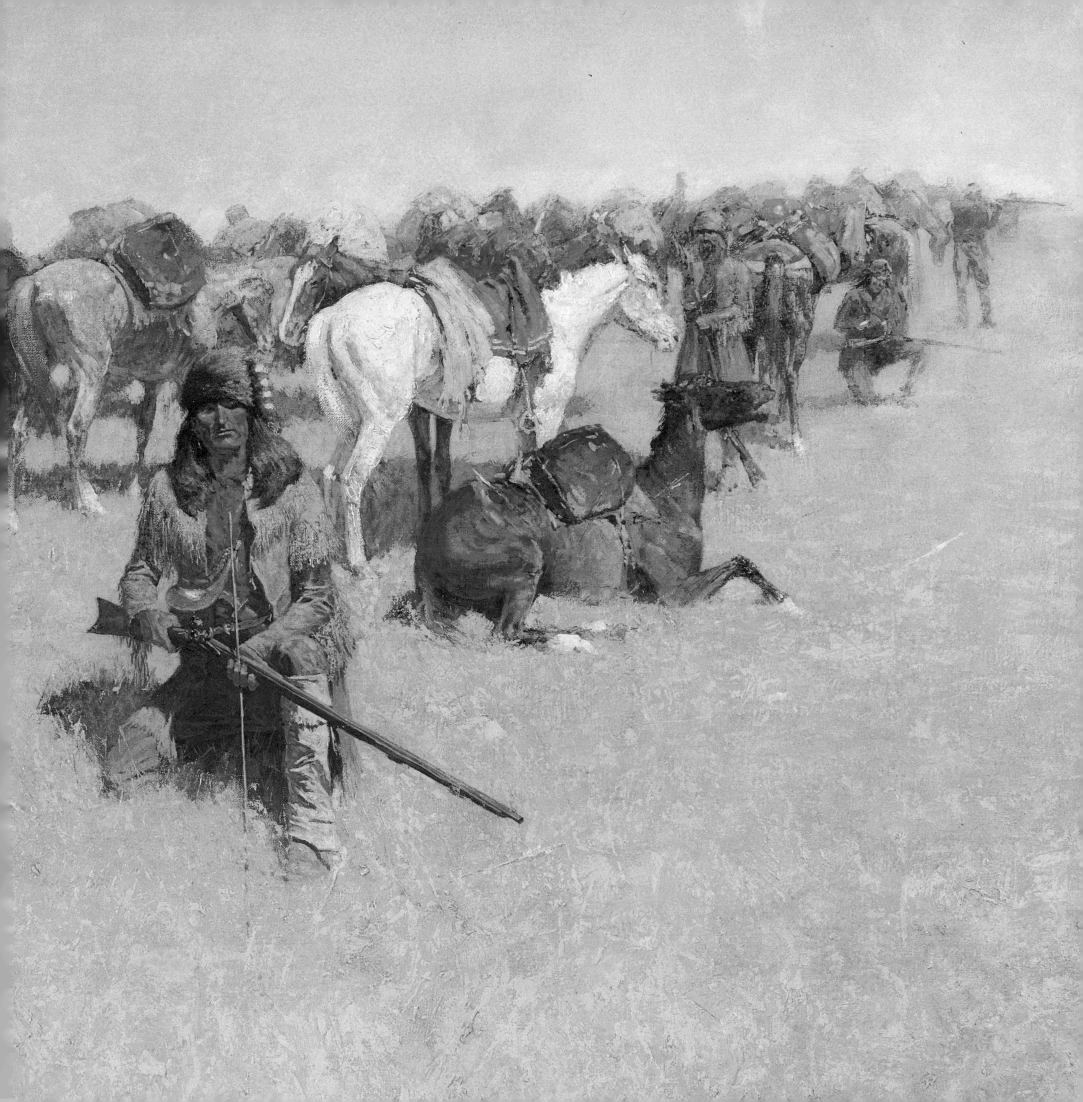

The Sergeant © July 30, 1904
Roman Bronze Works unnumbered cast, 10³/₁₆ H x 4¹³/₁₆ W x 5⁷/₁₆ D " (25.9 H x 10.2 W x 13.8 D cm.)
Estate of Eva Remington; FRAM 66.13

The subject of *The Sergeant* is often mistaken for a grizzled veteran of the Indian wars, but Remington actually intended the bronze as a tribute to a more recent ideal, the cowboys who rallied to their country's call in 1898 and volunteered for service in the First U.S. Volunteer Cavalry, the Rough Riders. Thus *The Sergeant* combines two Remington "types"—cowpuncher and soldier. His pleasure in modeling the craggy features is evident. In the record of copyrights kept by Eva Remington, this appears for *The Sergeant*: "Stern face—sharp nose—heavy moustache—prominent chin, cheek sunken. Hat tilted on back of head. Handkerchief around neck—"[1] And when Remington provided a pen sketch to decorate the brochure for his bronze exhibition at Knoedler Gallery in early 1905, it was *The Sergeant* that he chose to show. Here was one of his classic Western types updated to appeal to a new audience, and with its patriotic credentials in place. After all, Theodore Roosevelt himself, now ensconced in the White House, had given his nod of approval to Remington's subject.

As fond of types as Remington, Roosevelt, in the first of his articles about ranching in Dakota which Remington had illustrated back in the 1880s, had waxed eloquent on cowboys:

They are smaller and less muscular than the wielders of ax and pick; but they are as hardy and self-reliant as any men who ever breathed—with bronzed, set faces, and keen eyes that look all the world straight in the face without flinching as they flash out from under the broad-brimmed hats. Peril and hardship, and years of long toil broken by weeks of brutal dissipation, draw haggard lines across their eager faces, but never dim their reckless eyes nor break their bearing of defiant self-confidence… their appearance is striking…, and picturesque too, with their jingling spurs, the big revolvers stuck in their belts, and bright silk handkerchiefs knotted loosely round their necks over the open collars of the flannel shirts.[2]

"One of the boys" who accompanied Roosevelt in pursuit of three common thieves in 1886 (see pp. 60–63) served as Remington's inspiration in creating his version of the cowboy type in 1887.[3] Because the black and white oil titled *One of the Boys* shows only the cowboy's head, it is even more suggestive of the later bronze. Remington had not previously attempted a bust sculpture, but his approach in 1904 was effective: he dispensed with the shoulders and allowed the bandana to hold the head high, creating a Western air while carrying off the cocksure tone of the piece.

In making *The Sergeant* a cowboy-soldier, Remington naturally made reference to the President's service with the Rough Riders. The regiment had been recruited primarily in the four Western territories—New Mexico, Arizona, Oklahoma and Indian Territory. Describing the types who volunteered, Roosevelt wrote:

They were a splendid set of men, these South-westerners—tall and sinewy, with resolute, weather-beaten faces, and eyes that looked a man straight in the face without flinching….

In all the world there could be no better material for soldiers than that afforded by these grim hunters of the mountains, these wild rough riders of the plains.[4]

The Sergeant, in short, was a page from President Theodore Roosevelt's unchanging book of Western types, illustrated, as ever, by his favorite artist, Frederic Remington.

1. Eva Remington notebook of stocks, copyrights, etc., FRAM 96.2.
2. Theodore Roosevelt, "Ranch Life in the Far West: In the Cattle Country," *Century Magazine* 35 (February 1888): 502.
3. *One of the Boys* illustrated Theodore Roosevelt, "Sheriff's Work on a Ranch," *Century Magazine* 36 (May 1888): 42.
4. Theodore Roosevelt, "The Rough Riders: Raising the Regiment," *Scribner's Magazine* 25 (January 1899): 11.

Cover of the brochure for the Knoedler exhibition of Remington Bronzes, 1905
FRAM 71.824.72d

One of the Boys 1887
Black and white oil on academy board. 17¼" x 15⅞" (45.1 x 40.3 cm.)
Signed center right: Remington. / '87
Ex-collection: Gump's, San Francisco; private collector, 1930s; inherited by collector's son in 1950; gift of Chuck and Nan Wells; FRAM 91.6, CR 186

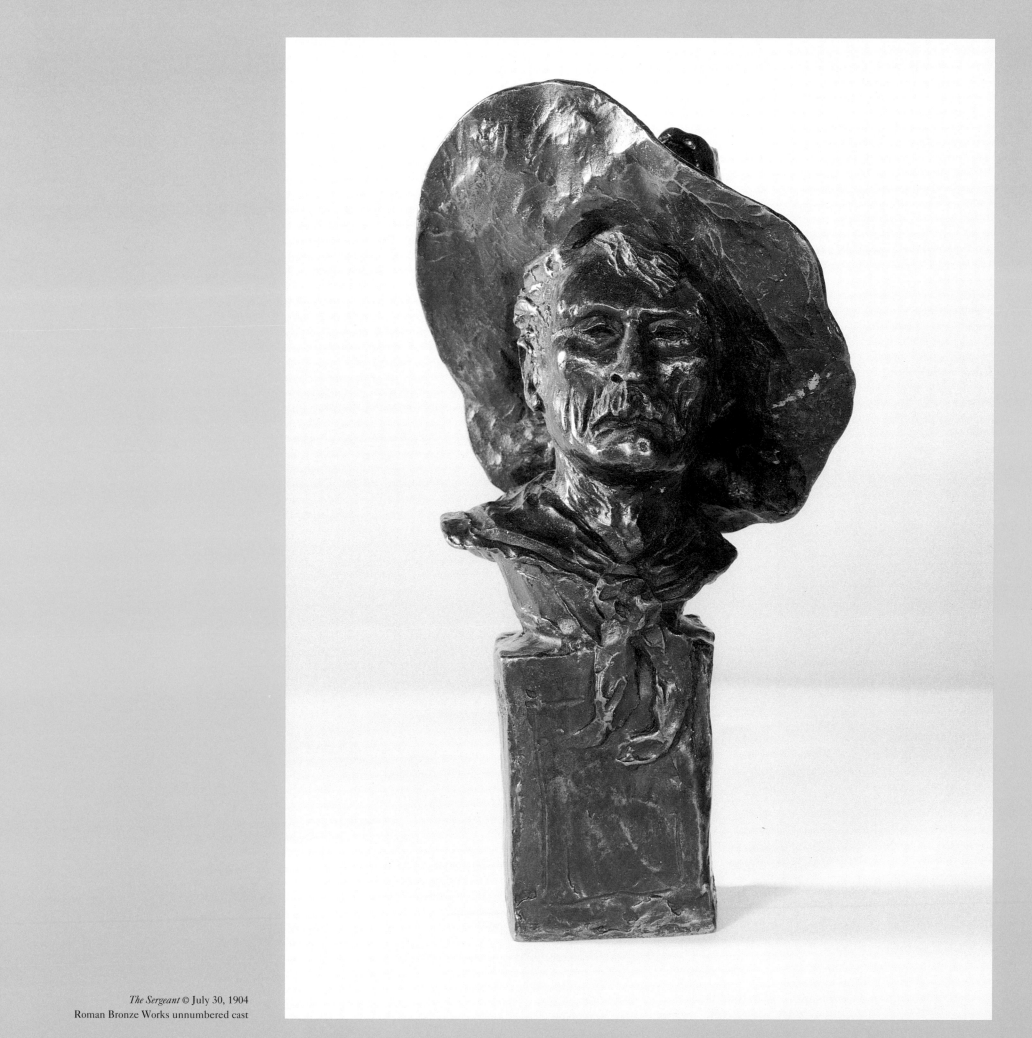

The Sergeant © July 30, 1904
Roman Bronze Works unnumbered cast

Polo © July 21, 1904
Roman Bronze Works cast no. 2 (1905) 21¹³⁄₁₆ H x 19¹³⁄₁₆ W x 19⁹⁄₁₆" D (55.4 H x 50.36 W x 49.7 D cm.)
Estate of Eva Remington; FRAM 66.10

Sculpture permitted two Frederic Remingtons to coexist. The old black-and-white man was able to turn off his color sense and indulge his love of form. It was a respite from his struggle to solve the problems of harmony and tonality in painting, and in his last years he went for sustained periods without painting at all as he directed his attention to mass and clay. The very different technical problems sculpture presented engrossed him. In 1904 he tackled a subject outside his usual line. He had often been assigned to illustrate military subjects unrelated to the frontier, and as a self-professed expert on horseflesh had covered the horse shows, horse races—and polo matches. From his perspective, a tough polo match was what a battle was supposed to be. It had all the elements of close combat—horsemanship and skill, courage and self-sacrifice, risk and danger. But it was battle without the intentional carnage, where the chivalric code of honor sadly lacking in modern warfare was translated into good sportsmanship. It is not surprising that there is such a close parallel between *Polo* and a Remington depiction of hand-to-hand combat like *Thrust His Lance Through His Body and Rode Him Down* (1889)—nor, for that matter, that a bronze like *Dragoons 1850* (1905) would "read" so much like one of Remington's illustrations of a polo match (see pp. 168–169).

Polo was limited to two lifetime castings. Perhaps the fallen horse's anatomical display offended propriety. Certainly, Remington had approached the group with calculation, as a technical exercise. Not a horse's hoof touches the ground—thus admitting Remington to the ranks of those who had mastered the art of levitation! *Polo*'s structure was carefully worked out. From one angle, the group forms an almost perfect pyramid, with the erect rider's head its apex and the apparent jumble of horses' heads and legs its slopes. It was also an exercise in texture. "The ponies and the 'fellows by jove' are slick," Remington wrote, "—so smoothe that a fly would sprain his ankle if he lit on them— but I'll soon be back to my less curried people who are more to my mind." Since *Polo* was such a depar- ture from the rest of his sculpture showing men *and* horses with the bark on, Remington may have been prepared for rejection. Still, he hoped "the dear d— public will like Frederic in his new costume."[1]

1. FR to Jack Summerhayes, [1904], *Selected Letters*, p. 347. Remington titled a book *Men with the Bark On* (New York: Harper & Brothers, 1900), and earlier used the phrase in a letter of January 29, 1893, to Poultney Bigelow: "d— Europe—the Czar—the arts—the conventionalities—the cooks and the dudes and the women—I go to the simple men—men with the bark on—the big mountains—the great deserts and the scrawny ponies—I'm happy" (*Selected Letters*, p. 157).

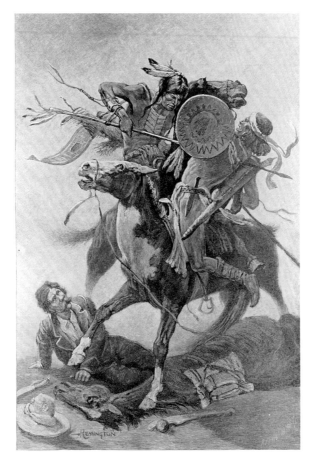

Thrust His Lance Through His Body and Rode Him Down
Harper's Weekly, December 7, 1889, p. 980

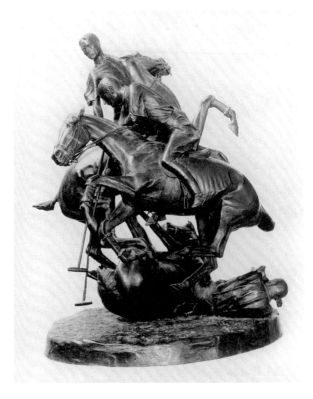

Polo © 1904
Photograph
FRAM 1918.76.73

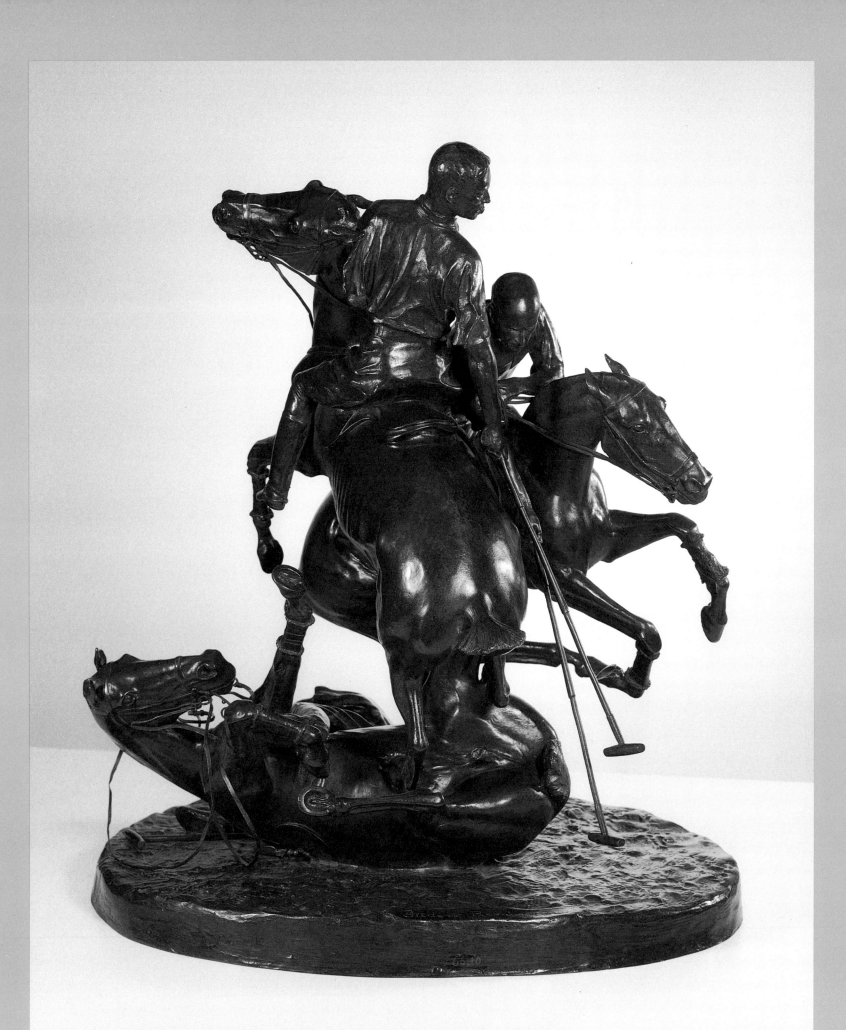

Polo © July 21, 1904
Roman Bronze Works cast no. 2

The Scalp © December 8, 1898 as *The Triumph*; remodeled ca. 1904

Roman Bronze Works cast no. 14 (ca. 1918–1919), 24⁵/₁₆ H x 21³/₈ W x 9¹/₄" D (61.8 H x 55.6 W x 23.5 D cm.)
Estate casting in accordance with Eva Remington's will
FRAM 66.7

*T*he *Scalp* found Remington at odds with himself. It was his first Indian sculpture, modeled in 1898, and was in keeping with his understanding of primitive savagery. Others had done the Indian—indeed, Augustus Saint-Gaudens called Indian subjects "the youthful sin of every American artist"[1]—but their sculptures were in either the heroic or the pathetic tradition, and thus highly romanticized by Remington's standards. He had made the "real" Indian a figure in his art, educating the public through word and picture. He apparently meant to do the same through bronze, though the theme he chose was actually a venerable one by 1898: an Indian holding aloft the scalp of a vanquished foe and emitting a triumphant howl. Seth Eastman's *The Death Whoop* (1850) had decorated the covers of all six volumes of Henry R. Schoolcraft's congressionally-subsidized work *Information Respecting the History, Condition and Prospects of the Indian Tribes of the United States* (1851–1857), and Eastman was not the first Western artist to portray scalping: George Catlin and Karl Bodmer both come to mind. But Eastman's *Death Whoop* (also known as *Scalp-Cry*) inspired countless imitations. Almost every popular history of the Indian wars in the late nineteenth century included an illustration or two of bloodthirsty savages wielding knives and waving scalps.[2]

The *Scalp* fit into an established iconographic tradition, then, but Remington added his own twist by putting the Indian on horseback. He had worked out the basic pose in *The War Song*, an illustration for Parkman's *The Oregon Trail* showing White Shield riding through his village, war-club held high, inciting the Lakota warriors to accompany him on a raid. The subject appealed to Remington enough that he worked it up into a major oil, *The Defiance*, in which the warrior now challenged a distant line of soldiers with his war-club.[3] The bronze substituted a scalp for the club, but if savagery was the intended message, Remington undercut it by his heroic treatment. In the sand casts of *The Scalp* made by the Henry-Bonnard Bronze Company between 1898 and 1900, the horse skids to a halt as the warrior, a rifle cradled in his left arm, whirls to face the viewer and display his trophy. A contemporary critic, Charles H. Caffin, was enthralled. He praised *The Scalp* as Remington's most technically accomplished bronze:

The composition is built up with a true feeling for what is big and impressive. The line made by the horse's fore leg upon the ground and the man's arm is an axis of determined energy, around which the rest of the parts are distributed with an excellent sense of balance. There is also a fine crescendo of energy. If you trace it upwards you will find no anticlimax; the supreme point, in every sense, is the clinched [sic] fist.[4]

As important as the vertical line created by the horse's stiffly planted left foreleg is the sloping line created by its right foreleg which, lifted high, echoes the Indian's upraised right arm and moves the eye effortlessly to the apex of the composition.

In praising *The Scalp*, Caffin was expressing a preference for the relatively conventional over the more innovative. After all, the idea of an equestrian Indian sculpture had been anticipated by Cyrus Dallin's *The Signal of Peace*, which half the country (including Remington, no doubt) saw at the World's Columbian Exposition in Chicago in 1893. And certainly *The Scalp* is a far less technically daring achievement than *The Broncho Buster*, *The Wounded Bunkie* and *The Wicked Pony*, which preceded it. But Caffin was also acknowledging the heroic effect of *The Scalp*. Whatever Remington's intentions when he created the group in 1898, he may have come to accept alternative readings of its meaning. In anticipation of an exhibition of his bronzes at Knoedler Gallery & Co. in January 1905, he reworked his original model for lost-wax casting by the Roman Bronze Works. He replaced the rifle with a war-club, turned the Indian's face slightly forward so that the tilt of the chin facilitated the upward movement (the "crescendo of energy"), and he repositioned the horse's left rear leg as it braces on what is now the marked incline of the base.[5] The triangle formed by its rear legs creates an aesthetically pleasing effect that simultaneously heightens the heroic impact of the group. No wonder some contemporaries thought *The Scalp* a tribute to the American Indian. "I went the other day to see those ripping bronzes of yours," R. W. Gilder, editor of *The Century*, wrote Remington in 1906:

They are all thoroly alive and thoroly original. There was one that impressed me especially, as it

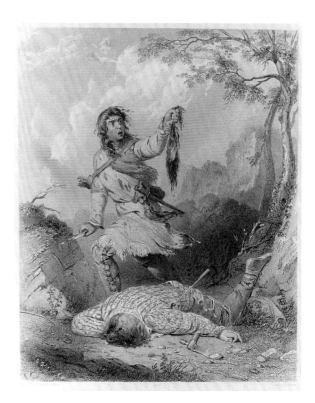

After Seth Eastman, *Scalp-Cry* [*The Death Whoop*] 1850
Henry R. Schoolcraft, *History of the Indian Tribes of the United States…*, vol. 2 (Philadelphia: Lippincott, Grambo, 1852), plate 10

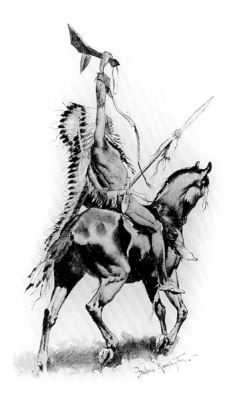

The War Song
Francis Parkman, *The Oregon Trail: Sketches of Prairie and Rocky-Mountain Life* (Boston: Little, Brown, and Company, 1892), p. 255

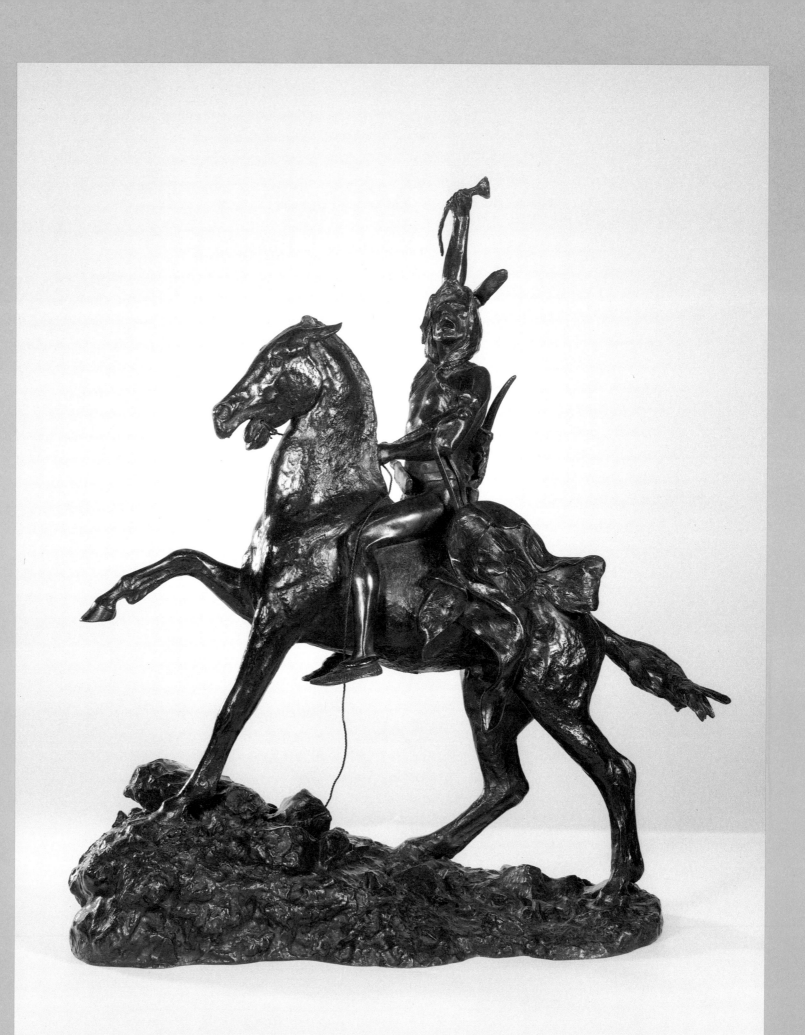

The Scalp © December 8, 1898 as
The Triumph; remodeled ca. 1904
Roman Bronze Works cast no. 14
(ca. 1918–1919)

had more beauty than some of the others, tho they all have the beauty of life. I mean the solitary Indian with his arm up, apparently shouting defiance to the whole tribe of the paleface. What do you call that one? You seem to sum up the wildman's attitude in that one gesture; and the horse in that is especially fine.[6]

Gilder could be discussing another Cyrus Dallin monument, *The Protest* (1904), which, like *The Signal of Peace*, showed a mounted Indian in full headdress with upraised right arm. Instead of offering a greeting of welcome, however, this Indian shakes a clenched fist at the white intruders; he symbolizes historical resistance.[7] That *The Scalp* was subject to similar interpretation indicates how far the concept had moved from Remington's original intention.

The revised model of *The Scalp* also bears comparison to Remington's only monumental sculpture, *The Cowboy*, which he completed in 1908 on commission for the Fairmount Park Art Association in Philadelphia. In both, the basic position of the horse's legs—one front leg lifted, the back legs separated to brace the animal on an incline—as well as the head tucked to the neck and the flying tail convey the impression of arrested motion. Since the rider in *The Cowboy* is bent forward in the saddle and his horse's head is down, the sculpture's line departs from the vertical thrust of *The Scalp*. But the close resemblance between the two suggests another reason why some regarded *The Scalp* as a tribute to the Indian. After all, it *looked* like *The Cowboy*, which was obviously heroic. Exhilarated by his success at meeting the challenges presented by monumental sculpture, Remington was more than ready to similarly honor other frontier "types." "I hope now some one will let me do an indian and a Plains cavalryman and then I will be ready for Glory," he wrote the secretary of the Fairmount Park Art Association after *The Cowboy's* unveiling—though Fairmount Park was not in the market for a Remington Indian, having commissioned *The Cowboy* to pair up with Cyrus Dallin's *The Medicine Man* (installed 1903).[8] There was talk in 1909 of erecting a memorial "to the memory of the North American Indian" on Staten Island, and both Dallin and Remington were interested in the commission.[9] The scheme never came to fruition, and Remington was dead by the end of the year. But one can speculate on what he might have produced—*The Scalp* transformed back into *The War Song*, perhaps.

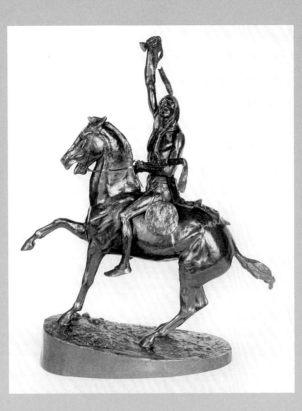

The Scalp
The Henry-Bonnard Bronze company cast no. 1 (1898)
The R. W. Norton Art Gallery, Shreveport, LA

The Cowboy, Fairmount Park, Philadelphia, 1908
Photograph, Book of Sculpture
FRAM 71.835

1. Royal Cortissoz, *American Artists* (New York: Charles Scribner's Sons, 1923), p. 71.
2. Eastman's *The Death Whoop* has a woodland setting; a distinctively plains Indian companion piece is Valentine W. Bromley's *Pahauzatanka, the Great Scalper* (1876). Mounted warriors with scalps in hand appeared mostly after 1898, though Richard C. Woodville's *Indian on Horseback Holding Scalp* probably preceded Remington's sculpture by a decade. Later examples include Carl Hassman's *Triumphant Warrior with Scalp* (1907) and Charles Schreyvogel's *The Scalp-Lock* (ca. 1900) and *The Victory* (ca. 1912). For Bromley and Woodville, see Paul Hogarth, *Artists on Horseback: The Old West in Illustrated Journalism 1857–1900* (New York: Watson-Guptill Publications, in cooperation with the Riveredge Foundation, Calgary, 1972), frontispiece, p. 210; and for Hassman, *American Paintings: Historical—Genre—Western* (New York: Edward Eberstadt & Sons, Catalogue 146, 1958), #79. Those interested in Schreyvogel's debt to Remington should compare *The Scalp-Lock* (Gustav Kobbe, "A Painter of the Western Frontier," *Cosmopolitan* 31 [October 1901]: 566) to *The Scalp*.
3. *The Defiance* was put up for auction in New York on January 13, 1893 at the conclusion of Remington's first one-man exhibition (*Catalogue of a Collection of Paintings, Drawings and Water-colors by Frederic Remington, A.N.A.* [New York: The American Art Galleries, 1893], #46), and again on May 28, 1987 (*Important American Paintings, Drawings and Sculpture* [New York: Sotheby's, Sale 5584, 1987], #140) under the title *Indian in Headdress*. It is illustrated in color in the Sotheby catalog.
4. Charles H. Caffin, "Frederic Remington's Statuettes: 'The Wicked Pony' and 'The Triumph,'" *Harper's Weekly*, December 17, 1898, p. 1222. *The Scalp* at the time was also known under the variant title *The Triumph*.
5. See Michael Edward Shapiro, *Cast and Recast: The Sculpture of Frederic Remington* (Washington, DC: Smithsonian Institution Press, for the National Museum of American Art, 1981), pp. 70–72.
6. R. W. Gilder to FR, March 24, 1906, FRAM 71.823.60.
7. Dallin was out to create a historical progression of four statues, each an independent allegorical work that collectively told the story of Indian dispossession and defeat. He sculpted *The Medicine Man* in 1898, five years after *The Signal of Peace* and four years before *The Protest*, and concluded the series with *The Appeal to the Great Spirit* in 1908. In his album "Book of Sculpture" (FRAM 71.835) Remington included pictures of all except *The Protest*. For Dallin's Indian sculptures, see John C. Ewers, "Cyrus E. Dallin: Master Sculptor of the Plains Indian," *Montana, the Magazine of Western History* 18 (January 1968): 34–43.
8. FR to Leslie Miller, June 25, [1908], *Selected Letters*, p. 392; Peggy and Harold Samuels, *Frederic Remington: A Biography* (Garden City, NY: Doubleday & Company, 1982), p. 365.
9. Brian W. Dippie, *The Vanishing American: White Attitudes and U.S. Indian Policy* (Lawrence: University Press of Kansas, 1982 [1991]), pp. 214, 217; Diary, May 12, 1909, FRAM 71.816.

Opposite page, detail:
The Scalp © December 8, 1898 as *The Triumph*; remodeled ca. 1904

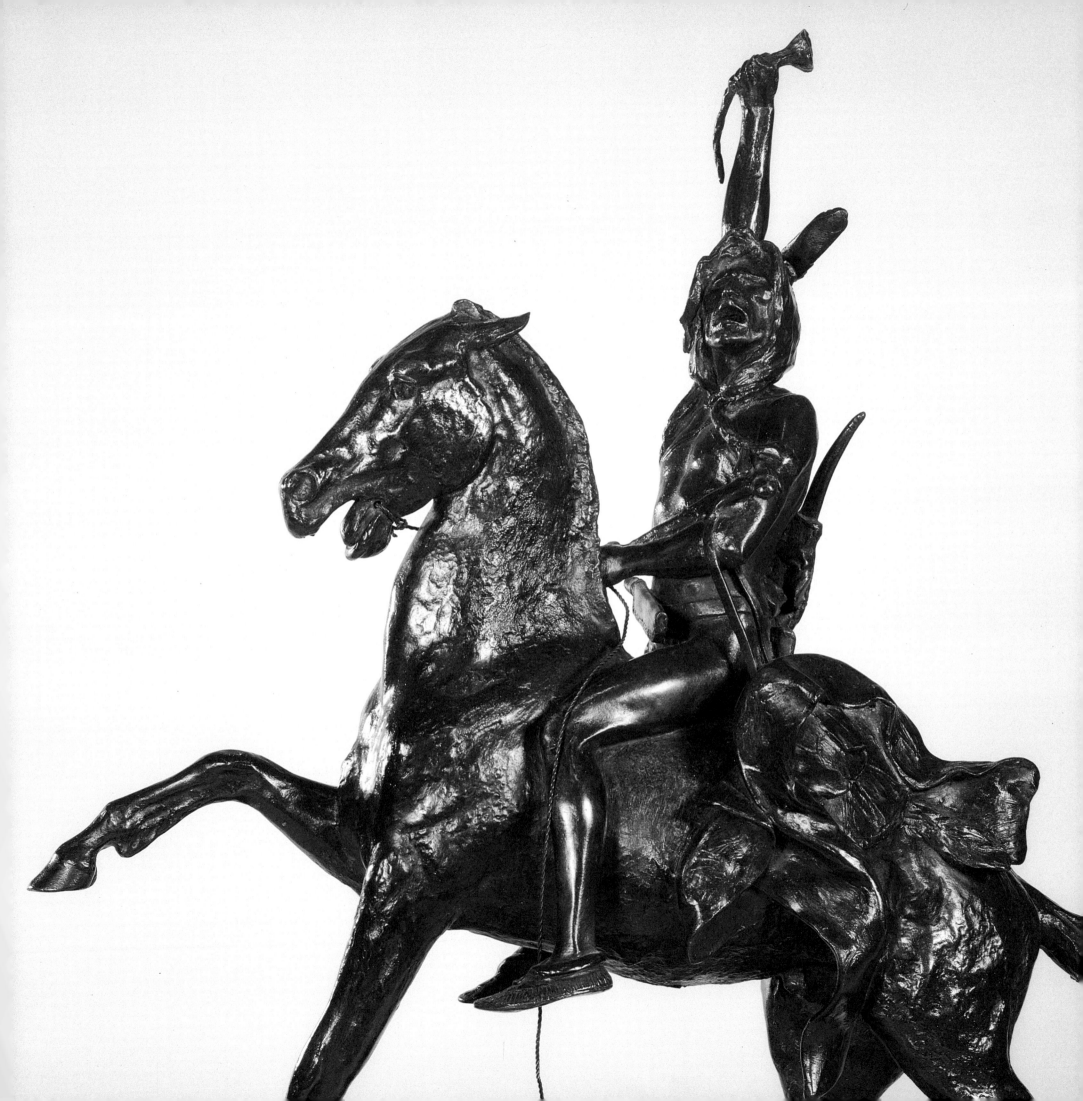

The End of the Day 1904

Oil on canvas, 26½ x 40" (67.3 x 101.6 cm.)
Signed lower right: Frederic Remington—.
FRAM 66.36, CR 2736

*T*he *End of the Day* shows two exhausted horses and a tired man whose work is almost done as he prepares to unhitch his team in the premature darkness of a winter's day. After the horses have been fed and stabled, their master will take his own ease in some brightly lit cabin where a blazing fire, a pipe and a dram or two await him. Though it shows a life of toil, *The End of the Day* imparts a festive air. The falling snow, the buildings and street and pine tree under a mantle of white, and the windows with their glowing invitation create an almost palpable sense of serenity and contentment. The painting looks like a Christmas card—indeed, Remington had actually conveyed his Christmas greetings to an uncle in Canton with a pen drawing of two patient horses hitched to a sled. *Collier's Weekly* reproduced *The End of the Day* as a double-page color spread in its issue of December 17, 1904.

The colors in *The End of the Day* are typical of Remington's nocturnes at a time when he still favored "the soft gray-blues of the moonlight,"[1] and had not yet begun to experiment with greens and browns. Here, a cold blue tone pulls together dark shadows and snow, while the yellow splashes of light provide warm contrast. In other respects, the painting, like his bronze *Polo*, was something of a departure for Remington. He drew its basic composition from his 1897 Western scene *Cow Pony Pathos*, showing horses at a hitching post blanketed by snow. But its immediate inspiration was a photograph in his collection of a man feeding a work horse on a winter's day, and it anticipates the North Country direction that several of his major paintings took in this period.

1. FR, "The Great Medicine-Horse: An Indian Myth of the Thunder," *Harper's Monthly*, September 1897; *Collected Writings*, p. 263.

Merry Christmas ca. 1890s
Ink on paper, 9 x 17" (22.9 x 43.2 cm.)
Signed middle right: Remington; inscribed lower left:
Merry ChristmAs
Ex-collection: William R. Remington, Canton, NY;
FRAM 66.99, CR 83

Cow Pony Pathos
Frederic Remington, *Drawings* (New York: R. H. Russell, 1897)

Photograph of man with horse
FRAM 1918.76.160.418

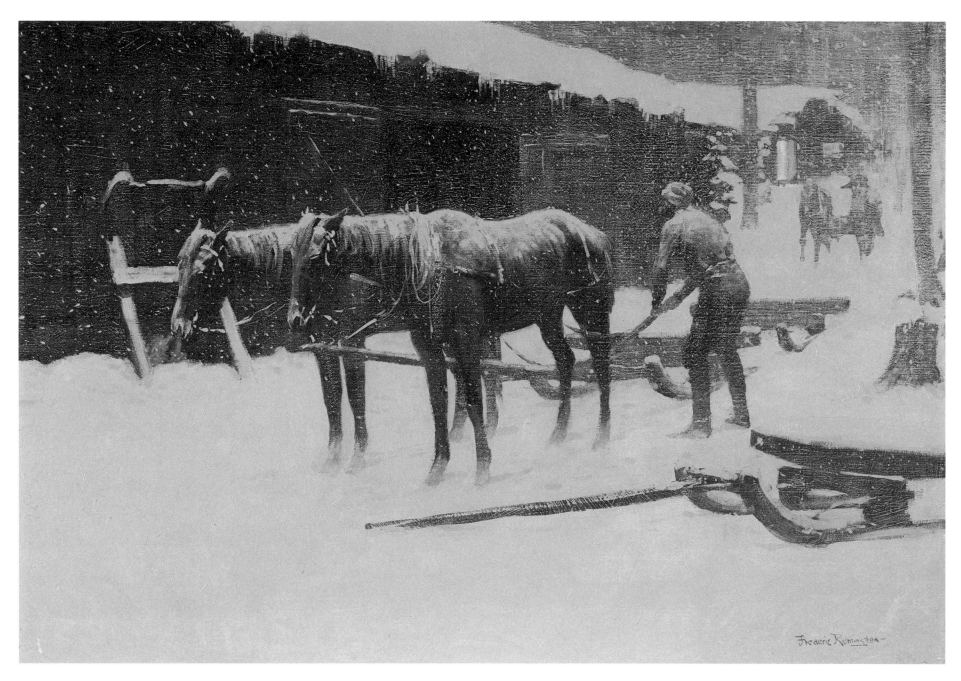

The End of the Day 1904

The Howl of the Weather 1905–1906; © 1906
Oil on canvas, 27 x 40" (68.6 x 101.6 cm.)
Signed lower right: Frederic Remington—.
FRAM 66.49, CR 2787

On January 18, 1906, Frederic Remington copyrighted nineteen oil paintings that were to be included in his annual spring exhibition at the Noe Galleries in New York City.[1] He obviously had been busy since his previous year's exhibition closed on April 1. Three of his new paintings—*The Howl of the Weather*, *Hauling the Gill Net* and *River Drivers in the Spring Break Up*—were distinguished by their subject matter. Instead of showing Western scenes, they were set in the area Remington knew best, his own home country, the St. Lawrence and Great Lakes region. Each pits man against the elements. If the paintings were an experiment in broadening Remington's appeal, it failed from a commercial point of view, since none sold. Thus they remained in Remington's hands at the time of his death in 1909, and now, appropriately, are displayed with the rest of the estate collection just a short stroll from the banks of the St. Lawrence River.

Remington portrayed canoeing at every stage of his career, and paid loving tribute to its pleasures in an 1893 article, "Black Water and Shallows." "The long still water is the mental side of canoeing," he observed, "as the rapid is the life and movement."[2] He recognized that what was sport for the urban outdoorsman was an essential mode of transportation for those who lived in the wilderness, and his pictures ranged from placid trout-fishing scenes to a painting as charged with energy as *The Howl of the Weather*. Greys dominate the picture, in the water, the distant hills and the sky overhead. Things *move*. The water and the weather contest the paddlers racing the storm to safety on an unseen shore. The frightened child clings to its mother, who looks as though she could use reassuring herself as she grasps the side of the canoe for support and with her other hand draws her blanket across to fend off the biting cold. The men, however, paddling furiously into the teeth of the gale, appear to relish the challenge. They lean into their work, the thrusting stroke of the one expertly implied by a thin line of brown paint for his paddle and white paint for the water dripping off its end.

The range of emotions shown in *The Howl of the Weather* makes it a human drama. In 1890

An Indian Canoe on the Columbia 1890–1891
Ink wash on paper, 15 x 22" (38.1 x 55.9 cm.)
Signed lower right: FREDERIC REMINGTON.—
Ex-collection: Mrs. E. C. Upton; FRAM 77.8, CR1173

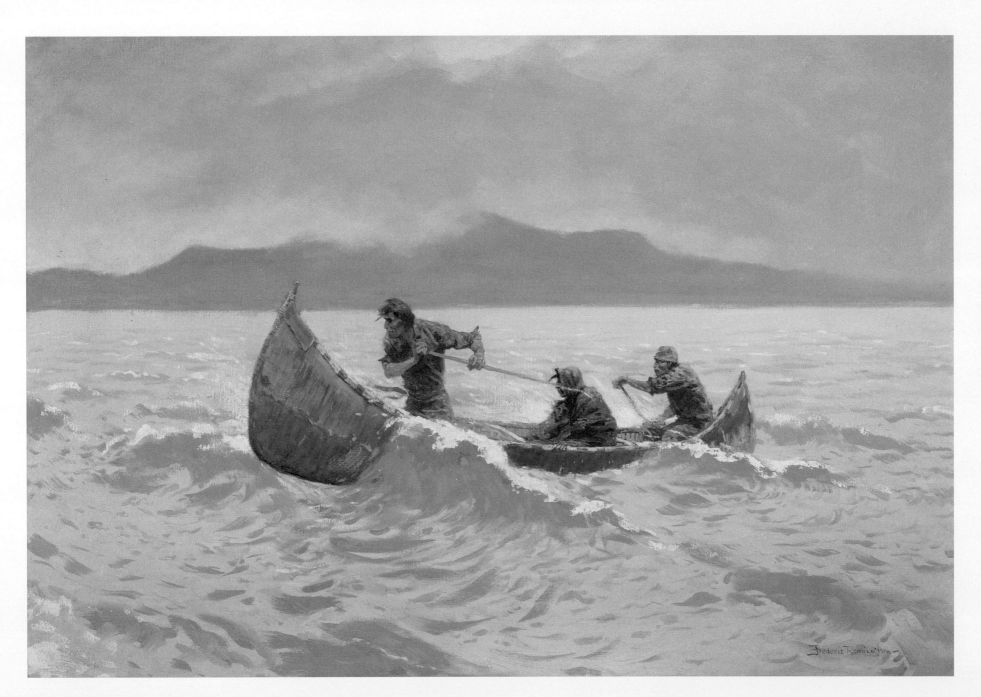

The Howl of the Weather 1905-1906, © 1906

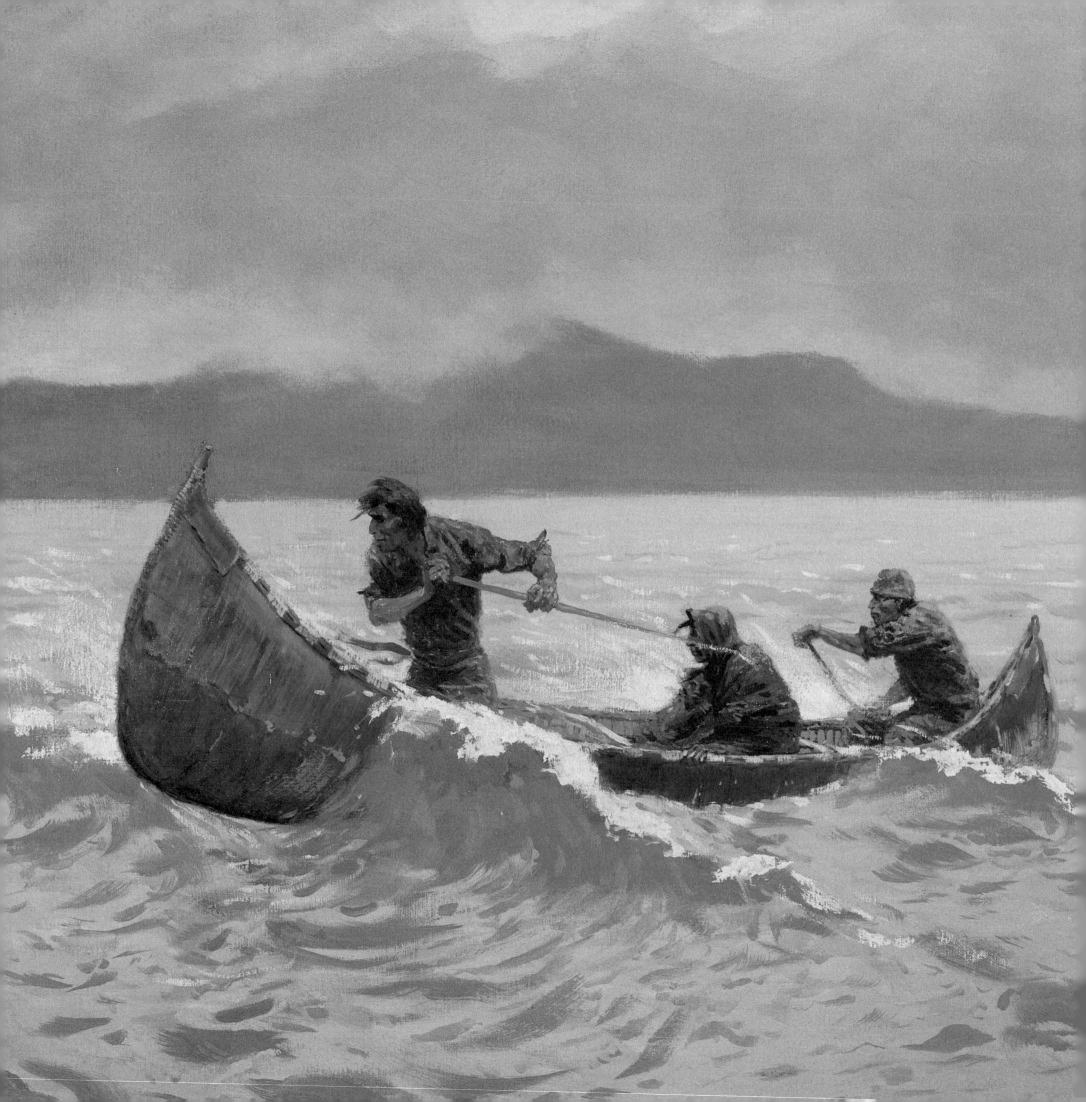

Remington saw a "queer"-shaped canoe in British Columbia, and incorporated it in an illustration, *An Indian Canoe on the Columbia*, published the following November.[3] The drawing's chief interest, apart from the canoe, is the Indian woman's worried reaction to what lies ahead on the river. Her concern anticipates that of the mother and child in *The Howl of the Weather*. As for the men, Remington knew their emotions firsthand. With a double-bladed paddle he would guide his canoe into the open waters off Ingleneuk on a windy day and meet the waves head on.[4] Man and canoe were "inseparable," a summer neighbor in 1902 noted. "Best exercise on earth," Remington told him, "feel my arm."[5] Long after his ballooning weight made other exercise impossible, he still loved to play bronco-buster and ride the "white horses" that galloped on the river.

Frederic Remington paddling his canoe, 1902
Photograph likely by Edwin Wildman, August 1902
Ingleneuk Album
FRAM 71.831.5

1. Of the twenty paintings exhibited at Noe Galleries February 5-17, 1906, only *Halt of a Cavalry Patrol to Warm*, reproduced in *Collier's Weekly* on September 23, 1905 as *A Halt in the Wilderness*, was not copyrighted the following January 18th. See *Special Exhibition of Recent Paintings by Frederic Remington* (New York: Noe Galleries, 1906).
2. FR, "Black Water and Shallows," *Harper's Monthly*, August 1893; *Collected Writings*, p. 105.
3. FR to Powhatan Clarke, September 13, 1890, *Selected Letters*, p. 101; Julian Ralph, "Dan Dunn's Outfit," *Harper's Monthly* 83 (November 1891): 881. The illustration's odd shape is explained by the *Monthly's* two-column format, to which it was meant to conform.
4. Atwood Manley, *Some of Frederic Remington's North Country Associations* (Ogdensburg: Northern New York Publishing Company, for Canton's Remington Centennial Observance, 1961), p. 31.
5. Edwin Wildman, "Frederic Remington, the Man," *Outing* 41 (March 1903): 713.

Opposite page, detail:
The Howl of the Weather 1905-1906; © 1906

Hauling the Gill Net 1905–1906; © 1906
Oil on canvas, 20¼ x 26" (51.4 x 66 cm.)
Signed lower right: Frederic Remington—
Inscribed on base, left: copyright 1906 by Frederic Remington
FRAM 66.56, CR 2751

Hauling the Gill Net is a straightforward picture with some nice touches. Its source is Remington's *Big Fishing— Indians Hauling Nets on Lake Nepigon*, which illustrated an essay by Julian Ralph in the April 4, 1891, *Harper's Weekly*. Each October, Ralph explained, the local Cree and Ojibiwa Indians went gill-netting on Lake Nipigon, thirty miles north of Lake Superior and, according to Ralph, an unrivaled fisherman's paradise. They attached sails to sloops of twenty-seven to thirty feet in length to catch the huge trout that spawned in the reefs offshore:

> *Gill nets are… set within five fathoms of the surface by setting the inner buoy in water of that depth, and then paying the net out into deeper water and anchoring it. The run and the fishing continue throughout October…. Sometimes the heads of two families are partners in the ownership of one of these sloops, but, however that may be, the custom is for the women and children to camp in tents along-shore, while the men (usually two men and a boy for each boat) work the nets. It is a stormy season of the year, and the work is rough and hazardous, especially for the nets, which are frequently lost.*

Big Fishing—Indians Hauling Nets on Lake Nepigon depicts what Ralph described with one major change. Though the gill-netters used sloops, Ralph noted that "the prettiest vehicles" in the region were the birchbark canoes, and "as the bark and the labor are easily obtainable, these picturesque vessels are very numerous."[1] Taking him at his word, Remington, who always favored the picturesque, replaced the sloop with a canoe.

Hauling the Gill Net is more artful than the original illustration. Remington set the figures higher in the composition, thereby conveying the buoyancy of the water and the rocking motion of the waves, which lift the prow of the canoe and the gill-netter's head above the horizon. The complex perspective is augmented by the curves of the canoe, which lend depth to a scene where the action is on a single plane. The elimination of the stand of trees and the nearby shoreline shown in *Big Fishing* both

simplifies the composition and, with land visible only in the far distance, makes the enterprise seem riskier, an impression heightened by the fisherman's hair blowing in the wind, the chop of the water and the storm clouds on the horizon. The dark grey clothing adds a somber note, though the canoe is vividly colored and the grey water (in comparison to that in *The Howl of the Weather*) is warmed by blues and greens. One assumes that the setting is still Lake Nipigon, though Eva Remington noted after her husband's death that the site was Chippewa Bay, where he had fished and paddled and played away his summers.[2]

1. Julian Ralph, *On Canada's Frontier: Sketches of History, Sport, and Adventure and of the Indians, Missionaries, Fur-Traders, and Newer Settlers of Western Canada* (New York: Harper & Brothers, 1892), pp. 116–17, 124.
2. Eva Remington notebook, stocks, copyrights, etc., p. 26, FRAM 96.2. But the copyright description on p. 113, prepared when Remington was still alive, makes no mention of the setting.

Big Fishing—Indians Hauling Nets on Lake Nepigon
Harper's Weekly
April 4, 1891, p. 237

BIG FISHING—INDIANS HAULING NETS ON LAKE NEPIGON.—Drawn by Frederic Remington.—[See Page 243.]

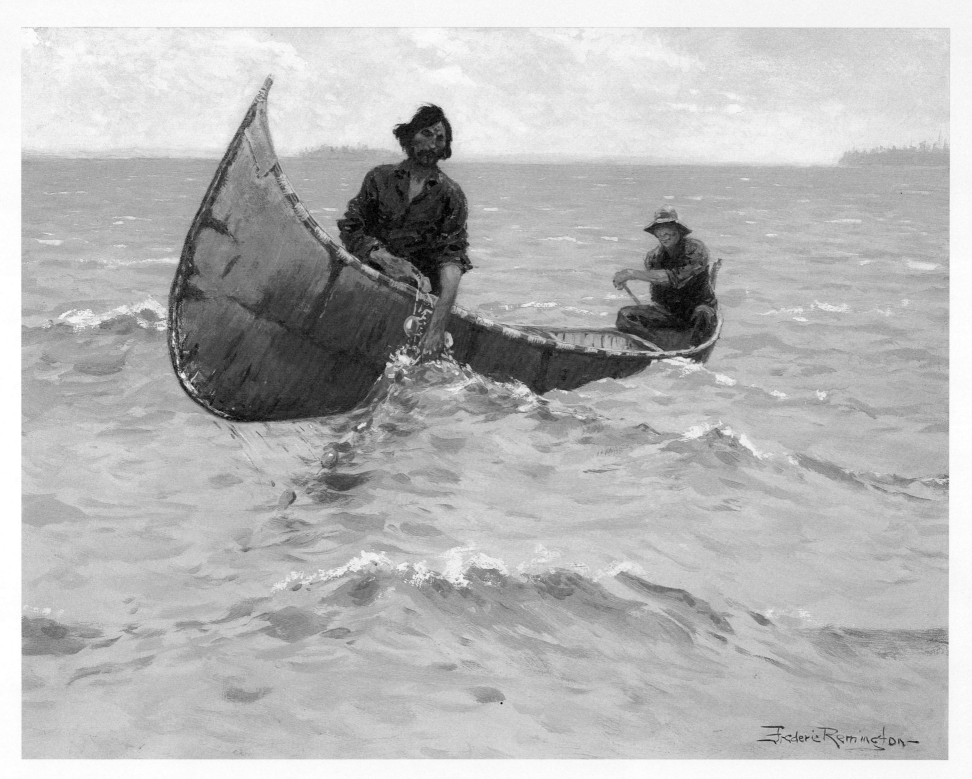

Hauling the Gill Net 1905–1906; © 1906

River Drivers in the Spring Break Up 1905–1906; © 1906

Oil on canvas, 27 x 40" (68.6 x 101.6 cm.)
Signed lower right: Frederic Remington— / copyright 1906 by Frederic Remington
FRAM 66.51, CR 2759

In recent years there has been a particular effort to place Remington within European and American artistic developments at the turn of the century. His late-life, painterly oils—as well as his own stated desire to concentrate on light and color and be regarded as an artist rather than an illustrator—have suggested analogies with both Impressionism and Tonalism. He is a more interesting painter when he is considered in association with Claude Monet, Edgar Degas and American contemporaries whom he admired like Willard L. Metcalf, Childe Hassam, Charles Rollo Peters and John Henry Twachtman, or on whom he kept a jealous eye like James McNeill Whistler—if only to show how he differed from them.[1] Of the three lake and river scenes he copyrighted on January 18, 1906, *River Drivers in the Spring Break Up* is the most experimental. Apart from subject matter, it closely equates with a Western oil that he copyrighted at the same time, *A Sunset on the Plains*, showing an Indian watering his horse below a tipi village. Both are Tonalist experiments—and neither sold at his Noe Galleries exhibition in New York City in February. Subsequently, Remington presented *A Sunset on the Plains* to the United States Military Academy at West Point (incongruous as it might seem both in content and in style), while *River Drivers* remained in his hands at the time of his death.[2]

Tonalism has been defined as an aesthetic that "contrasted sharply" with French Impressionism and its "high-key palette."[3] According to Will South, Tonalism refers "to images in which one color evenly pervades a picture's composition, masking the forms in poetic dimness."[4] Tonalism was an aesthetic ideally matched to Remington's purposes in *River Drivers in the Spring Break Up*. He wanted to capture a misty, foggy day on the river. Grey tones dominate. The ice is a creamy mint green, not an icy blue—faithful, it has been suggested, to the actual color of spring ice on the St. Lawrence.[5] The boat is a bright sienna, but the figures are grey with brownish-orange highlights, while the open water is grey with a brown undertone that lends a unifying warmth to the painting. The impression created, despite the ice floes on the river, is of a soft springtime

A Sunset on the Plains 1905–1906; © 1906
West Point Museum Collections, United States Military Academy, West Point, NY; CR 2763

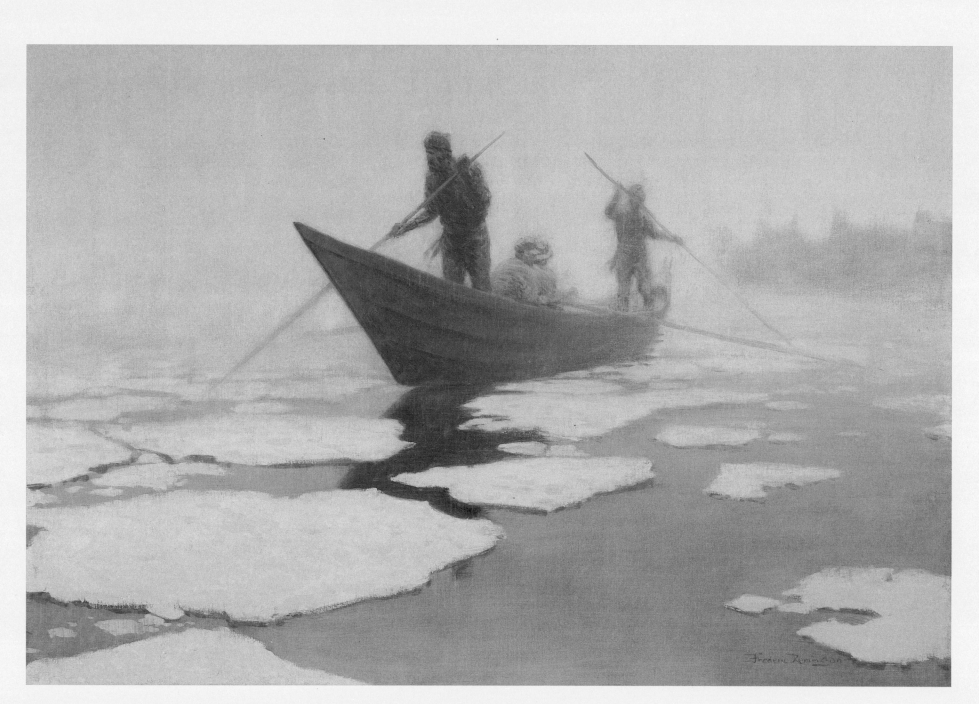

River Drivers in the Spring Break Up 1905–1906; © 1906

awakening; there is more drift than thrust to the picture as the figures seem to float out of a wintry dream. Remington bristled when his tonally-complex nocturnes were described as monochromatic, but the overall effect of *River Drivers* is exactly that. Almost a decade earlier, in the pastel *A Grey Day at Ralph's*, he had experimented with an outdoor sketch in low tones—grey sky, blue-grey water, muted greens in the trees with some yellow highlights.[6] *River Drivers in the Spring Break Up* extends such experimentation to a fully-realized work of art. Here the muted palette and soft focus are essential to the spirit of Remington's scene. They convey its intention, and the result is a painting faithful to Twachtman's prescription for creating mood: "A cloudy sky… and a fog to increase the mystery."[7]

1. See [Peter H. Hassrick], *Frederic Remington: The Late Years* (Denver: Denver Art Museum, 1981), pp. 7–15, and, for a refinement of his views, "Remington: The Painter," in Michael Edward Shapiro and Hassrick, *Frederic Remington: The Masterworks* (New York: Harry N. Abrams, for the Saint Louis Art Museum, in conjunction with the Buffalo Bill Historical Center, Cody, WY, 1988), pp. 126–69; Doreen Bolger Burke, "Remington in the Context of His Artistic Generation," in ibid., pp. 38–67; James K. Ballinger, *Frederic Remington* (New York: Harry N. Abrams, in association with The National Museum of American Art, Smithsonian Institution, Washington, DC, 1989), pp. 41–42, 128–41; and Joan Carpenter, "Was Frederic Remington an Impressionist?," *Gilcrease* 10 (January 1988): 1–19, which is useful in distinguishing Remington's work from French Impressionism and innovative in suggesting a kinship with Degas and (controversially) Symbolism in his late-life nocturnes. Remington's day scenes, in contradistinction to his nocturnes, do lean towards Impressionism, and Peter Hassrick has argued effectively for Impressionist passages in some of his major works. For a discussion specifically linking *River Drivers in the Spring Break Up* to Tonalism, see David Tatham, "Frederic Remington: North Country Artist," in *Artist in Residence: The North Country Art of Frederic Remington* (Ogdensburg, NY: Frederic Remington Art Museum, 1985), p. 11.

2. H. R. Scott to FR, February 27, 1907, FRAM 71.823.93, and A. S. Bottoms to FR, March 7, 1907, FRAM 71.823.73.

3. Katherine Plake Hough, "California Grandeur and Genre," in Iona M. Chelette, Katherine Plake Hough and Will South, *California Grandeur and Genre: From the Collection of James L. Coran and Walter A. Nelson-Rees* (Palm Springs, CA: Palm Springs Desert Museum, 1991), p. 10.

4. Will South, "Distinctions between Grandeur and Genre," in ibid., p. 13.

5. Shawn Thompson, "Frederic Remington in the Thousand Islands" (1993), unpublished manuscript, pp. 3–4; copy provided by Mr. Thompson of *The Whig-Standard*, Kingston, Ontario.

6. An 1896 date for this pastel is supported by a Remington letter. "I have cornered the New York market in pastel boards and am going up to St. Lawrence Co. for the summer and I am going to paint every d— thing in it," he wrote that year. (*Artist in Residence*, Checklist #30.) In April 1906 he dropped a line to Julian Ralph. They had been out of touch for a while, apparently, and Remington was planning a canoe trip on Lakes Champlain and George in May. It is possible Ralph had a property in the area, and that Remington made his pastel during a visit with him. (FR to Julian Ralph, April 6, 1896, and to Joel Burdick, [April 15, 1896], *Selected Letters*, p. 215.)

7. Quoted in Donelson F. Hoopes, *The American Impressionists* (New York: Watson-Guptill Publications, 1972), p. 94; and compare the Twachtman oil on the facing page, *Sailing in the Mist*, to Remington's *River Drivers in the Spring Break Up*. For Remington and Twachtman (who died in 1902, unconscionably neglected by the public, in Remington's opinion), see Peggy and Harold Samuels, *Frederic Remington: A Biography* (Garden City, NY: Doubleday & Company, 1982), pp. 340, 403–04.

A Grey Day at Ralph's ca. 1896
Pastel on grey paper, 21¼ x 29¼" (53.9 x 74.3 cm.)
Signed lower right: FrEderic Remington— / a grey day at Ralph's / —
Ex-collection: Robert Elowitch; FRAM 79.8, CR 2035

Evening in the Desert. Navajoes 1905–1906; © 1906

Oil on canvas, 20 x 26" (50.8 x 66 cm.)
Signed lower left: —Frederic Remington—
FRAM 66.54, CR 2747

Evening in the Desert. Navajoes is symptomatic of the sea change in Remington's art in the twentieth century. He would still paint action pictures of the sort that had made his reputation in the 1890s. But this oil is a study in tranquility. The tones are bright—a foreground shadow in desert beiges, pinks and turquoise greens; a middle band in brilliant yellow, the riders caught in the glare of the setting sun; the distant mountains in light purples and blues, with creamy highlights; and the sky itself a creamy pale turquoise. Only the middle band is vibrant; the other tones are restful, befitting the subject. When Remington visited Pueblo country in 1900, he dismissed the Indians as "too tame" and "too decorative" for his taste.[1] But on January 18, 1906, he copyrighted both *Evening in the Desert*, his Navajo study, and *Taos Pueblo*, a sunset scene. By then, light and the way it plays across surfaces, rather than action, was his preoccupation. Besides mid-day glare and his moonlights and firelights, he painted figures caught in the eerie orange glow of early evening, when shadows are at their longest, just before the sun slips from sight. The light in *Evening in the Desert* (and a related work like *Hole in the Day*, copyrighted at the same time) is more subtle and more challenging, with colors ranging from warm and hot tones to delicate pastels. The effect is exactly what Remington had once decried: decorative, peaceful, *soft*. He had purposely rejected the hard-edged and muscular in favor of atmosphere and mood, a development evidenced by many of the twenty paintings, including *Evening in the Desert*, that he exhibited at New York's Noe Galleries in February 1906. A reviewer who still found too much of the illustrator in Remington's other work singled out *Evening in the Desert* for praise as "one 'effect'" that was "true and pleasing in color."[2]

In the Betting Ring, one of the studies Remington made for his 1889 essay "On the Indian Reservations," provides a precedent for the grouping of figures in *Evening in the Desert*, while his annual show at Knoedler that December offered a variation on the theme in a painting titled *Who Comes There?* (see p. 72). In it, Remington turned the group of Indians towards the viewer, repeating the figure on the left with upraised arm. And he transformed the mood by setting the scene at night, replacing tranquility with an edgy tension. It was by reworking similar elements to different ends that Remington created variety within his consistent vision of the West.

1. FR to Eva Remington, November 6, 1900, *Selected Letters*, p. 318.
2. Als Ik Kan, "Notes: Reviews," *Craftsman* 10 (April 1906): 122.

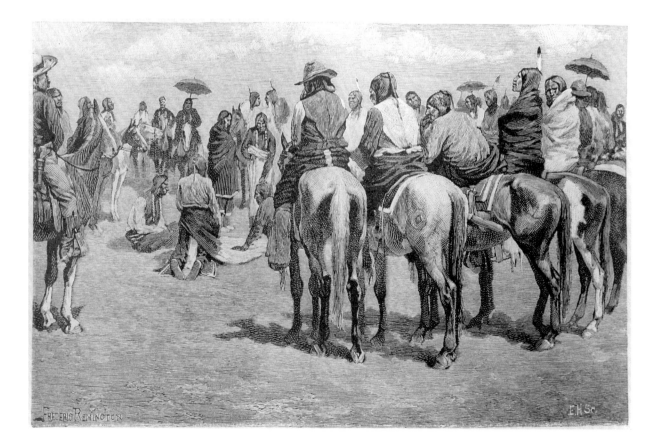

In the Betting Ring
Century Magazine 38 (July 1889): 402

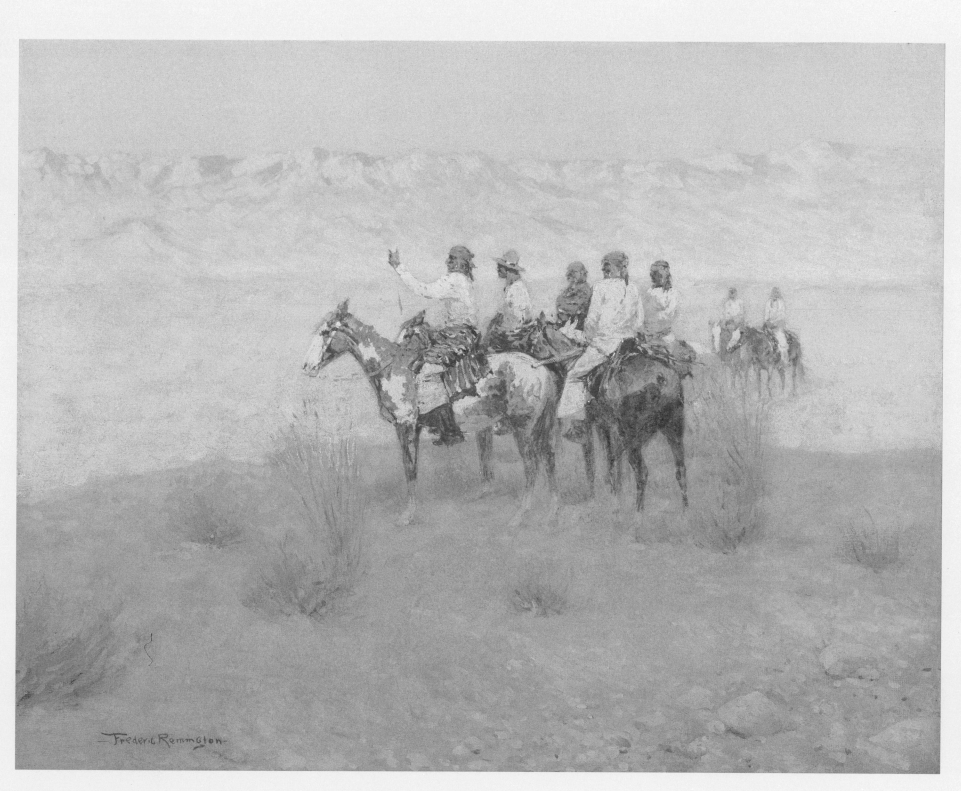

Evening in the Desert. Navajoes 1905–1906; © 1906

Dragoons 1850 © December 6, 1905
Roman Bronze Works cast no. 6 (ca. 1918–1919), 23⁹/₁₆ H x 46¹/₄ W x 18³/₁₆" D (59.9 H x 117.5 W x 46.2 D cm.)
Estate casting according to Eva Remington's will
FRAM 66.5

An examination of Remington's depictions of battle indicates that he did not relish the melee. He preferred something more orderly than the running fight—a charge, perhaps, with the cavalry in formation, a skirmish line, or a dismounted stand. *The Charge* (1897) and *An Old-Time Plains Fight* (ca. 1904) are typical examples. The melee, with figures interlocked in close-up combat, and tomahawks, spears and sabers clashing, was more often associated with Remington's rival, the New Jersey artist Charles Schreyvogel, whose painting *Even Chances* appeared in *Harper's Weekly* in 1902, three years before Remington copyrighted *Dragoons 1850*. (The U.S. Regiment of Dragoons, precursors to the U.S. Cavalry, was organized in 1833 specifically for service in the West; Remington illustrated the *Old United States Dragoon Uniform* in Parkman's *Oregon Trail* [1892], and *U.S. Dragoon, '47* in his *Drawings* [1897]. His bronze group set these stationary equestrian studies into motion.[1])

Dragoons 1850 is almost two-dimensional in its horizontal thrust: it reads from left to right as the eye moves over intertwined pairs of combatants and the riderless horse that leads the pack. The saber of one dragoon appears about to enter the eye of a war-club-wielding Indian; the other soldier hacks at his adversary, who attempts to parry the blow with lance and shield. The poses of the combatants are somewhat stiff and create awkward angles, but Michael Shapiro has noted the fluid poetry of the lead horse.[2] This horse also serves a narrative function. Its equipment indicates that it is a dragoon mount stolen by the Indians, precipitating the action portrayed.[3]

Remington had worked out the essential composition of *Dragoons 1850* in a polo illustration done a decade earlier, *"We've Got to Ride It Out. Come Along!"*[4] Illustration and bronze serve as a reminder of the close linkage in his mind between combat and sport, and of the chivalric ideal he still cherished despite the disillusioning reality of Cuba.

1. For a brief illustrated history of the Dragoons, see John Langellier and Bill Younghusband, *US Dragoons 1833–55* (London: Osprey, 1995).

2. Michael Edward Shapiro, "Remington: The Sculptor," in Shapiro and Peter H. Hassrick, *Frederic Remington: The Masterworks* (New York: Harry N. Abrams, for the Saint Louis Art Museum, in conjunction with the Buffalo Bill Historical Center, Cody, WY, 1988), p. 214.

3. I am indebted to Michael Greenbaum for this interpretation of the action depicted in the bronze. It is well founded in view of a painting by St. Louis artist Carl Wimar of *The Captive Charger* (1854), which could be considered a prelude to his *Indians Pursued by American Dragoons* (1853). See Rick Stewart, Joseph D. Ketner II, and Angela L. Miller, *Carl Wimar: Chronicler of the Missouri River Frontier* (Fort Worth, TX: Amon Carter Museum, distributed by Harry N. Abrams, Inc., New York, 1991), plates 4 and 2.

4. This illustrated Rudyard Kipling, "The Maltese Cat," *Cosmopolitan* 19 (July 1895): 314; Remington had created a similar grouping earlier in *The Game as Played by American Indians* in *Harper's Weekly*, August 1, 1891.

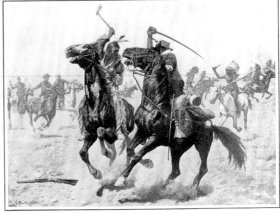

Charles Schreyvogel, *Even Chances*
Harper's Weekly, November 15, 1902, p. 1668

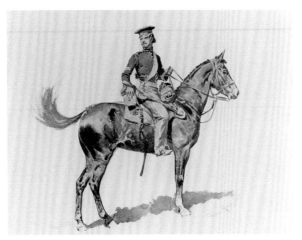

U.S Dragoon, '47
Frederic Remington, *Drawings* (New York: R. H. Russell, 1897)

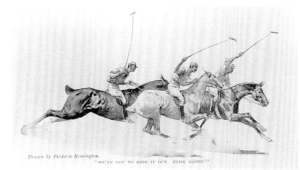

"We've Got to Ride It Out. Come Along!"
Cosmopolitan 19 (July 1895): 314

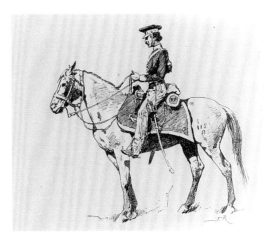

Old United States Dragoon Uniform
Francis Parkman, *The Oregon Trail: Sketches of Prairie and Rocky-Mountain Life* (Boston: Little, Brown and Company, 1892), p. 40

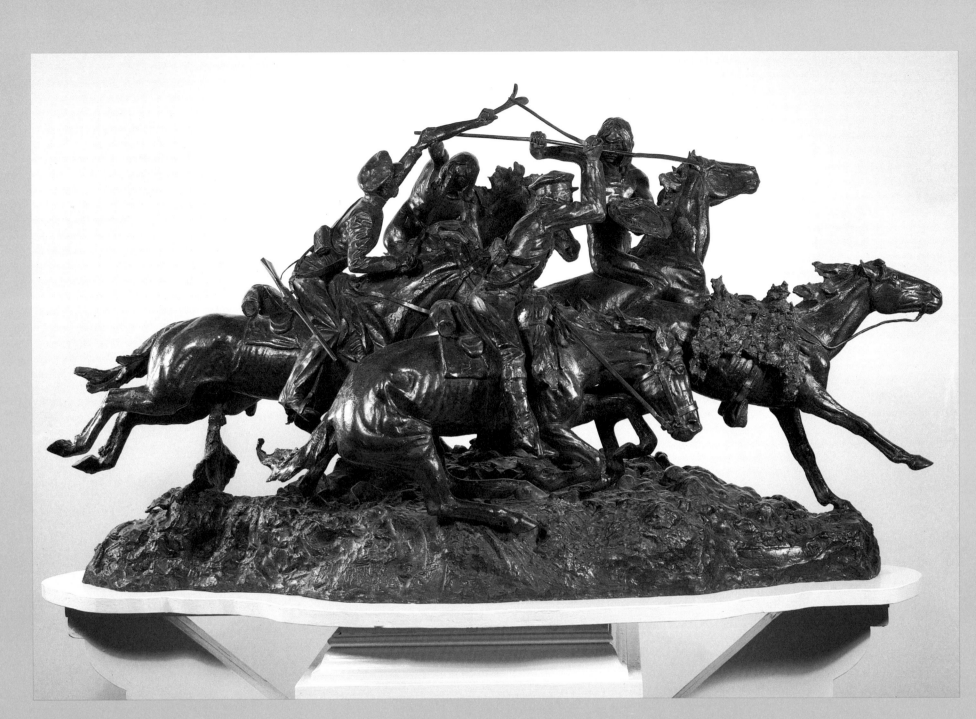

Dragoons 1850 © December 6, 1905
Roman Bronze Works cast no. 6 (ca. 1918–1919)

The Outlaw © May 3, 1906

Roman Bronze Works cast no. 38 (ca. 1918–1919), 23½ H x 16⁵⁄₁₆ W x 8⁷⁄₁₆" D (59.7 H x 41.4 W x 21.4 D cm.)
Estate casting in accordance with Eva Remington's will
FRAM 66.12

The bucking horse was a Remington staple. Such was *The Broncho Buster*'s success that he followed it immediately with another cowboy-horse confrontation, *The Wicked Pony*. By March 1896 he was bragging about his "new *mud*" to Owen Wister: "'How the broncho buster got busted'—its going to beat the 'Buster' or be a companion piece."[1] Cast in 1898, it shows the cowboy thrown to the ground and the triumphant horse, free at last of the rider perched on its back since 1895, about to trample him underfoot.

The Wicked Pony could be called a sequel, but *The Broncho Buster*'s real companion piece was a bronze copyrighted in 1906 as *The Outlaw*.[2] It is the totter to *The Broncho Buster*'s teeter—what goes up in the one comes down in the other, as the horse, having reared up on its hind legs, now crashes earthward on its forelegs. This jolting motion—and the shock it sends up the rider's spine—was exactly what Remington meant to convey in *A Bucking Bronco* (1888), his first published illustration on the theme. The rider in *The Outlaw* seems more relaxed, more fluid, and more in control. He will not win rodeo points bracing himself with his free hand on the horse's side, but he goes with the flow and appears less likely to suffer a dislocation of the coccyx. He is equipped with chaps and a look of confident determination, faithful to the cowboy image that Remington had impressed on the public's mind with drawings like *A "Sun Fisher"* (1897). "A first class flash rider or bronco-buster receives high wages and deserves them, for he follows a most dangerous trade, at which no man can hope to grow old," Theodore Roosevelt wrote.[3] The bronc rider in *The Outlaw* is a professional at work.

1. FR to Owen Wister, March 6, [1896], *Selected Letters*, p. 281.
2. Michael Edward Shapiro, *Cast and Recast: The Sculpture of Frederic Remington* (Washington, DC: Smithsonian Institution Press, for the National Museum of American Art, 1981), p. 108, locates two casts numbered 38, and designates the FRAM cast 38(B).
3. Theodore Roosevelt, "The Home Ranch," *Century Magazine* 35 (March 1888): 659.

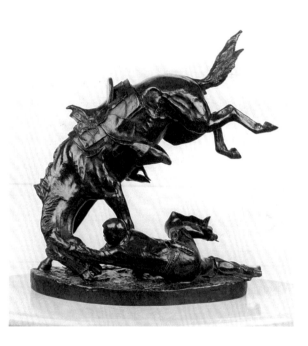

The Wicked Pony 1898
The R. W. Norton Art Gallery, Shreveport, LA

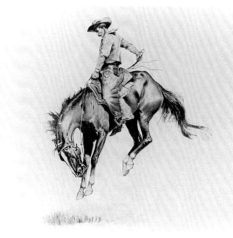

A "Sun Fisher"
Frederic Remington, *Drawings* (New York: R. H. Russell, 1897)

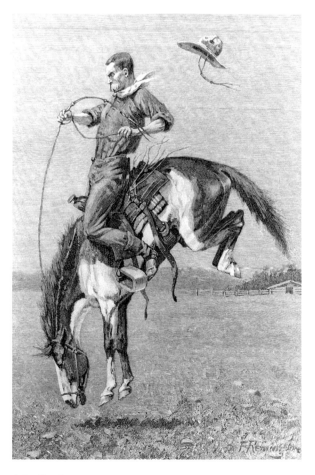

A Bucking Bronco
Century Magazine 35 (March 1888): 663

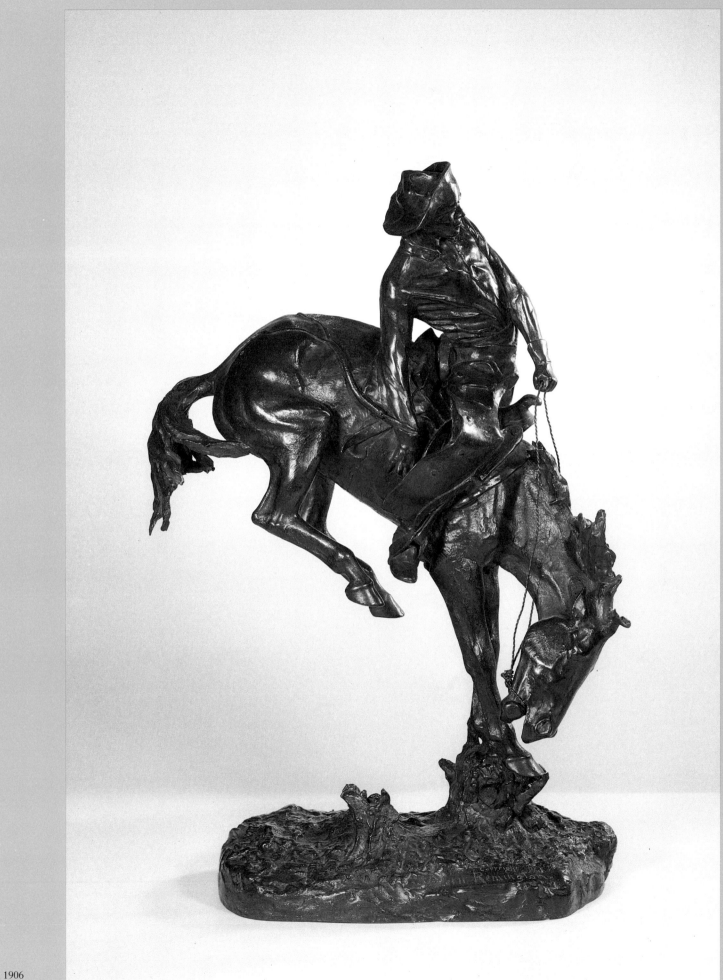

The Outlaw © May 3, 1906
Roman Bronze Works cast no. 38 (ca. 1918–1919)

The Last March 1906

Oil on canvas, 22 x 30" (55.9 x 76.2 cm.)
Signed lower right: Frederic Remington / Copyright 1906 by Frederic Remington
Museum purchase, 1948; FRAM 66.50, CR 2797

The Last March is Frederic Remington's ultimate minimalist surround. A nocturne in greens and creams and dark browns, it shows a saddled, riderless horse plodding over the snow-patched landscape, too exhausted to be concerned by the escorts charting its course to oblivion. No blood flows from wounds; no corpses litter the ground. But the sense of tragedy weighs heavily in the air. There has been a slaughter, and this is its dying echo. *The Last March* closely resembles Elizabeth S. Thompson, Lady Butler's masterpiece of pathos *The Remnants of an Army* (1879) showing, as the descriptive caption on the engraving put it, "Dr. Brydon the sole survivor of 16,000 of the British forces arriving exhausted at the gates of Jellalabad January 13 1842."[1] But Remington simplified his composition, omitting the rider and any reference to a specific event, thus giving his painting a timeless and universal appeal.

The composition of *The Last March* is reminiscent of another Remington study in pathos, *Missing* (1899). It showed a soldier afoot being led to torture and certain death by a convoy of mounted Indians; here, the soldier has been replaced by a horse, his implacable captors by wolves.[2] It is the same story told two different ways. After George Armstrong Custer fell on the Little Bighorn in 1876, a poet paid him tribute:

> *Among thy fallen braves thou liest,*
> *And even with thy blood defiest*
> *The wolfish foe.*[3]

In *The Last March*, "the wolfish foe" assumes literal form but still serves as metaphor, while the drooping, exhausted horse conjures up the legend of Captain Myles Keogh's charger Comanche, celebrated "sole survivor" of Custer's Last Stand.[4] "The horse is part of the soldier; / He mixed his blood with theirs," an anonymous poet wrote of Comanche in the *Army and Navy Journal* in 1878.[5] John Hay, personal secretary to President Abraham

Lincoln during the Civil War and Secretary of State under Presidents William McKinley and Theodore Roosevelt, in 1880 conjured up the scene that may have inspired Remington's painting:

> *And of all that stood at noonday*
> *In that fiery scorpion ring,*
> *Miles Keogh's horse at evening*
> *Was the only living thing.*

> *Alone from that field of slaughter,*
> *Where lay the three hundred slain,*
> *The horse Comanche wandered,*
> *With Keogh's blood on his mane.*[6]

The Last March was first exhibited at Remington's Knoedler exhibition in December 1906, where it attracted favorable attention. The *New York Times* critic grouped it with two other nocturnes, and noted: "All these pictures have more or less atmosphere, more or less tenderness, in the brushwork. Would they have it if the wizards of the brush in Europe had not fought against the hard academic style?"[7]

1. See Paul Usherwood and Jenny Spencer-Smith, *Lady Butler, Battle Artist, 1846–1933* (London: Alan Sutton Publishing Limited, for National Army Museum, 1987), pp. 76–77, pl. 6.
2. Remington did many hunting pictures but only a few wildlife studies. Wolves were a favorite late-life subject: *A Voice from the Hills* (©1906); *After the Bacon Rinds* (©1906; Gilcrease Museum, Tulsa, OK); *Lumber Camp at Night* (1906), reproduced in color in *Collier's Weekly*, November 10, 1906; *Wolf in the Moonlight* (ca. 1909; Phillips Academy, Andover, MA). He anticipated the theme of *The Last March* in an illustration titled *The Last Journey*, showing a pack of wolves trailing a wounded buffalo, in Francis Parkman, *The Oregon Trail: Sketches of Prairie and Rocky-Mountain Life* (Boston: Little, Brown, and Co., 1892), p. 229.
3. Edmund C. Stedman, "Custer," *New York Tribune*, July 13, 1876.
4. See Elizabeth Atwood Lawrence, *His Very Silence Speaks: Comanche—The Horse Who Survived Custer's Last Stand* (Detroit: Wayne State University Press, 1989), the best of more than a half dozen books and pamphlets on Comanche.
5. Anon., "Old Comanche," *United States Army and Navy Journal*, April 27, 1878, p. 604.
6. [John Hay], "Miles Keogh's Horse," *Atlantic Monthly* 45 (February 1880): 214–16.
7. "Paintings of Western Life by Frederic Remington, Indians, Cowboys, and Trappers," *New York Times*, December 23, 1906; also see the review in the *New York American*, December 22, 1906.

Elizabeth S. Thompson, Lady Butler, *The Remnants of an Army: Jellalabad, January 13th, 1842* 1879
The Tate Gallery, London

Missing 1899
Gilcrease Museum, Tulsa, OK
CR 2403

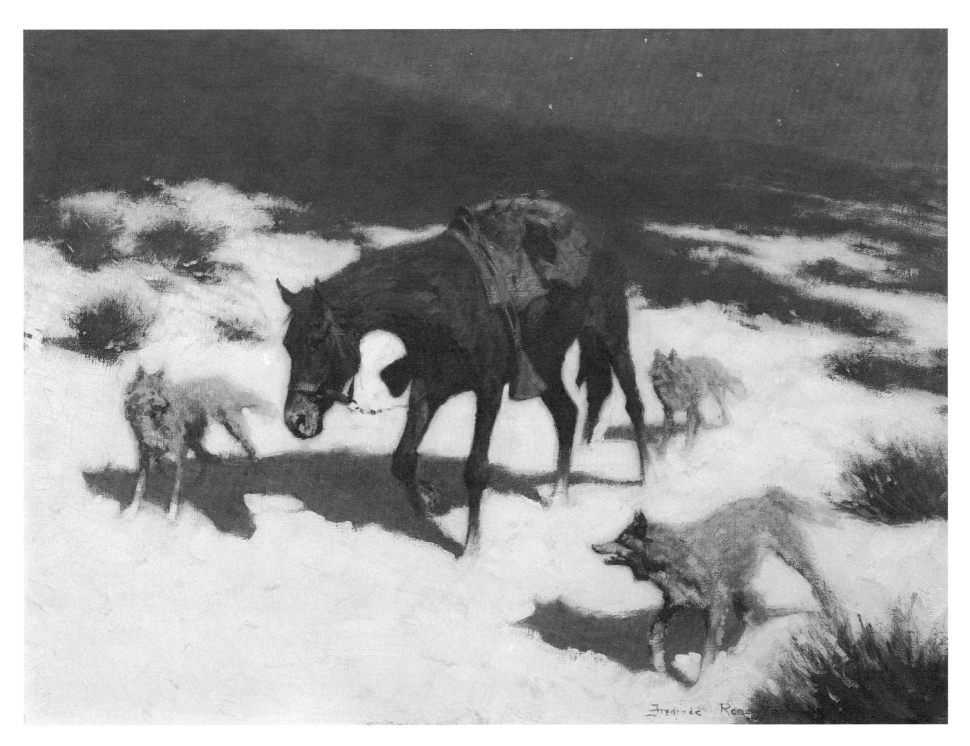

The Last March 1906

Snug Island (portrait of Eva Remington) 1888
Watercolor on paper, 17⅜ x 11⅝" (44.1 x 29.5 cm.)
Inscribed lower center: Snug Island-'88—
FRAM 66.90, CR 209

Waiting in the Moonlight ca. 1907–1909
Oil on canvas, 27 x 30" (68.6 x 76.2 cm.)
Unsigned
FRAM 66.38, CR 2833

Women rarely intruded on the masculine world of Remington's art. He sketched Eva several times (profile, facing left—it must have been her best side), and painted a modest but charming watercolor portrait of her at Snug Island in 1888. But exceptions to the rule are rare. Only the occasional unlovely Indian woman crept into an illustration—*Apache Woman with Rations* (ca. 1888), for example[1]—and this reluctance (or inability) to portray women put Remington at a decided disadvantage when he accepted the commission to illustrate Longfellow's *The Song of Hiawatha* in 1889. Minnehaha was unavoidable, and Remington's version of her was anything but poetic. She may have been the public's ideal of a beautiful Indian maiden, but in Remington's hands she was mostly bone and gristle and ungainly angles. Hiawatha fared much better. As late as 1902, Remington turned to his friend Charles Dana Gibson, who specialized in women, after all, to illustrate Katherine Searles, the major's daughter and the love interest in Remington's own novel, *John Ermine of the Yellowstone* (1902).[2] But the very fact of a love interest in that novel and in a short story he published the same year, "A Desert Romance," suggests a different Remington, fond of romantic conventions and perhaps struggling to express himself.

Remington was not given to sweet nothings, but was capable of expressing what he never showed in his art—sentiment. His letters to Eva often complained of loneliness. He missed her when he was away, and when she took ill in 1891, wrote a soldier friend, "Poor little soul I hope she pulls [through] all right because I wouldn't be of any more use than an old shoe if she weren't around to kind of 'luff me off when the wind's too breezy.'"[3] The poor-dear tone suggests, accurately, that Remington was most comfortable with the role of men as rescuers of imperiled femininity. For

example, he concluded "A Desert Romance" with this scene:

> … *a woman sprang up through the hole in the roof, and ran to the edge, crying: "Help, Colonel Simms! Oh, help me!"*
>
> *"Cover the roof with your guns, men," ordered Simms, and both he and the brother sprang forward….*
>
> *As they gained the side wall, Simms spoke. "Don't be scared, Miss Hall; jump. I will catch you," and he extended his arms. The girl stepped over the foot-high battlement, grasped one of the projecting roof timbers, and dropped safely into Colonel Simms's arms. She was sobbing, and Simms carried her away from the place. She was holding tightly to the neck of her rescuer, with her face buried in a week's growth of beard.*[4]

When men deviated from their proper role and made the mistake of falling in love, *they* became the imperiled ones in need of rescuing. That was the message of *John Ermine of the Yellowstone*, whose Indian-raised white hero stands no chance against the wiles of the major's daughter: "He was an easy victim of one of those greatest of natural weaknesses men have." John Ermine is literally doomed by that weakness—Remington kills him off at novel's end, but not before he gets to play the rescuing hero, sweeping Katherine up in his arms after she falls unconscious from her horse, and carrying her to the river to revive her. John Ermine rescues Katherine physically, in short, then needs her to rescue him from the torment of love. He proposes—"I shall never get well unless you come to my rescue…. Come, Katherine, say you will marry me; say it and save me"—and is promptly rejected as beneath her social station. And so his fate is sealed. Love-sick and heart-broken, he wounds her officer-fiancé and becomes "a fugitive

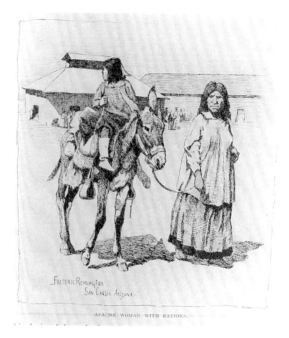

Apache Woman with Rations
Century Magazine 38 (July 1889): 396

"He Bore the Limp Form to the Sands"
Frederic Remington, *John Ermine of the Yellowstone* (New York: The Macmillan Company, 1902), p. 209

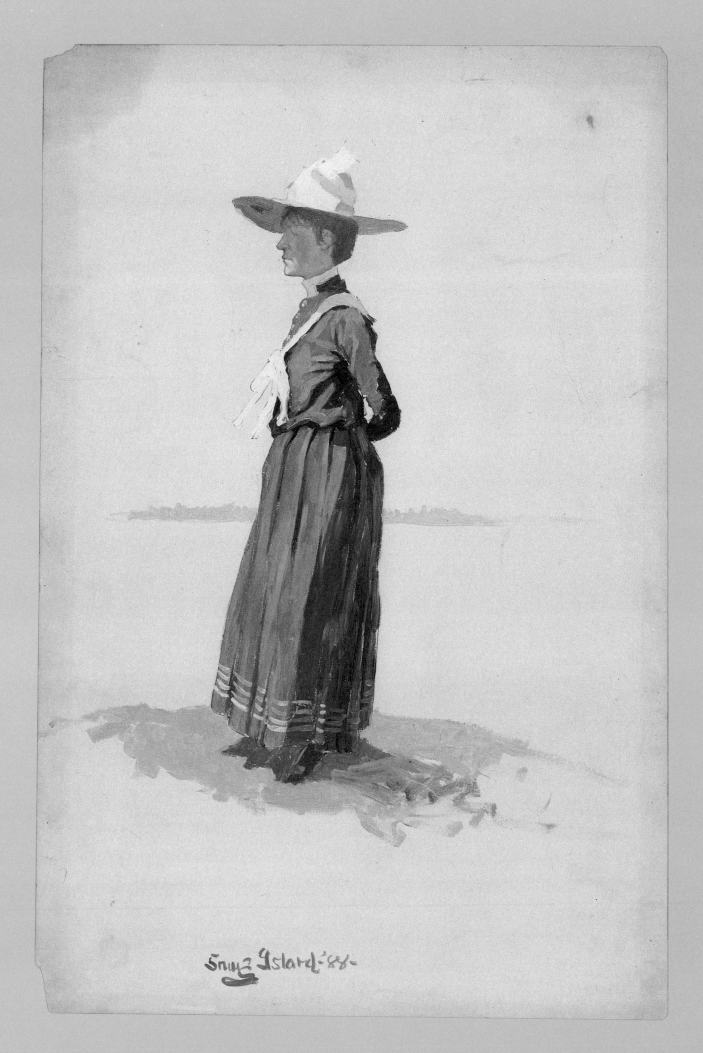

Snug Island (portrait of Eva Remington) 1888

criminal driven into the night" until death over-
takes him.[5] Perhaps Remington subconsciously
associated women with the civilized proprieties
that had tamed—and destroyed—his West. This
much is certain: though his writing gave voice to a
sentimental side, his glum take on love's cost was
consistent with his avoidance of women in his art.

In 1905, however, the romantic in
Remington surfaced in his painting as well. With
advancing years, growing eminence, and substantial
prosperity, he may have come to terms with his
feelings about women. He was himself someone
of stature, after all, and perhaps they seemed less
intimidating. A photograph with his neighbor
Virginia Thomas, wife of his friend Augustus,
shows him mugging affably. Certainly he must
have surprised his editors at *Collier's Weekly* when
he delivered *An Old Story in a New Way* for their
inspection. It showed a starry night, and wooing
lovers in a motorboat! *Collier's* published it as
a double-page color spread on May 13, 1905,
but Remington's judgment was conclusive: he
consigned the painting to a fire in 1908.[6] He had
not given up on the idea of painting a moonlight
courtship, however.

Between 1907 and 1909 Remington began
work on an oil painting known since as *Waiting in the
Moonlight*. A cowboy, leaning down from his saddle,
whispers something to a shy maiden. Her pose,
possibly meant to be winsome (for an alternative
interpretation, see the commentary with *Untitled*
[p. 216]), bore little resemblance to that of the
Indian women in a related composition, *There Was
No Flora McIvor* (1895). These mannish figures
would be more adept at bargaining than at playing
coy. The painting illustrated Owen Wister's
matter-of-fact account of cowboy "love":

> *If his raids, his triumphs, and his reverses have
> inspired no minstrel to sing of him who rode by
> the Pecos River and the hill of San Andreas, it is
> not so much the Rob Roy as the Walter Scott
> who is lacking. And the Flora McIvor! Alas! the
> stability of the clan, the blessing of the home
> background, was not there. These wild men
> sprang from the loins of no similar father, and
> begot no sons to continue their hardihood. War
> they made in plenty, but not love; for the woman
> they saw was not the woman a man can take
> into his heart.[7]*

This prejudice was Remington's as well. In his
novel he explained John Ermine's indifference to

An Old Story in a New Way ca. 1905
Collier's Weekly, May 13, 1905

Frederic Remington and Virginia Thomas
Photograph in Ingleneuk Island Album (Chippewa Bay), p. 36
FRAM 71.831.36

There Was No Flora McIvor
Harper's Monthly 91 (September 1895): 613

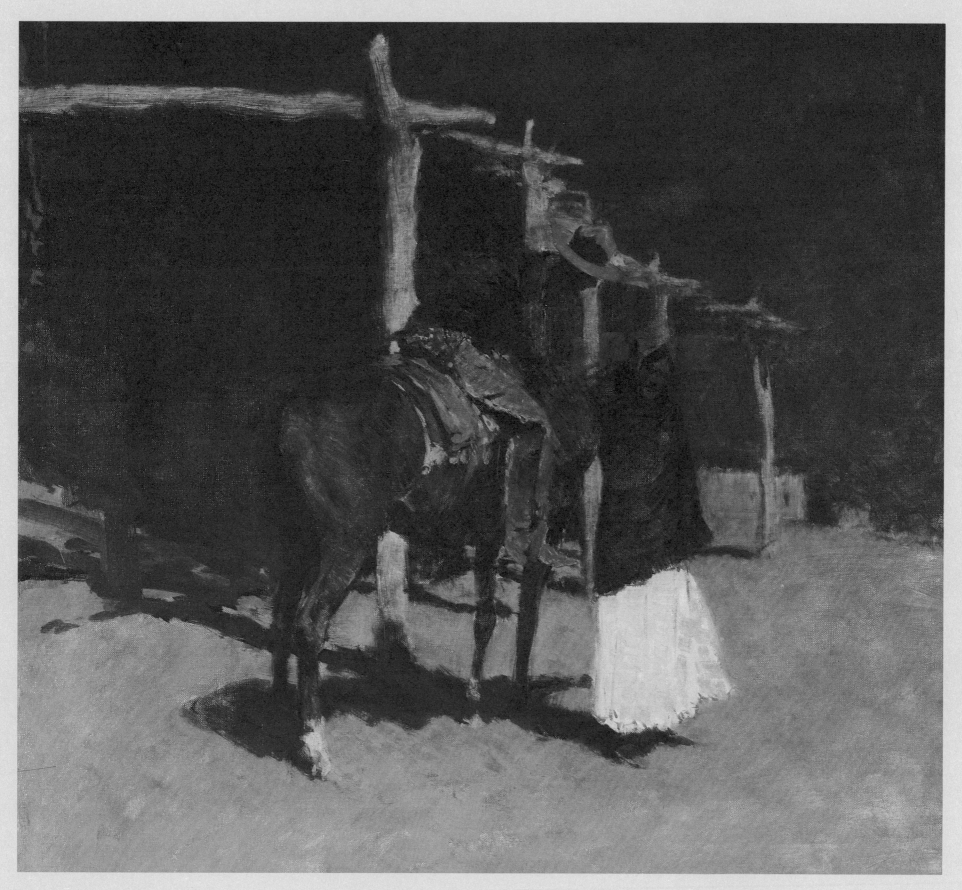

Waiting in the Moonlight ca. 1907–1909

the Crow women who would gladly have taken him into *their* hearts: "Ermine had known the easy familiarity of the Indian squaws, but none of them had ever stirred him."[8] It was a white man's fate to be brought down by a white woman. The mounted cowboy in *There Was No Flora McIvor* faced a different temptation, however.

　　Waiting in the Moonlight also harkens back to an illustration in *Hiawatha* showing a pair of handsome suitors gazing longingly at Minnehaha. Just as Remington in 1889 had trouble making Minnehaha seem a likely object for such adoration, he was evidently failing with the maiden in *Waiting in the Moonlight* nearly twenty years later. The painting is a nocturne in greens and browns. There are touches of cobalt blue in the woman's wrap and the cowboy's shirt. The color scheme is set, but the woman's face is not. It is likely Remington intended her to be a Mexican. He has merely sketched in her features, but they appear to have defeated him already. She will be no Flora McIvor either, though it was not for want of trying. Virginia Thomas posed for Remington, and his photograph of her in costume shows she was a beauty. In transferring her to canvas, however, Remington had lost Thomas' allure. If this painting was done as early as 1907, he abandoned it unfinished, but was not yet through with the theme.

　　Remington captured what he had been trying to express—the appeal of young love on a moonlit night—in a canvas shown in his final Knoedler exhibition, *The Love Call*. Royal Cortissoz, a critical eminence, paid it special attention. How had Remington resolved his own ambivalence about such subjects and his inability to portray attractive women? In *The Love Call* he simply eliminated the woman and portrayed her suitor, alone in the dark, piping away on his flute in eternal pursuit of what no man, in Remington's art, ever quite attained.[9]

And her lovers, the rejected,…| Handsome men with paint and feathers
Henry Wadsworth Longfellow, *The Song of Hiawatha* (Boston: Houghton, Mifflin & Co., 1891), facing p. 120

Virginia Thomas posing for *Waiting in the Moonlight* at Endion, New Rochelle, NY
FRAM 1918.76.152.91

The Love Call 1909
Sid Richardson Collection of Western Art, Fort Worth, TX; CR 2906

1. Four of the illustrations based on Remington's 1888 tour of the Southwestern Indian reservations featured women: *Apache Woman with Rations*, *Distribution of Beef at San Carlos Agency*, *Method of Sketching at San Carlos* (*Century Magazine* 38 [July 1889]: 396–98), and *A Cheyenne Camp* (*Century Magazine* 38 [August 1889]: 538). The photograph used in *A Cheyenne Camp* is in the FRAM 1918.76.160.484.

2. Remington's biographers doubt that Gibson did the female drawings, but the two pen sketches showing just Katherine Searles bear far more resemblance to Gibson's than to Remington's style. The statement that they were by Gibson was made by the knowledgeable Helen Card. See Peggy and Harold Samuels, *Frederic Remington: A Biography* (Garden City, NY: Doubleday & Company, 1982), p. 335; and [Helen Card], "Bibliographic Check List of Remingtoniana," in Harold McCracken, *Frederic Remington: Artist of the Old West* (Philadelphia: J. B. Lippincott Company, 1947), p. 145.

3. FR to Powhatan Clarke, [1891], *Selected Letters*, p. 117.

4. FR, "A Desert Romance: A Tale of the Southwest," *Century Magazine*, February 1902; *Collected Writings*, p. 444.

5. FR, *John Ermine of the Yellowstone* (1902); *Collected Writings*, pp. 512, 532, 539. The one illustration featuring Katherine that Remington did contribute to *John Ermine* shows Ermine carrying the unconscious girl.

6. Diary, January 25, 1908, and, at back, "Paintings which I *burned up*," FRAM 71.816. Remington listed "Moonlight Canoe" [*An Old Story in a New Way*] among the paintings destroyed.

7. Owen Wister, "The Evolution of the Cow-Puncher," *Harper's Monthly* 91 (September 1895): 614; Remington's illustration was on p. 613.

8. FR, *John Ermine of the Yellowstone* (1902); *Collected Writings*, p. 527.

9. See Royal Cortissoz, "Frederic Remington: A Painter of American Life," *Scribner's Magazine* 47 (February 1910): 188–90, which notes tellingly: "I recall, in passing, a picture of an Indian upright beneath a tree, and sedately piping to a maiden whom we are to imagine dwelling in one of the tepees not far distant. 'The Love Call,' as it is entitled, is, if you like, a romantic picture, an idyll of the starlight, but I confess that I cannot dilate with any very tender emotion in its presence. There is nothing languishing about this lover; he carries his pipe to his lips with a stiff gesture. In his ragged blanket he is essentially a dignified, not a sentimental image. It has not occurred to Mr. Remington to make his model 'pretty' or in any way to give his painting a literary turn. He has busied himself with his tones of gray and green; he has sought to draw his figure well…. Never was a picture bearing so poetic a title more realistically produced."

Opposite page, detail:
Waiting in the Moonlight ca. 1907–1909

The Sentinel 1907

Oil on canvas, 27 x 36" (68.6 x 91.4 cm.)
Signed lower left: Frederic Remington.
Inscribed bottom center: copyright 1907 by P. F. Collier & Son—
FRAM 66.46, CR 2841

Remington's illustrations for *John Ermine of the Yellowstone*—especially those depicting the course of Ermine's ill-starred infatuation with the major's daughter—were conspicuously stagey. In fact, the story, written in consultation with playwright Louis E. Shipman, was ready-made for adaptation to the stage, and almost as soon as the book was published in November 1902 Shipman began the task of turning the novel into a play. Remington was delighted, advising him closely on what concerned him most. His types must be faithfully reproduced on the stage. In his art, realistic detail lent credence to his inventions; in the play, to a plot that, much modified along the way, was about as contrived as any other on the stage. The difference would be the Remington touch, the *appearance* of truth. He harped on about cavalry equipment, Crow hair styles and the like in his letters to Shipman, and when the play debuted in Boston in September 1903, he was still as concerned with the costumes as with the drama.[1] Photographs of the actors playing Wolf Voice and the old mountaineer known as Crooked Bear show them tapping the same rich vein as the wagon guard in *The Sentinel*, and indicate Remington's success in transferring his types onto the stage. The cast photographs also speak intriguingly to a development in his art following *John Ermine of the Yellowstone*'s brief run on Broadway. In the past, Remington had often portrayed single figures against a flat surface (p. 57) or entirely freed of context (p. 114). After 1903 some of his major paintings included figures posed like actors caught in the spotlight. Stage center, suspended in the pool of their own shadow, they return the audience's gaze.

The Sentinel is a case in point. It draws on Remington's earlier work, notably his 1902 frontispiece portrait of John Ermine and a painting done the same year, *Moonlight in the Western Desert*, which illustrated Noah Brooks's reminiscences of crossing the plains to California in the 1850s. "While we were in the region deemed dangerous from Indians we massed in with other companies of emigrants, so that we were seldom less than one hundred and fifty strong," Brooks recalled. "A

Right:
John Ermine
Frederic Remington, *John Ermine of the Yellowstone*
(New York: The Macmillan Company, 1902)
frontispiece

Below right:
Albert Perry as "Wolf Voice, A Canadian Half Breed," 1903
Photograph by Windeatte, Chicago, IL
FRAM 1918.76.143

Below:
Carl Ahrendt as "Crooked Bear, a Trapper," 1903
Photograph by Windeatte, Chicago, IL
FRAM 1918.76.145

The Sentinel 1907

regular watch was kept by night, and the wagons were parked in a circle which could be used as a defense in case of an attack."[2] In nocturnes like *The Sentinel*, Remington often eliminated specific reference to the *cause* of the reaction shown; instead, his figures stare out of the picture at the viewer, into what would be for them a dark void. They do not know what is "out there." The viewer, in effect, *is* the cause of the reaction, and thus that cause exists entirely in the viewer's imagination. You can take from the picture whatever you bring to it—a narrative device that eschews plot for individual involvement, didacticism for subjectivity.

The Sentinel went well for Remington from the outset. He first mentioned it in his diary on June 25, 1907: "Worked on Sentinel. We have first moon now. clear nights and I studied until near 11 o'c last night." On the 26th he "worked on moonlight from my observations of last night," and on the 27th noted, "Worked hard on my pictures yesterday and with good success." *The Sentinel* is a flawless example of what Remington wanted to accomplish in his nocturnes. The muted palette, the range of greens with browns and dark blues in the shadows and the sky, the pale light reflecting off the canvas wagon cover, the olive and yellow-

orange tones in the man's buckskins, the splash of red in his shirt and the wheel axles—all contribute to Remington's quiet frontier epic. *The Sentinel* was finished by the middle of July and boxed and sent off with four other paintings to *Collier's*. It did not appear in the *Weekly* but was reproduced as a color print in 1909.[3] Meanwhile, Remington exhibited the painting at Knoedler in December 1907 to impressive notices.

The *New York Tribune*'s critic thought much of Remington's exhibition old hat, even "crude," but considered the night scenes "a great stride forward. It is not simply that he has changed his key. Study of the moonlight appears to have reacted upon the very grain of his art, so that all along the line, in drawing, in brush work, in color, in atmosphere, he has achieved greater freedom and breadth…. Best of all is the quiet scene with a single figure, the picture of 'The Sentinel.' The very spirit of the night is in this painting."[4] A reviewer in the *New York Press* was even more enthusiastic. Many of Remington's subjects caught his fancy, but he believed that "lovers of painting as paintings" would "linger longest over the wonderful technique" of *The Sentinel*. He named, as well, *The Moaning of the Bulls* (p. 185), concluding:

"These are canvases for our museums to consider seriously."[5]

Sales were slow, Remington complained on December 14, the last day of his "unfortunate Knoedler show." On the other hand, he had received "some quite good" press notices. "I don't care what such people say but realize that they have their effect."[6] Of course, he cared enormously what the critics had to say, and followed eagerly their dawning recognition that a familiar illustrator was becoming a most unfamiliar painter.

1. See Peggy and Harold Samuels, *Frederic Remington: A Biography* (Garden City, NY: Doubleday & Company, 1982), pp. 329–30, chap. 30; and FR to Louis Shipman, [summer 1903], *Selected Letters*, pp. 340–42.
2. Noah Brooks, "'The Plains Across,'" *Century Magazine* 63 (April 1902): 811.
3. Diary, June 25–27, July 18, 29, 1907, FRAM 71.815; Peggy and Harold Samuels, *Frederic Remington: The Complete Prints* (New York: Crown Publishers, 1990), #134.
4. Untitled clipping, *New York Tribune*, December 4, 1907, FRAM.
5. "Art Notes," *New York Press*, undated clipping [December 10, 1907], FRAM; also see "Paintings in Three Modes," *Brooklyn Eagle*, December 1, 1907. Remington's Diary, December 10, 1907, FRAM 71.815, mentioned the good notice by McCormack in the *Press*.
6. Diary, December 14, 1907, FRAM 71.715.

Moonlight in the Western Desert
Century Magazine 63 (April 1902): 812

Opposite page, detail:
The Sentinel 1907

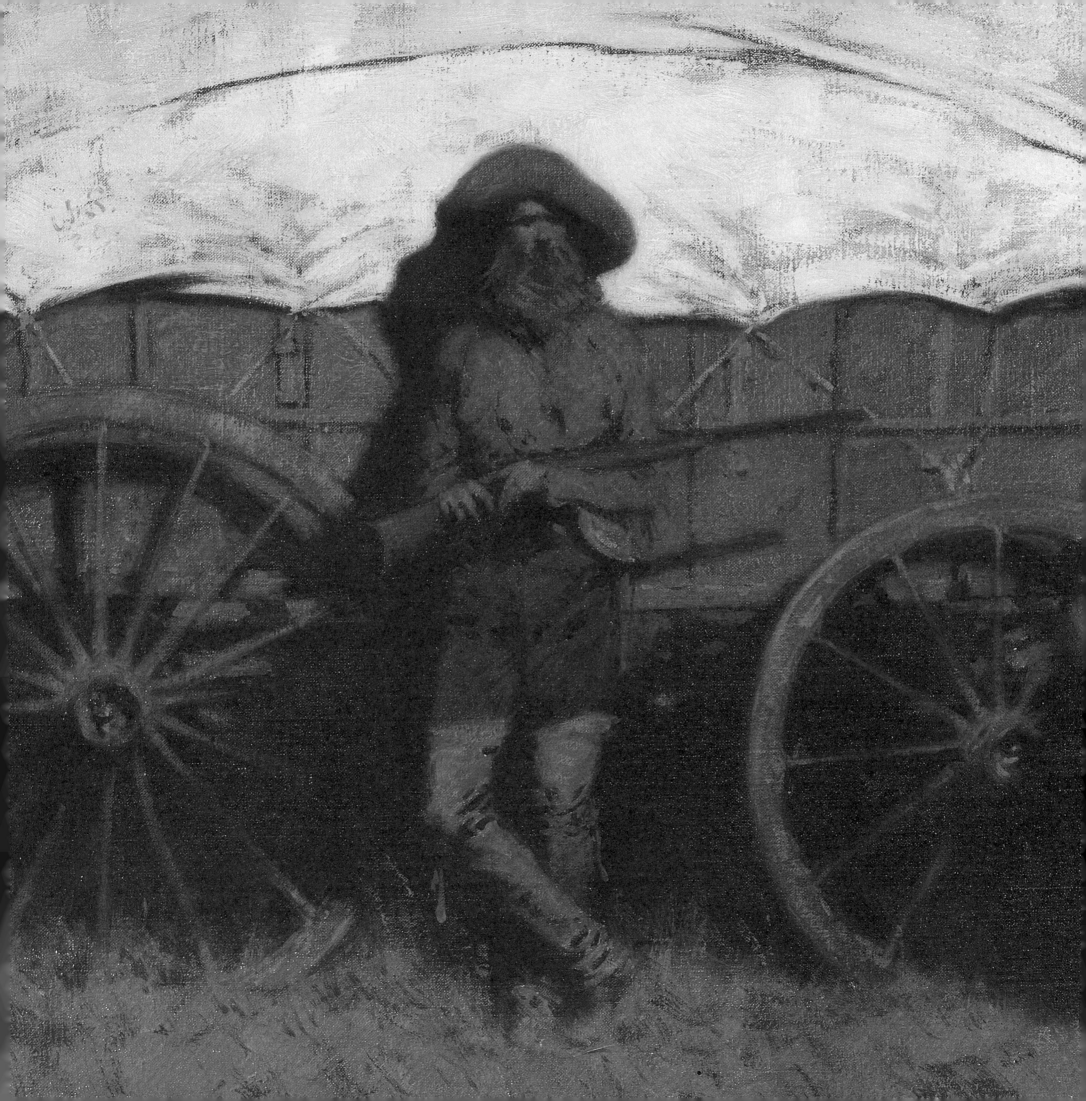

The Moaning of the Bulls 1907

Oil on canvas, 27 x 40" (68.6 x 101.6 cm.)
Signed lower right: Frederic Remington-
Inscribed bottom center: copyright 1907 by P. F. Collier & Son
Museum acquisition, 1965; Ex-collection McCaughen and Burr, Inc., St. Louis, MO; FRAM 66.75, CR 2822

The Moaning of the Bulls was an unusual subject for Remington. Apart from his wolf and horse studies, he did few major paintings that did not include human figures, and no other painting of cattle exclusively. In the confrontation shown here—a defiant stand-off between contesting parties—anticipation rather than action creates the tension that Remington favored in his later work. He had anticipated the pose of the bull on the right in 1896 when he showed a different confrontation, between a wild steer and a hunter armed with a gun loaded only with birdshot. It was in Remington's customary mode, since it combined outdoor activity and a Southwestern setting. Remington had been invited by military friends on a January quail hunt along the Rio Grande in Texas:

> At intervals we ran into the wild cattle
> which threaded their way to water, and it makes
> one nervous. It is of no use to say "Soo-bossy,"
> or to give him a charge of No. 6; neither is it
> well to run. If the matadores had any of the
> sensations which I have experienced, the gate
> receipts at the bull-rings would have to go up.
> When a big long-horn fastens a quail-shooter
> with his great open brown eye in a chaparral
> thicket, you are not inclined to "call his hand."[1]

The Moaning of the Bulls replaces the human actor with an animal one, and relocates the confrontation to what could be any pasture on a given night.

The painting suggests the country squire in Remington who, in the fall of 1909, would record in his diary an incident on his Connecticut estate: "Turned my new Jersey cow out with—others— she bawling where at we had a regular Spanish bull fight and cows and men went yelling and bawling through the dewey grass. Put her in horse pasture to quiet down."[2] Seen in that light, *The Moaning of the Bulls* could be considered Remington's moonlight courtship scene for 1907! His editors at *Collier's Weekly* were unmoved by his little drama of farm life, however, and though he sent the painting along as one of his regular contributions for the year, it was rejected for reproduction. The two Western action scenes submitted at the same time, *The Quarrel* [*A Show Down*] and *Navajo Raid*, were accepted, serving Remington notice that he was not welcome to depart from form.[3]

Though Remington exhibited *The Moaning of the Bulls* in New York in December 1907, in Chicago in February 1908, and in Boston in January 1909, it did not sell, indicating that the public was in agreement with his editors. Indeed, a nocturne Remington considered a "very successful picture" when he painted it in early August 1907 was described by one of the Boston critics as a "monotone in color."[4] Remington was rightfully perturbed. Whatever else his nocturnes were, they were not monochromatic. They were painstaking studies in moonlight and shadow, chiaroscuros of a complex sort, since they were necessarily in a low register, where tonal variations were infinitely subtle. In *The Moaning of the Bulls* Remington's colors ranged from olive greens to shades of brown. He was fully aware of the pitfalls in such a color scheme. Days before his exhibition opened at Knoedler in December 1908, for example, he was still trying to tone down the greens in a nocturne he had painted months earlier.[5] Since Remington was a perfectionist himself and proud of his ability to render night light, the Boston review of *The Moaning of the Bulls* was especially galling. "They call my moonlights 'monochromes,'" he complained to his diary. "No sales. I fear Boston will never enjoy Freddie again."[6]

1. FR, "The Blue Quail of the Cactus," *Harper's Monthly*, October 1896; *Collected Writings*, pp. 239–40.
2. Diary, September 30, 1909, FRAM 71.816.
3. Diary, August 20, 30, 31, 1907, FRAM 71.815.
4. Diary, August 3, 5, 1907, FRAM 71.815, and "Best," unidentified extract from a Boston paper, [January 1909], copied at the back of Diary, 1909, FRAM 71.816.
5. Diary, November 25, 27, 1908, FRAM 71.817. The painting in question was *The Call for Help* (The Museum of Fine Arts, Houston).
6. Diary, January 14, 1909, FRAM 71.816.

Too Big Game for Number Six
Harper's Monthly 93 (October 1896): 657

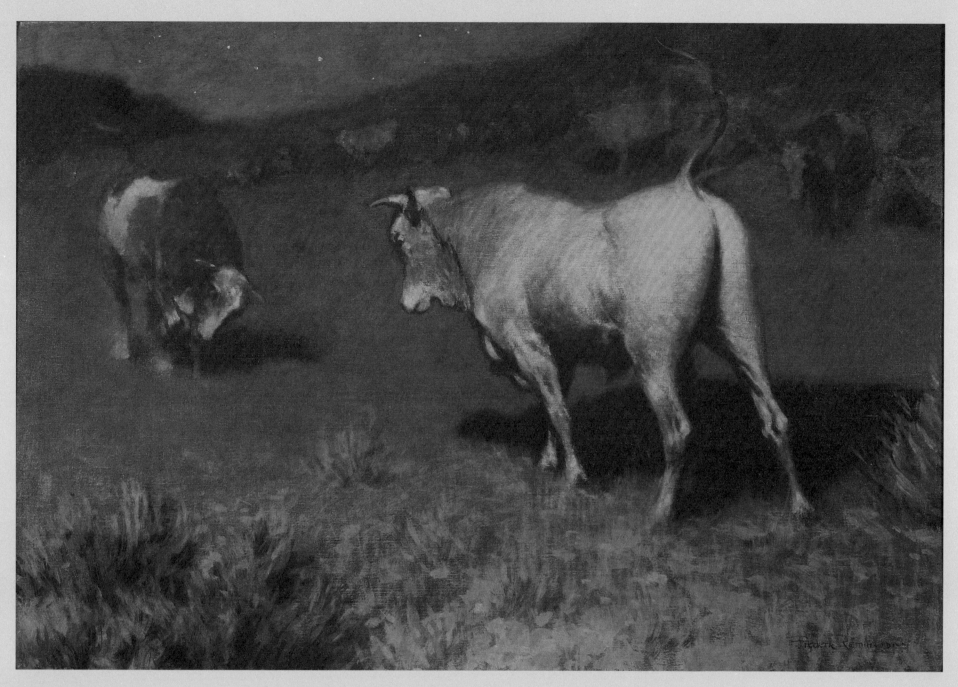

The Moaning of the Bulls 1907

Small Oaks 1887
Oil on canvas, 11¾ x 13¾" (29.9 x 34.9 cm.)
Signed lower right: Remington.; inscribed lower left: "Small Oaks" '87
FRAM 66.42, CR 86

Chippewa Bay 1888
Oil on paper, 11½ x 17¼" (29.2 x 43.8 cm.)
Signed lower left: Remington. / Chippeway Bay. 88
Museum purchase, 1959; Ex-collection: Mr. Dishaw, Canton, NY; FRAM 66.88, CR 198

Boat House at Ingleneuk ca. 1903-1907
Oil on academy board, 12 x 18" (30.5 x 45.7 cm.)
Unsigned
FRAM 66.78, CR 3017

Studio at Ingleneuk 1907
Oil on canvas board, 12 x 18" (30.5 x 45.7 cm.)
Signed lower left: Frederic Remington / Studio. 1907
FRAM 66.91, CR 2825

Pete's Shanty 1908
Oil on canvas, 12 x 16" (30.5 x 40.6 cm.)
Signed lower right: Frederic Remington / "Pete's shanty."
FRAM 66.76, CR 2863

Endion (Remington's home at New Rochelle) 1908
Oil on academy board, 12 x 16" (30.5 x 40.6 cm.)
Signed lower right: Frederic Remington / Sept. 15, 1908.
FRAM 66.125, CR 2865

It was said of George Catlin by a snide contemporary that he chose to paint Indians because there was no competition to expose his artistic deficiencies.[1] Remington was aware of similar reservations about his work. He might be lionized as a Western illustrator, but his artistry (particularly his color sense) was considered suspect. Straying outside his chosen field thus entailed risk, inviting comparisons that might not prove flattering.

Landscapes were a case in point. The landscape tradition was well established in American painting long before Remington was born, and many of his contemporaries earned substantial reputations for their outdoor scenes. His own efforts would naturally be subject to a critical scrutiny he did not risk when he painted Western action pieces. Nevertheless, Remington had always had an interest in landscape, as his early North Country oil sketches and watercolors show. In August 1887 he made a fishing trip to Chippewa Bay on the St. Lawrence, upriver from Ogdensburg,

and camped on what he called Small Oaks Island, in the Thousand Islands. It was an idyllic vacation, judging from a letter he wrote to Powhatan Clarke: "I am having a good time—doing a little 'pot boiling'—sketching a little—trying to catch muskalongue—eating more than is good for me—rowing getting up a muscle and in the evening I fight mosquitoes." The island was owned by a friend who had a small cottage on it, "but we 'are in camp,'" Remington told Clarke, "—camp is the only thing in summer." He illustrated tent, cot, table and chair in his letter, adding an inviting coffee pot perched on the rocks where the campers made their fire.[2] The oil *Small Oaks* is an equally literal transcription of the site, and the care Remington lavished on it indicates the pleasure he took in outdoor sketching—a pleasure evident in a photograph from the period showing him at work by his tent. The next year he did an oil study in pale blues and greens titled *Chippewa Bay*. Both paintings, though relatively somber-hued, anticipate the vibrant sketches he would make

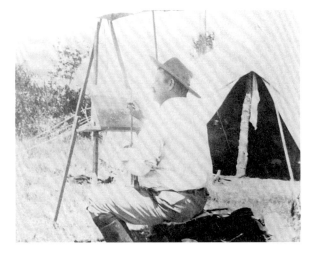

Frederic Remington painting out-of-doors, late 1880s
Photograph
FRAM

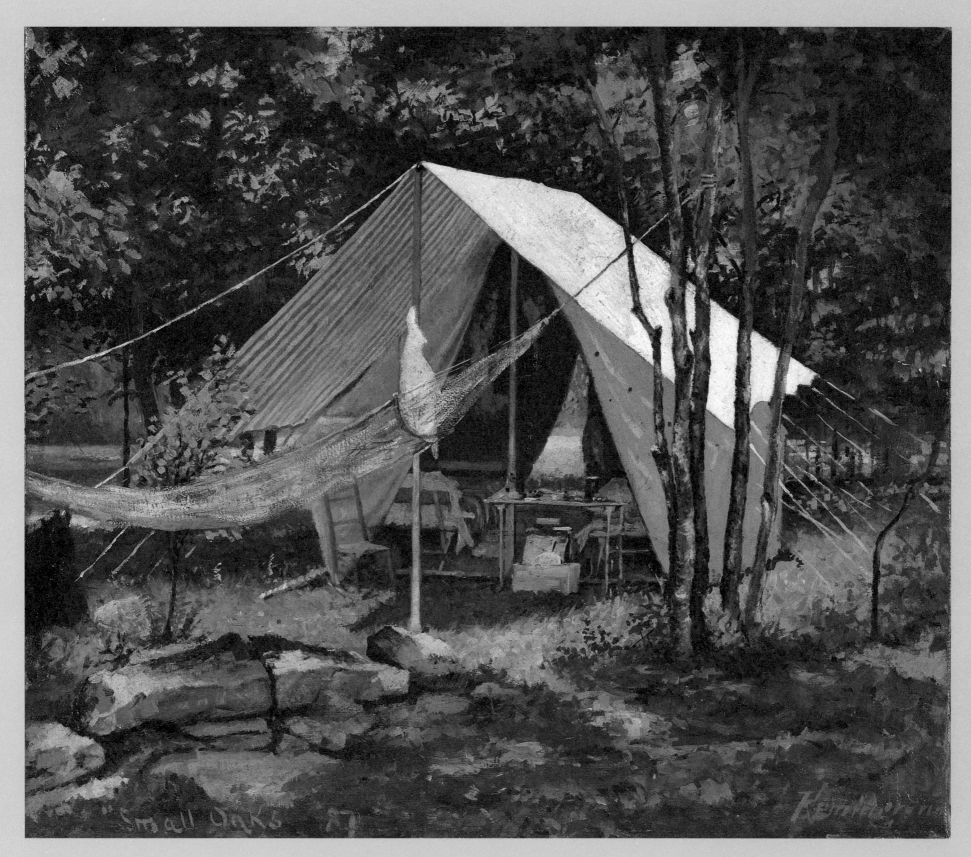

Small Oaks 1887

almost twenty years later on and around his own island in the bay. Remington's taste for landscape rarely surfaced in his early Western illustrations, where the challenge before him was to convey the vast expanse of plains and desert in the limited compass of a black-and-white reproduction. He made color notes and color studies out West for later reference. But he was no plein air painter at this time. His philosophy, articulated about 1890, rested on the premise that the artist had a critical role in transforming what he saw before him: "When you look at nature you know what you look at—you see what you see and what you do about it is art.—"[3]

This conviction stayed with Remington. Though he played at being a philistine when it came to Impressionism ("I've got two maiden aunts in New Rochelle that can knit better pictures than those!"), he closely followed trends in American art and made it a habit to keep up with the doings of the Society of Ten—the American Impressionist painters whose landscapes had earned his respect, even his envy.[4] He attended an exhibition of their "strong pictures" in March 1907, basked in the praise of Willard L. Metcalf, one of The Ten, for his Knoedler exhibition that December, and returned the favor a month later by visiting Metcalf's one-man show at the Montross Gallery and calling him "the boss of the landscape painters." A year later he still thought Metcalf "no. 1."[5] Since Remington also knew Childe Hassam, J. Alden Weir and Robert Reid, his preference is revealing. Metcalf was a cautious Impressionist. "He adopted the principles of diffused luminosity and broken color," Donelson F. Hoopes notes, "but he maintained a meticulous definition of form."[6] Remington, sculptor *and* painter, also never relinquished the illustrator's love of form; thus his fondness for Metcalf's brand of Impressionism. A week after visiting Metcalf's 1908 exhibition, Remington was outdoors painting some snowscapes of his own. It was pleasant to work in color after months mainly devoted to sculpting his Fairmount Park *Cowboy*, but he found himself reluctant to return to the studio: "I sometimes feel that I am trying to do the impossible in my pictures in not having a chance to work direct but as there are no people such as I paint its 'studio' or nothing. Yet these transcript from nature fellows who are so clever cannot compare with the imaginative man in long run."[7]

Remington's reservations suggest his own uncertainties throughout 1908. The American economy proved restless in a presidential election year, and so was he. His lucrative *Collier's* contract, with its guaranteed $12,000-a-year income, was threatened as advertising dried up and revenues fell. His "most unfortunate Knoedler show" in December 1907 had produced few sales and mixed reviews. But there were bright spots. Remington had no real financial worries—the Fairmount Park commission would tide him over until the economy turned around. And his nocturnes had been praised by the critics, bringing him the establishment recognition he coveted when, four days after his Knoedler show closed, the Pennsylvania Academy of Fine Arts, at Willard Metcalf's suggestion, requested two—*The Sentinel* and *The Desert Prospector*—for exhibition.[8] Still, Remington was at sea about the direction his work should take. Going West for fresh inspiration had long been "Shaddow Hunting," as he termed it, the Western scenery providing backdrops for imaginary set-pieces.[9] What else might he do?

The day after knocking the "transcript from nature fellows," then, Remington was in New York City visiting the exhibitions and musing on art. The Metropolitan Museum had acquired four of his bronzes in 1907—*The Broncho Buster*, *The Cheyenne*, *The Mountain Man*, and *Dragoons 1850*—and he went to view them. They were "beautifully shown," he noted, but the museum had not seen fit to add a Remington painting as well, so he toured their collection "without much zest."[10] At the American Art Association he brushed past the landscapes of Albert Bierstadt and offered the conventional wisdom—"big canvases but they won't do as we understand painting. The old men did not paint 'air'—they saw things darkly." (*Antoine's Cabin* [p. 83] was in the "airless" Bierstadt mode.) A discussion over lunch with the artist/critic Arthur Hoeber, who had just published an essay that damned the public for its neglect of "Americans who are making art history" like The Ten, brought him up to date on the gossip. Metcalf had sold only one painting at his exhibition, which was worrisome. But Remington was impressed by the progress made by another member of The Ten, Robert Reid, and he reversed his previous day's judgment: "Small canvases are best—all plein air color and outlines lost—*hard outlines* are the bane of old painters."[11] Still, the problem remained. The critical praise in which the American Impressionists basked did not necessarily add up to sales, and

Childe Hassam, *Early Summer Lake George*
Watercolor on paper
FRAM 66.126

Willard L. Metcalf, *Untitled* 1905
Oil on canvas
FRAM 66.135

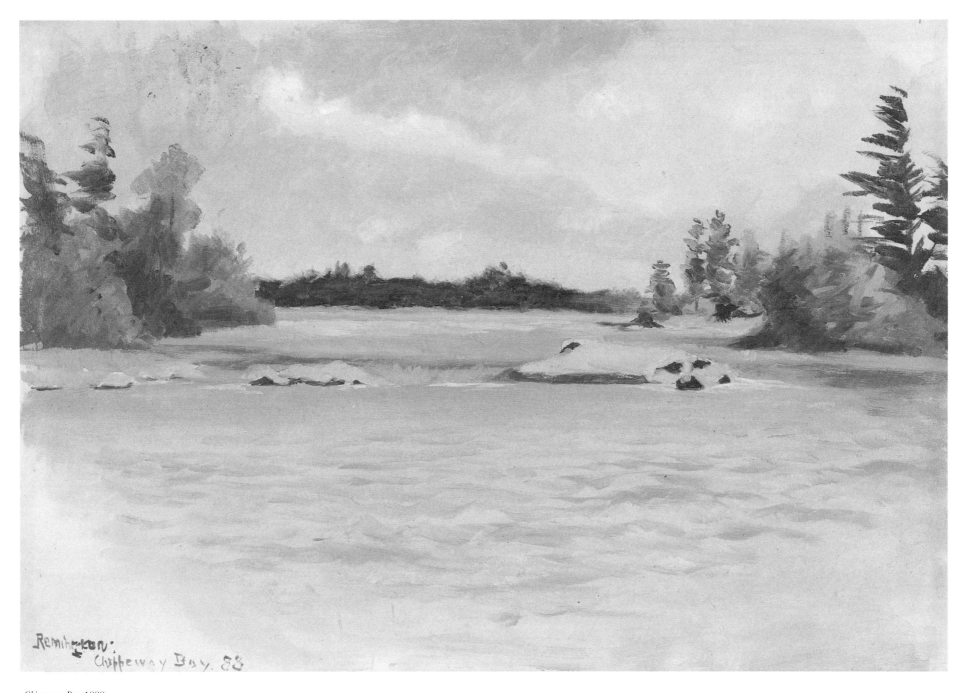

Chippewa Bay 1888
Oil on paper, 11¹/₂ x 17¹/₄" (29.2 x 43.8 cm.)
Signed lower left: Remington. / Chippeway Bay. 88
Museum purchase, 1959; Ex-collection: Mr. Dishaw, Canton, NY; FRAM 66.88, CR 198

Remington was always aware of the bottom line. Reid, he subsequently observed, was "cunning" at small landscapes, but his paintings lacked "sincerity": "they have a paint for paints sake draw to artists but d— by public. The public while not knowing why can detect sincerity." That was a pretty Olympian pronouncement for a man who was no populist himself, but it expressed his nervousness about deviating from his tried-and-true Western formula as he kept track of Reid's downward course to bankruptcy.[12] Still, Remington was enthusiastic about the National Academy's spring exhibition in 1908—"the Massacre of the Ancients," he called it on first viewing—and on March 23rd, four days after returning for a closer inspection and to admire another "splendid" exhibition by The Ten, he hung two of his island sketches in his New Rochelle home. They were important to him. They were where he wanted to be in his art. His situation at *Collier's* was nearing a crisis point with the publisher dissembling and the art editor hostile, but Childe Hassam had praised his recent work, and such praise had come to seem almost as important as commercial success.[13]

Contact with his Impressionist colleagues was clearly having an effect on Remington in this period. Theirs was the artistic company he wanted to keep, and so, without abandoning his bread and butter, "the 'Grand Frontier,'" he devoted his spare time to outdoor painting.[14] Each summer after finishing his major show pieces he rewarded himself by loafing and sketching the scenery around the island home in the St. Lawrence he had bought in 1900 and named Ingleneuk.

> *I am in Chippewa Bay 10 miles below Alexandria Bay. Seven miles wide here and blows like hell every minute. Got a dandy lumbered island—6 acres—good house—kitchen outside—boat house—two docks and a hospital tent. Its cool here all the while and I work summers. It was a good scheme since no one can live in New R— in the summer and work. It is cheaper than travel and anyhow summer is no time to spend on cars....[15]*

Remington fell in love with the place. No image from Ingleneuk is more appealing than his liquidy-leafy sketch of his boathouse as seen from the water. With an eye to color, he had his island handyman Pete Smith paint the house and boat house "pea-green—sure enough spring foliage—greenery-yellery you know." His friend John

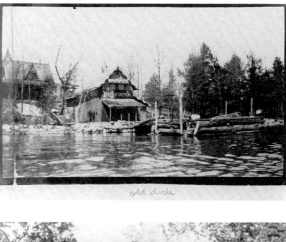

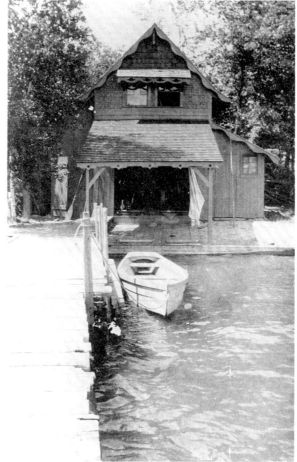

Boathouse and dock at Ingleneuk, old and new
Ingleneuk Album
FRAM 71.831.1; 71.831.2

Claude Monet, *Le pont d'Argenteuil* 1874
Musée d'Orsay, Paris

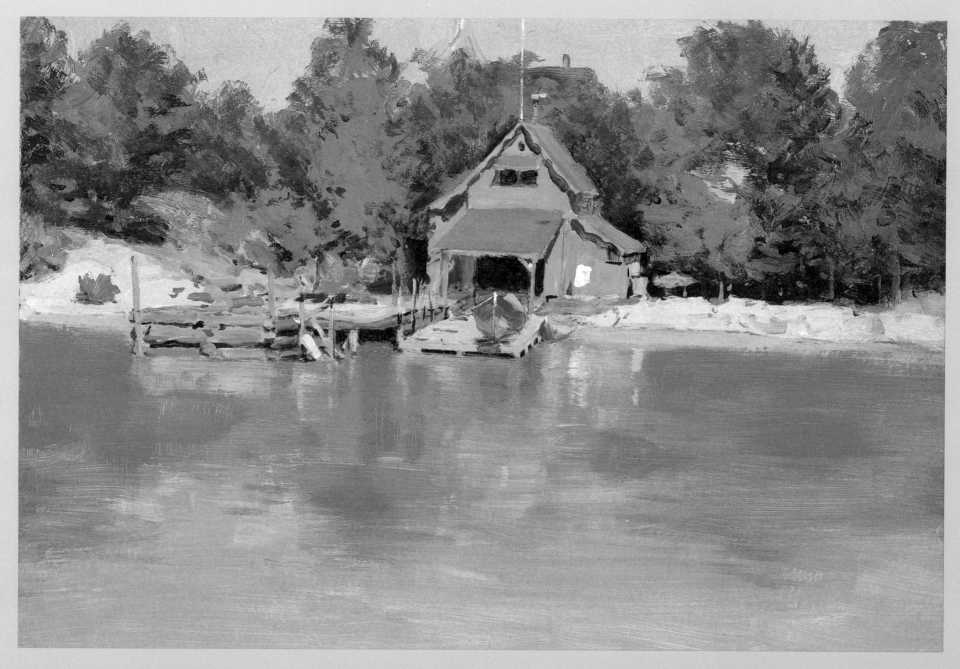

Boat House at Ingleneuk ca. 1903–1907
Oil on academy board, 12 x 18" (30.5 x 45.7 cm.)
Unsigned
FRAM 66.78, CR 3017

Howard was to procure the paint: "D— you we will see how much of an artist you are. I dont want any Paris green poison color such as you had on your house but the real touch of the April showers—now do you understand?"[16] Remington's oil study is a delight—vibrant greens, pale blues, a shimmering reflection. His brush stroking is fluid; the water laps across the picture, an invitation to summer, and to escape. "Oh I am itching to get up on that Island," he wrote in early spring of 1907:

> I look forward to it like a school boy. I want to
> get out on those rocks by my studio in a bath robe
> in the early morning when the birds are singing
> and the sun a shining and hop in among
> the bass. When I die my Heaven is going to be
> something like that. Every fellows imagination
> taxes up a Heaven to suit his tastes and I'de
> be mighty good and play this earthly game
> according to the rules if I could get a thousand
> eons of something just like that.[17]

Boat House at Ingleneuk has been dated 1903, though 1907 seems more likely, making it a companion piece to a study he made that June 21, *Remington's Studio at Ingleneuk*.[18] These would be the two island sketches he hung at New Rochelle in March 1908, with Pete's handiwork evident in the pea-green boat house and the pea-green studio. Remington noted that the water was high that spring and the trees slow to leaf, but mid-June had brought "the lazy summer days of fond memory."[19] The studio was a busy place as he worked on his *Collier's* pictures, but sitting nestled among the trees with the sun dappling its grey roof, it was consistent with his description of the island as a "fortress of Rest."[20]

In the summer of 1908, Remington picked up where he had left off at Ingleneuk, sketching outdoors most days despite a prolonged spell of inclement weather. He had begun to take himself seriously as a landscape painter. In August, Pete Smith helped him pack nine frontier scenes and "12 Chippewa Bay oil studies." One, made on June 26, showed Pete's cabin and was, Remington judged, a particular success, "a nice impressional use of the vivid greens of summer which it is hard to make interesting but I got the violet light all right."[21] *Pete's Shanty* justifies his enthusiasm. It is more daringly colored than the previous year's painting of his studio, and the brush work is notably freer. It bears comparison to two small landscapes Remington had acquired, an oil by Willard Metcalf and a watercolor by Childe Hassam, a comparison

flattering enough to Remington to explain why he would include *Pete's Shanty* among six small landscapes in his Knoedler exhibition that December. In 1902, as he watched an August sunset on the St. Lawrence, he told Edwin Wildman, "Seems as if I must paint them—seems as if they'd never be so beautiful again… But people won't stand for my painting sunsets," and he exploded with laughter. "Got me pigeon-holed in their minds, you see; want horses, cowboys, out West things—won't believe me if I paint anything else."[22] Including the six landscapes in his 1908 exhibition was a departure, then, that represented growing confidence in his outdoor work.[23]

Remington still had his doubts, of course. "The trouble with my landscapes is that they are merely pretty," he confessed. "I love the work tho." But could he make a living at it? His restlessness in 1908 went beyond his art. Since acquiring Ingleneuk in 1900 the island had been an annual passion. But three days after describing it in his diary on May 31, 1908 as "a Temple of Rest. A Hobboes Dream," he publicly offered it for sale.[24] Perhaps the cold, rainy, gusty weather that spring prompted his decision to sell, abruptly ending a love affair he had always declared eternal. But more important, a new dream far removed from any hobo's fantasy had seized the Remingtons. They

Remington's studio
Ingleneuk Album
FRAM 71.831.9

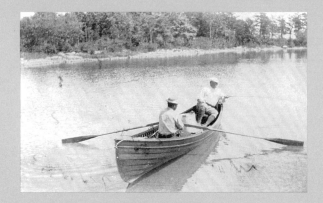

Remington loafing at Ingleneuk
Photograph by Edwin Wildman, August 1902,
Ingleneuk Album
FRAM 71.831.1

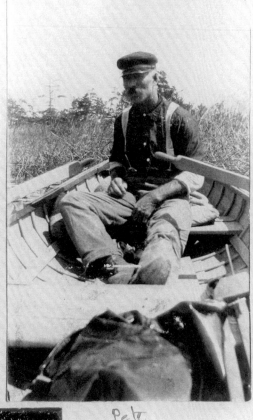

Pete Smith, Remington's handyman at Ingleneuk
Ingleneuk Album
FRAM 71.831.25

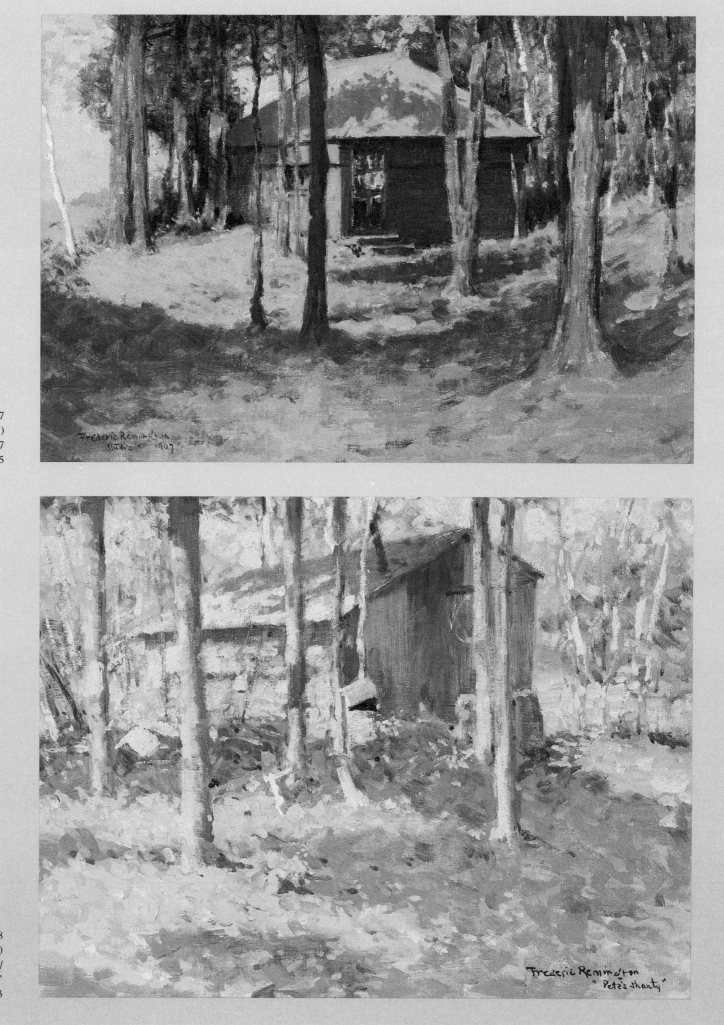

Studio at Ingleneuk 1907
Oil on canvas board, 12 x 18" (30.5 x 45.7 cm.)
Signed lower left: Frederic Remington / Studio. 1907
FRAM 66.91, CR 2825

Pete's Shanty 1908
Oil on canvas, 12 x 16" (30.5 x 40.6 cm.)
Signed lower right: Frederic Remington /
"Pete's shanty."
FRAM 66.76, CR 2863

would build a grand home in Connecticut commensurate with Frederic's enhanced artistic stature and their elevated social position.

When the Remingtons took up residence at 301 Webster Avenue in 1890, New Rochelle had seemed paradise enough, not just a home, as Frederic put it, but a gentleman's estate:

> —three acres—brick house—large stable—
> trees—granite gates—everything all hunk—
> lawn tennis in the front yard—garden—hen
> house—… located on the "quality hill" of New
> Rochelle—30 minutes from 42nd with two
> horses—both good ones on the place—duck
> shooting on the bay in the Fall—good society—
> sailing & the finest country 'bout you ever saw—
> what more does one want.

Eva was equally enthusiastic. "We have a lawn in front of the house about 200 ft. deep by nearly 200 ft. broad with many beautiful elm trees," she wrote. "Our home is old in style but so delightful. We have an *immense* piazza in front with vines running all over it, just the place for hammocks, big chairs, a table & luncheon if you like." At first they called it "Coseyo," but a cute name would not do for the the residence of an artist known for his men with the bark on, and soon it was renamed "Endion" ("sounds like Greek dont it—well its Ojibawa for '*The* place where I live'").[25] There Fred and Eva enjoyed the fruits of his commercial success. But New Rochelle had changed over the years— particularly in its ethnic complexion, Remington complained—and it was time to move on.

Consequently, both Ingleneuk and Endion were on the market in 1908. Despite economic uncertainty, Remington was sanguine about the future. On June 29 *Collier's* had at last stopped dithering and notified him he would be off the payroll come January 1909. That was a blow, and put house plans on hold; but, Remington vowed, if a Republican were elected president they would build come what may. By November they were committed to the move. Neither expressed much sentiment about leaving New Rochelle or Endion. It was the scene of their youths—"the best days of our lives," Remington acknowledged—and long a source of proprietorial pride. Just the previous September he had delighted in "the marvelous foliage of my trees and greenery of my lawn." But once the decision was made, they could barely wait to shake the dust of Endion off their shoes. "The era of the Remingtons at 301 is passing. Let her

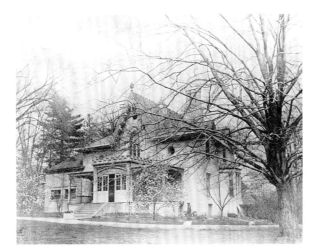

Endion: 301 Webster Avenue, New Rochelle, NY
Photograph, FRAM

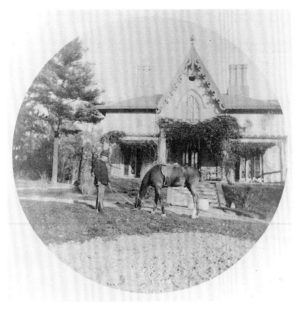

Remington and Beauty at Endion
FRAM 1918.76.152.13

Good times at Endion: Fred posing
FRAM 1918.76.152.94

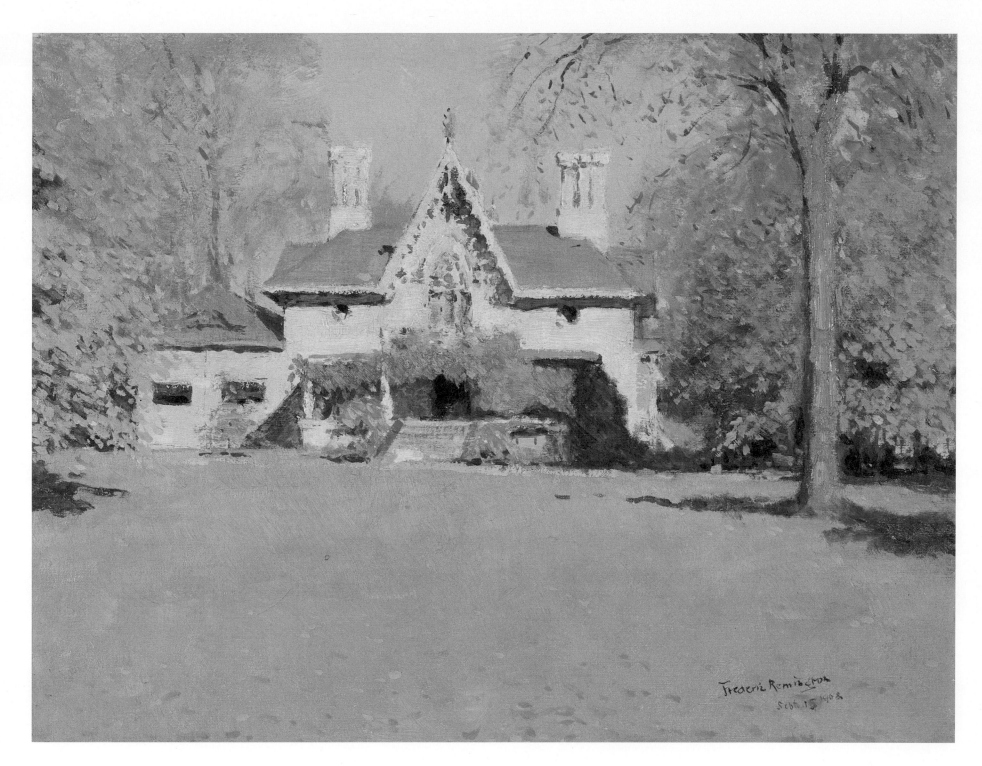

Endion (Remington's Home at New Rochelle) 1908
Oil on academy board, 12 x 16" (30.5 x 40.6 cm.)
Signed lower right: Frederic Remington / Sept. 15, 1908.
FRAM 66.125, CR 2865

pass," he wrote when the moment came to leave. But in mid-October 1908 he did show a soft spot. On successive days, beautiful and unseasonably hot, he made an oil painting of Endion "to remember it bye." The elms that had been Eva's pride provided both autumnal color and a challenge. Remington admitted his impatience when it came to puttering with foliage in his landscapes ("dib dib dib"), and his tones are subdued.[26] But he created a stately picture of the house they had called home for eighteen years, even if his distraction extended to misdating it by a month. The painting also attests to Remington's debt to Claude Monet, the one French Impressionist he named as an inspiration.[27] Just as *Boat House at Ingleneuk* compares to an early Monet oil, *Le pont d'Argenteuil* (1874), the effect created by the light playing on the surface of Endion in *Endion* is reminiscent of Monet's *La cathédrale de Rouen, le portail et la tour Saint-Romain, plein soleil: Harmonie bleue et or* (1894).

Claude Monet, *La cathédrale de Rouen, le portail et la tour Saint-Romain, plein soleil: Harmonie bleue et or* 1894
Musée d'Orsay, Paris

Opposite page, detail:
Endion (Remington's home at New Rochelle) 1908

1. William Dunlap, 1834, quoted in Brian W. Dippie, *Catlin and His Contemporaries: The Politics of Patronage* (Lincoln: University of Nebraska Press, 1990), p. 10.
2. FR to Powhatan Clarke, August 6, 1887, *Selected Letters*, p. 41.
3. Notebook (Frederic Remington / New Rochelle), FRAM 71.812.11.
4. "Remington's Frank Criticism," *Everybody's Magazine*, with Diary, March 26, 1909, FRAM 71.816.
5. Diaries, March 18, December 3, 1907, FRAM 71.815, January 2, 1908, FRAM 71.817, January 7, 1909, FRAM 71.816.
6. Donelson F. Hoopes, *The American Impressionists* (New York: Watson-Guptill Publications, 1972), p. 104.
7. Diary, January 15, 1908, FRAM 71.817.
8. Diary, December 14, 18, 1907, FRAM 71.815; Peggy and Harold Samuels, *Frederic Remington: A Biography* (Garden City, NY: Doubleday & Company, 1982), p. 396.
9. FR to John Howard, Thursday [April 25, 1907], FRAM; Diary, September 18, 1908, FRAM 71.817; and see *A Mining Town, Wyoming*, pp. 128–30.
10. Daniel C. French, Chairman, Committee on Sculpture, Metropolitan Museum, to FR, March 8, 1907, FRAM 71.815; Diary, January 16, 1908, FRAM 71.817. Eager for the recognition, Remington had offered the bronzes to the museum at cost.
11. Diary, January 16, 1908, FRAM 71.817; Arthur Hoeber, "Concerning Our Ignorance of American Art," *Forum* 39 (January 1908): 352, 355.
12. Diary, February 24, March 2, March 17, November 25, 1908, FRAM 71.817; Samuels and Samuels, *Frederic Remington*, p. 422. The lack of sales at the annual exhibitions of The Ten was one of Hoeber's complaints: "a sale… is almost unknown, and the members have to make up the cost of the show out of their own pockets, and it is doubtful if, picture for picture, a better modern exhibition is held anywhere in the world…." ("Concerning Our Ignorance of American Art," p. 355.)
13. Diary, March 14, 19, 23, May 10, 13, 1908, FRAM 71.817.
14. Diary, July 30, 1909, FRAM 71.816.
15. FR to Julian Ralph, [Summer 1900], *Selected Letters*, p. 313.
16. FR to John Howard, [1907]. On May 29, 1907, FR recorded in his diary: "Pete painting piazza but don't know how I am to keep Sandy [his dog] red instead of green." (FRAM 71.815).
17. FR to John Howard, [February 16, 1907], *Selected Letters*, p. 412.
18. The 1903 date derives from a passage in an article by Edwin Wildman, "Frederic Remington, the Man," *Outing* 41 (March 1903): 716. Wildman occupied a neighboring island within hallowing distance of Ingleneuk:

 Just after sunrise, a day before he left for his home in New Rochelle, Remington paddled out in the little bay, back of his island, and painted a sketch of his boathouse and the white rocks and green pines that line the shore.
 "First time I've touched the brush this summer," said he. "Got to take some of the light and water home with me to look at this winter. Just live to come up here—can't beat it anywhere—'cept out on the plains."

 Of course, Wildman was referring to the previous summer, which would date the painting 1902. *Boat House at Ingleneuk* is almost certainly not the study meant. Remington left Ingleneuk about the second week in September. The foliage shown here is a midsummer green, and much fuller than that depicted in the earliest photographs of Ingleneuk, while the boathouse itself has been modified and painted. The scene, with the house barely visible behind the trees, resembles the Ingleneuk of 1907 as described by Perriton Maxwell, "Frederic Remington—Most Typical of American Artists," *Pearson's Magazine* 18 (October 1907): 404:

 It is given to few men to live Crusoe-like on an island all their own; but Remington, besides possessing his own island, has augmented the boon with a substantial cottage, studio and outbuildings and lives apart from the herding crowd like a feudal lord of old. You cannot possibly disturb him at his work; you could not even locate this "Inglenuek" unless piloted to it. There are only five acres of it, but it is an impregnable stronghold and is, as the artist himself describes it, "the finest place on earth…." Here Remington works all summer…. I asked him for a photograph of the house at "Inglenuek." "Bless your soul," he replied, "it couldn't be photographed at any angle; it is solidly screened from view on all sides by the densest growth of trees along the St. Lawrence."

 And just so Remington showed it in this painting. Wildman repeated the substance of his article in "Along the Water Trail to Frederic Remington's Island Home," *New York Herald*, Magazine Sect., August 23, 1908.
19. Diary, June 14, 16, 21, 1907, FRAM 71.815.
20. FR to Jack Summerhayes, [1904], *Selected Letters*, p. 347.
21. Diary, August 12, June 26, 1908, FRAM 71.817.
22. Wildman, "Frederic Remington, the Man," p. 716.
23. While Remington worked over a few of the Western paintings in preparation for his Knoedler exhibition and modeled a new bronze, *Trooper of the Plains*, he kept his little landscapes in mind. Augustus Thomas saw them on October 31 and pronounced them on par with the best. "Says I will be a great landscapist," Remington noted. "One will always believe nice things of himself." Another friend told him the next day that they deserved "important frames." So on November 3 he sent six to his framer in New York City: *Chippewa Bay*, *The poole in the woods*, *Dark Island*, *The white birches*, *Pete's Camp* and *Wood Interior*. When they came back on the 16th he thought "they look quite fine dressed up"— "corking," as he put it nine days later. Before his exhibition opened at Knoedler he sold *Poole in the Woods*. In the catalog, *Dark Island* became *The St. Lawrence River* and *Pete's Camp* became *Pete's Shanty*. Diary, 1908, FRAM 71.817.
24. Diary, July 1, May 31, June 3, 1908, FRAM 71.817.
25. FR to Powhatan Clarke [December 1, 1889]; Eva Remington to Clarke [May 24, 1890]; FR to Clarke [August 7, 1890], *Selected Letters*, pp. 74, 94, 97. The story of how Endion got its name was repeated by Julian Ralph in "Frederic Remington," *Harper's Weekly*, January 17, 1891, p. 43. Since Ralph described the house as "pretty," and a later journalist described it as "cosy" (Charles H. Garrett, "Remington and His Work," *Success*, May 13, 1899; in Orison Swett Marden, ed., *Little Visits with Great Americans; or, Success Ideals and How to Attain Them*, 2 vols. [New York: The Success Company, 1905], I, p. 327), the original name was perhaps appropriate, and could further explain why both Remingtons were ready to move on to bigger things by 1908.
26. Diaries, June 29, 1908, FRAM 71.816; July 31, May 16, 1909, FRAM 71.817; September 8, 1907, FRAM 71.815; April 26, 1909, FRAM 71.817; October 15-16, 1908, FRAM 71.816; October 5, 1909, 71.817.
27. Giles Edgerton [Mary Fanton Roberts], "Frederic Remington, Painter and Sculptor: A Pioneer in Distinctive American Art," *Craftsman* 15 (March 1909): 669: "The one influence which Remington acknowledges frankly as of value to him in these later years of work is Monet; not his subjects or his individual technique, but his theory of light in relation to his art… that paint is merely the means of transferring the suggestion of light to a picture, a medium which should be used almost unconsciously, through which a man's expression of light becomes so fixed that a picture glows and quivers until it seems to exude the very palpitating quality which light itself holds…."

The Rattlesnake © January 18, 1905; remodeled and enlarged February 1908
Roman Bronze Works cast no. 100 (ca. 1918–1919), 23³/₁₆ H x 17¼ W x 12³/₈" D (58.9 H x 43.8 W x 31.4 D cm.)
Estate casting in accordance with Eva Remington's will
FRAM 66.5

Early in 1905 Frederic Remington copyrighted a bronze he called *The Rattlesnake*. Rattlesnakes! He had shown in a pen and ink published in *Harper's Weekly* on February 2, 1889, how an antelope handled the problem: one leap, and its hoofs were more than a match for the rattler's fangs. But an unsuspecting horse and rider were another matter. Here was a theme for man-horse action that did not pit the two, but showed them reacting together in surprise—the horse rearing in fright at the sound of the rattler, and the rider battling to stay aboard. The theme appealed to those in the know. Charles Francis Roe, an officer in the Sioux War of 1876, thought *The Rattlesnake* "the best thing I have ever seen. I had a horse bitten by a rattle snake near the Custer battle field while I was on his back—"[1] Veracity aside, *The Rattlesnake* is one of Remington's most effective sculptures. "Daringly cantilevered," as Michael Shapiro has noted, its twisting horse and rider invite multiple points of view.[2]

One of the first detailed accounts of the lost-wax method of bronze casting in relationship to Frederic Remington's work appeared in *Collier's Weekly*'s "Remington Number" of March 18, 1905. The author, James Barnes, described the process step by step, following an actual sculpture from plasteline model to finished casting. The model in question was the first version of *The Rattlesnake*. "Follow me," he promised his readers, "and you will see why there are no replicas—why each piece has been individualized by careful and conscientious effort." Barnes emphasized the artist's freedom to work directly on the wax impression created by the foundry:

With the apparently fragile shell before him he can take liberty. He can paint upon it with a brush dipped in the molten wax; he can smooth away with a scapula any ridge that does not strike his fancy; he can change the swing of a horse's tail, or gently alter the position of a lifted forefoot. The hollow model is his and he can enjoy once more the thrill of creative composition! Thus each piece is given an individuality soon to be duplicated in enduring metal. For instance, something was said

Antelope Killing a "Rattler" 1889
Pen and ink on paper, 15½ x 11¾" (39.4 x 29.9 cm.)
Signed lower left: —Remington-.
Acquired 1979; FRAM 79.7, CR437.

about the position of the rattlesnake…. Mr. Remington decided to change it; the little string of wax that represented the snake was bent and curved and again replaced; this time the effect seemed more pleasing. "Great fun," said he, "isn't it, eh? Just see what can be done with it— isn't it wonderful! You could work on this for days changing and rechanging as you like—the only limit is your time and patience. Great fun, eh?"

After describing the casting process, Barnes concluded: "… the now disintegrated matrix is removed, and here is our bronze figure before us wrapped in a labyrinth of metal vines… These are filed and cut away, the gold color of the metal is toned by chemicals, the appurtenances are added— a bridle, a quirt, a coiled lariat—and the bronze statuette is finished."[3]

The Rattlesnake © January 18, 1905;
remodeled and enlarged February 1908
Roman Bronze Works cast no. 100

It was appropriate that Remington mentioned the pleasure sculpting gave him, as well as the time and patience required, because in 1908 he grew dissatisfied with the original version of *The Rattlesnake* and, on January 21, decided to remodel it. He began work on the sculpture on January 30, determined to "greatly improve the old model for it is an excellent study of horse action in motion." He reported on his progress as the cold of January (which actually froze his modeling clay one day) turned to the warm rain of mid-February. On the 13th he thought the model finished but for "the surface fussing," on the 18th declared it done and "a great improvement on the other," but on the 20th "saw some defects… and went at it again." Another full day's work, and this time *The Rattlesnake* was finished. "It has taken me much longer to model than I had any idea of but is a good job and a good bronze," he told his diary. "Well worth while."[4] It was nearly four inches taller than the original version, and fundamentally changed in its basic lines by repositioning the horse's back legs and altering the twist of its head and neck and the angle of the cowboy's torso, producing what Riccardo Bertelli described as "quite a different action."[5] On March 20, Remington spent the morning at Roman Bronze Works and finished the first casting of his "new model" (as he put it) of *The Rattlesnake*.[6] After *The Broncho Buster*, it would prove his most popular bronze.

1. Charles F. Roe to FR [February 2], 1905, FRAM 71.823.91.
2. Michael Edward Shapiro, "Remington: The Sculptor," in Shapiro and Peter H. Hassrick, *Frederic Remington: The Masterworks* (New York: Harry N. Abrams, for the Saint Louis Art Museum, in conjunction with the Buffalo Bill Historical Center, Cody, WY 1988), p. 211.
3. James Barnes, "Frederic Remington—Sculptor," *Collier's Weekly*, March 18, 1905, p. 21.
4. Diary, January 21–February 20, 1908, FRAM 71.817; and Roman Bronze Works invoice, March 2, 1908, for the new plaster cast of *The Rattlesnake*, FRAM 96.8.16.
5. Riccardo Bertelli to Sarah Y. Raymond [August 12, 1927], FRAM; and see *Frederic Remington (1861–1909): Paintings, Drawings, and Sculpture* (Shreveport: The R. W. Norton Art Gallery, 1979), pp. 78–79, and Michael Edward Shapiro, *Cast and Recast: The Sculpture of Frederic Remington* (Washington, D.C.: Smithsonian Institution Press, for the National Museum of American Art, 1981), pp. 51, 53–54. Shapiro notes that of all Remington's works, "the original model of *The Rattlesnake* underwent the most radical change."
6. Diary, March 20, 1908, FRAM 71.817. This follows Bertelli's description in the Roman Bronze Works bill to FR, March 2, 1908 (FRAM 96.8.16), for time and expenses in "making new model and plaster cast of Rattlesnake."

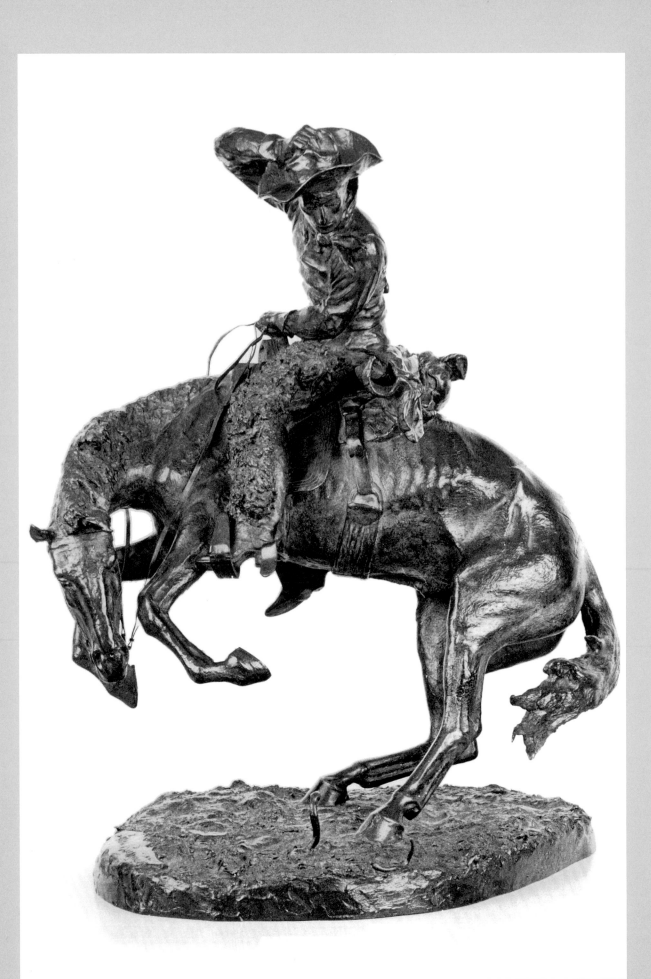

The Rattlesnake (original version)
Roman Bronze Works cast no.1 (1905)
The R. W. Norton Art Gallery, Shreveport, LA

Opposite page, detail:
The Rattlesnake © January 18, 1905; remodeled and enlarged February 1908
Roman Bronze Works cast no. 100 (ca. 1918-1919)

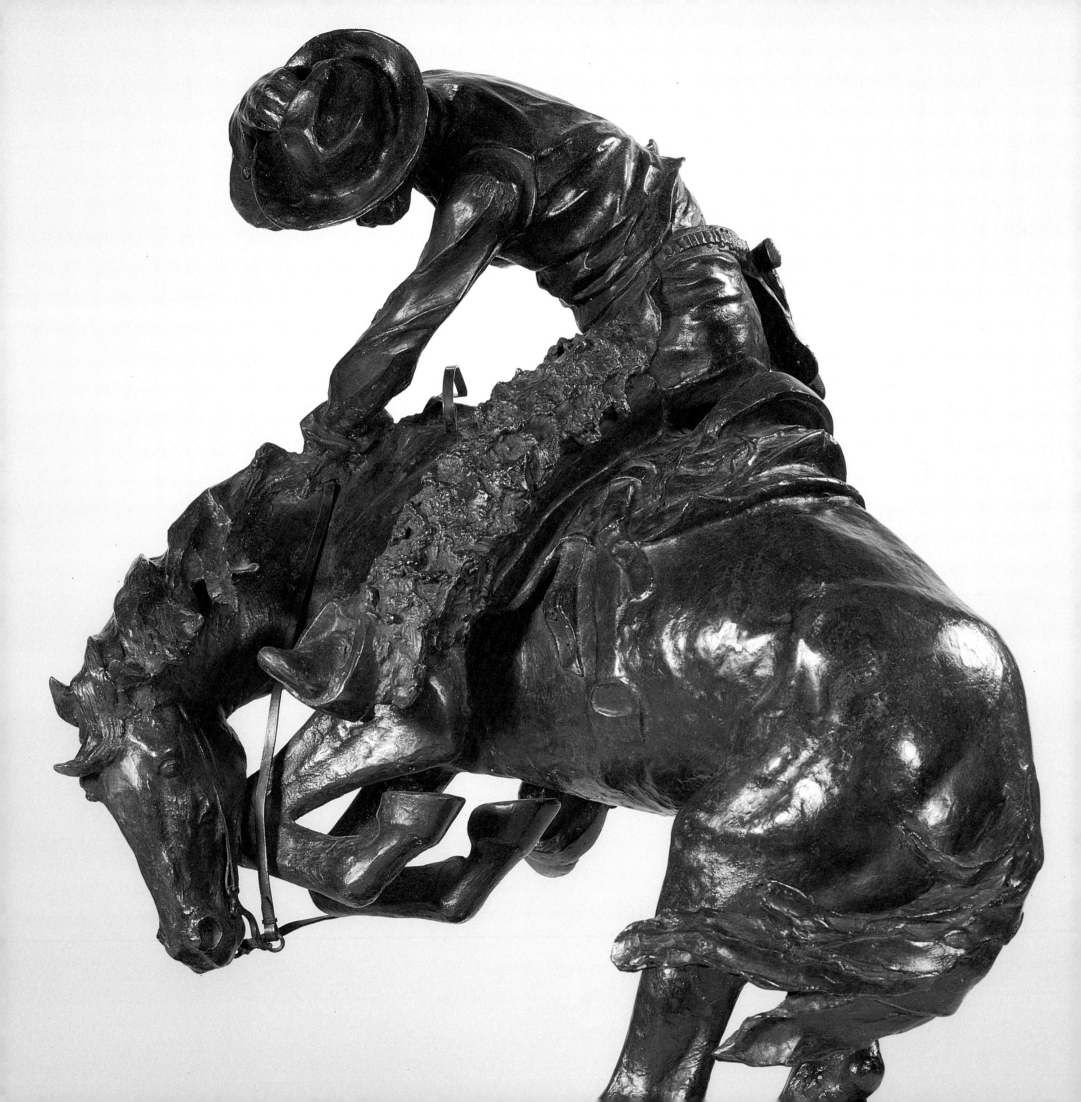

The Snow Trail 1908

Oil on canvas, 27 x 40" (68.6 x 101.6 cm.)
Signed lower left: Frederic Remington-;
Inscribed lower center: copyright 1908 by P. F. Collier & Son
FRAM 66.39, CR 2870

*T*he Snow Trail is one of Frederic Remington's most Impressionistic paintings. Red is everywhere, as though the imagined pleasure of a frisky horse ride on a bracing winter's day has stirred the artist's very blood. Remington uses red to sketch in the background figures (in his Impressionistic mode, he always did a certain amount of drawing with his paint) and to model the features of the foreground rider. It is in his face, his hair, his leggings. It flecks his horse's hide.[1] Though the sky in *The Snow Trail* has creamy undertones and the distant hills are a pale blue, the color scheme is hot, warming the winter's day and complementing the action. This is Remington at his most sanguine. There is no message here.

Remington often pictured horses charging at a gallop. He had captured the plodding tread of an exhausted mount and the light step of a prancer. In *The Snow Trail* the ponies *canter* through the snow, carrying their riders out of the cool shadows of the valley into the warm sunlight. The mood is entirely different from the rather grim, wintry scene that served as its precedent, *Horse of the Canadian North-West* (ca. 1888). The painting is lighthearted, invigorating, in line with the artist's mood on January 11, 1908, when he noted in his diary:

> Drove down along Farmington river [in Connecticut] and took a look up at the hills— and they are interesting each way—up or down. the rushing river—a cold blue through the snow fields is fine…. Splendid winter day and good sl[e]ighing. Loafed after luncheon until the sun was bout to set when I went across lake and made a dandy study of snow with the sun setting on it—a valuable note.[2]

A month later, *The Snow Trail* was finished and ready for shipping to *Collier's*.

An exercise in light and color, *The Snow Trail* is a throwback to the uncomplicated joy of racing a horse over the Kansas prairie (its "stride was steel springs under me") that Remington had vividly described in his first published article, "Coursing Rabbits on the Plains" (1887).[3] *The Snow*

Trail anticipates another horseback dash that Remington painted the next year, *The Buffalo Runners—Big Horn Basin*, where the tempo has picked up on a summer's day and the riders crest the ridge at full gallop. The two paintings would make a handsome pair. Both are exceptional Remingtons, though neither received much critical attention at the time. Remington's contemporaries had decided that he was at his best in his moonlights; his daylights were still overwrought— too intense, too raw, too vibrant to be considered art. One critic in 1909 welcomed his landscapes as "a refreshing contrast to the high-keyed hot red and yellows of his Indian scenes."[4] Some of his most pleasurable—and pleasurably innocent—work has thus gone unduly neglected. Remington might offend the modern sensibility with his frank celebration of the winning of the West. But in paintings such as *Buffalo Runners* and *The Snow Trail*, his West was a sunny playground devoid of moral ambiguity.

Horse of the Canadian North-West
Century Magazine 37 (January 1889): 340

The Buffalo Runners—Big Horn Basin 1909
Sid Richardson Collection of Western Art, Fort Worth, TX
CR 2895

1. After *The Snow Trail* was framed for exhibition at Knoedler, Remington decided it "lacks color in figure," and on November 27 he retouched it at the framer's shop. Some of the red was no doubt added at this juncture. Diary, November 25, 27, 1908, FRAM 71.817.
2. Diary, January 11, February 15, 1908, FRAM 71.817. Peter H. Hassrick, "Remington: The Painter," in Michael Edward Shapiro and Hassrick, *Frederic Remington: The Masterworks* (New York: Harry N. Abrams, for the Saint Louis Art Museum, in conjunction with the Buffalo Bill Historical Center, Cody, WY, 1988), p. 155, reproduces an oil study of snow-patched hills that suggest those in the background of *The Snow Trail*; it was likely made on the Connecticut trip. In his diary for January 10, Remington noted: "In afternoon we drove along the high hills in a sleigh and got splendid views—mountains mauve with the leafless timber and patched with snow. Many old abandoned farms in fact country is quite wild as result of abandonment."
3. FR, "Coursing Rabbits on the Plains," *Outing*, May 1887; *Collected Writings*, p. 3.
4. "Works by Mann and Remington," *American Art News*, December 11, 1909.

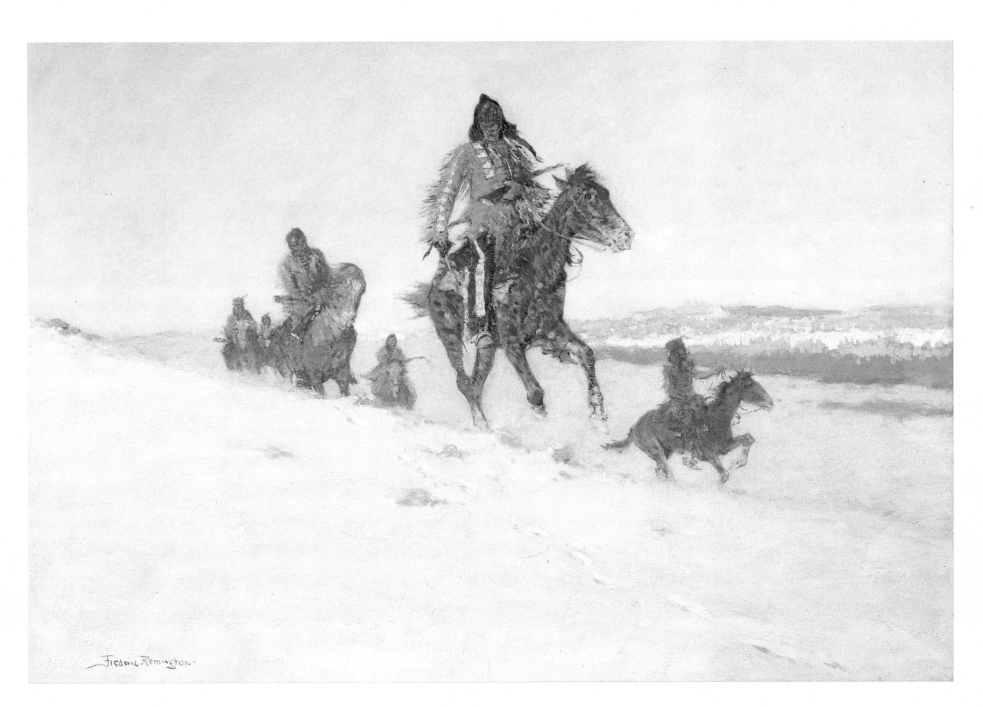

The Snow Trail 1908

The Savage © December 14, 1908
Roman Bronze Works cast no. 5 (June 1, 1914), 11 H x 6¹/₁₆ W x 5¹/₂" D (27.9 H x 15.4 W x 14 D cm.)
Estate casting in accordance with Eva Remington's will
FRAM 66.14

The foreground figure in *The Snow Trail* holds his head tilted back at an angle Remington favored in portraying Indians as born stoics possessed of a primitive hauteur. It is also a pose reminiscent of the Indian portraits that the photographer Frank A. Rinehart made at the Trans-Mississippi Exposition and Indian Congress, held at Omaha in 1898. Remington added a selection of Rinehart's portraits to his research files, and in 1908 bought George Bird Grinnell's *The Indians of Today*, which reproduced a number more.[1]

If Remington's Indian heads are virtually interchangeable, however, it is not because of Rinehart. They are faithful to the artist's preconceptions about the "savage" type—high-cheekboned, low-browed, wide-mouthed and massive-jawed, a Stone Age man trapped in the modern world. By the end of the nineteenth century, Remington was prepared to grant the Indians respect. But he never revised his earlier opinion of a Sioux dating from the time of the Ghost Dance War: "I sat near the fire and looked intently at one human brute opposite, a perfect animal, so far as I could see. Never was there a face so replete with human depravity, stolid, ferocious, arrogant, and all the rest…. As a picture, perfect; as a reality, horrible."[2]

Remington compressed his understanding of the American Indian type into a single bronze in 1908. He made his first stab at an "Indian head in sculpture" in February, but abandoned it as "spoiled" when it "got 'pretty' under my hand." He tackled the subject again on a foggy, warm day that November. He was working in the afternoon gloom—"very dark and trying on the eyes," he noted—but finished the bust at a sitting. No one would describe this Indian head, with its bared teeth and scowl, as too pretty.[3] Intended as a companion piece to *The Sergeant* (p. 147), it designated its subject not as a warrior or a brave or a tribal member, but by the word that best conveyed Remington's meaning—*The Savage*.

Kills Enemy, Sioux
Photograph copyright 1898 by F. A. Rinehart, Omaha
FRAM 1918.76.160.632

Chief Wolf Robe, Cheyenne
Photograph copyright 1898 by Frank A. Rinehart, Omaha
FRAM 1918.76.160.272

1. See Royal Sutton, *The Face of Courage: The Indian Photographs of Frank A. Rinehart* (Fort Collins, CO: The Old Army Press, 1972), and Bill and Verla Rieske, *Historic Indian Portraits: 1898 Peace Jubilee Collection* (Salt Lake City: Historic Indian Publishers, 1974).
2. FR, "Lieutenant Casey's Last Scout: On the Hostile Flanks with the Chis-Chis-Chash," *Harper's Weekly*, January 31, 1891; *Collected Writings*, p. 75. Remington was writing in 1891 in the heat of emotion following the death of Lieutenant Casey (see pp. 76–78), but the same viewpoint informed his entire novel *The Way of an Indian*, written in 1900 and published serially in 1905–1906.
3. Diary, February 15, 19, 22, November 24–25, 1908, FRAM 71.816.

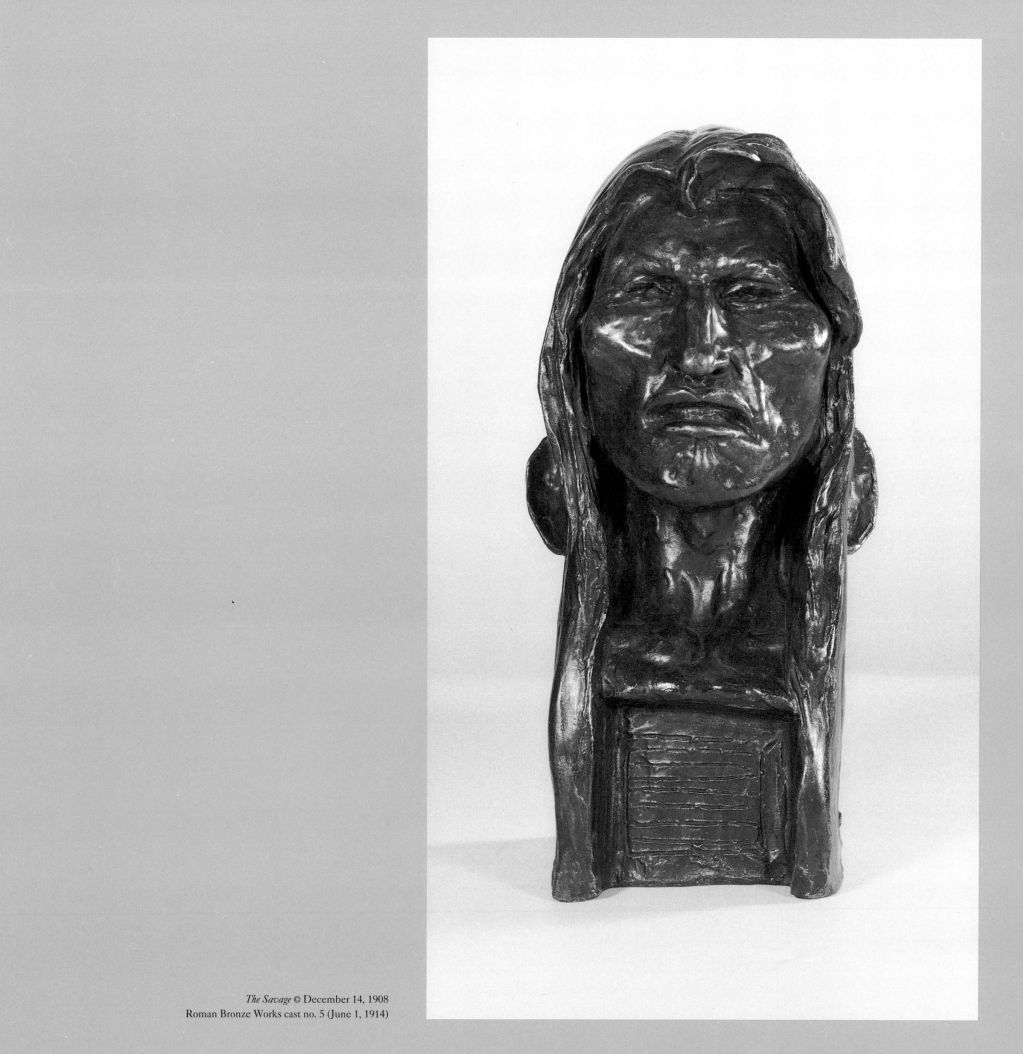

The Savage © December 14, 1908
Roman Bronze Works cast no. 5 (June 1, 1914)

Squatter's Cabin (*Squatter's Shanty near a Glacial Stream*) 1908

Oil on canvas, 27 x 40" (68.6 x 101.6 cm.)
Unsigned
FRAM 66.47, CR 3030

In September 1908 Frederic Remington made his last trip West. It was an unsettling, disillusioning experience that only confirmed his worst suspicions. He was too old, too soft, too used to his creature comforts to put up with the inconveniences of travel. Perhaps he was mentally unprepared for any discomfort at all. That February, acknowledging a need for fresh inspiration, he jotted in his diary that he might "run out" West in April—as though the trip was equivalent to a dash to the corner store for groceries. When he actually left, on September 9, it was with his mind more on his *Collier's Weekly* contract and his stock portfolio than on the journey ahead. His complaints were immediate—bad food, oppressive heat, a drunken lout for a fellow passenger—and this was just the train ride from New York to Sheridan, Wyoming. "Most grilling day I can remember to have endured," he wrote while passing through Nebraska.[1] His spirits began to lift with the cooler weather in Sheridan. The area was rich in the kind of Indian wars lore that had for so long been his bread and butter, and in Cody he would join George T. Beck, a local entrepreneur, on a well-equipped hunting and fishing party into the Absaroka Mountains. Expecting he might be gone as long as a month, Remington wrote Eva on the 15th that he would paint his way "slowly up the valley" while he adjusted to the thin mountain air. In fact, he did not last a week.[2]

The first night out he wrote in his diary: "In camp late—blowing—cold—teepee tents. D— near busted my hip lying on ground. Rain during night. I feel the high air of this 7000 ft. altitude. I don't like it." There were compensations, including a "good talk" by a roaring campfire one evening (the "real thing—smoke blowing in your face and sparks flying") that inspired his oil *The Hunters' Supper* (p. 217) the next year.[3] Still, when the party proceeded into the mountains a few days later, Remington stayed behind with the man hired as cook and wagon driver. He watched the hunters wend their way up "over the trail into timber around a bend & gone," and soon abandoned the base camp where he was to have awaited the others, returning to Cody through snow and sleet on the 24th. Fearing pneumonia, he "tanked up on

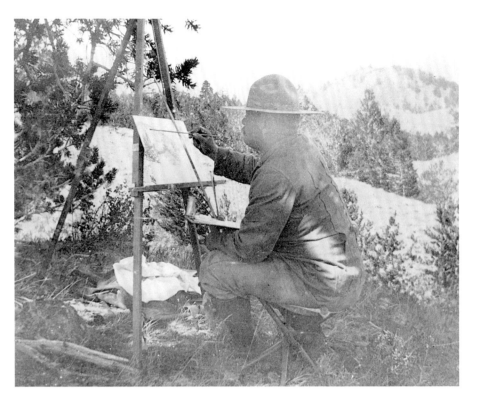

Frederic Remington at work outdoors
Wyoming, September 1908
FRAM

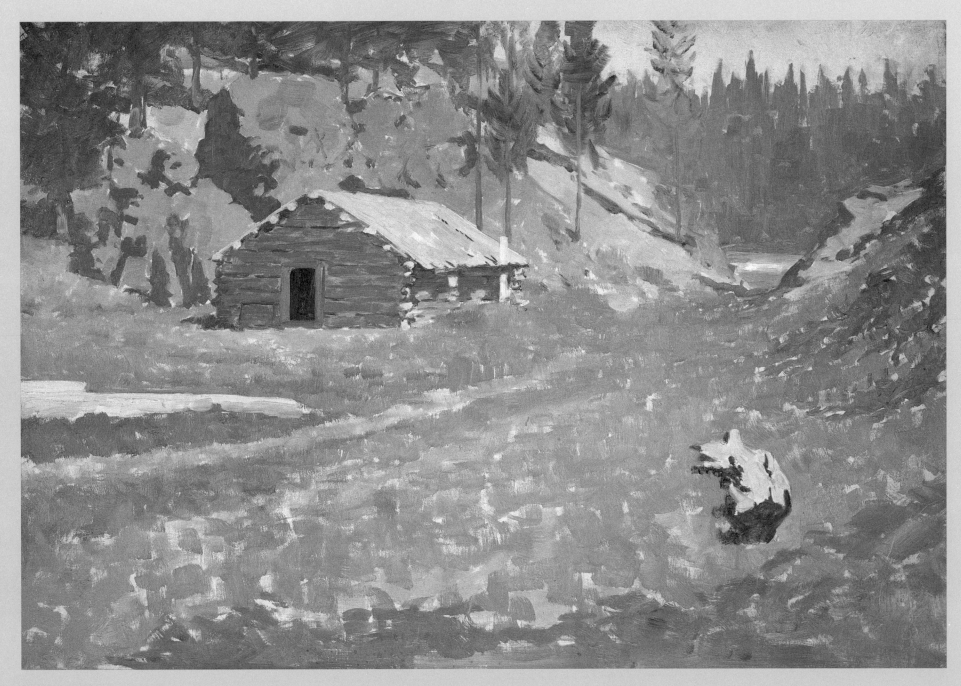

Squatter's Cabin (*Squatter's Shanty near a Glacial Stream*) 1908

whiskey" and wrote Beck a studiedly breezy letter explaining his decision:

> *Immediately you left I lost control of my emotions—I painted and had a good time but eight days did me—and then the clouds came so Ben and I organized a retreat. We arrived here to day and I am going out [of Cody] to-morrow—I know not where—Ben is going back with this letter and 4 bottles of Bourbon (with compliments) to meet you when you return.*[4]

Remington thought of sketching ponies on the Crow Reservation, but abandoned that plan as well and made a beeline home, arriving on September 29. Glad to be back, he bathed twice and sank into the comfort of his own bed. He would not go West again.

The 1908 excursion was unexceptional: all of Remington's Western trips after the turn of the century proved more or less disillusioning. Why, then, did he make them? In 1907 he told a revealing story. An editor a few years earlier had asked him why he did not go West oftener. "What for?" "To collect material." Remington was silent. "It would have taken too long to make him understand," he recalled. "I go West now every year, but only to paint landscapes—not 'to get material.'"[5] Where in the past he had gone West in search of local color, after 1899 he went West in search of natural color. He had always been dazzled by the brilliant effects created by clear Western air—color, he wrote in Mexico, which "is beyond the comprehension of our gloomy Northern mind."[6] Even on his final trip to Wyoming he remarked on qualities he had first observed twenty years before: "The transparency of air up here is confusing to paint. Sage brush under your nose has the same vividness as mountains 40 miles away. It is quite unbelievable to one who has not seen it. The blue sky is vivid."[7]

In his desire to slough off the habits of the illustrator, Remington experimented freely. *Squatter's Cabin* is a case in point. In one of the early Frederic Remington Memorial brochures it was listed apart from the St. Lawrence River scenes as *Squatter's Shanty near a Glacial Stream*, indicating it was a Western subject, though at more than two by three feet it is nearly twice as large as Remington's usual field studies.[8] A photograph of the artist painting in Wyoming above Irma Lake shows a typical academy board on his easel. George Beck, his host in 1908, provided an interesting description of the artist at work. "When he started to paint, his rapidity and his accuracy were wonderful to watch," Beck observed:

> *He carried around a small, smooth board with a hole cut in it for his thumb instead of a regular palette. His pockets would be bulging with tubes of color and he always had a huge fistful of brushes and pencils.*
>
> *After the scene was sketched he would daub a lot of primary colors on the board and, taking a brush, he'd mix a shade he wanted. Then taking another brush he'd dab spots of this color all over the canvas. Throwing that brush on the ground, he would take another and start on another color, repeating the process of putting it on in spots where ever the color hit his eye.*
>
> *Finally he would get so many bright daubs of paint on the canvas that it looked more like a sample of Joseph's coat of many colors than a picture. And then he would begin mixing some dark paint for the shadows. Once he had his shadows in, the picture suddenly stood out—completed.*[9]

Whether or not *Squatter's Cabin* was painted in Wyoming, it conforms to Beck's description. Its colors range from apple green in the grass to pinkish-flesh tones in the cabin roof and the hills behind, and mauve in the shadows. The water is green and white, the distant trees green and purple, and the sky a pale blue. The rock in the foreground, strangely rendered, seems a comparatively conventional touch in a landscape as daringly colored as this one. With its cracked surface, it is reminiscent of the dominating boulder in *A Mining Town, Wyoming* (pp. 130–131). It also suggests Remington's continuing reliance on a foreground object to balance his landscape compositions.

1. Diary, February 20, September 11, 1908, FRAM 71.817.
2. FR to Eva Remington, [September 15, 1908], *Selected Letters*, p. 401. It should be noted that Remington's own plans had originally called for an excursion of "say ten days" or less; likely he agreed to the longer trip in an expansive mood after several drinks with his host. See FR to George T. Beck, August 2, 7, [1908], Buffalo Bill Historical Center, Cody, WY.
3. Remington sketched in the painting (which he called "Camp of Hunters" at the time) on December 23, 1908. (Diary, FRAM 71.817.)
4. FR to George T. Beck, Thursday [September 24, 1908], Buffalo Bill Historical Center, Cody, WY; and, for the entire excursion, Diary, September 16–29, 1908, FRAM 71.817. George Beck's narrative of the trip (*Cody Enterprise*, April 15, 1996) is a devastating commentary on Remington's self-indulgence.
5. Perriton Maxwell, "Frederic Remington—Most Typical of American Artists," *Pearson's Magazine* 18 (October 1907): 405.
6. Notebook, FRAM 71.812.8.
7. Diary, September 19, 1908, FRAM 71.817.
8. *The Frederic Remington Memorial, Ogdensburg, N.Y. Opened July 1923* (Ogdensburg, NY: Republican-Journal, [1923]).
9. *Cody Enterprise*, April 15, 1996.

Opposite page, detail:
Squatter's Cabin (Squatter's Shanty near a Glacial Stream) 1908

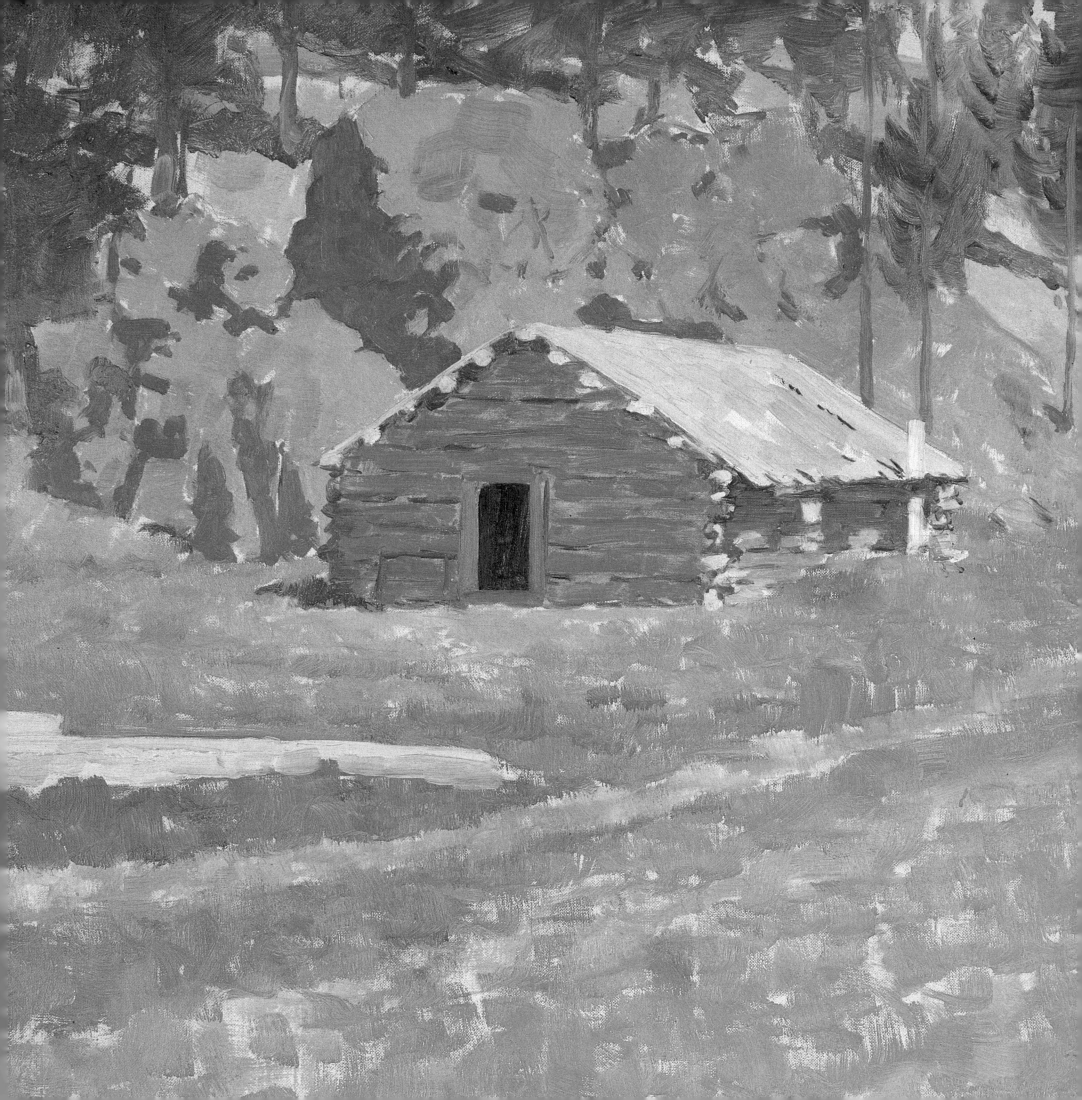

[*Ghost Stories*] (unfinished) ca. 1908–1909

Oil on canvas, 30 x 27" (76.2 x 68.6 cm.)
Unsigned
FRAM 66.53, CR 2911a

On January 18, 1906, Remington copyrighted an oil painting under the title *The Ghost Stories*. It showed an older Indian telling scary tales to four children gathered before him, their impressionable faces registering emotions that maturity would teach them to conceal. Remington did a variation on this theme the next year, *Story of Where the Sun Goes*, showing a wizened Indian explaining the mystery of day's end to three rapt children. They face outward, lit by the fiery glow of the sunset they are observing; *The Ghost Stories*, in contrast, is a night scene, as befits its subject, and Remington had fun with it. He showed a wolfish dog on the edge of the circle of firelight with its head turned away from the speaker staring uneasily into the surrounding darkness.[1]

There is a universal quality to both scenes, though the immediate inspiration behind them was Remington's interest in what he regarded as primitive superstition. Indeed, he was not religious himself, remarking of his wife who periodically was, "There is nothing like being eclectic in such matters. A religion does no harm if one doesn't take it too seriously."[2] But Indian beliefs struck him as serious. They were *the* key to understanding the "savage child-mind," a subject he explored fully in his novel *The Way of an Indian*, written at the turn of the century.[3] Its Cheyenne protagonist is a bloodthirsty subhuman who continually seeks guidance from bats and spiders and wolves, reading good and bad medicine in all of nature, including thunderstorms. Theodore Roosevelt, who had praised an earlier Remington effort to penetrate that "child-mind," applauded again: "It may be true that no white man ever understood an Indian, but at any rate you convey the impression of understanding him!"[4] Remington's pictorial interest in the theme went back further—to his commission to illustrate Francis Parkman's *Oregon Trail* in 1892. One passage he selected for illustration told of how the Sioux responded to a rain storm by sending out thunder-fighters who tried to drive off the black thunder-bird with its roaring wings by firing arrows and musket balls overhead while beating on drums, blowing on eagle-bone whistles, and setting up a cacophony of their own sufficient to frighten it

away.[5] Remington worked a variation on his *Oregon Trail* illustration in *The Coming Storm* (1897), and remained enamored of the theme of the superstitious Indian reading omens and signs in nature.[6]

On January 25, 1908, three days after putting the final touches on *Story of Where the Sun Goes*, Remington struggled with a new painting. "Did 'Thunder Fighter' 3 times," he wrote in his diary, "and don't know yet whether I shall be able to satisfy myself." There is a possibility that the painting in question is this unfinished oil. If so, it survived an act of artistic vandalism that same day when Remington, perhaps frustrated by his failure, burned up "a lot of old canvases."[7] The canvases were not that old—one had been published in *Collier's Weekly* as recently as November 2, 1907. But artists besides Remington have vented their frustrations on unsold pictures, and he spared more than he let on.

Thematically, the unfinished painting (which acquired the title *Ghost Stories* after Remington's death) closely resembles a 1909 oil, *The Mystery*.[8] In both, two Indian riders pause, facing the viewer. One raises an arm towards the sky which the other studies with rapt interest. Companions ride up behind. Since the unfinished oil is a rough draft, Remington's intentions are not fully realized. He planned a nocturne, in contrast to *The Mystery*, a daytime scene. Thus the color scheme runs to greens, blues and browns, with the background figures merely suggested by a few strokes of brown. What is clear is that Remington intended a painting that, like *The Mystery*, would express the pervasive power of nature over natural man. He explored the same theme in such related works as *The Mystery of the Thunder* (ca. 1897), "*Pretty Mother of the Night—White Otter is No Longer a Boy*" (ca. 1900) and *The Scouts* (ca. 1908). In each work, paired figures face forward, leaving the source of their reaction to the viewer's imagination, though *The Mystery of the Thunder* illustrated an essay by Remington, "The Great Medicine-Horse: An Indian Myth of the Thunder," that explained the mystery. Ever since the "medicine-horse" of the Crow Indians ascended to the skies to challenge the thunder bird, he wrote, the Crows viewed

The Mystery 1909
El Paso Museum of Art, El Paso, TX
CR 2911

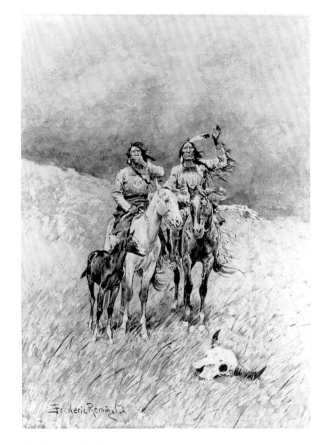

The Mystery of the Thunder
Harper's Monthly 95 (September 1897): frontispiece

[*Ghost Stories*]
(unfinished)
ca. 1908–1909

storms as battles in which the horse, lightning coming from its nostrils, chased the thunder bird, which answered with a roar. It was this encounter that held the two riders in awe.[9]

In his major oils, Remington did not want to be so explicit. Storytelling was the mark of an illustrator, not an artist; anyway, it was the *general* phenomenon of Indian pantheism he meant to convey. But during the summer of 1908 he created a tonal poem, *With the Eye of the Mind*, that managed to combine the literal and the symbolic in his most compelling work on the theme of Indian mysticism. The viewer gazes at the same sign in the sky as the Indians, and has the same opportunity to decide its meaning.

1. For reproductions of both, see Harold McCracken, *The Frederic Remington Book: A Pictorial History of the West* (Garden City, NY: Doubleday & Company, 1966), p. 81 (*The Ghost Stories*, mistitled *The Story Teller*) and p. 91 (*Story of Where the Sun Goes*, in color).
2. Diary, January 19, 1908, FRAM 71.817.
3. FR, *The Way of an Indian* (1906); *Collected Writings*, p. 582.
4. Theodore Roosevelt to FR, February 20, 1906; also, December 28, 1897, FRAM 71.823.16; 71.823.6. In his earlier letter Roosevelt was praising Remington's story "Massai's Crooked Trail," *Harper's Monthly*, January 1898: "The whole account of that bronco Indian, atavistic down to his fire stick; a revival, in his stealthy, inconceivably lonely and bloodthirsty life, of a past so remote that the human being, as we know him, was but partially differentiated from the brute; seems to me to deserve characterization by that excellent but much-abused adjective, *weird*."
5. Francis Parkman, *The Oregon Trail: Sketches of Prairie and Rocky-Mountain Life* (Boston: Little, Brown, and Company, 1892), pp. 208–09. Remington's illustration was titled *The Thunder-Fighters Would Take Their Bows and Arrows, Their Guns, Their Magic Drum*; the original, altered, is now in the Sid Richardson Collection of Western Art, Fort Worth, TX, and is reproduced in Brian W. Dippie, *Remington & Russell (Revised Edition): The Sid Richardson Collection* (Austin: University of Texas Press, 1994), pp. 30–31.
6. FR, *Drawings* (New York: R. H. Russell, 1897).
7. Diary, January 25, 1908, FRAM 71.817.
8. Eva Remington notebook, stocks, copyrights, etc., p. 92, FRAM 96.2, describes *The Mystery* (copyrighted December 1, 1909): "Front view of two mounted Indians in foreground—others approaching—" and indicates that at one time the painting was in her possession and hung "north of fireplace." This suggests a confusion with the unfinished oil that became known as *Ghost Stories*. *The Mystery*, in turn, has long been known as *Sign of Friendship*; I appreciate Peter Hassrick's help in straightening out the titles.
9. FR, "The Great Medicine-Horse: An Indian Myth of the Thunder," *Harper's Monthly*, September 1897; *Collected Writings*, p. 267.

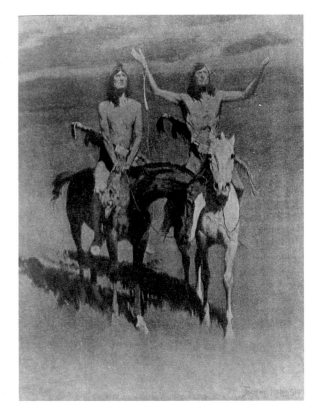

"Pretty Mother of the Night—White Otter Is No Longer a Boy" ca. 1900
Cosmopolitan Magazine 40 (November 1905): 45

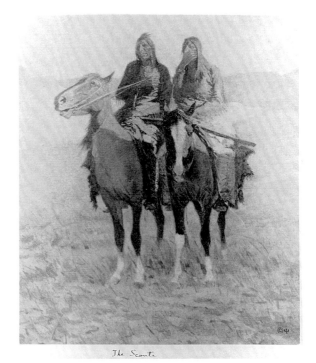

The Scouts ca. 1908
Collier's Weekly, May 22, 1908, cover

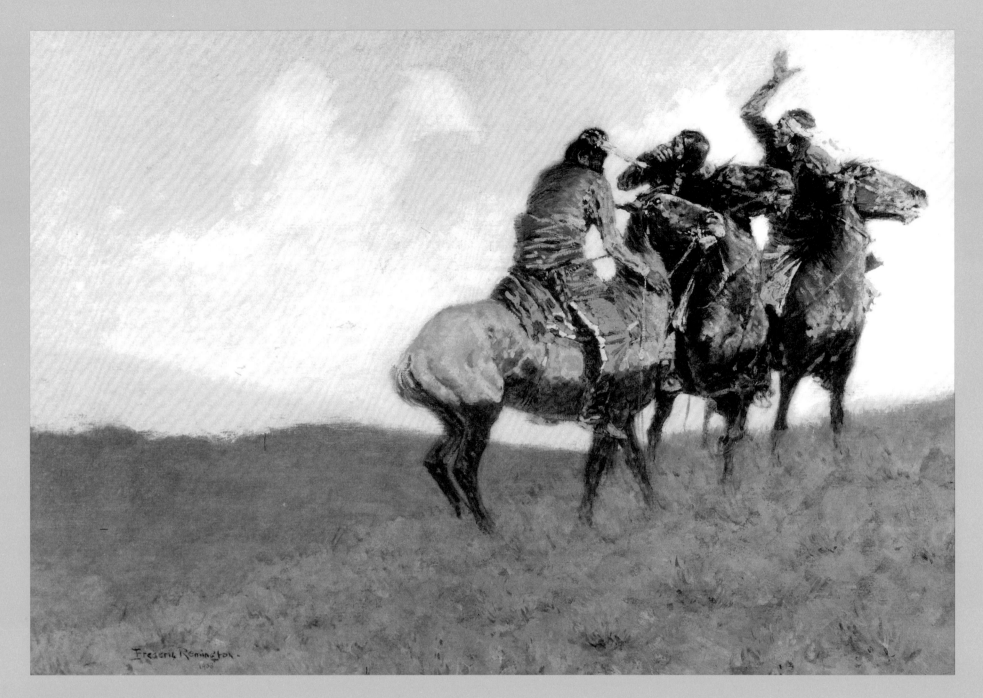

With the Eye of the Mind 1908
Gilcrease Museum, Tulsa, OK
CR 2889

Untitled (possibly *The Cigarette*) ca. 1908–1909

Oil on canvas, 30 x 27" (76.2 x 68.6 cm.)
Signed lower left: —Frederic Remington. / 1909 [1910?]
FRAM 66.40, CR 2925

In her last will and testament, Eva Remington bequeathed "the last painting done by my late husband, Frederic Remington," to what is now the Frederic Remington Art Museum.[1] The painting she meant has gone untitled though titles have been suggested—*A Camp Scene*, *Around the Campfire*, and *Frying Pan Civilization*.[2] There are other possibilities, including one that would date the unfinished painting a year earlier.

In his diary for July 19, 1908, Remington, blissfully unaware of how hard mortality was crowding him, wrote of a lazy summer Sunday at Ingleneuk. He passed the medicine ball back and forth with a neighbor, and read an Owen Wister story in the *Saturday Evening Post*. He liked it, and in his diary he wrote of Wister, whose work he had illustrated so often in the past, "He really does the spirit of the thing with no fuss or exaggeration. He makes it live." On the other hand, Remington found something bad to say about an artist whose paintings, to his taste, had enjoyed altogether too much of a vogue. James McNeill Whistler's art might be at the cutting edge of American experimentalism, but Remington, even at his most experimental, required that a painting be *about something*. Whistler, with his doctrine of art for art's sake, failed the test. He was obscure to pointlessness, "lacking in the only characteristic which distinguishes an artist from a common man—imagination." His work was as dark as soot or the inside of a jug. Still, Remington was attracted to Whistler. The more he dueled with the ghost of an artist dead since 1903, the more he paid him tribute.[3] Whistler's nocturnes in blue and gold and arrangements in grey and black explored tonal complexities in the lowest key. Since night color had become Remington's own obsession in his late forties, Whistler's influence was inescapable.

That July Sunday at Ingleneuk Remington worked on a nocturne that was coming along nicely—*Apache Scouts Listening*—and mentioned another that he called "The Cigarette." He did not mention it again. But a glance at this oil showing four men relaxing by a small campfire outside a cabin, two with cigarettes visible, one exhaling, suggests that this may be the painting referred to. It resembles *The Casa Camadra*, which illustrated

Two photographs at the Casa Camadra, February 1893
(Remington seated in a white shirt)
FRAM 1918.76.160.215; 1918.76.160.190

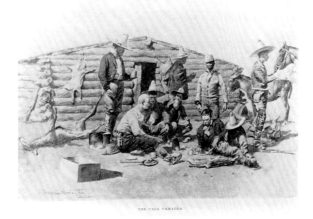

The Casa Camadra
Harper's Monthly 88 (February 1894): 353

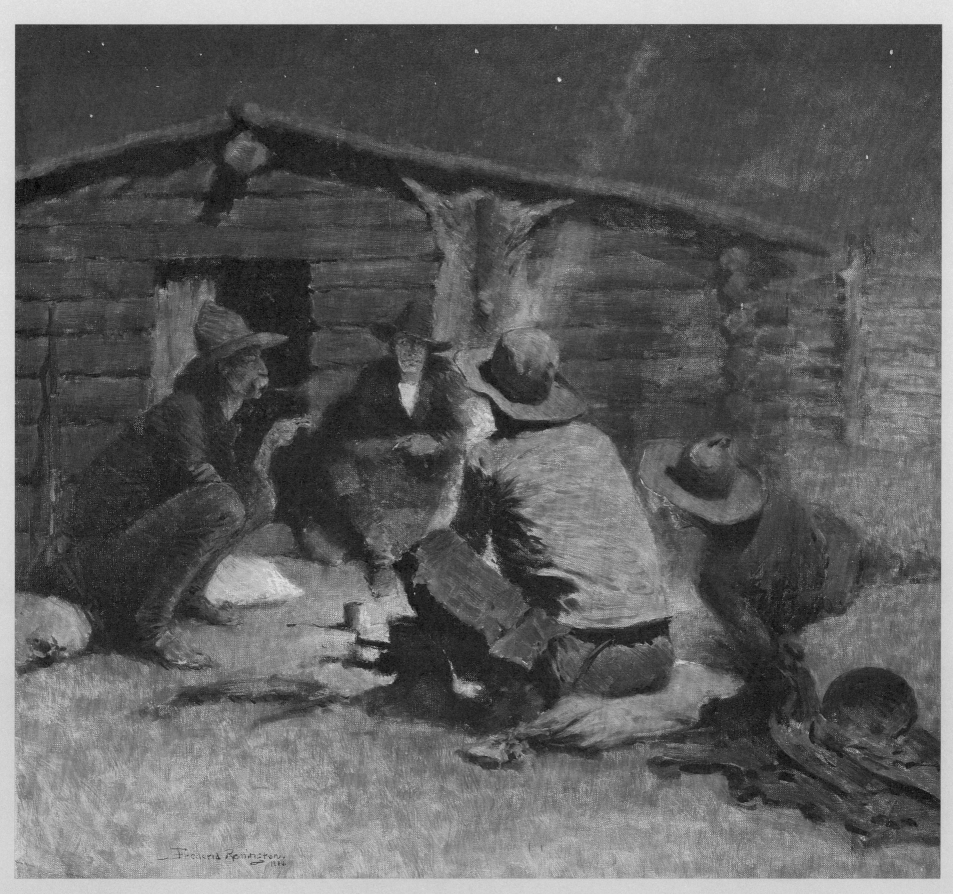

Untitled ca. 1908–1909

Remington's 1894 article "In the Sierra Madre with the Punchers." *The Casa Camadra*, in turn, derived from photographs made on a vast cattle ranch "225 of the longest miles on the map" northwest of Chihuahua in Mexico.[4] Remington's text described his party's arrival at one of the outlying properties (the Casa Camadra) after a cold day's journey:

> … as we rode in, it was raining a cold sleet. The little log cabin was low, small, and wonderfully picturesque…. Inside of the cabin was William [the cook] by a good fire…. Between various cigarettes, the last drink of tequela, and the drying of our clothes, we passed the time until William had put the "grub" on a pack-saddle blanket… we did not dine—we flew in…. Outside, the cold rain had turned into a wet snow, and we all crowded into the little place and squatted or lay about on the floor…. The punchers consume enormous quantities of meat, and when satiated they bring forth their cornhusks and tobacco-pouches and roll their long thin cigarettes, which burn until they draw their serapes about their heads and sink back in dreamless sleep. It is all beautifully primitive, and… I think how little it takes to make men happy…. A chunk of beef, a cigarette, an enveloping serape, with the Sierras for a bedroom….[5]

That pleasant memory translated into this late-life reverie in oil paints—a quiet smoke outside a cabin on Frederic Remington's vanished frontier. (The squatting figure on the left resembles a photograph by John A. Johnson of a Wild West show Indian in cowboy gear enjoying a smoke; it was copyrighted in 1908 as *The Cigarette*.)

Left untitled—and with a signature that may have been added by another hand—this unfinished painting has been described as Remington's last ever since his widow's death. Remington worked on several paintings at a time, and brought out old pictures for refinement months after he began them. That could explain Eva Remington's impression that this was his final effort, and justify using the older title "The Cigarette." On the other hand, Remington was working on some new paintings in December 1909 just before he was stricken ill, and recorded two titles in his diary—"The Cow Proposition" and "Freeze Out." It makes sense that both unfinished canvases would be in the Frederic Remington Art Museum as part of the estate collection. "Freeze

Out" could refer to the painting known as *Waiting in the Moonlight* (usually dated 1906–1907) if that shy maiden is actually *rebuffing* the cowboy's advances (p. 177). *The Love Call* had sold at Remington's Knoedler exhibition earlier that month, and Remington may have thought he was onto a good thing with courtship scenes. By the same reasoning, the sale that December of *The Hunters' Supper* may have inspired him to attempt another campfire scene, this time with cowboys discussing the cattle that were their livelihood—thus "The Cow Proposition." It does bear comparison to *The Hunters' Supper*, which includes seven figures. Two, seated facing one another in front of a roaring campfire, dominate the foreground. One is silhouetted by the fire's glow, which is so brilliant that the night is rendered virtually black; a tent, set to the right, its canvas surface illuminated by the firelight, acts as a giant reflector. In the untitled painting, the effect sought—and achieved—is entirely different. The seated figure with his back to the viewer blocks most of the campfire from sight. The moonlight is paramount, the firelight secondary. Where *The Hunters' Supper* is a study in contrast, this oil, with its greens and browns and subdued light, is a study in muted tonalities.

The Cigarette 1908
Photograph by John A. Johnson
Library of Congress, Washington, DC (LC-USZ62-101196)

1. Last Will and Testament of Eva A. Remington (probated December 23, 1918), copy, FRAM 97.3.
2. *Pictures in West Gallery* (card, ca. 1923), item 11, and *The Frederic Remington Memorial, Ogdensburg, N.Y. Opened July 1923* (Ogdensburg, NY: Republican-Journal, [1923]), item 11, title added in longhand. The source for *Frying Pan Civilization* is an entry in Remington's diary for December 19, 1909, FRAM 71.816: "They are getting up a show of Americans in Berlin. I wonder. A good title 'Frying-Pan Civilization.'" From the context, it would appear Remington was actually speaking about a good title for the proposed Berlin exhibition.
3. Diaries, July 19, 1908, FRAM 71.817, March 24, 1909, FRAM 71.816, and January 16, 1908, FRAM 71.817. Remington also commented on Whistler and his artistic creed on September 17, 1907, FRAM 71.815, and March 19, 1908, FRAM 71.816, always negatively; but he added books about him to his library.
4. FR, "An Outpost of Civilization," *Harper's Monthly*, December 1893; *Collected Writings*, p. 114.
5. FR, "In the Sierra Madre with the Punchers," *Harper's Monthly*, February 1894; *Collected Writings*, pp. 124–25.

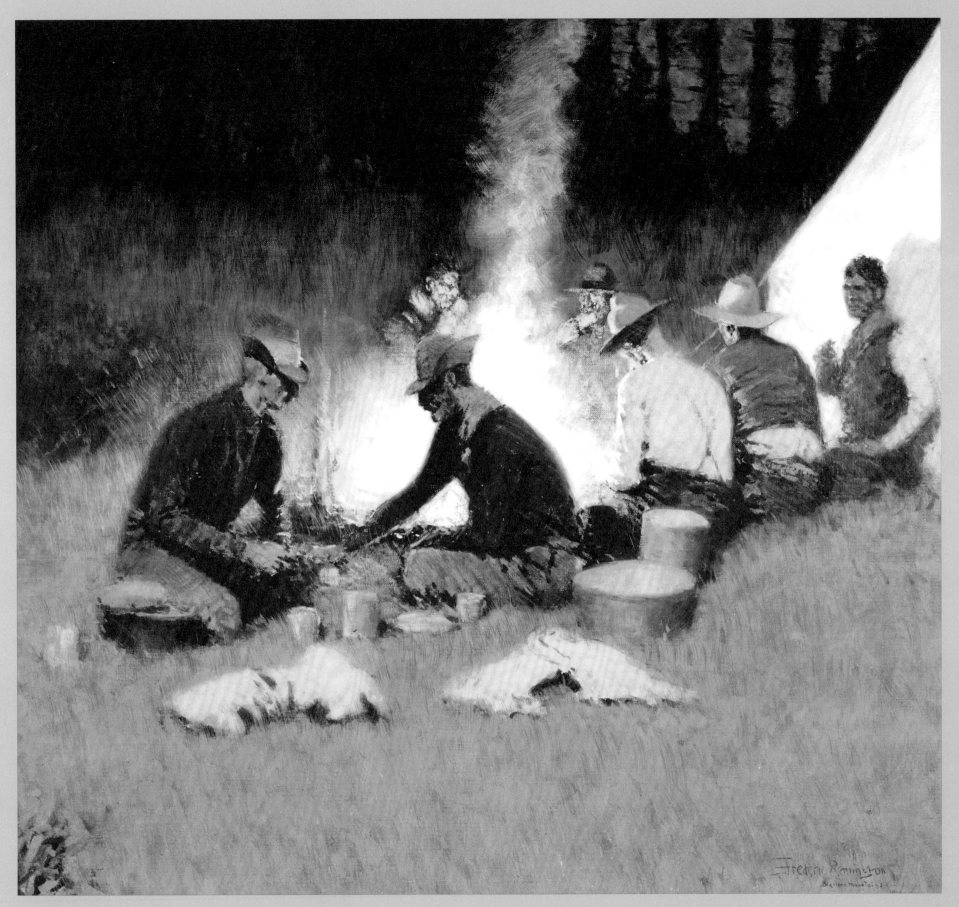

The Hunters' Supper 1909
National Cowboy Hall of Fame and Western Heritage Center,
Oklahoma City, OK
CR 2904

Trooper of the Plains © January 13, 1909

Roman Bronze Works cast no. 15 (ca. 1918–1919), 25¹⁵/₁₆ H x 28½ W x 9⅜" D (65.9 H x 72.4 W x 23.8 D)
Estate casting in accordance with Eva Remington's will
FRAM 66.04

Trooper of the Plains was an overt bid to
recapture the title that Remington had
held for years: *the* artist-historian of the
Indian-fighting army. Given his artistic
priorities in 1908, it was a title he should have
willingly relinquished. But in 1903, Remington
had engaged in a public controversy with a painter
he did not like—over accuracy, not artistry—and
five years later he was still smarting.

Charles Schreyvogel had managed to get
under Remington's skin. Born in New York the
same year as Remington and trained in Germany,
he had come to Western subjects belatedly, in
1893, after the Indian wars were but a memory,
and had made a name for himself with his often
melodramatic depictions of Indian-cavalry action.
The topper for Remington came in 1900, when
Schreyvogel won the Thomas B. Clarke Prize
of the National Academy of Design for *My Bunkie*, a
painting clearly derived from Remington's 1896
bronze *The Wounded Bunkie*. When a portfolio of
Schreyvogel paintings appeared in *Cosmopolitan* the
next year, Remington made a list of the errors he
found, and in 1902—about the time Schreyvogel
was proclaimed "The West's Painter-Laureate"
in *Harper's Weekly*, of all places—Remington
attempted to recruit Owen Wister to write an
essay denouncing "the fools who are trying to
confuse the public, by their ignorance, into
thinking that they too understand."[1] He was
echoing Wister's own conceit about the unspoken
bond that existed upon meeting another who knew
the West firsthand: "both of us have been *out there*;
both of us understand."[2] Schreyvogel did not
qualify for membership in that exclusive club,
Remington insisted, though he had made several
Western excursions since 1893, visiting Colorado,
Arizona, Wyoming and Montana. He had also
visited Buffalo Bill's Wild West show, and
learned many of his heated-up moves from what
he witnessed inside the arena. He loved head-on
charges and acrobatic spills, horses and men
tumbling to the ground. His West was all gunfire
and war whoop—stagey, exciting, and better tuned
than Remington's increasingly moody version to
the tastes of a public raised on dime-novel
fantasies.[3] Remington, too, had always relied on

imagination in creating his Western epics. But
he saw himself as bound by the probabilities
established through on-the-spot observation. His
approach was realistic if not documentary, and he
painted routine cavalry patrols as well as sudden
brushes and desperate stands.

Remington's simmering anger at
Schreyvogel boiled over in 1903. The *New York
Herald* that April 19 greeted Schreyvogel's latest
Western painting—a careful reconstruction of a
peace parley between George Armstrong Custer,
three members of his staff, and four Kiowa leaders
on the Southern plains in 1869 titled *Custer's
Demand*—with a laudatory, full-page review.
Custer's Demand was praised both as "mere
picture" (admirably composed and vividly three-
dimensional) and as sound history.[4] This time
Remington was not waiting for Wister. He viewed
the painting, jotted down nine errors he had
spotted, and dashed off a letter to the *Herald*
detailing his criticisms. Aesthetics did not enter
into the discussion. "While I do not want to
interfere with Mr. Schreyvogel's hallucinations,"
he began, "I do object to his half baked stuff being
considered seriously as history." He expanded his
list of mistakes to an even dozen—equipment, hats,
boots and uniform color were all wrong for the
1860s—and concluded that while the painting was
"very good" for one "who knows only what
Schreyvogel does know about such matters," it was
hardly history.[5] Remington had immediate cause to
regret his attack. It turned out that Elizabeth
Custer, the General's widow, warmly admired
Schreyvogel's work.[6] Worse yet, one of the officers
present at the parley had assisted Schreyvogel in
his research and was not about to accept Remington
as authority on what things *should* have looked
like in 1869. Colonel John Schuyler Crosby
defended Schreyvogel point by point and, with the
starchiness of an officer of long service, dismissed
Remington's "gratuitous criticism" by "referring to
certain facts that I know, and Mr. Remington could
not, because I was present at the moment Mr.
Schreyvogel depicts on canvas and Mr. Remington
was riding a hobby horse, which he seems to do
yet."[7] The whole thing was an embarrassment, and
after firing a parting shot Remington limped off to

Charles Schreyvogel, *Custer's Demand* 1903
Gilcrease Museum, Tulsa, OK

Opposite page:
Trooper of the Plains
© January 13, 1909

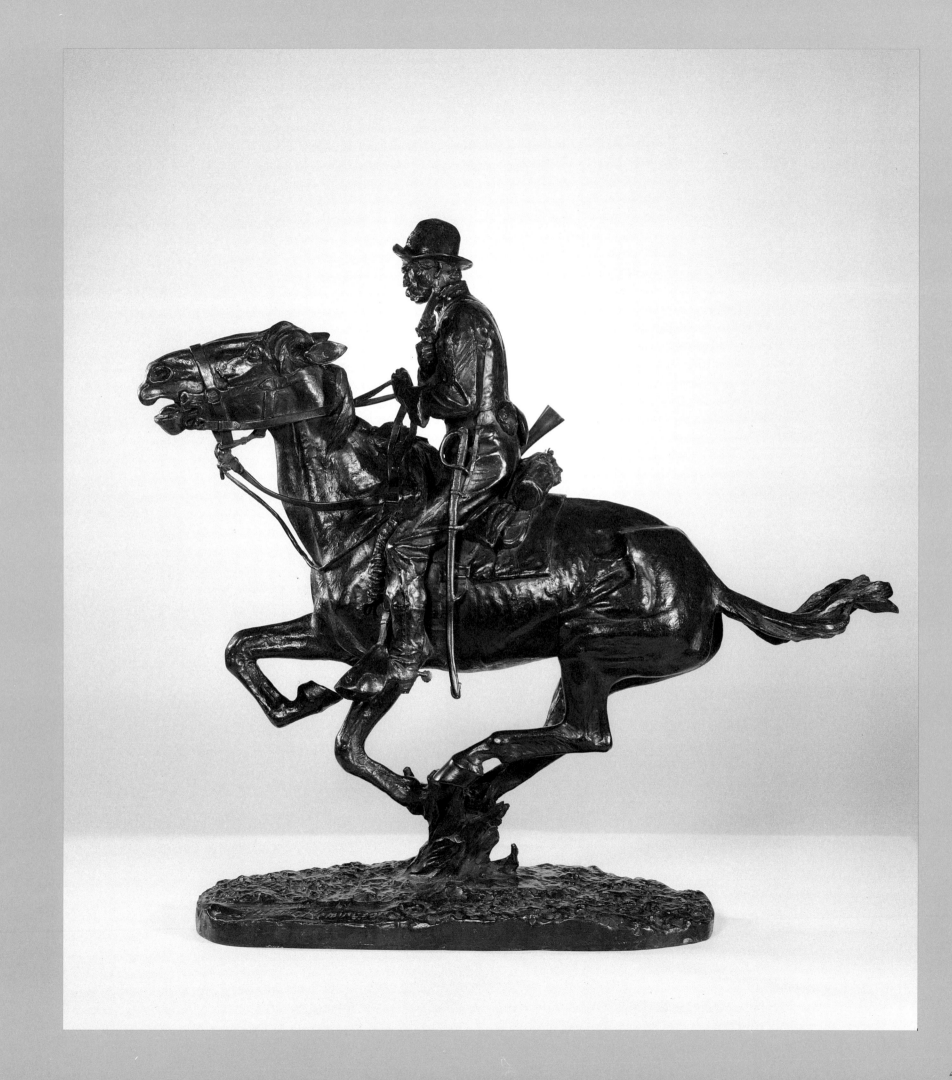

lick his wounds, aware that even his friends thought he had made a fool of himself.[8]

What was remarkable, as Colonel Crosby noted, were the grounds Remington had chosen for his attack. Had he stuck to matters artistic, Crosby would have bowed to his "superior knowledge."[9] But *history*? Moreover, by his attack on Schreyvogel's accuracy, Remington had opened his own work to nit-picking and now had to be self-consciously concerned about errors and anachronisms in his historical subjects.[10] Following the newspaper controversy, he contacted Crosby privately and indicated he had been "getting ready for years to make a try at General Custer" and wanted to ask him "some questions."[11] The record is silent as to whether Remington met Crosby and made his peace. But he was still unrepentant four years later when he indicated to a reporter that the "achievements" of latecomers to Western art "must be a mere reflection of what others have done, the pictorial reconstruction of what is no more."[12] That, of course, was exactly his own situation, and when he chose to rebut *Custer's Demand* indirectly by painting and sculpting *his* version of cavalry activity in the 1860s, he, like Schreyvogel, had to consult an expert—General Edward M. "Jack" Hayes, whose experiences in Indian warfare reached back to the late 1850s in Texas. Hayes "fought in many a wild charge" during the Civil War and from 1866 to 1893 served with the Fifth Cavalry on the Western plains.[13] His expertise was unquestionable.

Hayes may have offered Remington advice on an ambitious painting of a cavalry charge, *On the Southern Plains*, that he completed and displayed at Knoedler in 1907. His working title was "On the Southern Plains in the Sixties," and it directly anticipated a sculpture he began on October 7, 1908, after retouching an oil of a cavalry charge (likely *On the Southern Plains*). He had added flecks of color to create a "vibratory" effect—to capture the motion of running horses "so you would feel the details and not *see* them." Sculpture demanded a return to the literal, of course: the positioning of the horse's legs rather than Impressionistic techniques served to convey motion. But Remington reported "a good start for my model cavalry man of the plains 60'ties." The group would consist of a soldier mounted on a horse at full gallop, his pistol drawn and held across his chest in a pose Remington had explored in another painting done that year, *Cutting Out Pony Herds*. To ensure accuracy, he used a horse with a history (it had killed a coachman) as his model. And with an eye to the same sort of

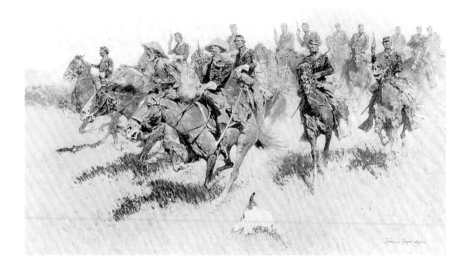

On the Southern Plains 1907–1908
Metropolitan Museum of Art, New York, NY
CR 2843

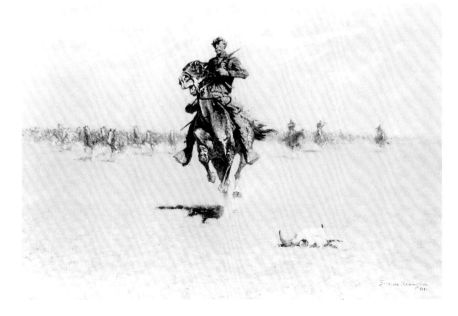

Cutting Out Pony Herds 1908
Museum of Western Art, Denver, CO
CR 2852

criticisms he had leveled at Schreyvogel, he made sure through Hayes that details like the soldier's campaign hat were correct. As the model neared completion, on October 27, Remington noted it was "'A Frontier Trooper '68' and is the old type kit, and &c as I have got it from Jack Hayes and others. I don't know if it will be popular but it will have a historical value." His neighbor Augustus Thomas dropped in on the 31st and pronounced it "Very Remington," an interesting judgment that suggests he saw it as a throwback. While the sculpture resembles figures in several later Remington paintings, among his bronzes it most resembles *Cheyenne*. In both, the racing horse and rider are suspended in the air, here by a clump of sagebrush. Work on the group proceeded rapidly—it was in wax by November 10, and Remington applied his last touches the next day. "A very fine figure," he observed: "I don't know of its popularity but it is the man of that period."[14] To underline his intention of summarizing an entire historical epoch in a single bronze, he copyrighted it on January 13, 1909 as *Trooper of the Plains*.

Presumably *Trooper of the Plains* was also intended to vindicate Remington's position in the controversy over *Custer's Demand*. That was why he attached such importance to its historical accuracy. But Schreyvogel had seized the high ground in 1903 and never relinquished it, steadfastly refusing to swap insults, and praising Remington as the foremost Western artist. Among the condolences Eva Remington received after her husband's death was a gracious telegram from Schreyvogel. It read: "My deepest sympathy for the great loss to you and to our nation."[15] Remington might "dispise" Charles Schreyvogel, but he could not best him.[16]

1. Gustav Kobbe, "A Painter of the Western Frontier," *Cosmopolitan* 31 (October 1901): 563–73; FR, Notebook, FRAM 71.812.6; "The West's Painter-Laureate," *Harper's Weekly*, November 15, 1902, p. 1668; FR to Owen Wister, [September 1902], *Selected Letters*, p. 303.

2. Owen Wister, "Concerning the Contents," in FR, *Drawings* (New York: R. H. Russell, 1897).

3. Charles Schreyvogel, *My Bunkie and Others: Pictures of Western Frontier Life* (New York: Moffat, Yard & Company, 1909); and, for a biography and portfolio, James D. Horan, *The Life and Art of Charles Schreyvogel: Painter-Historian of the Indian-Fighting Army of the American West* (New York: Crown Publishers, 1969).

4. "'Custer's Demand,' Schreyvogel's Latest Army Picture," *New York Herald*, April 19, 1903.

5. Notebook, FRAM 71.812.6 (entry headed "Schreyvogel / 'Custer's Demand'"); "Finds Flaws in 'Custer's Demand,'" *New York Herald*, April 28, 1903.

6. "Schreyvogel Right, Mrs. Custer Says," *New York Herald*, April 30, 1903.

7. "'Mr. Schreyvogel Paints the Facts,'" *New York Herald*, May 2, 1903.

8. See Horan, *The Life and Art of Charles Schreyvogel*, pp. 34–40; and R. C. Wilson, "The Great Custer Battle of 1903," *Mankind* 5 (February 1976): 52–59.

9. "Mr. Schreyvogel Paints the Facts.'"

10. See, for example, Horan, *Life and Art of Charles Schreyvogel*, pp. 39–40, and Peggy and Harold Samuels, *Frederic Remington: A Biography* (Garden City, NY: Doubleday & Company, 1982), p. 344; and, for the controversy in the context of Remington's own artistic priorities, see Brian W. Dippie, "Frederic Remington's West: Where History Meets Myth," in Chris Bruce, et al., *Myth of the West* (Seattle: The Henry Art Gallery, University of Washington, 1990), pp. 110–19.

11. FR to John Schuyler Crosby, May 6, 1903, in Horan, *The Life and Art of Charles Schreyvogel*, p. 38. This followed a last letter from Remington to the *Herald* ("Mr. Remington Once More," *New York Herald*, May 3, 1903), in which he mentioned an additional error in *Custer's Demand* but conceded that Crosby "has prepared me for burial to his entire satisfaction." Crosby responded with a letter to Remington on May 3 in which he noted that "there seems to be several spasmodic kicks left in the corpse still," and proposed a meeting at his club (FRAM 71.823.96). Remington's letter of the 6th suggested his home at New Rochelle instead. This was fencing rather than fence-mending, and reflects Remington's mood. Worth noting is that the *Herald* on May 3 also carried a correction from Crosby to his published letter ("'Not' Inserted in Wrong Place") that served to sustain Schreyvogel against another of Remington's charges, that he had depicted Custer's boots incorrectly.

12. Perriton Maxwell, "Frederic Remington—Most Typical of American Artists," *Pearson's Magazine* 18 (October 1907): 400. Remington may have been reacting to a letter published in the March 23, 1907 *Collier's Weekly*, criticizing his lackadaisical series of paintings on the theme "The Great American Explorers": "No one has preserved for us and interpreted so well the life of the old Far West, and he did this, not by producing listless sketches of somnambulists walking in the desert, but by putting on paper cowboys, cavalry, Indians and bucking broncos that fairly leaped and neighed with life. It would be too much to ask Mr. Remington to produce each month such a stirring composition, for instance, as Schreyvogel's 'My Bunkie', but that will suggest the sort of thing he, for his own artistic

reputation if nothing else, ought to do for you." The war of reputations continued beyond the grave. Accuracy was Remington's "religion," his good friend Augustus Thomas wrote in 1913:

> *In his chosen field he abhorred anachronisms. There was considerable eclat over the exhibition of a painting by a new-comer. The subject showed in an Indian fight the rescue of one trooper by another. Remington took one look at it and turned away in disgust. Bits of arms, uniforms, and harness that had never met outside of a museum were assembled in the picture. To the ordinary observer their association was harmonious; but to his expert eye it was falsehood and fake.*

("Recollections of Frederic Remington," *Century Magazine* 86 [July 1913]: 358.)

13. Charles King, *Campaigning with Crook and Stories of Army Life* (New York: Harper & Brothers, 1890), p. 64; John M. Carroll and Byron Price, comps., *Roll Call on the Little Big Horn, 28 June 1876* (Fort Collins, CO: Old Army Press, 1974), p. 133.

14. Diaries, March 16, September 23–24, 1907, October 3, 7–8, 15, 27, 31, November 10–11, 1908, FRAM 71.815, 71.817. Besides the cavalry paintings mentioned, the horse and rider in *Trooper of the Plains* should be compared to the figures in *Against the Sunset* (1908) and *The Stampede* (1908). *On the Southern Plains* was exhibited at Knoedler in New York in December 1907 as *The Southern Plains*, at Henry Reinhardt's in Chicago in February 1908 as *On the Southern Plains*, and at Doll & Richards' in Boston in January 1909 as *On the Southern Plains, 1868*, having been reworked in the process.

15. Charles Schryeyvogel to Eva Remington, December 27, 1909, FRAM 96.8.13. Eva was obviously touched, since in her diary for 1912 she noted Schreyvogel's death as one among several losses to American art that year. See Atwood Manley and Margaret Manley Mangum, *Frederic Remington and the North Country* (New York: E. P. Dutton, 1988), p. 224.

16. FR to Crosby, May 6, 1903.

The Outlier (preliminary version) 1909

Oil on canvas, 30¼ x 27⅛" (76.8 x 68.6 cm.)
Unsigned
FRAM 66.57, CR 2913a

This painting is a preliminary (and presumably failed) version of a celebrated oil of the same title that Remington exhibited at Knoedler in December 1909. At first glance, the two are very similar: an Indian sits on his horse, facing ahead. He is bare-chested, with a rifle across his lap and a single feather stuck in his hair, which cascades to his shoulders. In the preliminary study he has a top-knot similar to the Indian's in *The Snow Trail* (p. 203). *The Outlier*'s head is rotated slightly to his left in both versions, while his horse, which stands at an angle in the first, is shown straight on in the final one. The moon rests on the hill behind. In the preliminary study, the Indian seems more massive across the chest because the viewer's angle of vision is almost dead level with horse and rider, which are set further back in the second version. Since the viewer now looks up at them, the horizon line bisects the rider at the knee instead of the waist. But why was the first version abandoned?

In his diary that July 6, Remington noted that he had finished one nocturne at a single sitting (*The Love Call*—see p. 178) and "got a scheme" on *The Outlier*. It proved resistant, however. On September 25, after finalizing his portrait of General Leonard Wood (see p. 242), he wrote that he had "destroyed 'Outlier' and must do him over again." Mid-October brought victory: "I modeled and laid in 'Outlier' for 10th time. I will not be licked." …"Worked on my 'Outlier'—my old companion—I have a good start." …"Worked—made the great total propostion 'Outlier' to set up—"… "Worked—made huge success of 'Outlier'." While he worked on the painting, Childe Hassam twice dropped in to visit, and on October 20 rendered judgment: *The Outlier* was the "best" of Remington's new paintings.[1]

Hassam's enthusiasm is instructive. One of America's most renowned Impressionists, he had commented in the past on Remington's nocturnes and, with J. Alden Weir and Willard Metcalf, both members of The Ten and Remington acquaintances, had been experimenting with nocturnes himself since 1906. Metcalf had attracted public attention in 1907 when his *May Night* was awarded a gold medal and purchased for a substantial sum by the Corcoran Gallery of Art in Washington, DC.[2] Its tones were similar to those Remington favored in his night scenes, a melding of browns and greens to convey moonlight. The preliminary version of *The Outlier* is in that color range. Apart from the moon, which is a heavy yellow impasto over a brown base, the paint is applied thinly, with the texture of the canvas showing through the figure of the Indian and the grass. The sky is blue-brown in tone, the hill behind deep olive and brown, and the foreground olive and forest green with brown shadows. The Indian is all in browns, and Remington has sketched directly on the canvas trying to satisfactorily position the hand and the rifle. There is blue in the Indian's hair, and blue lines to suggest features of the horse's head and anatomy. But the essential color scheme would have been similar to that of *The Sentinel* (p. 181), judging from the white horse, which Remington has rendered in yellow-green.[3] When he abandoned the painting, he commented, "I am not up to that low tone." The finished version of *The Outlier* is a distinct departure. Remington adopted a silvery-blue color scheme and made the horse brown with white markings that almost glow in the dark. One sees Hassam's hand in all this. Remington's brushwork, notably on the horse and man, is especially Impressionistic. His pleasure with the end result—and Hassam's praise—suggest that more silvery-blue nocturnes would have followed.

1. Diary, July 6, September 25, October 14–17, 20, 1909, FRAM 71.816. For Remington's relationship with Hassam in this period, see Peggy and Harold Samuels, *Frederic Remington: A Biography* (Garden City, NY: Doubleday & Company, 1982), pp. 431–32.
2. Elizabeth de Veer, "The Life," in De Veer and Richard J. Boyle, *Sunlight and Shadow: The Life and Art of Willard L. Metcalf* (New York: Abbeville Press, and Boston University, 1987), pp. 84, 88; and see Doreen Bolger Burke, "Remington in the Context of His Artistic Generation," in Michael Edward Shapiro and Peter H. Hassrick, *Frederic Remington: The Masterworks* (New York: Harry N. Abrams, for The Saint Louis Art Museum, in conjunction with the Buffalo Bill Historical Center, Cody, WY, 1988), pp. 60–63; and James K. Ballinger, *Frederic Remington* (New York: Harry N. Abrams, in association with The National Museum of American Art, Smithsonian Institution, Washington, DC, 1989), pp. 128–35.
3. Diary, October 1, 1909, FRAM 71.816.

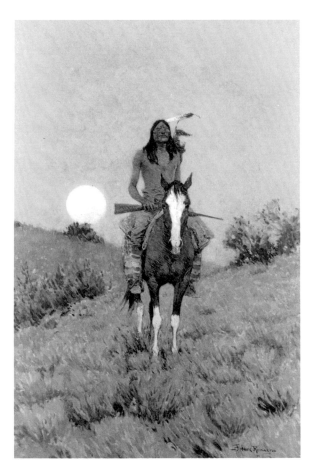

The Outlier 1909
The Brooklyn Museum; Bequest of Miss Charlotte R. Stillman
CR 2913

Opposite page:
The Outlier
(preliminary version)
1909

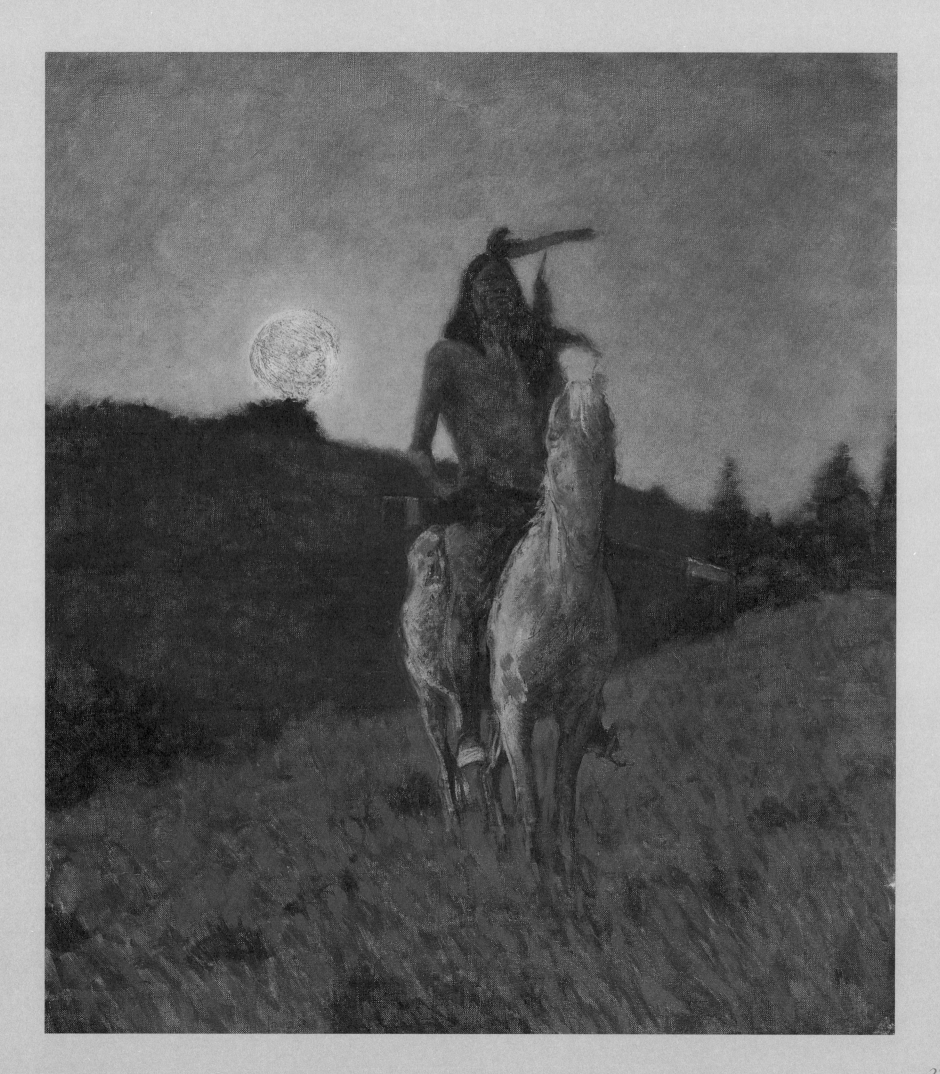

The Sun Dance 1909

Oil on canvas, 27 x 40" (68.6 x 101.6 cm.)
Signed lower left: Frederic Remington / 1909.
FRAM 66.55, CR 2923

Frederic Remington, traveling by rail across Canada with his wife Eva and the writer Julian Ralph on assignment for *Harper's*, may have witnessed a Sun Dance on July 12, 1890 on the Blackfoot Reserve in southern Alberta. Ralph supposedly found the prospect of viewing the dancers' self-torture uninviting, leaving Remington to attend alone. That December 13, just as the Ghost Dance among the Sioux was capturing reader interest across the United States in the weeks before the battle at Wounded Knee, *Harper's Weekly* published Remington's drawing *The Ordeal in the Sun Dance among the Blackfeet Indians*. It showed a single dancer leaning back against the thongs skewered through his chest. *If* Remington actually witnessed such self-torture, he was among the last to see it practiced by the Blackfeet. There is reason for doubt. The self-torture rite was banned that year on the Blackfoot Reserve, and Remington's illustration was obviously modeled on a photograph he had acquired in Alberta of a Blood Indian dancer, taken three years before.[1] He was squeamish and not any more likely than Ralph to take in a ceremony he might find upsetting. When he wrote an army friend the month after visiting Alberta, he did not mention the Sun Dance, let alone self-torture, only that his party "saw a 'pony dance' at the Blackfoot Reserve and it was tremendous"—a fact Ralph mentioned as well in *Harper's Monthly*.[2] Perhaps Remington's Sun Dance illustration was simply a bit of Indian wars sensationalism designed to cash in on the public's interest in the Ghost Dance by providing graphic evidence of what was deemed still-thriving barbarism on the Western plains.

This much is certain: the Sun Dance had planted itself in Frederic Remington's mind, corroborating his belief in the impassable gulf forever separating savage and civilized man. Its pictorial possibilities fascinated him, and in the last year of his life he took an almost perverse pleasure in painting a major oil showing the Sun Dance. He was persuaded the subject would be unsalable ("I'll never sell it—it will give everyone the horrors") but wanted to paint it anyway "for the love of Record of Great Things."[3] The Sun Dance was like a demon he had to exorcise. It doubtless stirred childhood

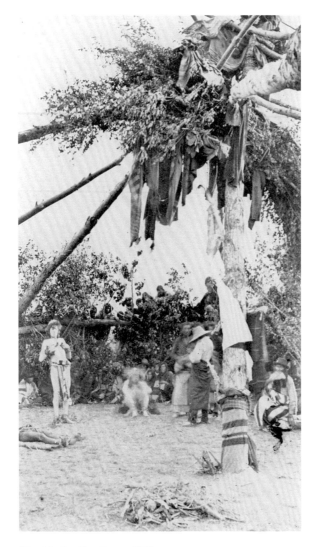

Blood Indian Sun Dance, 1887
Photograph by Boorne & May, Photographers, Calgary, N.W.T.
FRAM 1918.76.160.274

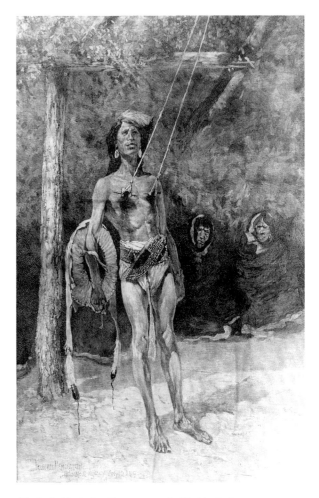

The Ordeal in the Sun Dance among the Blackfeet Indians
Harper's Weekly, December 13, 1890, p. 976

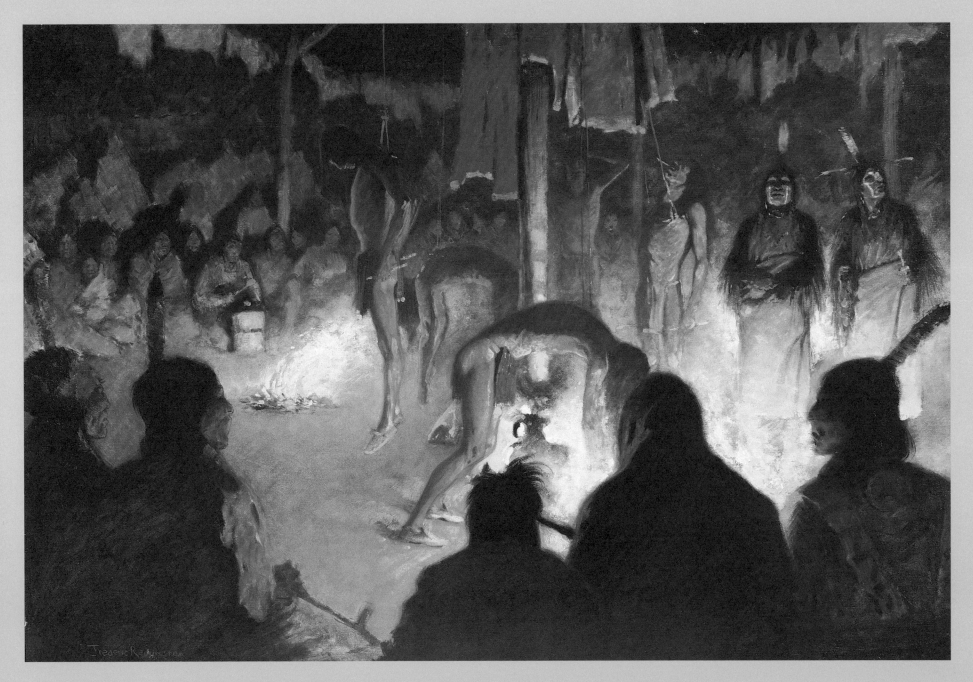

The Sun Dance 1909

memories of reading George Catlin's vivid description (in words and pictures) of the Mandan O-kee-pa ritual.[4] Indeed, in transforming the Sun Dance from a daytime activity performed under a covering of boughs into a dramatic, nighttime ceremony, Remington both saluted Catlin's portrayal of Mandan self-torture inside a medicine lodge and deliberately tipped his own composition towards the demonic. He distinguished between his nocturnes featuring moonlight (the land bathed in an ethereal glow, the shadows a study in intricate tonalities) and those featuring firelight, which created strong contrasts as flickering yellow-orange flames and black shadows played on human features. The effect he was striving for in *The Sun Dance* was genuinely horrific. One brave is suspended by skewers through his back; two others droop in an effort to pull themselves free. The composition echoes Remington's 1887 depiction of a Buffalo Dance, while a Blackfoot dance he had witnessed in 1890, the Soldier Clan Dance, provided him with models for two of his Sun Dancers. The impassive, blanket-wrapped brave on the right staring straight out at the viewer is lit dramatically from below; Remington earlier used this effect in *Protecting the Whiskey Trader* (1906) and *Shotgun Hospitality* (1908). The Sun Dance pole bisects the picture. The vertical dancers on either side of the pole provide symmetry, while the drooping dancers pointed in opposite directions actually lace the halves together. In turn, the assembled Indians outside the circle of firelight create a dark frame around the central action.

On March 8th Remington confessed in his diary, "Awful time with my 'Sun Dance'—a most difficult proposition."[5] He never sorted out all the problems; the composition remains more daring than unified, and it strains to hold together. It may be that this, as much as the subject, was responsible for the painting's failure to sell at his Knoedler exhibition that December. Remington, however, found confirmation for his earlier prediction. "The 'Sun Dance' did not sell," he wrote a friend on December 20, "so you see I consecrate my horrors to the academic—no one wants horrors in the house."[6]

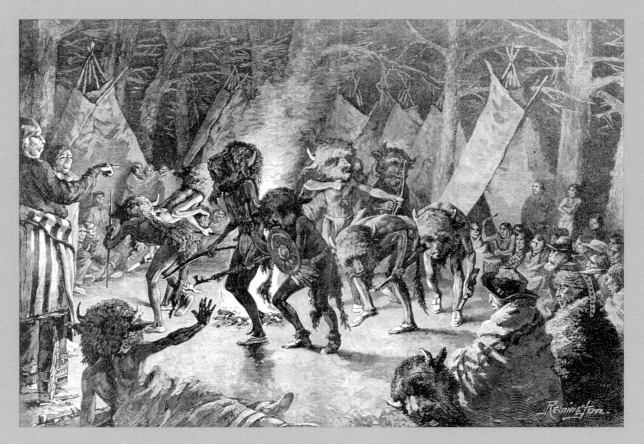

The Buffalo Dance
Harper's Weekly, May 7, 1887, p. 332

Sketch in the Soldier Clan Dance
Harper's Monthly 84 (December 1891): 40

Opening of the Soldier Clan Dance
Harper's Monthly 84 (December 1891): 37

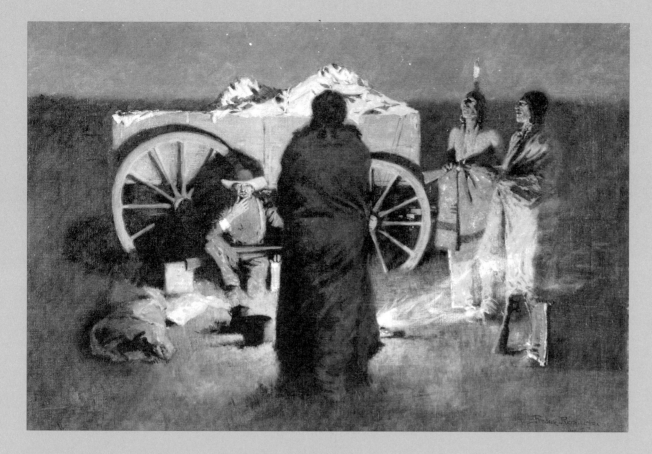

Shotgun Hospitality 1908
Trustees of Dartmouth College,
Hanover, NH; CR 2869

1. Remington likely purchased two views of the Sun Dance made by photographer W. Hanson Boorne in July 1887, since his drawing combines a photograph of the Blood Indian leaning back against the thongs and another showing a dancer with his arms at his sides and his shield behind him. See "W. Hanson Boorne, Photographic Artist," *Alberta History* 25 (Spring 1977): 19; and, for Boorne's account of the Sun Dance, "Notes on the Canadian Indian 'Sundance' Ceremony and the 'Brave Making'" (1887), see Brock V. Silversides, *The Face Pullers: Photographing Native Canadians 1871–1939* (Saskatoon: Fifth House Publishers, 1994), pp. 7–9, 47.
2. FR to Powhatan Clarke, August 7, 1890, *Selected Letters*, p. 97; Julian Ralph, "Chartering a Nation," *Harper's Monthly* 84 (December 1891): 40–42.
3. Diary, February 28 1909, FRAM 71.817.
4. "A Few Words from Mr. Remington," *Collier's Weekly* 34 (March 18 1905): 16; and Remington's oil *Mandan Initiation Ritual (The Sundance)*, in *The Art of Frederic Remington: An Exhibition Honoring Harold McCracken at the Whitney Gallery of Western Art* (Cody: Buffalo Bill Memorial Association, 1974), p. 26, #20. This may actually have been intended to illustrate Frederick Schwatka, "The Sun-Dance of the Sioux," *Century Magazine* 39 (March 1890): 753–59, but was possibly deemed too graphic even for Schwatka's graphic text. Five Remington illustrations accompanied the article, none showing self-torture.
5. Diary, March 8, 1909, FRAM 71.817.
6. FR to Albert S. Brolley, December 20 1909, *Selected Letters*, p. 436.

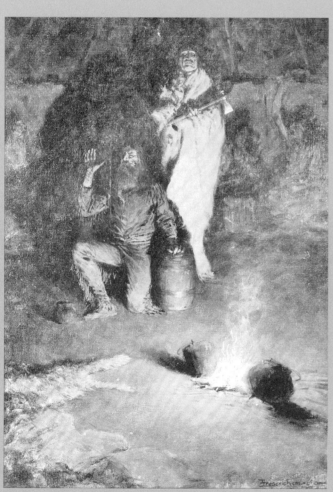

Protecting the Whiskey Trader 1906
The University of Arizona Museum of Art, Samuel L. Kingan
Collection, Tucson, AZ; CR 2806

Pontiac 1909

Oil on board, 12¼ x 16¼" (31.1 x 41.3 cm.)
Signed lower left: Frederic Remington / "Pontiac" '9
FRAM 66.44, CR 2901

The Moose Country 1909

Oil on board, 18⅞ x 15" (47.9 x 38.1 cm.)
Signed lower right: Frederic Remington / Canada.-
FRAM 66.48, CR 2910

Canada 1909

Oil on board, 12 x 16" (30.5 x 40.6 cm.)
Signed lower left: Frederic Remington / "Canada"
FRAM 66.58, CR 2896

Pontiac Club, Canada 1909

Oil on board, 12 x 16" (30.5 x 40.6 cm.)
Signed lower right: Frederic Remington / "Pontiac" '9
FRAM 66.60, CR 2916

Having sold off Ingleneuk, and having devoted his energies through the late spring and early summer of 1909 to his new home in Connecticut (Lorul Place, as it became known), Remington was looking for an outdoor escape. He was not up to the West, given his unhappy experiences in Wyoming the previous year. But John Howard, who had been Remington's loyal friend in acquiring, caring for and disposing of Ingleneuk, was on hand to offer an alternative in 1909: a private sportsman's club in Canada. The Pontiac Game Club was remote, located in the southwestern corner of Quebec a hundred miles by railroad, two hours by steamer, and sixteen miles by wagon from Ottawa. The club, founded in 1898, leased exclusive hunting and fishing rights to 180 square miles of lakes and forests, and had erected outcamps as well as its main quarters on Lake Somerville.[1] Howard's description of it appealed to Remington, and he purchased a share on April 30, 1909. "It will *do*," he believed, and after settling in at Lorul Place, he and Eva left on July 31 for a two-week vacation at the club. Though the wagon trip in was hard, his first impressions were positive: "Club a fine comfortable jumble of log cabins on a beautiful lake." There was a good deal of sitting around and drinking scotch, however, and the trout refused to bite. Remington's mood changed. Such clubs delighted in initiation rites to cut down oversized egos. A new member's name might be repeatedly forgotten, his capacity for drink stretched to the limit, and a lake accessible only by portage and hard walking recommended. But Remington's particular complaints turned on the difficulty of getting to and from the club itself. He had been spoiled by Ingleneuk's convenience. His love affair with the island lasted eight years; that with the Pontiac Club, but a season. By November he was looking to sell off his share: "It dont appeal to me and I want to resign…. The fact is I have got to travel in my capacity as a painter and shall not soon again confine myself to one spot…. I like Pontiac as a pure and simple 'sit down and rest up' proposition but it dont call to me to paint."[2]

Nevertheless, the two weeks in Canada had proven fruitful. Remington sketched most days and was pleased with the results. *Pontiac* repeats his motif of a path or road winding towards a cluster of buildings in mid-distance—here, the club's "comfortable jumble of log cabins." With its vibrant greens and creamy blue sky above, the painting is an invitation to visit. Remington's late-life landscapes touched on a tranquil spot inside him. The sketching outdoors was liberating. Every year he had to plan out his major frontier paintings. The sketches, by comparison, were relatively spontaneous—two days' work at most, instead of the weeks that some of his big productions required. None of the endless monkeying to achieve elusive effects, and to populate his Western dreamscapes with the characters and action the public expected of him. This is not to say that Remington could entirely

Frederic and Eva Remington on the porch of the Annex, their quarters at the Pontiac Club, August 1909
"A Snow-Shoe Trip to California" Album
FRAM 71.834.92.

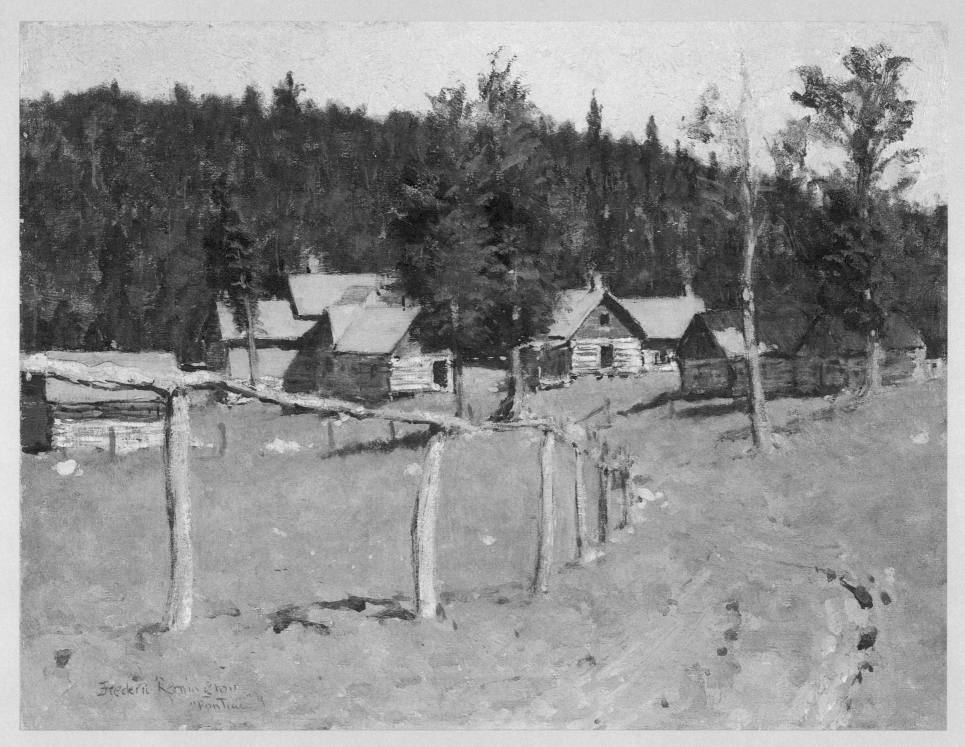

Pontiac 1909

resist touching up his landscapes, and making them, as well, "new problems to solve."[3] But even as his Western paintings were becoming more generalized as to time and place, his outdoor sketches were notable for their fidelity in recording his immediate impressions of what was before him.

Remington still adhered to certain conventions in his sketching. He continued to favor foreground objects as aids to perspective. *The Moose Country*, with its blasted tree stump on the left, belongs to an American landscape tradition reaching back to Thomas Cole. Gnarled, blasted trees spoke to the rawness of American nature, and to a taste for the picturesque. The tree stump also served an allegorical end in American landscape, symbolizing civilization's relentless advance on a retreating wilderness.[4] The purpose of the Pontiac Club, of course, was to hold such advance at bay; but the club's lease embraced an area that had already been logged for its pine, and Remington's sketch is likely faithful to what he saw. The sketch also has its share of artistic contrivance, judging from photographs of the club's quarters on Lake Somerville made from the same lookout as *The Moose Country*, which show a substantial screen of trees in the foreground. When Remington ascended the steep hill with a guide on the afternoon of August 9, he observed that the view was "beautiful but all green."[5] For his sketch, then, he consciously selected a vantage point where dead trees could provide contrast to the green sameness, while making their own picturesque statement.

A tree stump also decorates the foreground of *Canada*. This is a lovely painting—simple and appealing, with its olive-brown trees, deep shadows in blues and red-brown, puffy clouds, and liquid reflections. The blue in the water is slightly darker than the creamy, robin's-egg blue sky also featured in *Pontiac Club, Canada*. Here, the absence of any foreground creates a less decorous, more rugged impression. The water serves as a dreamer's highway, unbounded and beckoning as it opens to the left beyond the clumps of trees. (Remington anticipated this effect earlier in *Stream*, a watercolor painted in the 1890s.) The reflections are complex, suggesting ripples on the water's surface; the soft blues contrast with the dark mass of trees.

Remington made several additional sketches at the Pontiac Club. He copyrighted only *The Moose Country*, but included three others in his Knoedler exhibition that December—*The Birch Forests*, *Sun-set*, *Canada Woods* and *Pontiac* (a generic title that may not indicate the painting in the

Frederic Remington Art Museum collection). A critic writing in the *American Art News* found the small landscapes a "refreshing contrast" to Remington's Western set pieces, "low in tone and comparatively soft in color."[6] In discussing the landscapes, Royal Cortissoz chose to comment on a winter scene sketched that February in Massachusetts, *The White Country*, whose delicate "*nuances* of white and russet tone" he admired. Cortissoz's choice was consistent with his preference for the muted tonalities of Remington's Western nocturnes. Still, he judged the landscapes collectively "of uncommon merit."[7] Basking in a friend's praise of the exhibition, Remington asserted that he was "a *plein air* man by instinct" and was "getting at things better."[8] Had he lived on, most certainly he would have made outdoor sketching an even higher priority.

1. James A. Baker, *We Went to Heaven before We Died* (Rutland, VT: Academy Books, for the author, 1991), pp. 4–19.
2. Diary, March 31, April 14, 30, May 7, July 16, July 27–August 19, November 9, 1909, FRAM 71.816; Baker, *We Went to Heaven before We Died*, pp. 25–28; FR to John Howard, [November 1909], *Selected Letters*, p. 429. FR's letters to Howard prior to his visit were full of enthusiasm for the club, ibid., pp. 426–29.
3. Diary, August 28, 30, 1909, FRAM 71.816.
4. See Nicolai Cikovsky, Jr., "'The Ravages of the Axe': The Meaning of the Tree Stump in Nineteenth-Century American Art," *Art Bulletin* 61 (December 1979): 611–26.
5. Baker, *We Went to Heaven before We Died*, chap. 4, pp. 5, 13; Diary, August 9, 1909, FRAM 71.816. Remington had earlier studied photographs of the club ("Log cabins, hills—trees beautiful water") that likely included the view from the Lookout, as it was known. "They give you a perfect idea of the place and it suits me perfectly," he wrote John Howard: "A bunch of log houses in an ocean of trees with water going out into the unknown." Diary, May 7, 1909; *Selected Letters*, p. 426.
6. "Works by Mann and Remington," *American Art News*, December 11, 1909, clipping in FRAM.
7. Royal Cortissoz, "Frederic Remington: A Painter of American Life," *Scribner's Magazine* 47 (February 1910): 195; Diary, February 4, 1909, FRAM 71.816.
8. FR to Albert S. Brolley, December 8, [1909], Buffalo Bill Historical Center, Cody, WY; and *Selected Letters*, p. 434, where "*plein air*" is rendered incorrectly.

Stream ca. 1890s
Watercolor on paper, 14 x 20" (35.6 x 50.8 cm.)
Unsigned
FRAM 66.260

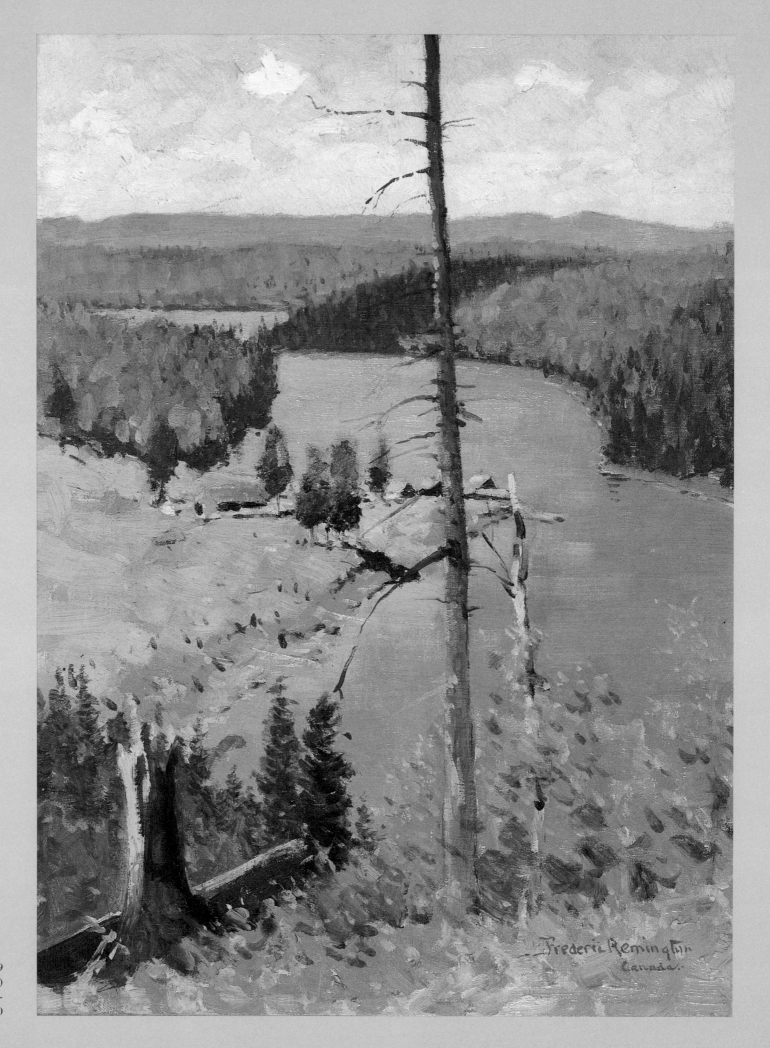

The Moose Country 1909
Oil on board, 18⅞ x 15" (47.9 x 38.1 cm.)
Signed lower right: Frederic Remington / Canada.-
FRAM 66.48, CR 2910

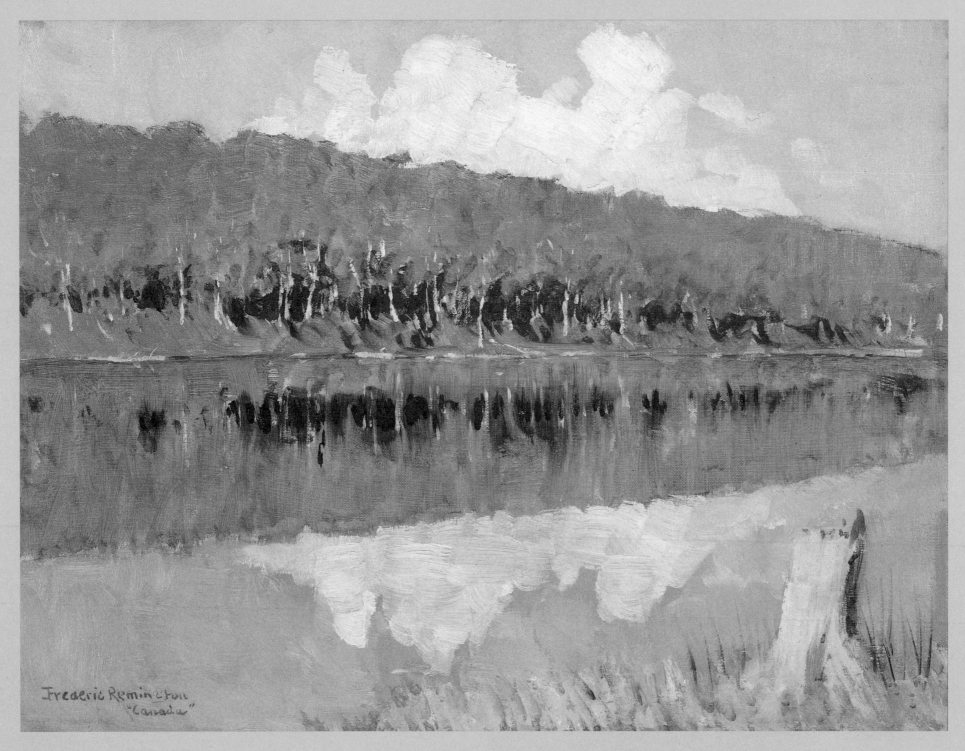

Canada 1909
Oil on board, 12 x 16" (30.5 x 40.6 cm.)
Signed lower left: Frederic Remington / "Canada."
FRAM 66.58, CR 2896

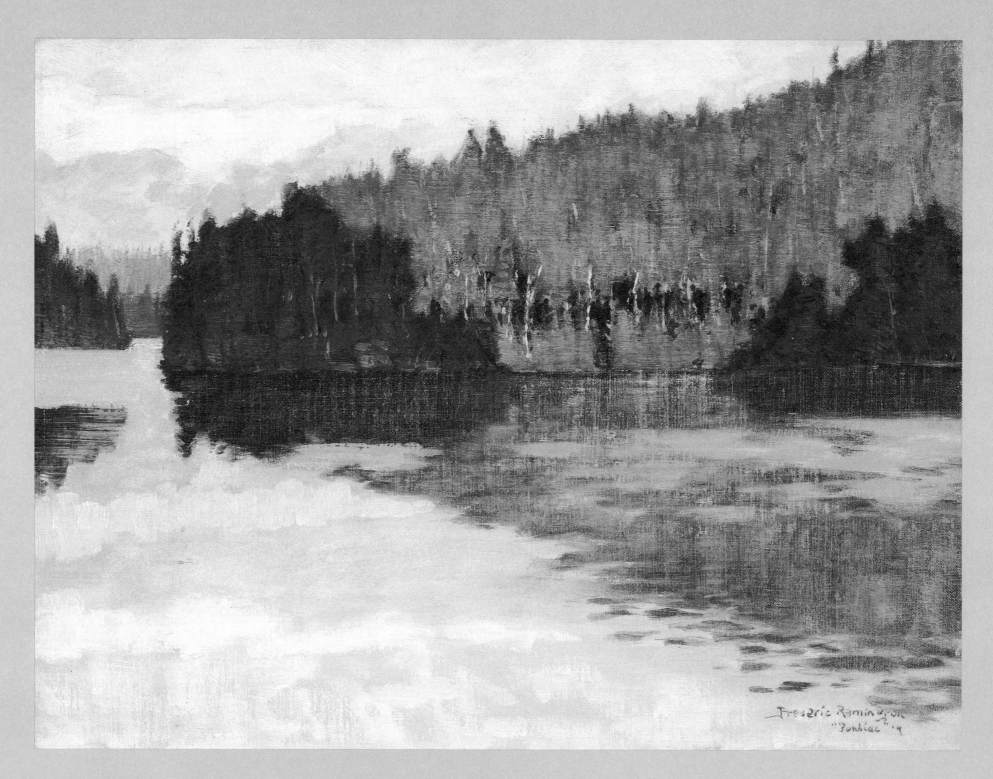

Pontiac Club, Canada 1909
Oil on board, 12 x 16" (30.5 x 40.6 cm.)
Signed lower right: Frederic Remington / "Pontiac" '9
FRAM 66.60, CR 2916

Horse Studies

Horses were a point of pride to Remington—horses and horse lore. "It was Remington who first gave character to the horse in art," an appreciative writer noted in 1905: "to this artist every horse was a little different from every other horse, not only in its lines and its color, but in its disposition and characteristics."[1] Remington grew up in a world without automobiles, in which everyone was more or less familiar with "that faithfulest of our brute allies."[2] But Remington had a *passion* for horseflesh. Beginning in 1890 he covered the annual horse show at Madison Square Garden for *Harper's Weekly*. His wash drawing *Norman Percheron*, published in the *Weekly* for November 13, 1890, shows the delight he took in equine variety.[3] Remington rode well and took pride in his own horses. An army officer who first met him in the field in 1890 and then visited him at his home in New York, observed:

> *Whether you meet him on a bony troop horse jogging along a mountain trail, or astride a well fed hunter taking the hedges of the Rosetree Hunt, you are forced to admit that he understands the horse and how to ride it; and this knowledge is not more the result of training than of a natural sincere love of the animal. Those in his own stable are of the kind you are familiar with in his pictures—fiery, long-limbed, striding roadsters. One day as we were starting for a ride on the road he said, patting one of them on the flank, "I know the shape of every muscle in his body."*[4]

A series of photographs taken at his home in New Rochelle show Remington exercising Beauty, a favorite bay. He inspected her teeth and hooves, and rode her around with jaunty confidence. Indeed, he was confident enough about his own horse expertise to be undeterred by Western preferences. On a visit to a ranch in Mexico in 1893, he noted the ribbing he took for using a "new-fangled" officer's saddle. He also noted that his horse was grateful, and that at the end of the day it was still loping along comfortably while the other mounts were rubbed sore by their Mexican cow-saddles.[5]

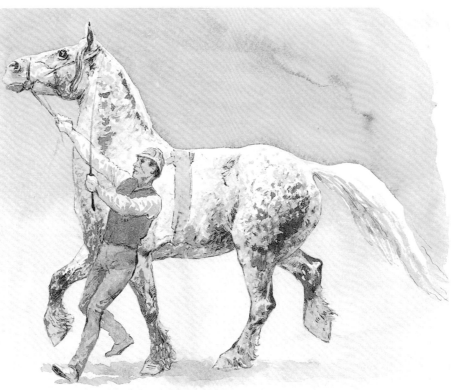

Norman Percheron 1890
Ink wash on paper,
11⅞ x 11¾" (30.2 x 29.9 cm.)
Signed lower left:
—REMINGTON.—
FRAM 66.104, CR 1093

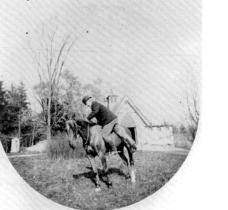
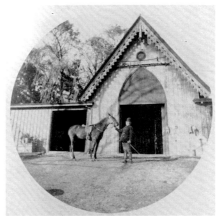

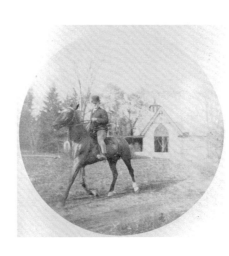

Remington with his horse
Beauty, New Rochelle
FRAM 1918.76.152.74;
1918.76.152.101;
1918.76.152.26;
1918.76.152.53

(clockwise, from top left.)

Opposite page:
A Study ca. 1908
Oil on canvas
25 x 25" (63.5 x 63.5 cm.)
Signed lower right: Frederic
Remington / A Study —
FRAM 66.84, CR 2866

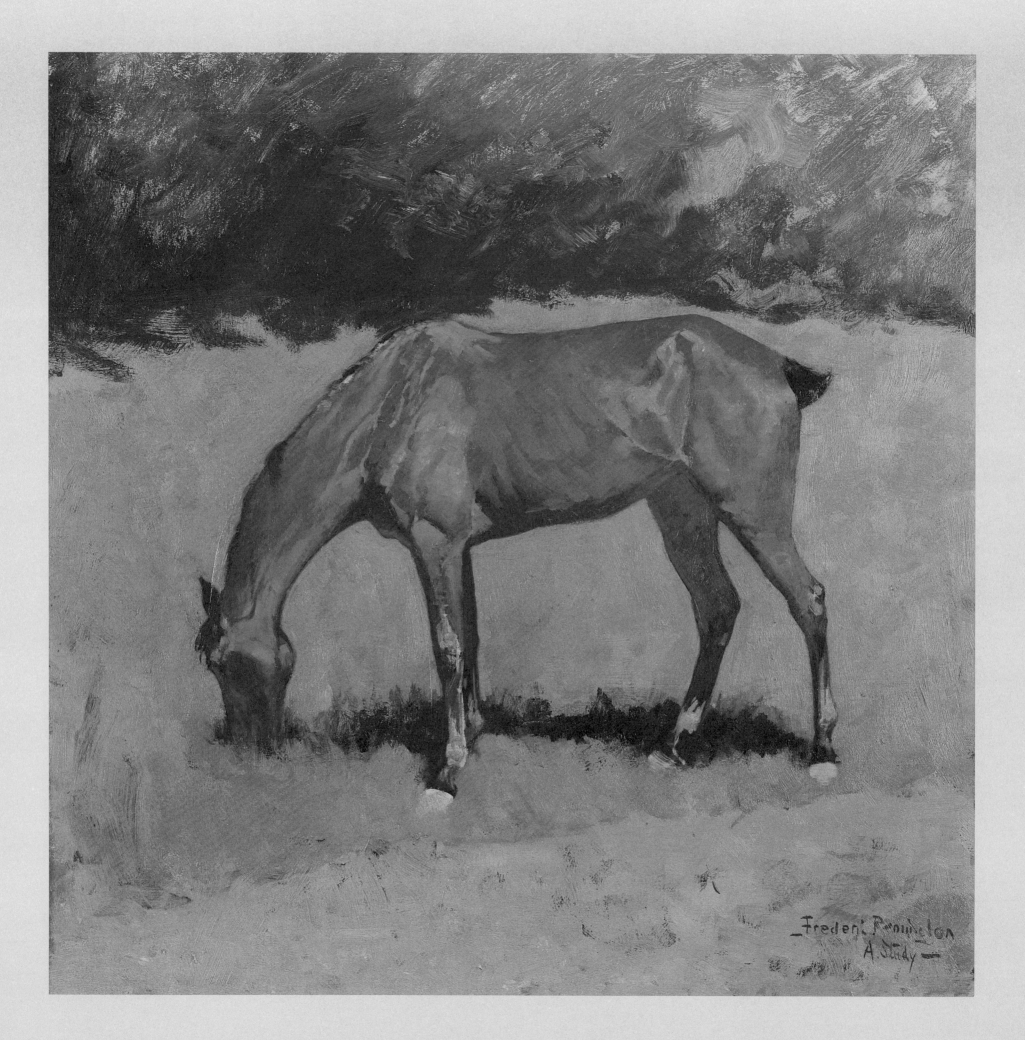

Being a dude did not necessarily mean being wrong, and Remington's art—that is, his claims to creating a Western art grounded in intimate, firsthand knowledge—turned on a demonstrated familiarity with fine points and distinctions. The theme of one of his earliest articles, published in *Century Magazine* in January 1889 under the title "Horses of the Plains," was that nearly four centuries of adaptation to a "great variety of dissimilar conditions" had "so changed the American 'bronco' from his Spanish ancestor that he now enjoys a distinctive individuality." Remington illustrated his point, further distinguishing between the Texas pinto, the cayuse or mustang of the Northwest, and the Indian pony, and said of the lot what he said of the pony: "He may be all that the wildest enthusiast may claim in point of hardihood and power… but he is not beautiful."[6] The Western type, man and animal, was built for survival, not appearances—though Remington, of course, found their appearances entrancing.

To keep Western light, color, and peculiarities before him as he worked on his major oils back East, Remington kept oil sketches near at hand. A photograph of him in his New Rochelle studio in 1907 at work on the model for *The Buffalo Horse* shows some of his many horse studies arranged on the wall behind. A visitor discussed them with the artist a few years earlier:

> "*How do you get that peculiar alkali, yellowish air of the plains?*" I asked, as we stood before an example of Mr. Remington's art.
> "*Only by having lived there, and after a dint of study. That is a dust study.*"
> "*And those blue shadows are correct?*"
> "*Yes; you cannot have a black shade out in the open, and the atmosphere there causes that particular shade. That one above, though, which is also a study, shows an almost steel gray shadow, while that other one is still darker. These are 'color notes,' of Indian ponies, and bronchos. There is no crest or arch to their necks. They are really degenerated horses, but they can go.*"[7]

Of all that Remington saw and painted—including his late-life North Country landscapes—his horse studies convey the purest enjoyment. "I hardly need to say that he loves the horse," his friend Julian Ralph noted in 1895, adding a quip that has embedded itself in the Remington lore: "what not every one knows is that he has said he would be proud to have carved on his tombstone the simple sentence, 'He knew the horse.'"[8]

Frederic Remington making a field sketch, Fort Robinson, ca. 1905
FRAM 1918.76.158.58; 1918.70.9

Frederic Remington sculpting *The Buffalo Horse*, 1907
FRAM 1918.76.160.67

1. Charles Belmont Davis, "Remington—The Man and His Work," *Collier's Weekly*, March 18, 1905, p. 15.
2. Julian Ralph, "Frederic Remington," *Harper's Weekly*, February 2, 1895, p. 688.
3. See FR to Fred B. Schell, October 11, 1890, *Selected Letters*, p. 106. Remington commented on his annual assignment in letters to friends, acknowledging that the horse shows were good for his pocketbook as well: FR to Poultney Bigelow, [October 1892], and FR to Owen Wister, [October 1895], *Selected Letters*, pp. 155, 277.
4. Alvin H. Sydenham, "Frederic Remington," in Deoch Fulton, ed., *The Journal of Lieut. Sydenham, 1889, 1890; And His Notes on Frederic Remington* (New York: The New York Public Library, 1940), p. 29; a fuller version is in *Selected Letters*, pp. 180–86.
5. FR, "In the Sierra Madre with the Punchers," *Harper's Monthly*, February 1894; *Collected Writings*, p. 124.
6. FR, "Horses of the Plains," *Century Magazine*, January 1889; *Collected Writings*, pp. 15–21.
7. Charles H. Garrett, "Remington and His Work," *Success*, May 13, 1899; in Orison Swett Marden, ed., *Little Visits with Great Americans; or, Success Ideals and How to Attain Them*, 2 vols. (New York: The Success Company, 1905), I, p. 331.
8. Ralph, "Frederic Remington" (1895), p. 688. David Tatham, in commenting on the manuscript of this catalog (March 16, 1995), offered the pertinent observation that, had Remington lived on beyond 1909, he would have faced real difficulty in finding a place for himself in an American art whose focus was rapidly shifting from rural to urban subjects, accommodating a Modernist vision that had little use for Old West romantics or men who "knew the horse."

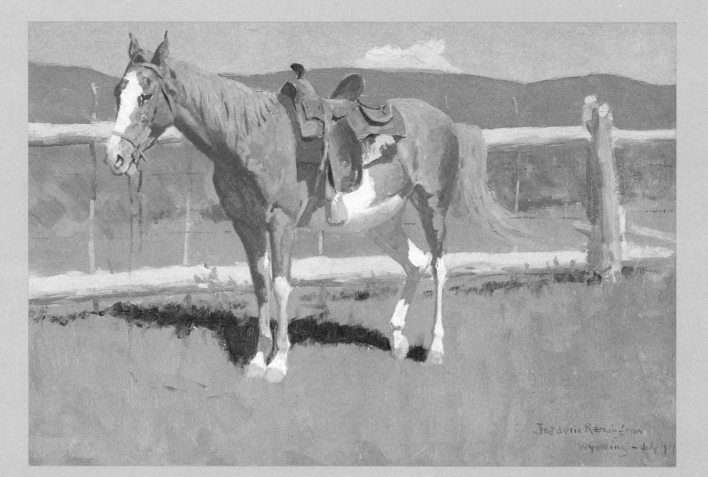

Sorrel Horse Study 1899
Oil on academy board, 11¾ x 17½" (29.8 x 44.5 cm.)
Unsigned
FRAM 66.85, CR 2407

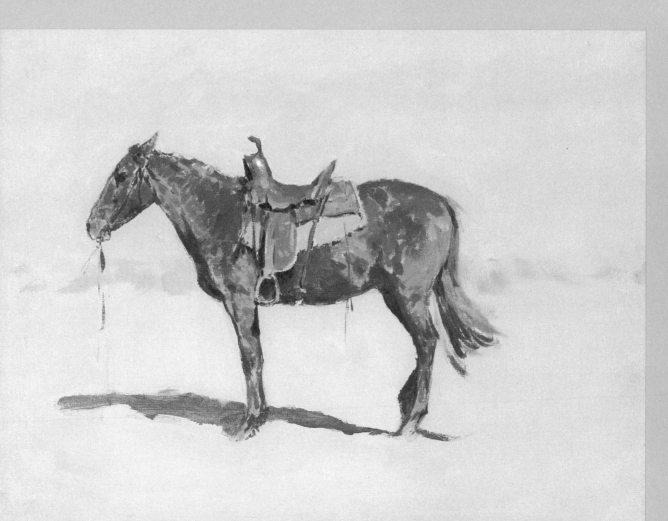

Untitled horse study n.d.
Oil on canvas, 12 x 46" (30.5 x 40.6 cm.)
Unsigned
FRAM 66.86, CR 2947

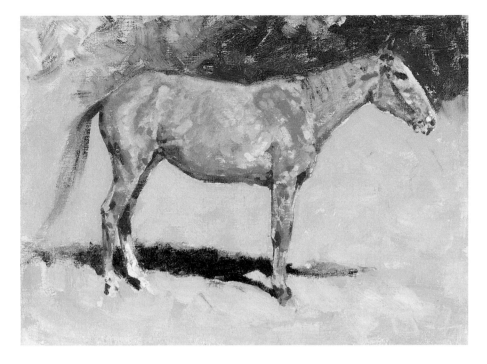

Untitled horse study n.d.
Oil on canvas board, 10 x 14" (25.4 x 35.6 cm.)
Unsigned
FRAM 66.111, CR 2949

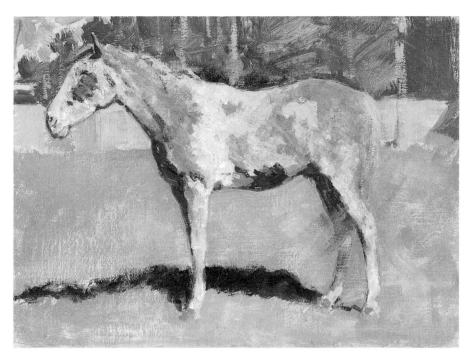

Untitled horse study n.d.
Oil on canvas board, 10 x 14" (25.4 x 35.6 cm.)
Unsigned
FRAM 66.112, CR 2950

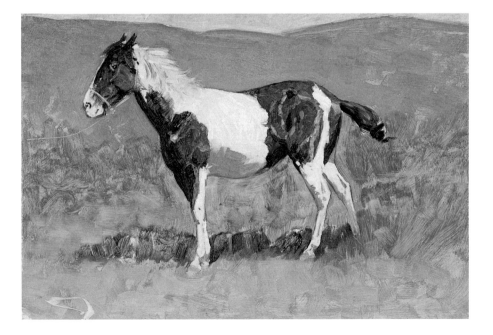

Untitled pony study n.d.
Oil on academy board, 12 x 18" (30.5 x 45.7 cm.)
Unsigned
FRAM 66.87, CR 2948

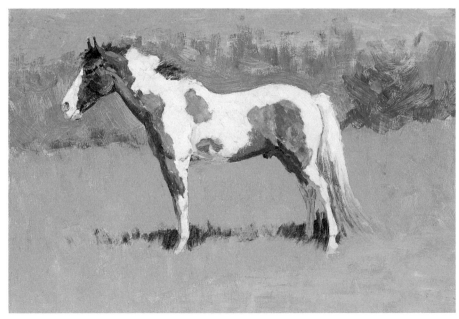

Untitled horse study n.d.
Oil on academy board, 12 x 18" (30.5 x 45.7 cm.)
Unsigned
FRAM 66.113, CR 2951

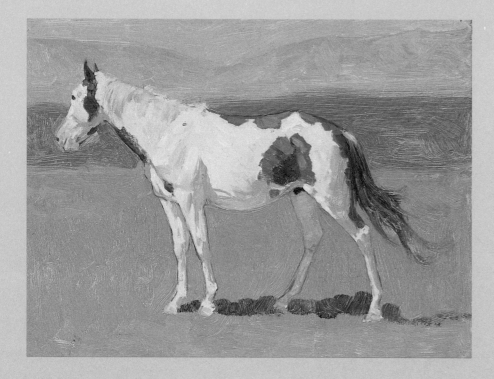

Untitled horse study n.d.
Oil on academy board, 9 x 12" (22.9 x 30.5 cm.)
Unsigned
FRAM 66.114, CR 2952

Untitled horse study n.d.
Oil on academy board, 9 x 12" (22.9 x 30.5 cm.)
Unsigned
FRAM 66.115, CR 2953

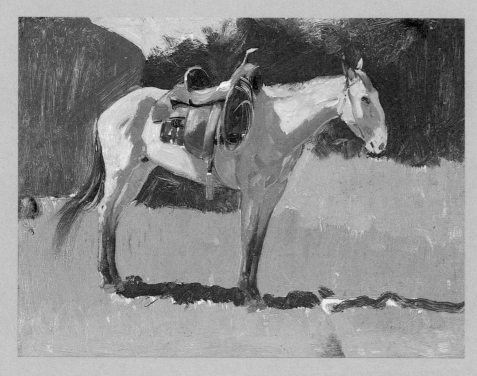

Untitled horse study n.d.
Oil on academy board, 9 x 12" (22.9 x 30.5 cm.)
Unsigned
FRAM 66.116, CR 2954

Untitled horse study n.d.
Oil on academy board, 9 x 12" (22.9 x 30.5 cm.)
Unsigned
FRAM 66.117, CR 2955

Untitled horse study n.d.
Oil on canvas board, 12 x 16" (30.5 x 40.6 cm.)
Unsigned
FRAM 66.118, CR 2956

Untitled horse study n.d.
Oil on stretched canvas, 12 x 16" (30.5 x 40.6 cm.)
Unsigned
FRAM 66.119, CR 2957

Untitled horse study n.d.
Oil on academy board, 12 x 18" (30.5 x 45.7 cm.)
Unsigned
FRAM 66.120, CR 2958

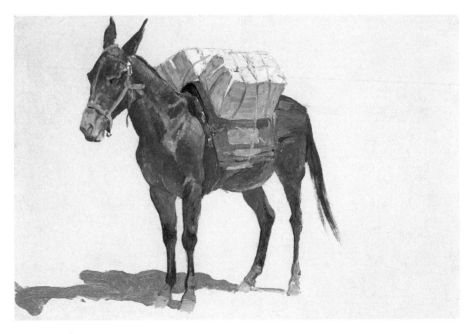

Untitled pack mule study n.d.
Oil on canvas, 12 x 18" (30.5 x 45.7 cm.)
Unsigned
FRAM 66.83, CR 2960

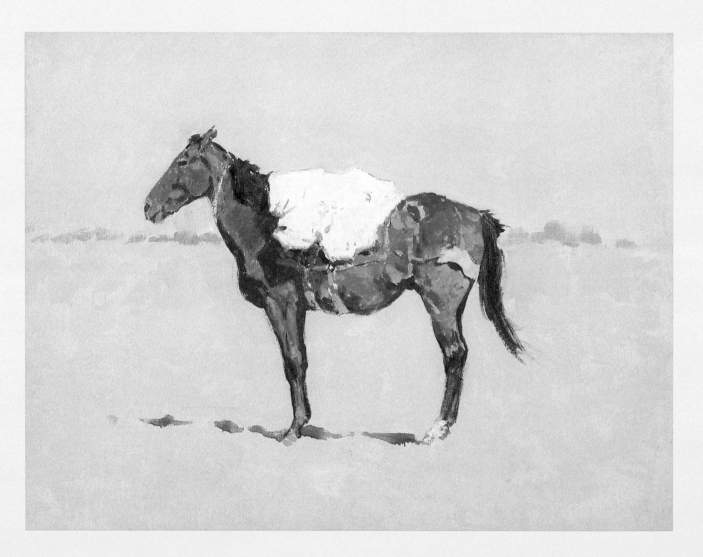

Study for *Pack Horse* n.d.
Oil on canvas, 12 x 16" (30.5 x 40.6 cm.)
Unsigned
FRAM 66.82, CR 2405a

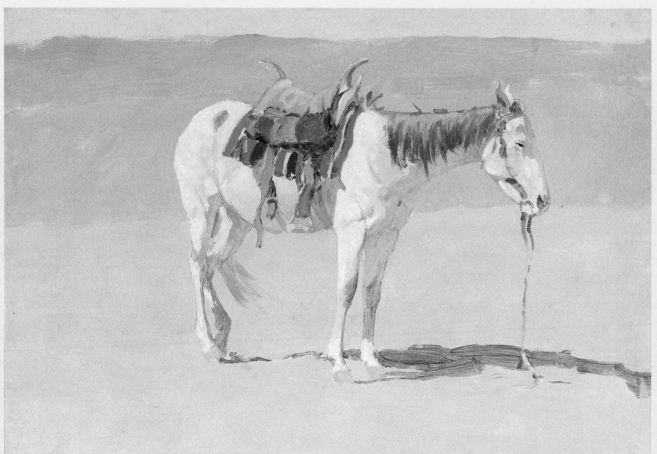

Study for *Squaw Pony* ca. 1900
Oil on board, 12 x 18" (30.5 x 45.7 cm.)
Unsigned
FRAM 66.81, CR 2486a

General Leonard Wood on Horseback (sketch in oils) 1909

Oil on canvas, 30 x 30" (76.2 x 76.2 cm.)
Unsigned
FRAM 66.59, CR 2908a

Remington had continued to report on the army through the 1890s—maneuvers, service against labor protesters in Chicago, war preparations. But his position was clear. "D— the future," he wrote his friend Lieutenant Powhatan H. Clarke at the beginning of the decade: "—soldiers by profession deal with the future—artists deal with the past though. I dont care a d— what you cavalrymen are going to do—its what you have done."[1] After covering the mopping-up operations in Cuba, Remington abandoned the army for good. It was no longer of interest to him, he said. His army was the frontier army which won the West. The Rough Riders were a worthy idea, but the actual fighting in Cuba had only served to demonstrate the vast gulf separating his boyhood dreams of clashing armies on valorous fields, and the reality of modern warfare's long-distance death. It was all too cold and impersonal to stir the artistic imagination. "Frankly I know nothing about the army as it is right now," he told a journalist in 1907. "I have had nothing to do with soldiers since the war in Cuba. I only knew the soldier as a part of my West, and the West and the soldier closed together. The uniformed fighting man passed on and off my board a long time since."[2]

Why, then, a throwback like this equestrian portrait of General Leonard Wood, commander of the Rough Riders and a Spanish-American War hero? Remington had painted his share of gallant officers in the past, but portraiture was never his forte[3] and seemed inconsistent with his stated artistic goals in 1909.

One explanation is that Leonard Wood was exceptional. A medical doctor, born in New Hampshire in 1860 and trained at Harvard, Wood joined the army medical corps in 1885 and saw service during the Geronimo campaign as a surgeon and a combat officer. In 1898, when war with Spain appeared imminent, he conceived the idea of recruiting a volunteer regiment of cavalry—the Rough Riders—in Arizona, New Mexico and Indian Territory and, with Theodore Roosevelt his second in command, served as its colonel. Remington chose to see Wood as a model of the Indian wars veteran who brought all his craft and

courage to Cuba. "Soldiers and residents in the Southwest had known him ten years back," he wrote in 1898. "They knew Leonard Wood was a soldier, skin, bones, and brain, who travelled under the disguise of a doctor...."[4] Wood's star continued to rise after the Spanish-American War. He served as military governor of Cuba and, promoted to the rank of major general in 1903, the Philippines, and would later assume the duties of army chief of staff.[5] Remington, who had known him since the 1880s and had followed his career with admiration, decided to invite him up to Lorul Place to discuss the Apache wars and, as things evolved, to paint his portrait.

Artistic issues, too, entered the project. Remington would paint the general out-of-doors—an experiment, he told a friend, corresponding with his discovery (based on his recent landscapes) that he was "a *plein air* man by instinct."[6] Wood arrived on September 4, his orderlies and horses the next morning. Remington, who had hoped "it don't get cloudy," found himself setting up his easel in a "great wind": "It blew terrible but I made a drawing"—the red outline visible in the oil sketch.[7] They had a two-and-a-half hour session in the morning, another after lunch. "He got in the bulk of his framework for the sketch and filled in sufficiently to give him an idea of the color value under the conditions of light," Wood noted.[8] The next day they went at it again in "a blazing light."[9] Remington also took several Kodaks of the general for use as references in the finished portrait.[10] But the fact remained he had painted Wood from life, "out of doors with only two sittings," and that was a departure.[11] Subsequently, he produced a more detailed, polished portrait for exhibition that December, *Maj. General Leonard Wood, U.S.A.*

Four months after his visit to Lorul Place, General Wood was composing a memorial tribute to Frederic Remington. The artist's sudden death had caught everyone by surprise. Remington's "army subjects" were "wonderfully good (great would be a better word)," Wood wrote: "... he has perpetuated the work and type of the soldiers of the plains and of the great Southwest in summer and in winter, but always in action, always doing something..."[12] Wood's own portrait is

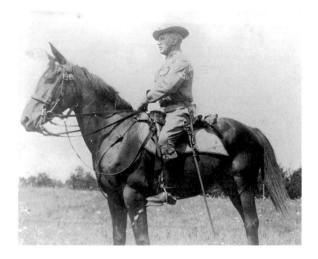

General Leonard Wood posing at Ridgefield, Connecticut
September 6, 1909
Photograph by Frederic Remington
FRAM 1918.76.121.9

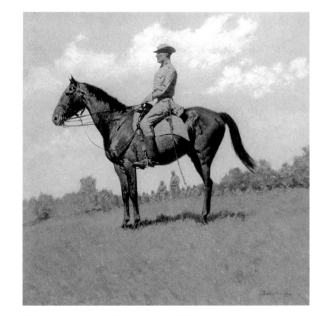

Maj. General Leonard Wood, U.S.A. 1909
The West Point Museum, United States Military Academy
West Point, New York
CR 2908

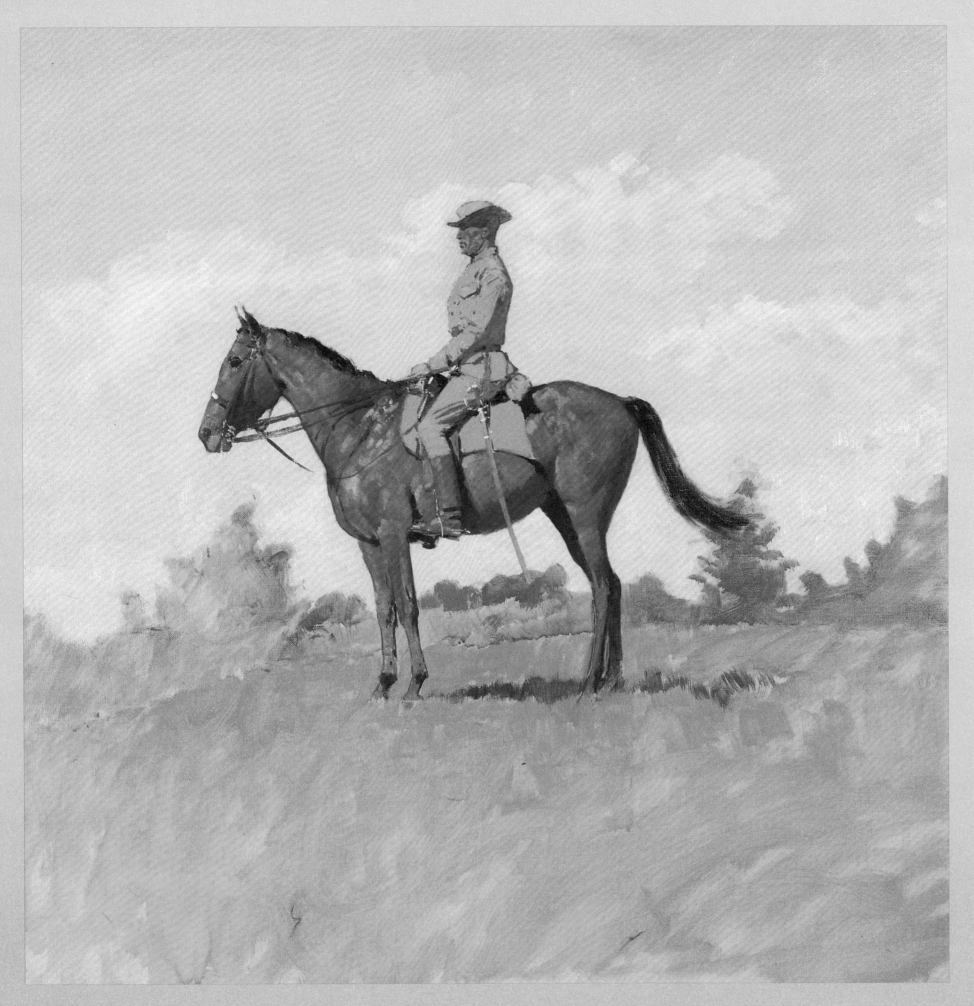

General Leonard Wood on Horseback (sketch in oils) 1909

another matter. It is a pretty staid affair, though faithful to a point Remington had made earlier: "A man on a horse is a vigorous, forceful thing to look at. It embodies the liveliness of nature in its most attractive form, especially when a gun and sabre are attached."[13] The oil sketch shows the general posed in his khaki uniform—a little taller in the saddle than his photograph indicates, though the horse, a handsome bay named Walking John, is magnificent in both. The sun shines. The sky is a robin's-egg blue with puffy white clouds. The lush meadow grass and the trees fringing Remington's Connecticut estate are suggested in broad strokes of olive and forest green. In the autumn of his life, Remington had accomplished the improbable: he had made the military seem positively peaceful.

Wood had some reservations about his portrait. He thought the pose fine "but face rather tough."[14] (Roosevelt complained about individual faces not showing at all in *The Charge of the Rough Riders* [p.121].)[15] Nevertheless, Wood was grateful for the artist's attention—and even more grateful when Remington gave him the portrait after his Knoedler exhibition closed that December.[16]

1. FR to Powhatan Clarke, January 30, 1890, *Selected Letters*, p. 90.
2. Perriton Maxwell, "Frederic Remington—Most Typical of American Artists," *Pearson's Magazine* 18 (October 1907): 404–05.
3. FR to John Howard, December 1, [1898], *Selected Letters*, p. 406: "Impossible—I couldn't do a job of your boy—the nearest I come to portraiture is once in a while a stray soldier."
4. FR, "With the Fifth Corps," *Harper's Monthly*, November 1898; *Collected Writings*, p. 341.
5. For an admiring contemporary biography, see Eric Fisher Wood, *Leonard Wood: Conservator of Americanism* (New York: George H. Doran Company, 1920). Wood died in 1927.
6. FR to Albert S. Brolley, December 8 [1909], Buffalo Bill Historical Center, Cody, WY; *Collected Letters*, pp. 434–35.
7. Diary, September 3, 5, 1909, FRAM 71.816.
8. Leonard Wood diary entry, quoted in James K. Ballinger, *Frederic Remington's Southwest* (Phoenix: Phoenix Art Museum, 1992), p. 88.
9. Diary, September 6, 1909, FRAM 71.816.
10. Wood diary entry, quoted in Ballinger, *Frederic Remington's Southwest*, p. 88.
11. FR to Bolley, December 8, [1909].
12. Leonard Wood, "The Man We Knew," *Collier's Weekly*, January 8, 1910, p. 12.
13. FR, "The Essentials at Fort Adobe," *Harper's Monthly*, April 1898; *Collected Writings*, p. 289.
14. Leonard Wood diary entry, quoted in Ballinger, *Frederic Remington's Southwest*, p. 89.
15. Theodore Roosevelt, quoted in Peggy and Harold Samuels, *Frederic Remington: A Biography* (Garden City, NY: Doubleday & Company, 1982), p. 291.
16. Leonard Wood to FR, September 7, October 4, December 9, 1909, FRAM 71.823.45, 71.823.46, 71.823.47.

Opposite page, detail:
General Leonard Wood on Horseback
(sketch in oils) 1909

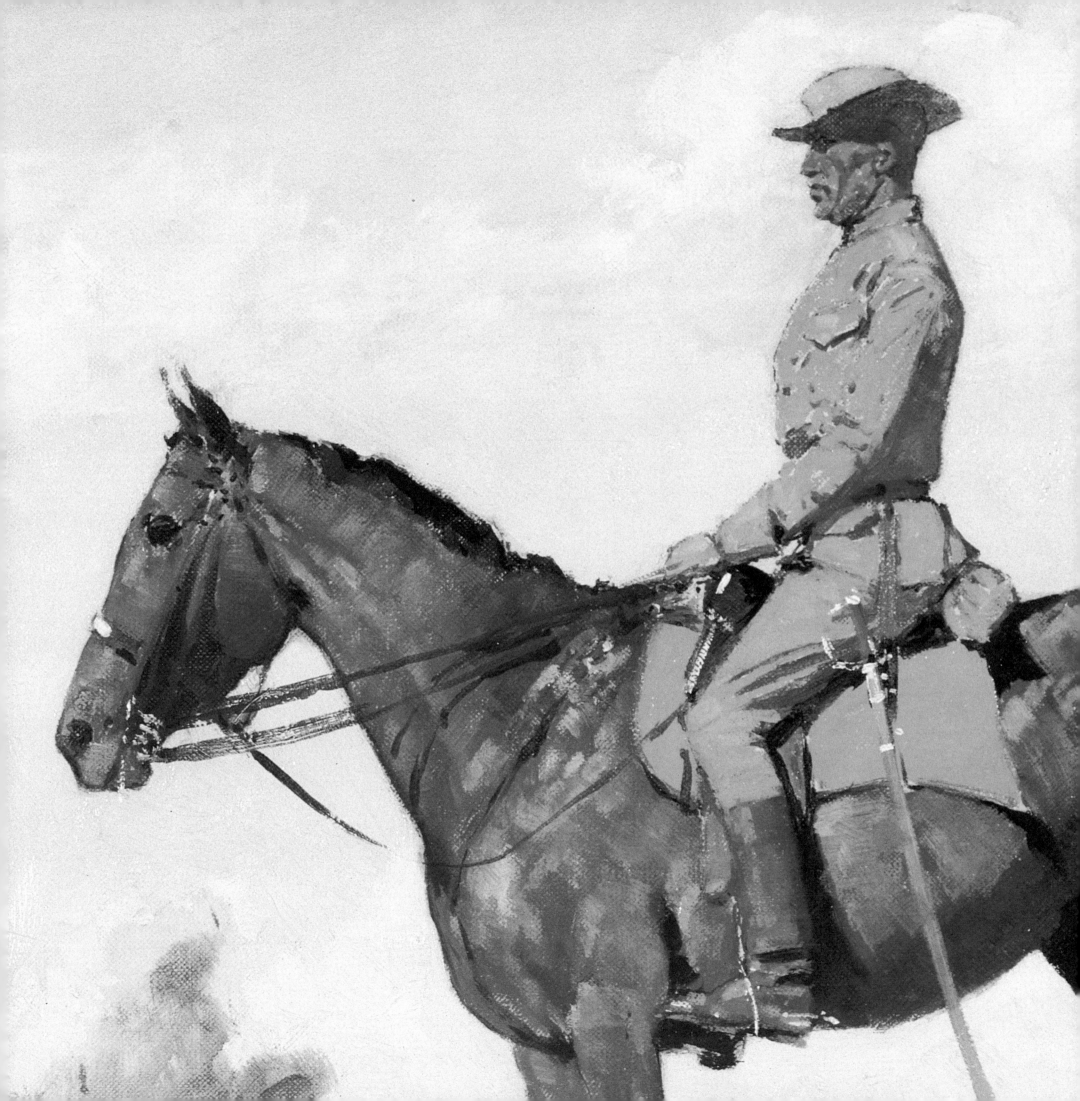

The Stampede © April 13, 1910

Roman Bronze Works cast no. 3 (ca. 1918–1919), 22¹¹/₁₆ H x 48¾ L x 18¹¹/₁₆" D (57.6 H x 123.8 W x 47.5 D cm.)
Estate casting in accordance with Eva Remington's will
FRAM 66.11

On September 26, 1909, perhaps recalling the success of his painting *The Stampede* which he had sold at his Knoedler exhibition the previous December, Frederic Remington began work on a challenging project, "a solid group of cowboy and steers in sculpture—'The Stampede.'"[1] Artists before Remington had made the stampede part of the lore of the cowboy, and he had contributed to the body of imagery as early as 1888. The subject appealed to him, he told *The Stampede*'s buyer, because "I think the animal man was never called on to do a more desperate deed than running in the night with long horns taking the country as it came and with the cattle splitting out behind him, all as mad as the thunder and lightning above him, while the cut banks and dog holes wait below, nature is merciless."[2] Remington worked on the model through October, recording steady progress. He "put some guts" in the cowboy on the 15th, and on the 21st studied the anatomy of the Texas steer, presumably in one of his reference books (when he was working on his group *The Buffalo Horse* in 1907, he took the opportunity to study buffalo anatomy firsthand at the Bronx Zoo).[3] The results pleased Remington—"bulls are fierce in mud," he observed on the 23rd, and the group was far enough along for him to show it, to the applause of friends ("a winner") on the last day of October. November began less auspiciously. "One of my bulls disintegrated—fell to pieces—thus making it necessary to do him over again," Remington noted. But, with his usual efficiency, he plugged along, and the group was finished, cast in plaster and shipped to Roman Bronze Works before the month was out.[4]

Remington never saw *The Stampede* in wax. The group was complex, and Riccardo Bertelli at the time was more interested in pushing for an enlargement of *The Broncho Buster*, a sure-fire commercial proposition. Remington's Knoedler exhibition and his work on the enlargement preoccupied him till December 10, and by then he, too, was committed to making it the foundry's priority. "We want to get this out as soon as possible," he wrote Bertelli the day he finished. "I would even give it presidence of the last group."[5] Since Remington

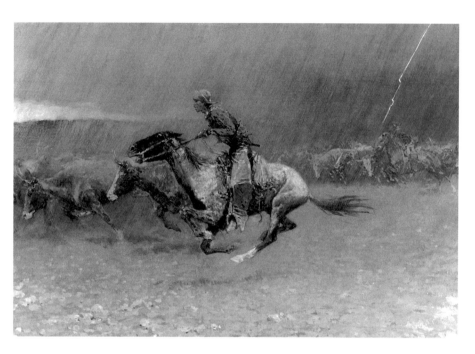

The Stampede 1908
Gilcrease Museum, Tulsa, OK
CR 2872

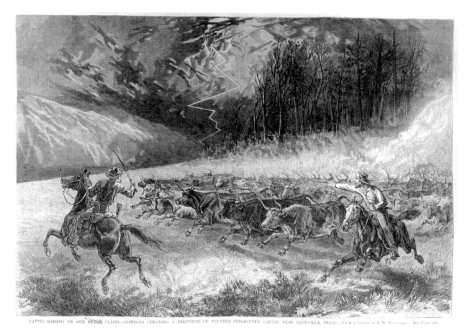

L. W. MacDonald, *Cowboys Checking a Stampede of Thunder-Frightened Cattle*
Frank Leslie's Illustrated Weekly, May 28, 1881
Milstein Division of United States History, Local History and Genealogy, The New York Public Library, Astor, Lenox and Tilden Foundations

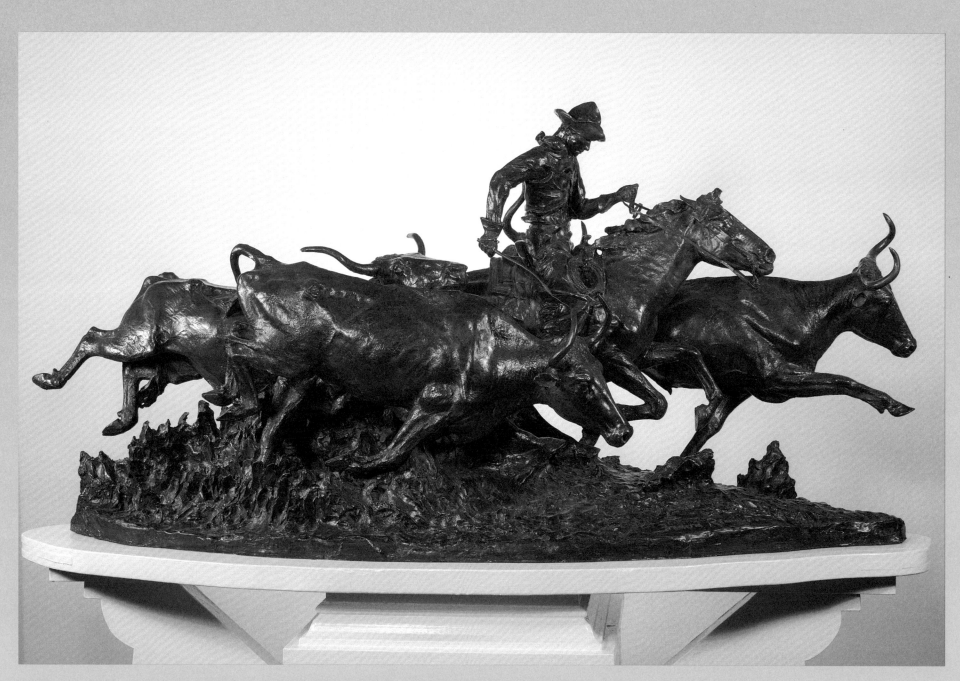

The Stampede © April 13, 1910

was stricken ill within less than two weeks and died December 26, he had no further creative input in *The Stampede*. Eva Remington copyrighted the "group of four steers & mounted cowboy—50 inches long by 20 wide by 23 high" on April 13, 1910, and turned to another artist from Ogdensburg for help in casting it. Sally James Farnham has been described as a "minor sculptor."[6] Remington did not consider her minor. He was smitten with the "gorgeous" Sally, and accepted, even encouraged, her incursions into the male bastion of military art. Jealous of others who might compete with him for sculpture commissions, he gladly shared his fund of knowledge with her.[7] Eva Remington consulted with Farnham at the Roman Bronze Works around the time she copyrighted *The Stampede*, and it is frequently said that Farnham "completed" the unfinished sculpture. What is meant is unclear. Remington regarded the group as finished when he had it cast in plaster, and the plaster was prepared under his close (and approving) supervision. But Farnham likely worked on the wax positives prior to casting in bronze, making the surface finish of the sculpture her contribution.[8]

 Dragoons 1850 (p. 169) and *The Stampede* were Remington's most elaborate bronzes. They are similar in format, though, as Michael Shapiro notes, *The Stampede* more successfully resolves the formal problems inherent in such complex, unidirectional compositions.[9] The jutting head, horns and right foreleg of the lead bull as it plunges into space complement the airborne posterior of the hind bull, and the cowboy propels the composition forward while breaking the horizontal plane created by the surging steers. From Eva Remington's viewpoint, casting *The Stampede* was a business decision. The foundry saw it as directly comparable to *Dragoons 1850* in pricing it at $2,500 ($500 more than *Coming Through the Rye*). Since Eva would receive a royalty of $1,225 on each casting sold, she may well have anticipated a handsome income from its sale.[10] This much is certain: the bronzes were her main hope for a steady income after death stilled her husband's hand.

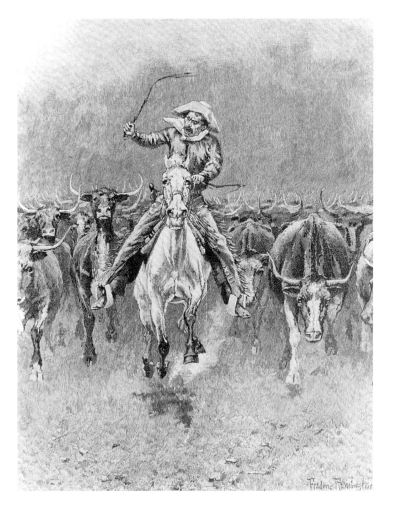

In a Stampede
Century Magazine 35 (April 1888): 865

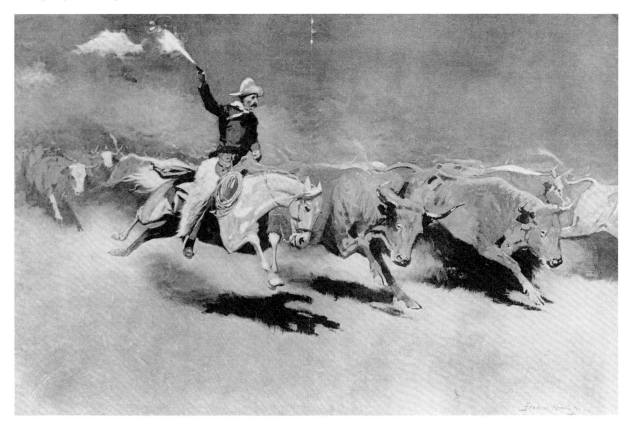

The Round-Up
Collier's Weekly, August 26, 1899, pp. 12–13

1. Diary, September 26–27, 1909, FRAM 71.816.

2. FR to Mr. Schofield, December 12, 1908, *American Scene* 5, no. 4 (1964): 64.

3. Diaries, October 15, 21, 1909, FRAM 71.816, September 16–17, 1907, FRAM 71.815. Remington "knew the horse" (pp. 234–41), but animals generally were not his forte—see Brian W. Dippie, *Remington and Russell: The Sid Richardson Collection (Revised Edition)* (Austin: University of Texas Press, 1994), p. 26, and Owen Wister, *Roosevelt: The Story of a Friendship, 1880–1919* (New York: Macmillan Company, 1930), p. 31. Remington readily conceded pride of place to others. He acquired models of a snarling dog and a mountain lion by Antoine Barye, and a bronze buffalo by Henry M. Shrady, and he admired the oils of the gifted outdoor artist Carl Rungius, whose painterly renditions of wildlife in their natural habitat would have appealed to his taste for landscape as well. See Michael Edward Shapiro, *Cast and Recast: The Sculpture of Frederic Remington* (Washington, DC: Smithsonian Institution Press, for the National Museum of American Art, 1981), pp. 42–43; Diary, October 4, 1907; FRAM 71.815; Shapiro, "Remington: The Sculptor," in Shapiro and Peter H. Hassrick, *Frederic Remington: The Masterworks* (New York: Harry N. Abrams, for the Saint Louis Art Museum, in conjunction with the Buffalo Bill Historical Center, Cody, WY, 1988), p. 190; Diary, February 23, 1908; FRAM 71.817; FR to Carl Rungius, [ca. May 7, 1908], November 27, [1909], Carl Rungius Papers, Glenbow Museum, Calgary, Alberta; Diary, November 26, 1909; FRAM 71.816; and Jon Whyte and E. J. Hart, *Carl Rungius: Painter of the Western Wilderness* (Vancouver, BC: Douglas & McIntyre, in association with The Glenbow-Alberta Institute, 1985). Sculpture more than painting tested Remington's appetite for the literal, for though his sculpture may have become increasingly painterly over time, as Michael Shapiro has argued ("Remington: The Sculptor," pp. 221–22), his approach permitted no Impressionistic fudging of details.

4. Diary, October 23, 31, November 1, 3, 6, 8, 24–27, 1909, FRAM 71.816.

5. Diary, December 10, 1909; FRAM 71.816; FR to Riccardo Bertelli, Friday [December 10, 1909], *Selected Letters*, p. 444.

6. Eva Remington notebook, stocks, copyrights, etc., p. 70, FRAM 96.2; Shapiro, "Remington: The Sculptor," p. 190.

7. Diaries, December 8, 1908, November 16, 1907, November 26, 1908, FRAM 71.817; 71.815; FR to Sally Farnham, [1909], *Selected Letters*, pp. 446–47. The originals, plus two additional letters to Farnham (one dated November 10, 1896, showing the length of the friendship) and one to Farnham's husband, are in the Buffalo Bill Historical Center, Cody, WY.

8. See Shapiro, *Cast and Recast*, pp. 59, 84; and "Remington: The Sculptor," p. 232; and Diary, November 24 ("Contini [who made the plaster cast] is a wonder"), November 26–27, 1909. FRAM 71.816. Judging from the ledger book information that Shapiro provides (p. 88), *The Stampede* was not actually cast until 1916. By then Eva Remington was also living in Ogdensburg.

9. Shapiro, "Remington: The Sculptor," p. 214.

10. Peggy and Harold Samuels, *Frederic Remington: A Biography* (Garden City, NY: Doubleday & Company, 1982), p. 442. In fact, *The Stampede* was cast only twice in Eva's lifetime.

The Broncho Buster © October 1, 1895; remodeled 1909
Roman Bronze Works cast no. 19 (ca. 1918–1919), 32½ H x 28⁵⁄₁₆ W x 17⁷⁄₈" D (82.6 H x 71.9 W x 45.4 D cm.)
Estate casting in accordance with Eva Remington's will
FRAM 66.8

On a mid-September day in 1898, Theodore Roosevelt stood before the assembled ranks of the Rough Riders at Camp Wikoff, Montauk Point, Long Island. The "cowboy" volunteers, having served their country with honor in Cuba, were soon to be mustered out for the return to civilian life. But first they had a presentation to make. One of the troopers stepped forward bearing an object wrapped in a horse blanket, "and on behalf of the regiment," Roosevelt recalled,

> presented me with Remington's fine bronze, "The Bronco-buster." There could have been no more appropriate gift from such a regiment, and I was not only pleased with it, but very deeply touched with the feeling which made them join in giving it. Afterward they all filed past and I shook the hands of each to say good-by.[1]

Naturally Roosevelt had a few words to say: "I am proud of this regiment, because it is a typical American regiment, made up of typical American men. The foundation of the regiment was the 'Bronco Buster,' and we have him here in bronze."[2] Remington was thrilled. The Rough Riders' putting their "brand" on *The Broncho Buster* was "the greatest compliment I ever had or ever can have," he informed Roosevelt, and was gratified when Roosevelt responded that he had "long looked hungrily at that bronze, but to have it come to me in this precise way, seemed almost too good."[3]

Eleven years later, on the afternoon of October 12, 1909, Riccardo Bertelli, proprietor of the Roman Bronze Works, joined the Remingtons and their other guests, Poultney Bigelow and the Childe Hassams, for dinner. He stayed overnight at Lorul Place, and was off the next morning by ten o'clock. "Think we will enlarge 'Broncho Buster,'" Remington noted in his diary after Bertelli's departure. Whose idea this was is unclear. But Remington had never forgotten the publicity that attended the Rough Riders' presentation of his bronze to Roosevelt, and it did not hurt that the grateful recipient had spent most of the twentieth century ensconced in the White House. Remington's model in progress, *The Stampede*,

Colonel Roosevelt Thanking his Officers and Men upon the Presentation to him of the Bronze Bronco-buster.

Colonel Roosevelt's Farewell to the Rough Riders.

Theodore Roosevelt thanking the Rough Riders and bidding them farewell after the presentation of *The Broncho Buster*, September 13, 1898
Photographs in *Scribner's Magazine* 25 (June 1899): 684–85

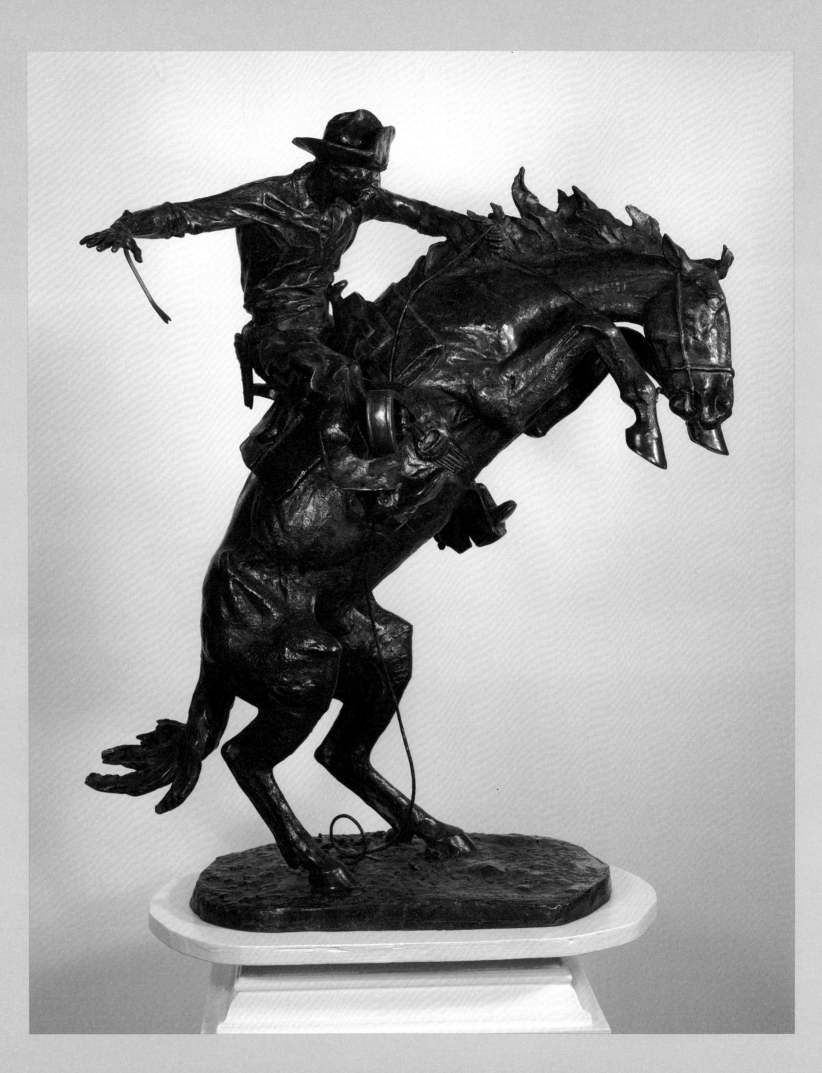

The Broncho Buster
© October 1, 1895
remodeled 1909
Roman Bronze Works
cast no. 19 (ca. 1918-1919)

would be another intricate and costly piece, while *The Broncho Buster*, his most popular subject, was a sure thing. The one-and-a-half size enlargement that he recommended to Bertelli would generate new interest while increasing profits for sculptor and foundry alike, since it would naturally cost more than the original version.[4] Perhaps a larger *Broncho Buster* would also remind the public of its creator's preeminence in Western sculpture and of his availability for another heroic-sized commission equivalent to the Fairmount Park cowboy.[5] Whatever their reasoning, both Remington and Bertelli approved the project. And so Remington's very first model became his last model as well.

With Remington nagging him, Bertelli personally delivered a plaster enlargement of *The Broncho Buster* to Lorul Place on November 14. Remington realized at once that he would have to remodel it—"I certainly have learned a lot since I did that." Consequently, he completed *The Stampede* first, and then, exhibiting his usual perfectionism, turned a simple money-making proposition into a fresh challenge as he labored on the new model from November 20 to December 10 before putting away his sculpting tools and declaring it "finished."[6] "It will make your eyes hang out on your shirt-front," he told Bertelli. "Get ready to retire the small one."[7] The new model was cast in plaster on December 15, and Remington urged Bertelli to give it priority over *The Stampede*, but he did not live to see it in bronze.[8] Instead, Roman Bronze Works continued to churn out the small-size *Broncho Buster*, producing only two casts of the larger version before June 1912, and just nineteen all told.[9]

Remington made many changes to *The Broncho Buster* in the process of remodeling it. The cowboy now sits straighter in the saddle, for example, his right hand thrown out for balance, his splayed fingers echoing the horse's pawing hoofs. But the particulars of the enlargement are less important than the overall effect. When Remington created *The Broncho Buster* in 1895, he boasted that he would "endure in bronze." The enlargement self-consciously asserts that proposition: its enhanced scale argues for enhanced significance. Horse and rider still battle one another for mastery, but *together* they yearn for immortality. The 1909 *Broncho Buster* pays loving tribute to horse and rider, but even more, to the aspiration of its creator to "rattle down through all the ages."[10]

1. Theodore Roosevelt, "The Rough Riders: The Return Home," *Scribner's Magazine* 25 (June 1899): 690; and Peggy and Harold Samuels, *Frederic Remington: A Biography* (Garden City, NY: Doubleday & Company, 1982), p. 288.
2. Theodore Roosevelt's address, September 13, 1898, quoted in G. Edward White, *The Eastern Establishment and the Western Experience: The West of Frederic Remington, Theodore Roosevelt, and Owen Wister* (New Haven: Yale University Press, 1968), p. 169.
3. FR to Theodore Roosevelt, Thursday [September 15, 1898], and Roosevelt to FR, September 19, 1898, *Selected Letters*, pp. 230–31.
4. Diary, October 12–13, 20, 1909, FRAM 71.816.
5. Samuels and Samuels, *Frederic Remington*, p. 432, advance this theory, though it contradicts their earlier observation (p. 367) that *The Broncho Buster* "told a savage story to draw the viewer's attention to a relatively small object and might be overwhelming if enlarged into the heroic size it was not designed for."
6. FR to Riccardo Bertelli, Monday [November 8, 1909], Tuesday [November 9, 1909], *Selected Letters*, pp. 444–45 (where Tuesday is incorrectly rendered Sunday); Diary, November 9, 14, 17, 20, 22–25, 28–29, December 5–10, 1909, FRAM 71.816.
7. FR to Riccardo Bertelli, [December 1909], *Selected Letters*, p. 444.
8. Diary, December 15, 1909, FRAM 71.816; FR to Riccardo Bertelli, Friday [December 10, 1909], *Selected Letters*, p. 444.
9. Michael Edward Shapiro, *Cast and Recast: The Sculpture of Frederic Remington* (Washington, DC: Smithsonian Institution Press, for the National Museum of American Art, 1981), p. 99.
10. FR to Owen Wister, [January 1895], *Selected Letters*, p. 263.

Opposite page, detail:
The Broncho Buster © October 1, 1895
remodeled 1909
Roman Bronze Works cast no. 19
(ca. 1918-1919)

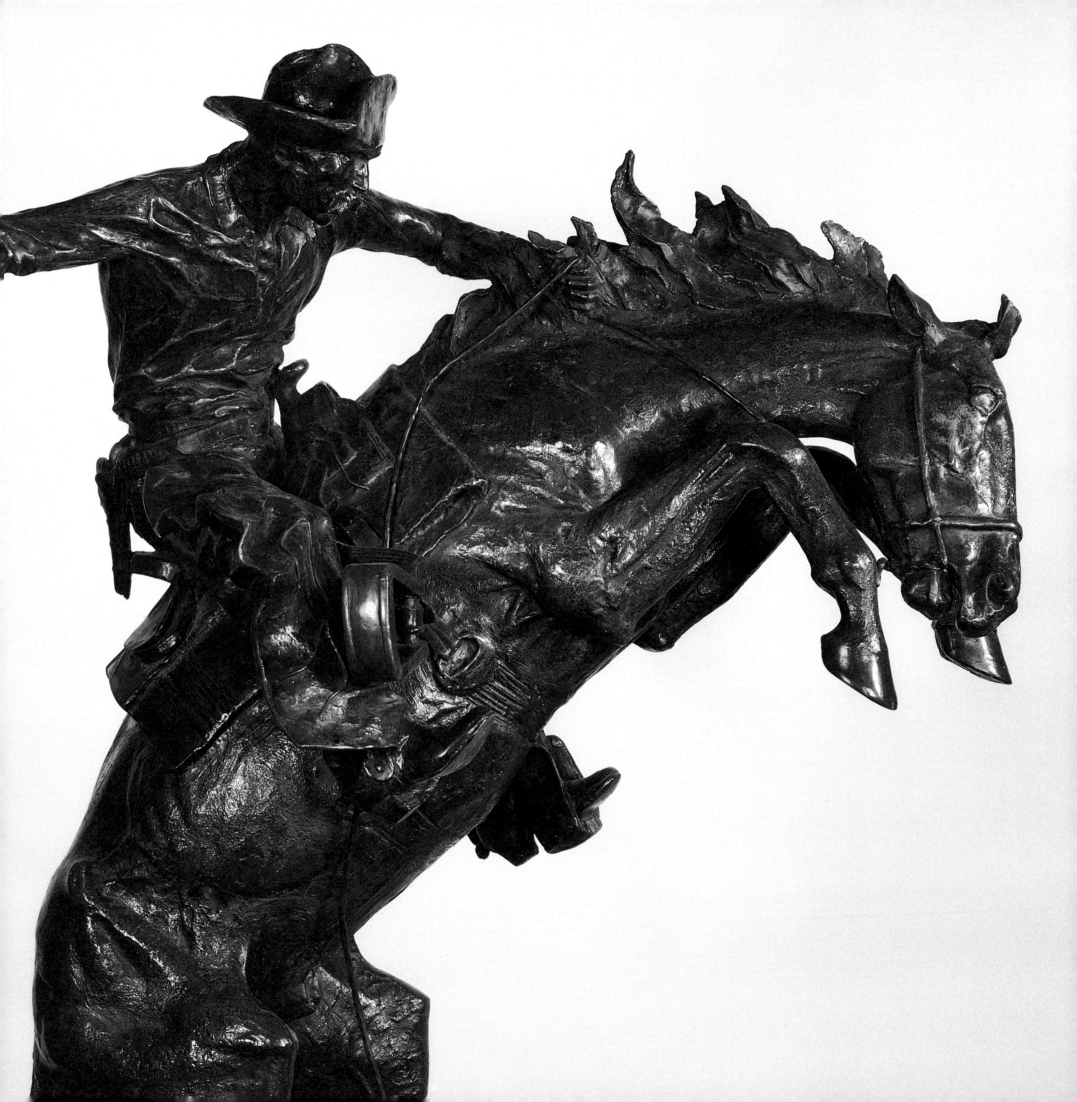

Index

Selected Bibliography

Allen, Douglas. *Frederic Remington and the Spanish-American War*. New York: Crown Publishers, 1971.

The Art of Frederic Remington: An Exhibition Honoring Harold McCracken at the Whitney Gallery of Western Art. Cody: Buffalo Bill Memorial Association, 1974.

Bacheller, Irving. "The Rustic Dance," *Cosmopolitan* 12 (April 1892): 650–52.

Baker, James A. *We Went to Heaven before We Died*. Rutland, VT: Academy Books, for the author, 1991.

Ballinger, James K. *Frederic Remington*. New York: Harry N. Abrams, in association with The National Museum of American Art, Smithsonian Institution, Washington, D.C., 1989.

___. *Frederic Remington's Southwest*. Phoenix: Phoenix Art Museum, 1992.

Barbusse, Henri (translated by Frederic Taber Cooper), *Meissonier*. New York: Frederick A. Stokes Company, 1914.

Barnes, James. "Frederic Remington—Sculptor," *Collier's Weekly*, March 18, 1905, p. 21.

Bederman, Gail. *Manliness & Civilization: A Cultural History of Gender and Race in the United States, 1880–1917*. Chicago: University of Chicago Press, 1995.

Bercovitch, Sacvan. *The American Jeremiad*. Madison: University of Wisconsin Press, 1978.

Bidwell, John. "The First Emigrant Train to California," *Century Magazine* 41 (November 1890): 106–30.

Bigelow, Poultney. "An Arabian Day and Night," *Harper's Monthly* 90 (December 1894): 3–13.

___. "The Cossack as Cowboy, Soldier, and Citizen," *Harper's Monthly* 89 (November 1894): 921–36.

___. "Emperor William's Stud-Farm and Hunting Forest," *Harper's Monthly* 88 (April 1894): 742–55.

___. "In the Barracks of the Czar," *Harper's Monthly* 86 (April 1893): 770–85.

___. "Why We Left Russia," *Harper's Monthly* 86 (January 1893): 294–307.

Bold, Christine. *Selling the Wild West: Popular Western Fiction, 1860–1960*. Bloomington: Indiana University Press, 1987.

Brooks, Noah. "'The Plains Across,'" *Century Magazine* 63 (April 1902): 803–20.

Brown, Mark H., and W. R. Felton. *Before Barbed Wire: L. A. Huffman, Photographer on Horseback*. New York: Henry Holt and Company, 1956.

Browne, Margaret Fitzhugh. "Frederic Remington's Wild West Comes East," *Boston Evening Transcript*, Mag. Sect., August 4, 1923.

Caffin, Charles H. "Frederic Remington's Statuettes: 'The Wicked Pony,' and 'The Triumph,'" *Harper's Weekly*, December 17, 1898.

Carpenter, Joan. "Frederic Remington's French Connection," *Gilcrease* 10 (November 1988): 1–26.

___. "Was Frederic Remington an Impressionist?," *Gilcrease* 10 (January 1988): 1–19. *Catalogue of a Collection of Paintings, Drawings and Water-colors by Frederic Remington, A.N.A*. New York: The American Art Galleries, 1893.

Chelette, Iona M., Katherine Plake Hough, and Will South. *California Grandeur and Genre: From the Collection of James L. Coran and Walter A. Nelson-Rees*. Palm Springs, CA: Palm Springs Desert Museum, 1991.

Cikovsky, Jr., Nicolai. "'The Ravages of the Axe': The Meaning of the Tree Stump in Nineteenth-Century American Art," *Art Bulletin* 61 (December 1979): 611–26.

Clarke, Powhatan. "A Hot Trail," *Cosmopolitan* 17 (October 1894): 706–16.

Coffin, William A. "American Illustration of To-day," *Scribner's Magazine* 11 (March 1892): 333–49.

___. "Remington's 'Bronco Buster,'" *Century Magazine* 52 (June 1896): 319.

Cortissoz, Royal. *American Artists*. New York: Charles Scribner's Sons, 1923.

___. "Frederic Remington: A Painter of American Life," *Scribner's Magazine* 47 (February 1910): 181–95.

Crawford, Alta M., and Gordon R. Schultz. "Frederic Remington: Artist of the People," *Kansas Quarterly* 9 (Fall 1977): 88–118.

Crooker, Orin Edson. "A Page from the Boyhood of Frederic Remington," *Collier's Weekly*, September 17, 1910, p. 28.

Custer, Elizabeth B. *Tenting on the Plains; or, General Custer in Kansas and Texas*. New York: Charles L. Webster & Co., 1887.

Davis, Charles Belmont, editor. *Adventures and Letters of Richard Harding Davis*. New York: Charles Scribner's Sons, 1917.

___. "Remington—The Man and His Work," *Collier's Weekly*, March 18, 1905, p. 15.

Davis, Richard Harding. *The West from a Car-Window*. New York: Harper & Brothers, 1892.

Deming, Therese O., compiler (edited by Henry Collins Walsh). *Edwin Willard Deming*. New York: The Riverside Press, 1925.

De Quille, Dan [W. Wright]. "An Indian Story of the Sierra Madre," *Cosmopolitan* 19 (June 1895): 180–95.

de Veer, Elizabeth, and Richard J. Boyle. *Sunlight and Shadow: The Life and Art of Willard L. Metcalf*. New York: Abbeville Press, and Boston University, 1987.

Dippie, Brian W., editor. *Charles M. Russell, Word Painter: Letters 1887–1926*. Fort Worth: Amon Carter Museum, with Harry N. Abrams, New York, 1993.

___. *Custer's Last Stand: The Anatomy of an American Myth*. Lincoln: University of Nebraska Press, 1994 [1976].

___. "Frederic Remington's West: Where History Meets Myth," in Chris Bruce, et al., *Myth of the West* (New York: Rizzoli, for the Henry Art Gallery, University of Washington, Seattle, 1990), pp. 110–19.

___. "Frederic Remington's Wild West," *American Heritage* 26 (April 1975): 6–23; 76–79.

___. *Remington & Russell (Revised Edition): The Sid Richardson Collection*. Austin: University of Texas Press, 1994.

___. *The Vanishing American: White Attitudes and U.S. Indian Policy*. Lawrence: University Press of Kansas, ca. 1982 [1991].

Edgar, Randolph, editor. *The Miller's Holiday: Short Stories from The Northwestern Miller*. Minneapolis: Miller Publishing Company, 1920.

Edgerton, Giles [Mary Fanton Roberts]. "Frederic Remington, Painter and Sculptor: A Pioneer in Distinctive American Art," *Craftsman* 15 (March 1909): 658–70.

Ewers, John C. "Cyrus E. Dallin: Master Sculptor of the Plains Indian," *Montana, the Magazine of Western History* 18 (January 1968): 34–43.

Fairbanks, Charles M. "Artist Remington at Home and Afield," *Metropolitan Magazine* 4 (July 1896): 445–50.

___. "'The Wounded Bunkie,'" *Harper's Weekly*, November 18, 1896. *The Frederic Remington Memorial, Ogdensburg, N.Y. Opened July 1923*. Ogdensburg, NY: Republican-Journal, [1923].

Frederic Remington (1861–1909): Paintings, Drawings, and Sculpture. Shreveport: The R. W. Norton Art Gallery, 1979.

Frederic Remington: The Soldier Artist. West Point, NY: The United States Military Academy—The Cadet Fine Arts Forum, 1979.

Fulton, Deoch, editor. *The Journal of Lieut. Sydenham 1889, 1890; And his notes on Frederic Remington*. New York: The New York Public Library, 1940.

Garland, Hamlin. "At the Brewery," *Cosmopolitan* 13 (May 1892): 34–42.

___. *Roadside Meetings*. New York: Macmillan Company, 1930.

Garrett, Charles H. "Remington and His Work," Success, May 13, 1899; in Orison Swett Marden, ed., *Little Visits with Great Americans; or, Success Ideals and How to Attain Them*, 2 vols. (New York: The Success Company, 1905), I, 327–33.

Godfrey, E. S. "Custer's Last Battle," *Century Magazine* 43 (January 1892): 358–84.

Greenbaum, Michael D. *Icons of the West: Frederic Remington's Sculpture*. Ogdensburg, NY: Frederic Remington Art Museum, 1996.

Harper, J. Henry. *The House of Harper: A Century of Publishing in Franklin Square*. New York: Harper & Brothers, 1912.

Harrington, Peter. *British Artists and War: The Face of Battle in Paintings and Prints, 1700-1914*. London: Greenhill Books, and Stackpole Books, Mechanicsburg, PA, in association with Brown University Library, Providence, RI, 1993.

Haskell, Francis, and Nicholas Penny. *Taste and the Antique: The Lure of Classical Sculpture, 1500-1900*. New Haven: Yale University Press, 1982.

[Hassrick, Peter H.] *Frederic Remington: The Late Years*. Denver: Denver Art Museum, 1981.

___. *Frederic Remington: Paintings, Drawings, and Sculpture in the Amon Carter Museum and the Sid W. Richardson Foundation Collections*. New York: Harry N. Abrams, in association with the Amon Carter Museum of Western Art, 1973.

___. *The Remington Studio*. Cody, WY: Buffalo Bill Historical Center, 1981.

___. "Frederic Remington's Studio: A Reflection," *The Magazine Antiques* 146 (November 1994): 666-73.

___, and Melissa J. Webster. *Frederic Remington: A Catalogue Raisonné of Paintings, Watercolors and Drawings*. Cody, WY: Buffalo Bill Historical Center, in association with University of Washington Press, Seattle, 1996.

Hoeber, Arthur. "Concerning Our Ignorance of American Art," *Forum* 39 (January 1908): 352–61.

___. "From Ink to Clay," *Harper's Weekly*, October 18, 1895.

Hogarth, Paul. *Artists on Horseback: The Old West in Illustrated Journalism 1857–1900*. New York: Watson-Guptill Publications, in cooperation with the Riveredge Foundation, Calgary, 1972.

Hoopes, Donelson F. *The American Impressionists*. New York: Watson-Guptill Publications, 1972.

Horan, James D. *The Great American West: A Pictorial History from Coronado to the Last Frontier*. New York: Crown Publishers, 1959.

___. *The Life and Art of Charles Schreyvogel: Painter-Historian of the Indian-Fighting Army of the American West*. New York: Crown Publishers, 1969.

Hough, Emerson. "Texas Transformed: A Story Regarding the Exchange of Certain Historical Hats," *Putnam's Magazine* 7 (November 1909): 200–07.

Howard, John C. *A History of the Ogdensburg Public Library and Remington Art Memorial*. Ogdensburg: Trustees of the Ogdensburg Public Library, [1938].

Hyde, Anne Farrar. *An American Vision: Far Western Landscape and National Culture, 1820-1920*. New York: New York University Press, 1990.

Jacobs, Wilbur R., editor. *Letters of Francis Parkman*, 2 vols. Norman: University of Oklahoma Press, in co-operation with The Massachusetts Historical Society, 1960.

Janvier, Thomas A. "The Mexican Army," *Harper's Monthly* 79 (November 1889): 813–27.

Jussim, Estelle. *Frederic Remington, the Camera & the Old West*. Fort Worth: Amon Carter Museum, 1983

___. *Visual Communication and the Graphic Arts: Photographic Technologies in the Nineteenth Century*. New York: R. R. Bowker Company, 1974.

King, Charles. *A Daughter of the Sioux*. New York: The Hobart Company, 1903.

Kipling, Rudyard. "The Maltese Cat," *Cosmopolitan* 19 (July 1895): 303–15.

Kobbe, Gustav. "A Painter of the Western Frontier," *Cosmopolitan* 31 (October 1901): 563–73.

Langellier, John, and Bill Younghusband. *US Dragoons 1833–1855*. London: Osprey, 1995.

Larson, Judy L. *American Illustration, 1890-1925: Romance, Adventure & Suspense*. Calgary, Alberta: Glenbow Museum, 1986.

Laut, Agnes C. "The Fights of the Fur Companies: A Chapter of Adventure in the Louisiana Purchase," *Century Magazine* 67 (April 1904): 797–816.

Lawrence, Elizabeth Atwood. *His Very Silence Speaks: Comanche—The Horse Who Survived Custer's Last Stand*. Detroit: Wayne State University Press, 1989.

Limerick, Patricia Nelson, Clyde A. Milner II, and Charles E. Rankin, editors. *Trails: Toward a New Western History*. Lawrence: University Press of Kansas, 1991.

Longfellow, Henry Wadsworth. *The Song of Hiawatha*. Boston: Houghton, Mifflin & Co., 1890.

Lorand, Ruth. "Beauty and Its Opposites," *Journal of Aesthetics and Art Criticism* 52 (Fall 1994): 399–406.

Madsen, Brigham D. *The Northern Shoshoni*. Caldwell, ID: The Caxton Printers, 1980.

Manley, Atwood. *Some of Frederic Remington's North Country Associations*. Ogdensburg: Northern New York Publishing Company, for Canton's Remington Centennial Observance, 1961.

___, and Margaret Manley Mangum. *Frederic Remington and the North Country*. New York: E. P. Dutton, 1988.

Maxwell, Perriton. "Frederic Remington—Most Typical of American Artists," *Pearson's Magazine* 18 (October 1907): 395–407.

McCracken, Harold. *Frederic Remington: Artist of the Old West*. Philadelphia: J. B. Lippincott Company, 1947.

___. *The Frederic Remington Book: A Pictorial History of the West*. Garden City, NY: Doubleday & Company, 1966.

___. *A Catalogue of the Frederic Remington Memorial Collection*. New York: Knoedler Gallery & Co., for The Remington Art Memorial, Ogdensburg, NY, 1954.

Meigs, John, editor. *The Cowboy in American Prints*. Chicago: The Swallow Press [Sage Books], 1972.

Morison, Elting E., editor. *The Letters of Theodore Roosevelt*, 8 vols. Cambridge: Harvard University Press, 1951-54.

Nemerov, Alexander. *Frederic Remington & Turn-of-the-Century America*. New Haven: Yale University Press, 1995.

Paintings and Drawings by Mr. Frederic Remington. Boston: Hart & Watson, [1897].

Parkman, Francis. *The Oregon Trail: Sketches of Prairie and Rocky-Mountain Life*. Boston: Little, Brown, and Co., 1892.

Pennell, Joseph. *Pen Drawing and Pen Draughtsmen…*. London and New York: Macmillan & Co., 1889.

Persons, Stow. "The Cyclical Theory of History in Eighteenth Century America," *American Quarterly* 6 (Summer 1954): 147–63.

Pizer, Donald, editor. *Hamlin Garland's Diaries*. San Marino, CA: The Huntington Library, 1968.

Pugh, David G. "Virility's Virtue: The Making of the Masculinity Cult in American Life, 1828–1890." Unpublished Ph.D. thesis, Washington State University, 1978.

Ralph, Julian. "Antoine's Moose-yard," *Harper's Monthly* 81 (October 1890): 651–66.

___. "Chartering a Nation," *Harper's Monthly* 84 (December 1891): 27–42.

___. "Dan Dunn's Outfit," *Harper's Monthly* 83 (November 1891): 880–94.

___. "Frederic Remington," *Harper's Weekly*, January 17, 1891, p. 43.

___. "Frederic Remington," *Harper's Weekly*, February 2, 1895, p. 688.

___. *On Canada's Frontier: Sketches of History, Sport, and Adventure and of the Indians, Missionaries, Fur-Traders, and Newer Settlers of Western Canada*. New York: Harper & Brothers, 1892.

___. "Where Time Has Slumbered," *Harper's Monthly* 89 (September 1894): 613–29.

Remington, Frederic. *A Bunch of Buckskins*. New York: R. H. Russell, 1901.

___. "A Few Words from Mr. Remington," *Collier's Weekly*, March 18, 1905, p. 16.

___ (introduction by Owen Wister). *Done in the Open*. New York: P. F. Collier & Son, 1903.

___ (introduction by Owen Wister). *Drawings*. New York: R. H. Russell, 1897.

___. "With the Fifth Corps," *Harper's Monthly* 97 (November 1898): 962–75.

Rieske, Bill, and Verla Rieske. *Historic Indian Portraits: 1898 Peace Jubilee Collection*. Salt Lake City: Historic Indian Publishers, 1974.

Roosevelt, Theodore. "Buffalo-Hunting," *St. Nicholas* 17 (December 1889): 136–43.

___. "In Cowboy-Land," *Century Magazine* 46 (June 1893): 276–84.

___. "Frontier Types," *Century Magazine* 36 (October 1888): 831–43.

___. "The Home Ranch," *Century Magazine* 35 (March 1888): 655–69.

___. *National Ideals/The Strenuous Life/Realizable Ideals*. (The Works of Theodore Roosevelt [National Edition], Vol. XIII.) New York: Charles Scribner's Sons, 1926.

___. "Ranch Life in the Far West: In the Cattle Country," *Century Magazine* 35 (February 1888): 495–510.

___. "The Ranchman's Rifle on Crag and Prairie," *Century Magazine* 36 (June 1888): 200–12.

___. "The Rough Riders: Raising the Regiment," *Scribner's Magazine* 25 (January 1899): 3–20.

___. "The Rough Riders: The Cavalry at Santiago," *Scribner's Magazine* 25 (April 1899): 420–40.

___. "The Rough Riders: The Return Home," *Scribner's Magazine* 25 (June 1899): 677–93.

___. "The Round-up," *Century Magazine* 35 (April 1888): 849–67.

___. "Sheriff's Work on a Ranch," *Century Magazine* 36 (May 1888): 39–51.

Samuels, Peggy, and Harold Samuels, editors. *The Collected Writings of Frederic Remington*. Garden City, NY: Doubleday & Company, 1979.

___. *Frederic Remington: A Biography*. Garden City, NY: Doubleday & Company, 1982.

___. "Frederic Remington, the Holiday Sheepman," *Kansas History* 2 (Spring 1979): 2–13.

___. *Remington: The Complete Prints*. New York: Crown Publishers, 1990.

Schreyvogel, Charles. *My Bunkie and Others: Pictures of Western Frontier Life*. New York: Moffat, Yard & Company, 1909.

Schwatka, Frederick. "The Sun-Dance of the Sioux," *Century Magazine* 39 (March 1890): 753–59.

Scott, Hugh Lenox. *Some Memories of a Soldier*. New York: The Century Co., 1928.

Shapiro, Michael Edward. *Cast and Recast: The Sculpture of Frederic Remington*. Washington, D.C.: Smithsonian Institution Press, for the National Museum of American Art, 1981.

___, and Peter H. Hassrick. *Frederic Remington: The Masterworks*. New York: Harry N. Abrams, for the Saint Louis Art Museum, in conjunction with the Buffalo Bill Historical Center, Cody, 1988.

Special Exhibition of Recent Paintings by Frederic Remington. New York: Noé Galleries, 1906.

Splete, Allen P., and Marilyn D. Splete, editors. *Frederic Remington—Selected Letters*. New York: Abbeville Press, 1988.

Stewart, Rick, Joseph D. Ketner II, and Angela L. Miller. *Carl Wimar: Chronicler of the Missouri River Frontier*. Fort Worth: Amon Carter Museum, distributed by Harry N. Abrams, New York, 1991.

Summerhayes, Martha. *Vanished Arizona: Recollections of the Army Life of a New England Woman*. Salem, MA: The Salem-Press Co., 2nd ed., 1911.

Sutherland, A. *A Summer in Prairie-land: Notes of a Tour through the North-West Territory.* Toronto: Methodist Book and Publishing House, 1881.

Sutton, Royal. *The Face of Courage: The Indian Photographs of Frank A. Rinehart.* Fort Collins, CO: The Old Army Press, 1972.

Taft, Robert. *Artists and Illustrators of the Old West, 1850–1900.* New York: Charles Scribner's Sons, 1953.

___. "The Pictorial Record of the Old west, V: Remington in Kansas," *Kansas Historical Quarterly* 16 (May 1948): 113–35.

Tatham, David, and Atwood Manley. *Artist in Residence: The North Country Art of Frederic Remington.* Ogdensburg: Frederic Remington Art Museum, 1985.

Testi, Arnaldo. "The Gender of Reform Politics: Theodore Roosevelt and the Culture of Masculinity," *Journal of American History* 81 (March 1995): 1509–1533.

Thomas, Augustus. *The Print of My Remembrance.* New York: Charles Scribner's Sons, 1922.

___. "Recollections of Frederic Remington," *Century Magazine* 86 (July 1913): 354–61.

Tompkins, Jane. *West of Everything: The Inner Life of Westerns.* New York: Oxford University Press, 1992.

Upton, Richard, compiler. *The Indian as a Soldier at Fort Custer, Montana.* El Segundo, CA: Upton and Sons, 1983.

Usherwood, Paul, and Jenny Spencer-Smith. *Lady Butler, Battle Artist, 1846–1933.* London: Alan Sutton Publishing Limited, for the National Army Museum, 1987.

Vorpahl, Ben Merchant. *My Dear Wister—: The Frederic Remington-Owen Wister Letters.* Palo Alto: American West Publishing Company, 1972.

___. *Frederic Remington and the West: With the Eye of the Mind.* Austin: University of Texas Press, 1978.

Waring, George E., Jr. "The Horse in Motion," *Century Magazine* 24 (July 1882): 381–88.

White, G. Edward. *The Eastern Establishment and the Western Experience: The West of Frederic Remington, Theodore Roosevelt, and Owen Wister.* New Haven: Yale University Press, 1968.

White, Richard, and Patricia Nelson Limerick. *The Frontier in American Culture.* Berkeley: University of California Press, for the Newberry Library, Chicago, 1994.

Whyte, Jon, and E. J. Hart. *Carl Rungius: Painter of the Western Wilderness.* Vancouver, B.C.: Douglas & McIntyre, in association with The Glenbow-Alberta Institute, 1985.

[Wildman, Edwin] "Along the water Trail to Frederic Remington's Island Home," *New York Herald,* Magazine Section, August 23, 1908, p. 7.

___. "Frederic Remington, the Man," *Outing* 41 (March 1903): 712–16.

Willing, Paul. *L'Expédition du Mexique (1861–1867) et la guerre Franco-Allemande (1870-1871).* Les collections historiques du Musée de l'Armée, 3. Arcueil: P.R.E.A.L., for Société des amis du Musée de l'Armée, 1984.

Wilson, R. C. "The Great Custer Battle of 1903," *Mankind* 5 (February 1976): 52 59.

Wister, Fanny Kemble, editor. *Owen Wister Out West: His Journals and Letters.* Chicago: University of Chicago Press, 1958.

Wister, Owen. "The Evolution of the Cow-Puncher," *Harper's Magazine* 91 (September 1895): 602–17.

___. "A Kinsman of Red Cloud," *Harper's Monthly* 88 (May 1894): 907–17.

___. "Remington—An Appreciation," *Collier's Weekly,* March 18, 1905, p. 15.

___. *Roosevelt: The Story of a Friendship,* 1880-1919. New York: Macmillan Company, 1930.

Wood, Eric Fisher. *Leonard Wood: Conservator of Americanism.* New York: George H. Doran Company, 1920.

Wood, Leonard. "The Man We Knew," *Collier's Weekly,* January 8, 1910. p. 12

Wylder, Delbert E. *Emerson Hough.* New York: Twayne Publishers, 1981.